Aphrodite
AND THE GODS OF LOVE

Aphrodite
AND THE GODS OF LOVE

Edited by Christine Kondoleon with Phoebe C. Segal

with contributions by Jacqueline Karageorghis, Christine Kondoleon,
Rachel Kousser, Diana K. McDonald, Vinciane Pirenne-Delforge,
Gabriella Pironti, David Saunders, and Phoebe C. Segal

MFA PUBLICATIONS
Museum of Fine Arts, Boston

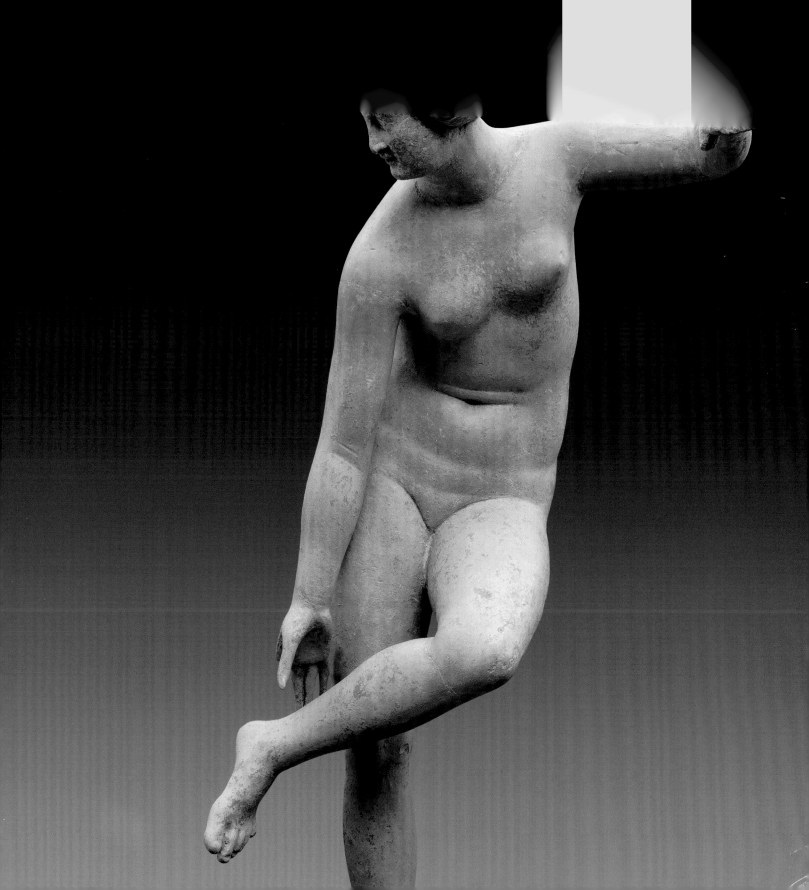

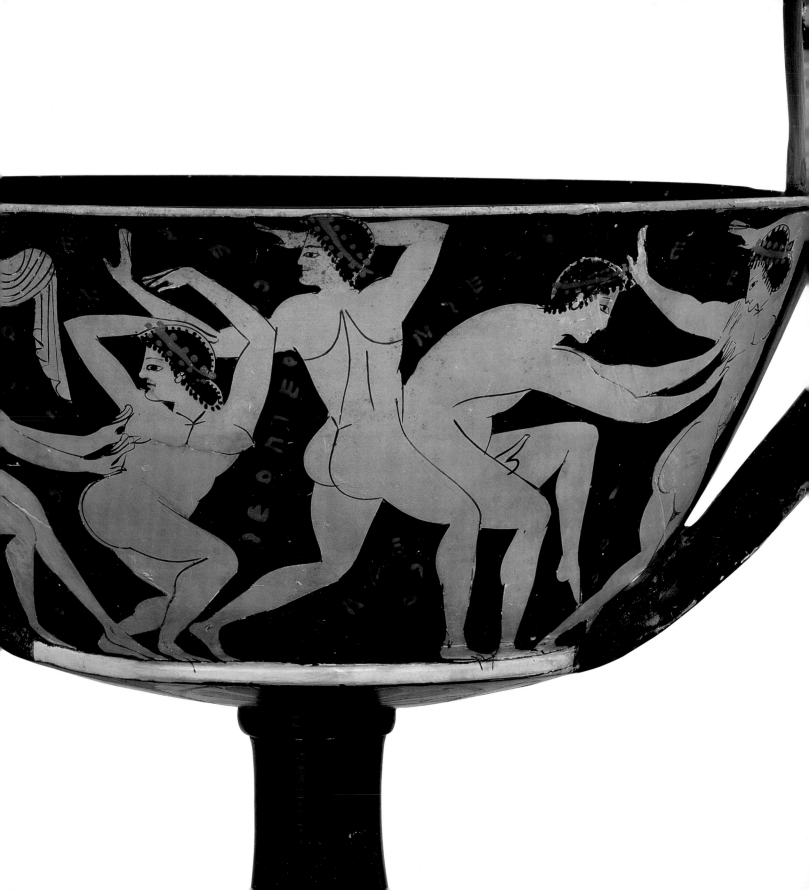

CONTENTS

.

DIRECTOR'S FOREWORD

■ ■ ■ ■ ■

WE ARE PROUD TO PRESENT "Aphrodite and the Gods of Love," the first exhibition in the United States to explore the subject of the ancient Greek goddess of love and beauty. While most of the works are drawn from our own distinguished collection of Greek and Roman art, the exhibition is greatly enriched by important loans from Naples and Rome. Images of the goddess and her associates, especially her ever-popular son Eros, reveal to us the many facets of the goddess in Greek myth, ritual, and everyday life. The exhibition charts Aphrodite's origins in the Near East, especially on Cyprus; her rise as a major deity for the Greeks; and her central role for the Romans as the divine ancestor of Julius Caesar and Augustus.

Boston's collection is rich in representations of Aphrodite and her children, the love gods Priapos, Eros, and Hermaphrodite. This is due in large part to the collecting tastes and passions of Edward Perry Warren around the turn of the twentieth century. A favorite of his was a fourth-century-B.C. marble head of Aphrodite, a star of this exhibition. It was one of the earliest fragments of antiquity to become widely known and admired in the United States—Henry James was moved to describe this very head when writing about our young museum in his book *The American Scene* in 1907.

We gratefully acknowledge our generous exhibition sponsor United Technologies Corporation, and the A. G. Leventis Foundation for providing the funding for this catalogue. We also want to thank the Leon Levy Foundation for their grant that made possible the conservation of the Greek vases in the show, the John and Sonia Lingos Family Foundation for their support of the handheld multimedia guide, and the Hellenic Women's Club (EOK) for supporting the conservation of the marble inscription that is a centerpiece of the exhibition. Great Roman works are on loan thanks to our Italian colleagues at the Museo Archeologico Nazionale di Napoli and the Palazzo Massimo alle Terme, Museo Nazionale Romano. These loans continue our historic partnership with Italy. We are also grateful to the Worcester Art Museum, Massachusetts; the Bowdoin College Museum of Art, Brunswick, Maine; and an anonymous private lender for loans that have enriched our exhibition.

MALCOLM ROGERS
Ann and Graham Gund Director
Museum of Fine Arts, Boston

SPONSOR'S FOREWORD

■ ■ ■ ■ ■

THE A.G. LEVENTIS FOUNDATION is delighted to support the publication of this catalogue, which complements the exhibition "Aphrodite and the Gods of Love." This is the first time that an exhibition mounted in the United States has been dedicated to Aphrodite; it will be a unique opportunity for the wider American public to explore this enigmatic goddess, who is so strongly and evocatively connected with our concepts of female beauty and human love.

The calibre of the international scholars brought together to contribute to this catalogue ensures not only that it will be a befitting companion to this exceptional exhibition, but also that it will also stand independently as an important tool to bring the many different aspects of the fascinating persona of Aphrodite to light.

For over thirty years the A. G. Leventis Foundation has viewed the preservation and promotion of the cultural heritage of Cyprus as one of its central concerns. Aphrodite is seen by many as the emblem of the island, one of our most famous "exports." It is fitting that our Foundation has been able to assist in bringing this important project to fruition.

ANASTASIOS P. LEVENTIS
Chairman
The A. G. Leventis Foundation

ACKNOWLEDGMENTS

■ ■ ■ ■ ■

APHRODITE AND THE GODS OF LOVE features many superb and fascinating objects from the Greek and Roman collection of the Museum of Fine Arts, Boston. This exhibition made its first appearance in a different form at our sister museum, the Nagoya/Boston Museum of Fine Arts in Japan, tracing the development of the goddess visually through the ages until modern times; in its current incarnation, "Aphrodite and the Gods of Love" highlights the depth of our holdings. I would like to thank Ann and Graham Gund Director Malcolm Rogers, Deputy Director Katherine Getchell, and the exhibition committee for their enthusiastic support of both shows. I am also grateful to the team at Nagoya—Director Dr. Shinkuchi Baba, Secretary General Takeshi Nagura, General Manager Satoko Inokuchi, and most especially Curator Emiko Tanaka—for their keen interest and excellent presentation of the first phase of this exhibition.

Outstanding loans from the collections in Rome and Naples add immeasurable depth and an international dimension to our show and allow us to more fully present the goddess in her ancient context. These Italian loans also represent a continuation of the special relationship between the Republic of Italy and the Museum of Fine Arts, Boston, and we are honored to be part of the programming for the 150th anniversary of the Italian Republic. The support of our colleagues, particularly Stefano de Caro, Rosanna Binacchi, and Anna Maria Moretti, at the Ministero per i Beni e le Attività Culturali in Rome and Naples has proved invaluable. The friendship and support of the Consul General of Italy in Boston, Giuseppe Pastorelli, and his predecessor, Liborio Stellino, is much appreciated. We also remain grateful to the Embassy of Italy in Washington, D.C., for its continued interest in and collaboration with the MFA.

For their help in facilitating loans, I would like to express our gratitude to Valeria Sampaolo at the Museo Archeologico Nazionale in Naples; Rita Paris at the Palazzo Massimo alle Terme, Museo Nazionale Romano, in Rome; James Welu at the Worcester Art Museum in Massachusetts; Kevin Salatino at the Bowdoin College Museum of Art in Brunswick, Maine; and Laura Siegel at Robert Haber Ancient Art in New York who assisted with the loan from a private lender who wishes to remain anonymous. We also appreciate the enthusiasm and interest of our curatorial colleagues at the respective venues, most especially Karol Wight, Claire Lyons, Ken Lapatin, and David Saunders at the Getty Villa in Malibu, California, and Jessica Powers at the San Antonio Museum of Art in Texas.

I am deeply grateful to United Technologies Corporation for their support of this exhibition in Boston and to the A. G. Leventis Foundation for their grant that made it possible to produce this volume. The Leon Levy Foundation grant was critical for the conservation of several Greek vases in the exhibition, the John and Sonia Lingos Family Foundation generously funded the handheld multimedia guide, and the Hellenic Women's Club (EOK)

made possible the conservation of the monumental marble inscription. For the contents of the catalogue, I am indebted to the authors, Jacqueline Karageorghis, Diana K. McDonald, Vinciane Pirenne-Delforge, Gabriella Pironti, Rachel Kousser, David Saunders, and Phoebe Segal. Each of them carefully considered the challenge posed by the exhibition within their respective fields of expertise. John Oakley deserves much credit for generously sharing his knowledge and insights about Aphrodite and marriage in ancient Greek culture. We also learned a great deal about Aphrodite from scholars Bettina Bergmann, Stephanie Budin, Sadie Pickup, Amy Smith, Alan Shapiro, Jeff Spier, and Anja Ulbrich. Cliff Ackley, Department Chair and Ruth and Carl J. Shapiro Curator of Prints, Department of Prints, Drawings, and Photographs, kindly allowed us to include four beautiful prints.

Among the individuals at the MFA who contributed to "Aphrodite and the Gods of Love," I want first and foremost to name Phoebe Segal, the curatorial research associate for the exhibition, who has worked steadily and with great scholarly insight and curatorial passion on this project for over three years. In addition, I want to single out Brenda Breed for her diligent work in the initial stages of this project. For their sagacity and valuable support, I also want to thank my colleagues in the Department of Art of the Ancient World: Lawrence Berman, Norma Jean Calderwood Senior Curator of Ancient Egyptian, Nubian, and Near Eastern Art; Lisa Çakmak, Niarchos Classical Fellow; Mary Comstock, Cornelius and Emily Vermeule Curator and Keeper of Coins, Greek and Roman Art; Denise Doxey, curator, Ancient Egyptian, Nubian, and Near Eastern Art; Rita Freed, John F. Cogan, Jr. and Mary L. Cornille Chair, Art of the Ancient World; Laura Gadbery, Curatorial Planning and Project Manager; Richard Grossmann, Mary Bryce Comstock Assistant Curator of Greek and Roman Art and Keeper of Coins and Medals, and John Herrmann, Jr., John F. Cogan Jr. and Mary L. Cornille Curator Emeritus, Classical Art.

Abigail Hykin oversaw the remarkably successful conservation of the objects by a talented team including Flavia Perugini, Kent Severson, Monica Berry, and Nina Vinogradskaya. Brett Angell, Steve Deane, Jean-Louis Lachevre, and Dante Vallance created a diverse array of mounts. Kim Simpson and James Cain assisted with the transportation and storage of the objects. In the Registrar's office, Siobhan Wheeler coordinated the loans and arranged the logistics of the tour of the exhibition; Victoria Reed, Monica S. Sadler Curator for Provenance, and Julia McCarthy assisted with provenance research. I would like to thank our Exhibitions and Design team led by Patrick McMahon, especially Anna Bursaux, who negotiated the tour of the exhibition; Virginia Durruty, the exhibition designer; and, for her graphic displays, Jennifer Liston Munson. For didactics in the exhibition and related public programs, I thank Ben Weiss, Leonard A. Lauder Curator of Visual Culture; Barbara Martin, Barbara and Theodore Alfond Curator of Education; Jenna Fleming; and Lois Solomon. Melissa Gallin in Development assisted us with our foundation and corporate outreach. I am indebted to Mark Polizzotti, Emiko Usui, Cynthia Randall, Terry McAweeney, and Jodi Simpson at MFA Publications, and editor Julia Gaviria, for their help in producing this attractive catalogue, and to Greg Heins and Michael Gould of the MFA's Imaging Studios for the handsome photographs that fill these pages.

CHRISTINE KONDOLEON
George D. and Margo Behrakis Senior Curator of Greek and Roman Art
Museum of Fine Arts, Boston

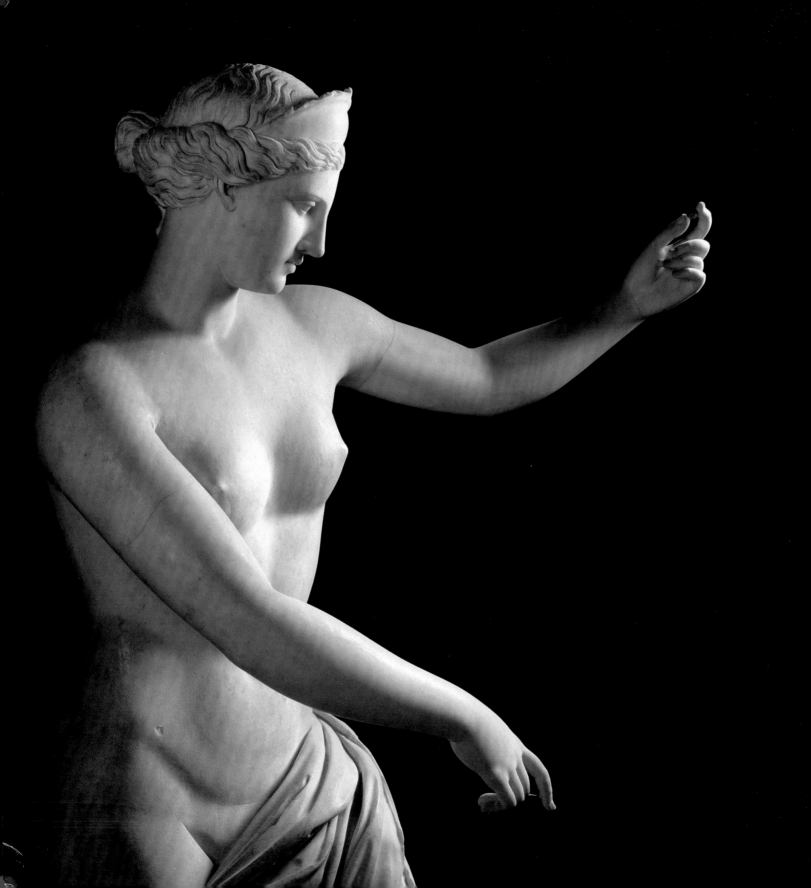

INTRODUCTION

.

Christine Kondoleon

ecognized today as the Greek goddess of love and beauty, Aphrodite (or Venus, as the Romans knew her) was among the most powerful divinities and a popular subject in ancient art. *Aphrodite and the Gods of Love*, published to accompany the first exhibition devoted solely to Aphrodite and her realm, brings together some of the most significant and best-known depictions of the goddess from the MFA's collections, enriched by outstanding works from Italy.

Aphrodite appeals across time to modern tastes and sensibilities, but it is important to recognize that her image today has been filtered through the perspectives of the eighteenth, nineteenth, and twentieth centuries. Indeed, while the postclassical reception of the goddess has focused on her legacy as an icon of romantic love and ideal beauty, ancient sources describe a much more varied, complex, even dangerous figure. The objects gathered in this book reveal Aphrodite in her multivalent roles as adulterous seductress; instigator of sexual desire; mother to the mischievous Eros and to the sexual outliers Hermaphrodite and Priapos; patroness of brides, seafarers, and warriors; and an agent of political harmony. The many epithets applied to her—Enoplon (armed), Pontia (of the sea), Epistrophia (head twister), and Charidotes (joy giver), among others—express her range of powers and spheres of influence, and sometimes point to her dual nature, for she was both earthly (Pandemos) and celestial (Ouranos), a promoter of communal peace who also incited men to arms. Ancient women and female divinities and their cults have been the topic of much scholarly attention, but a focus on Aphrodite herself has been slower to gather momentum. Relatively recent studies of the goddess have made it possible to approach her with fresh eyes, and the exceptional holdings of the MFA's collection allow for a visual testing of these new insights.

The present book is organized into five sections, beginning with an exploration of Aphrodite's origins and ancestors in the Near East, Egypt, and Cyprus. According to legend, it was in Cyprus, a Mediterranean crossroads, that she alighted onto earth and from Cyprus that her cult spread to the

Greek mainland. In Greece, Athens and Corinth in particular provided fertile ground for the development of Aphrodite's cult, judging by the discovery of sanctuaries and votives, and these worship centers are the focus of the second section. The third section discusses the paradox of Aphrodite as both an unfaithful wife with famous sexual liaisons (Ares, Anchises, Adonis) and a patroness of Greek brides. Since seduction was the key to producing legitimate heirs—the primary goal of marriage—Aphrodite's image often appears on Greek nuptial vessels, as well as on objects relating to beautification (such as perfume jars, mirrors, and jewelry) used by brides in preparation for their weddings. In the fourth section the focus shifts to the many faces of Aphrodite's son Eros (Cupid to the Romans), who dominates gods and humans and sometimes even controls his mother. The ancient perception of Aphrodite as a powerful deity, even surpassing Herakles in might, was often expressed through Eros's mischief, while concepts of sexuality were conveyed in myths and artworks about Aphrodite's other children, Priapos and Hermaphrodite. Finally, the fifth section is devoted to the theme of ideal beauty, both for public admiration and for private functions. Aphrodite's female sensuality was most dramatically and boldly conceived by Praxiteles (fourth century B.C.), who presented her as a nude bather, thereby introducing the female nude in Western art for the first time (see fig. 9, p. 150).

Throughout, both exhibition and catalogue consider how visual representations of Aphrodite have evolved across time and place as a key to understanding her dynamic identity. From her early worship in the Near East as a fertility deity and her legendary birth in the waters off Cyprus, where she was worshipped initially in the aniconic form of a black rock, to the voluptuous figure she acquired in the hands of Greek sculptors, who gave her lasting form as a goddess of sex and desire, and finally through her Roman incarnation as Venus, mother of Aeneas and divine ancestor of Augustus, her story took thousands of years to unfold. Moreover, because she figured so prominently in the daily lives of mortals—she controlled their desires, their loves, and their fertility—this story is fraught with dramatic twists and turns.

The random texts and artworks that have survived give us only a glimpse of the complicated process by which the goddess took form. Our clues come from teasing out how she was received in different times, places, and cultures—for the challenges of understanding the Hellenistic Aphrodite, often depicted as a nude bather, are distinct from those of the Roman Venus, who appears with a spear and shield. Her meaning and function also vary depending on whether she is in a temple, a public market, or a private gar-

den. Yet there are also notable points in common. Both Greeks and Romans associated Aphrodite with gardens and vegetation, for instance. Her most official temple in Athens was known as en Kepois, or "in the gardens," and one of the most popular Greek religious festivals was the mourning of Adonis, Aphrodite's handsome mortal lover, whom Athenian women commemorated by planting seedlings on their roofs. Meanwhile, various Roman authors, such as Varro and Pliny, characterized Venus as the one who protects the gardens—or as Plautus amusingly put it in a fragment: "The cook ate Neptune [fish], Ceres [bread], Venus [vegetables] too, That had known Vulcan [fire]."[1] As is well known, the names of the goddess and her children vary depending on whether we're speaking about Greeks or Romans, and the same holds true for artistic style; Roman sculptors tended to emulate the Greek artists, and some objects found in Roman contexts are clear adaptations of earlier Greek models. Here again, however, the division between Greek and Roman cultures is not always so clear, as some objects were made in the Roman East specifically for Greeks.

Inscriptions speak across centuries of the goddess's pervasive influence on her ancient followers. The earliest Greek writing that refers specifically to Aphrodite is a verse on a drinking cup from the late eighth century B.C.:[2] "I am Nestor's wine-cup, good to drink from. Whoever drinks from this wine-cup, beautifully crowned Aphrodite's desire will seize him immediately"—an early example of the age-old link between drinking and desire. Art produced for the Greek symposium, such as painted vases and poetry, similarly immortalized these themes; as we learn from Plato, topics of love and ideal beauty were often discussed at these male drinking parties, and the characteristics of the heavenly and earthly Aphrodite vigorously debated. For Plato, beauty is the object of love; as he states in the *Symposium*, "Eros was born to follow and serve Aphrodite."[3] But Plato also finds Eros in artistic and intellectual pursuits such as science, poetry, and law.

The cult of Aphrodite, associated as it was with bodily desire (*porneia*), has been characterized by the scholar Nigel Spivey as "a shameless salutation of life below the belt."[4] Ancient texts refer to her devotees practicing her arts, *ta aphrodisia* (caresses and sex), often on cushions set up in the fragrant gardens surrounding her temple. There is no doubt that Western notions of the female nude and the ensuing history of its objectification by the male gaze started its art-historical life with the sculpture of Aphrodite that Praxiteles created for the temple at Knidos, which Pliny the Elder in the first century A.D. hailed as the greatest sculpture in the world.[5] Indeed, this marble likeness even moved some admirers to passionate acts. Lucian, the

Greek satirist of the second century A.D., relates how he and two traveling companions, one heterosexual and the other homosexual, were visiting the Knidian Aphrodite, each of them finding her irresistible. They remark on a stain on her marble backside, which a priestess explains was left there by a youth who had spent the night locked in with the statue. When he had consummated his unrequited passion for the goddess, he threw himself into the sea.[6] Later, the statue was removed by Constantine for his new Christian capital along the Bosphorus, where not surprisingly it was maligned by Christian bishops and eventually destroyed.

The Platonic notion of Aphrodite's dual nature prevailed in the Renaissance, with the earthly, sensual goddess depicted as a nude, and the intellectual, heavenly one draped. In more modern times, eighteenth- and nineteenth-century gentleman collectors and scholars were drawn to the goddess and her related deities because of their predilection for erotic art, especially phallic imagery. Several of the more prominent ones, such as Sir Richard Payne Knight and Sir William Hamilton, actively revived the cult of Priapos and collected works related to the phallus for a "Secret Museum" at the British Museum. They attributed their interests to the generative powers of sexual organs that they related to creativity in all fields, but the fact is that latter-day antiquarians, like their ancient predecessors, often valued the goddess and her offspring mainly as a means of exploring sexuality. The collection of such works continued into the late nineteenth century and counted among its participants such noted travelers and intellectuals as Goethe and Freud. To put in perspective how "modern" the antiquarians really were, consider that only in 2000 did the Italian authorities open to the public the reserved cabinet of "obscene art" (the Gabinetto Segreto) at the National Archaeological Museum in Naples.

The American classicist Edward Perry Warren (1860–1929) was a worthy successor to these earlier antiquarians, and his taste exerted a great influence on the MFA's collection of ancient arts.[7] Warren, a dealer, collector, and philosopher, had perspicacious insights into the meaning and function of erotic works in ancient society. Most specifically, he acquired works that revealed the Greek taste for homoerotic subjects. His passion for Greek art expressed his personal proclivities and a lifestyle shaped around Greek aesthetics and male companionship. As one historian succinctly put it, "Without Warren we would know much less than we do about homosexuality and classical art."[8] Warren's family ties to Boston and to the MFA motivated his many important gifts, but he also acted as a purchasing agent in partnership with his companion from Oxford, John Marshall. The activities

of these two men from 1894 to 1904 allowed Boston to form the premier collection of Greek and Roman art in America. They were responsible for the acquisition of the famed Bartlett Head (cat. no. 125, p. 174), the Capitoline Aphrodite (cat. no. 127, p. 155), and the Marlborough Gem (cat. no. 113, p. 141)—all world-renowned objects that are highlighted in this book. The exhibition spotlights for the first time Warren's unusual taste, in stark contrast to the treatment given many of his acquisitions, which were hidden away from public view for fear they might offend. For example, the large-scale marble Priapos (cat. no. 123, p. 131) and the Roman reliefs with copulation scenes (cat. no. 101, p. 120; cat. no. 107, p. 127) were oddities for the times in which they were collected, but today they offer unique insights into ancient life.

While artists and writers kept Aphrodite vibrant and vivid through the ages, scholars seemed to shy away from exploring her until more recently. What makes this especially curious is that, rather than being an obscure recent discovery, Aphrodite is a well-known goddess whose profile and myths have been integrated into Western art and literature for many centuries. Perhaps her association for the ancients with mixis (sexual coupling) and desire, through the agency of her son Eros, proved too sensitive a topic for most earlier students of the ancient world. But over the past decades, as discussions about sexuality have become more open and mainstream, the love goddess has begun emerging from the haze of saccharine sweetness and idealized loveliness to appeal to a new generation, one better prepared for her complexities and contradictions. This book, like the exhibition it accompanies, announces that her time has come again.

CHRISTINE KONDOLEON
George D. and Margo Behrakis Senior Curator of Greek and Roman Art
Museum of Fine Arts, Boston

APHRODITE'S ANCESTORS

■ ■ ■ ■ ■

Diana K. McDonald
Jacqueline Karageorghis

ANCIENT NEAR EASTERN GODDESSES OF LOVE

Great light, heavenly lioness, always speaking words of assent! Inana, great light, lioness of heaven
—HYMN TO INANA AS NINEGALA (INANA D)

phrodite, the "Heavenly One," was the femme fatale of Mount Olympus. She was irresistibly beautiful, powerful, capricious, tempestuous, and famous for the unhappy fates of her various lovers. As such, she was a perfect subject for the arts. The European tradition of the nude female in art began in the mid-fourth century B.C. with Praxiteles's famed Aphrodite of Knidos (see fig. 9, p. 150). This sculpture, which broke from the Western custom of depicting female forms draped, in reality reflected a long tradition in the ancient Near East of goddesses who were forthright in their sexuality. Indeed, Aphrodite's alluring and dangerous qualities arose from her many predecessors in the ancient Near East. Beginning in the late 4th millennium B.C., the Sumerians, who inhabited Mesopotamia ("the land between two rivers" to the Greeks; present-day Iraq), built temples to Inana, "Lady of Heaven," a complex goddess of love and nature. She was called Ishtar in the Semitic tongue of the Akkadians, the succeeding occupants of Mesopotamia (beginning about 2390 B.C.), who endowed her with a more aggressive character, and in the following millennia she was worshipped as a goddess of sex and war.

This powerful Mesopotamian goddess, often referred to today by the dual name Inana/Ishtar, was associated with attributes and symbols—including nudity, the morning and evening star, the lion, birds, and objects of war—that later appear in the imagery of Aphrodite and other Near Eastern goddesses. In particular, Ishtar's lion companion provides the key to her complex nature.[2]

Aphrodite came to Greece by way of Cyprus, but her manifestation was heavily influenced by the goddesses to the east. In addition to the Sumerian Inana and the later Akkadian Ishtar, Ishara, a goddess of sex in the

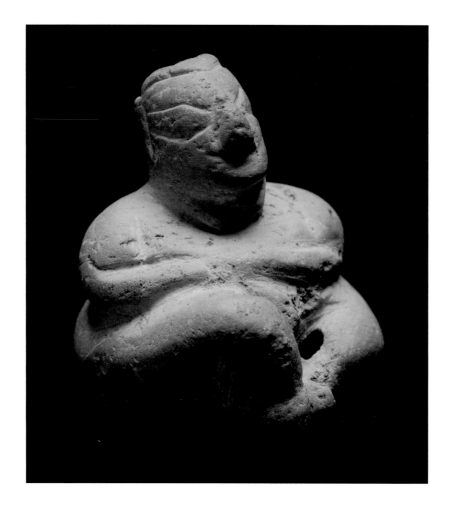

Semitic tradition, perhaps a bridal version of Ishtar, may also have contributed to Aphrodite's persona.[3] She also appears to have been influenced by a number of goddesses from the Levant, notably Astarte, a West Semitic version of Ishtar, who is often depicted nude, standing on lions or horses. Astarte and other Syrian goddesses, including Qudsu or Quedeshef, spread to Egypt and became popular during the New Kingdom (1550–1070 B.C.). These goddesses were depicted frontally nude, in association with lions, horses, snakes, and other animals; Qudsu is shown standing on the back of a lion in an Egyptian stele of the Nineteenth Dynasty (1295–1203 B.C.).[4] In Egypt, the indigenous goddess Hathor ruled over the realms of love, sex, motherhood, music, and funerary ritual, and was often shown in the guise of a heavenly cow, an epithet also applied to Inana in Sumerian literature: "You are a great cow among the gods of heaven and earth."[5]

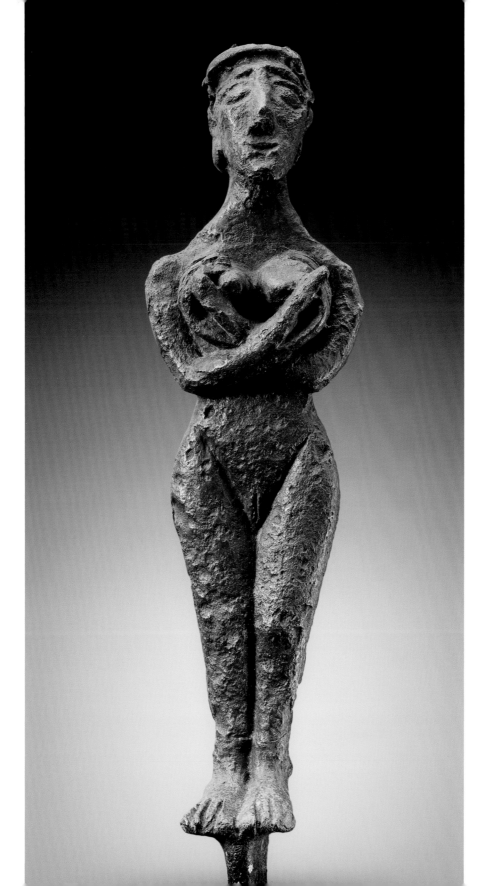

Figurine of a nude female holding her
breasts
Near Eastern, Levantine, from
Tell Judeidah (Syria)
Early Bronze Age, 3200–2800 B.C.
Bronze with silver
H. 19 cm (7⁷⁄₁₆ in.)
(cat. no. 2)

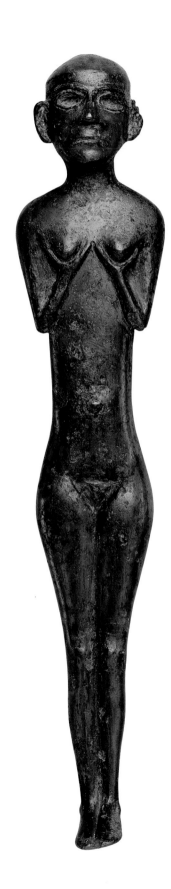

In the ancient Eastern Mediterranean, images associated with these goddesses, or votives to them, often took the form of clay and stone figurines, terracotta plaques, seals, metal figurines, and ivory, gold, or bronze plaques. Examples range from the tiny Anatolian Neolithic sixth-millennium-B.C. figurine of a rotund seated woman (cat. no. 1, p. 18) to slimmer, more lissome frontal nudes. These include a Syrian early Bronze Age woman crossing her arms and clasping her breasts (cat. no. 2, p. 19), excavated at Tell Judeidah with her male mate, and a later Anatolian copper lady cupping her breasts (cat. no. 3). From Egypt, a musical instrument, a rattle called a sistrum (cat. no. 5), depicts Hathor's face with her characteristic bovine ears. The Egyptian mother goddess Isis, crowned with horns and a disk, was frequently represented with her infant son Horus in her lap—imagery that is often echoed in Cypriot mother/child figurines (cat. no. 7, p. 26; cat. no. 13, p. 35).

A terracotta plaque (cat. no. 4, p. 20) exemplifies the weaving together of symbols pertaining to sexuality and goddesses from different cultural traditions across the Mediterranean. A nude, frontally facing woman, evoking images of Astarte and wearing a short Egyptian wig, stands in a niche between two Egyptian columns borne by lions with open mouths. Atop the columns are heads of Bes, the Egyptian bow-legged dwarf deity with lion traits who is associated with sexuality, childbirth, and the protection of home and hearth. The lions associated with the nude female figure recall the Mesopotamian lions of Ishtar, and seem to be guarding her. These symbols clearly resonated with peoples throughout the ancient Mediterranean world, calling to mind Claude Lévi-Strauss's contention that imported ideas take root only if the importing culture needs them.[6]

Both Aphrodite and Inana/Ishtar share associations with the evening and morning star (the planet Venus), a focus on sexual love, and links with war and strife. Characterized by fierce tempers, aggressive sexuality, deep jealousies, and rages, neither is considered a good wife or mother. Although both are connected to some degree with the fertility of the land, they are more concerned with the

*Statuette of a nude female holding
her breasts*
Near Eastern, Central Anatolian
Early Hittite, about 2000 B.C.
Copper
H. 25.4 cm (10 in.)
(cat. no. 3)

Sistrum
Egyptian
Late period, Dynasty 26–30,
664–332 B.C.
Bronze
H. 44.5 cm (17 ½ in.)
(cat. no. 5)

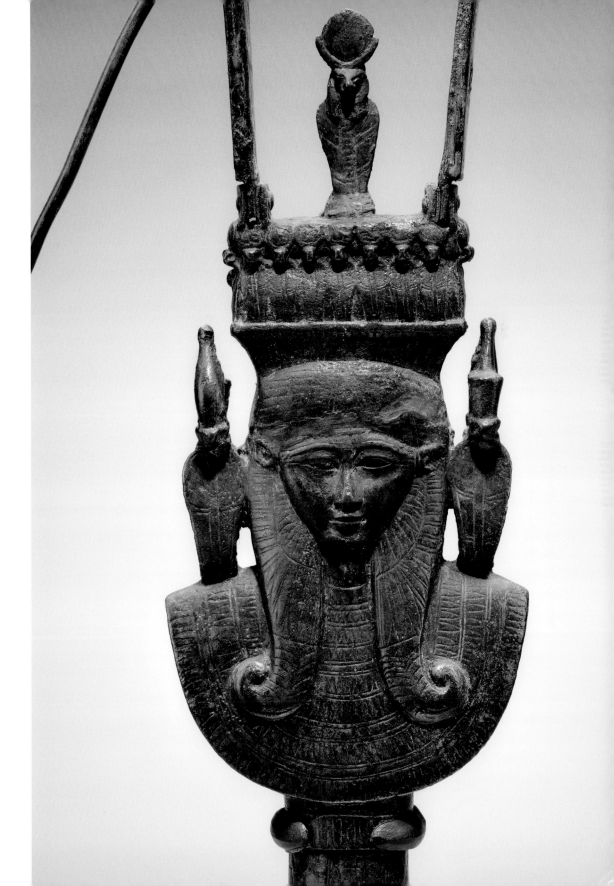

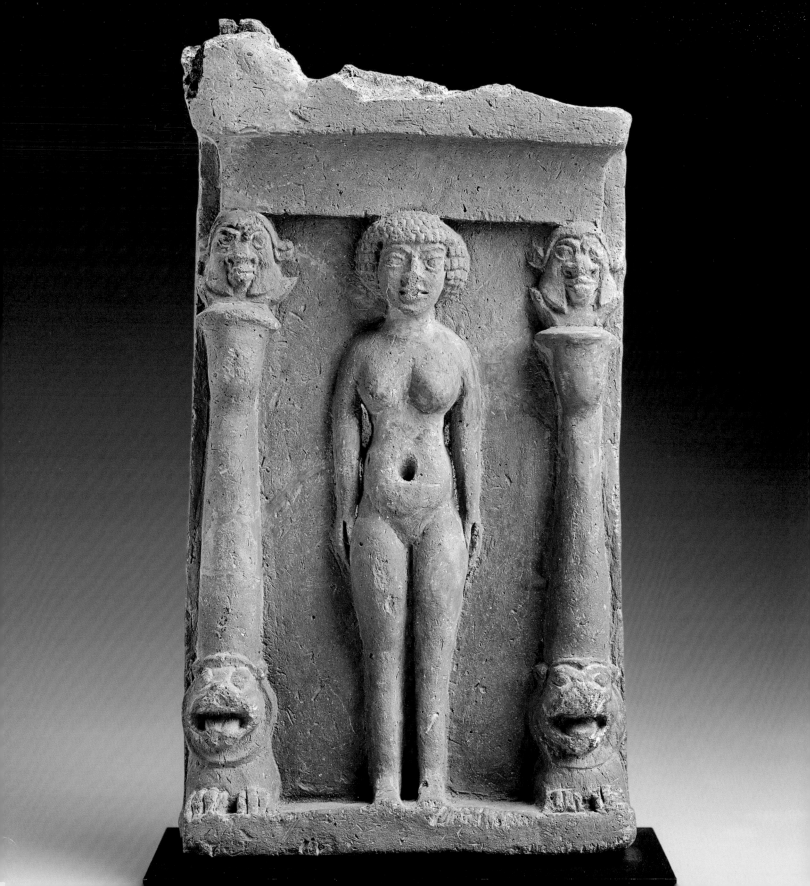

arousal of sexual desire in the human and animal world than with marriage and childbirth; they deal with the "before" rather than the "after." A closer look at Inana/Ishtar elucidates the parallels with Aphrodite.

Inana/Ishtar, queen of heaven and earth, is well known from ancient literature and features prominently in both the Babylonian *Epic of Gilgamesh* and the Sumerian myth "Inana's Descent into the Underworld." She is described as a heavenly divinity associated with the morning and evening star in literature such as an Old Babylonian prayer to "Ishtar as Venus," where she is characterized as a "moon lioness."[7] Sumerian and Akkadian literature, unlike Greek, possesses a wealth of love songs, incantations, and erotic poetry that evoke Inana's powers, most notably in the services of love. Much of this power derives from Inana's extraordinary beauty and allure, localized in her sexual attributes. She is a goddess of potency and of the possibility of sexual union in both humans and animals. Inana/Ishtar entices her lovers with her charms but does not bear children or form lasting unions. She is accordingly described in unflattering terms as vain and jealous. Moreover, her lovers, including the mortal vegetation god Dumuzi, frequently meet with untimely death, humiliation, or misfortune. War is proverbially described as "the playground of Ishtar," and she is portrayed as bloodthirsty and violent.[8] Nevertheless, her sexual charms, or *kuzbu* ("allure" in Akkadian), are considerable and remain manifest even when she is shown armed, winged, and ready for battle.

Inana's power stimulates male desire and results in the fertility of the land and its creatures, which comes to a halt when she descends into the Underworld. She seems to be associated primarily with sexuality outside of conventional marriage, as is the case in *Gilgamesh* and other literary texts. But she is also linked with the Mesopotamian Sacred Marriage ceremony, which was enacted by the Mesopotamian ruler and the priestess of Inana and consisted of the union of Inana with the "Wild Bull" Dumuzi. The ceremony ensured fertile soils and provided a form of divine legitimacy to the king who performed it. Inana is dressed and bejeweled for this rite, a theme echoed by the dressing of Aphrodite in Cyprus and reflected in the artistic emphasis on these goddesses' necklaces and bracelets (cat. no. 25, p. 58).[9]

Myths allude to Inana's nudity and to sacrifice. In the saga of her descent into the Underworld, she is required to relinquish one of her garments at each of the seven gates, leaving her naked. Her sister Ereshkigal, queen of the Underworld, is unwilling to release Inana from her deathly domain, unless Inana finds a replacement.[10] Inana chooses her mortal lover Dumuzi, and demons fetch him to take her place and hence to die. This

Model shrine with nude goddess
Eastern Mediterranean
6th–3rd century B.C.
Terracotta
H. 26 cm (10¼ in.)
(cat. no. 4)

"substitution sacrifice" motif harks back to agrarian views of herd animals, which were said to feel relief at the sacrifice of one of their number.[11] The myth bears similarities to Aphrodite's relationship with Adonis, who, like Dumuzi, is a vegetation god and who dies as a result of loving the goddess.

Some see Inana/Ishtar as representing the civilizing influences of society, in part because her actions help define the boundaries of human social behavior. Sex itself was viewed in Mesopotamia as a civilizing act; in *The Epic of Gilgamesh*, the harlot Shamhat civilizes and humanizes the man-beast Enkidu, Gilgamesh's companion, by having sex with him. In the same epic and other texts, however, Ishtar also acts outside the realms of what most societies consider acceptable behavior, perhaps because she is a goddess and transcends such limits.[12] This unusual comportment helps explain the choice of the lion as her symbol and companion—more than a means of identification, the animal represents her very character and actions (fig. 1; cat. no. 4, p. 22).

Lion behavior was well chronicled by Mesopotamians, and the animal's potency is acknowledged and admired in texts and incantations for sexual potency.[13] Lions are known to copulate as many as forty times a day. The female takes the initiative, teasing the male who is attempting to become the head of a pride of related females. The lioness is able to suppress her fertility until she has selected the best male; thus, her lustiness serves a purpose. Ishtar, with her many lovers, mirrors the behavior of the insatiable and powerful lioness, who controls the fate of the lion and his reproductive success. In the Sumerian myth "The Courtship of Inana and Dumuzi," the pair makes love fifty times in one night, after which Dumuzi assumes kingship.[14] Ultimately, however, Inana/Ishtar turns her lovers into beasts or kills them.[15] Death and destruction usually follow in her wake. She symbolizes not only the civilizing and uplifting aspects of female power but also the chaos that ensues from the forces of sex and desire.

Inana/Ishtar is in many respects the perfect anthropomorphization of the lioness: she is aggressive and bloodthirsty, an efficient huntress who has a seemingly insatiable sexual appetite; as kingmaker, she controls the choice of males and can suppress her capacity for motherhood; she is ill-tempered, mercurial, and seductive. These leonine qualities apply not only to Inana/Ishtar but to other goddesses as well, such as Ishara, Astarte, Anat, and Qudsu.

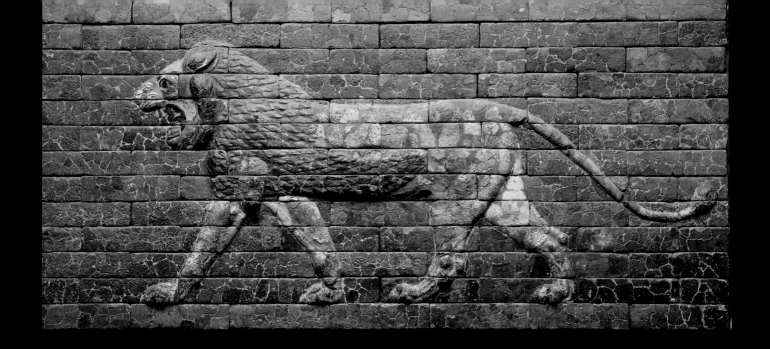

The sexual power, beauty, capriciousness, and bellicosity of Inana/Ishtar and other ancient Near Eastern goddesses presage Aphrodite's multifaceted character. Although Aphrodite lacks the lioness of the Near Eastern goddesses as symbol and metaphor, she reflects a similar emphasis on sexuality, multiple partners, female power through naked allure, and the incitement to violence or war, often in the wake of love. Aphrodite, however, is tamer, less powerful and bloodthirsty. She represents a domesticated version of Inana/Ishtar and her sisters. The responsibility of all these goddesses is to arouse desire and to maintain the sexual activity of humans and animals. In doing this, they ultimately give joy, meaning, and fertility to the world.

— D.K.M.

Fig. 1
Relief with striding lion
Near Eastern
Neo-Babylonian period,
604–561 B.C.
Glazed bricks
W. 232 cm (91 5/16 in.)

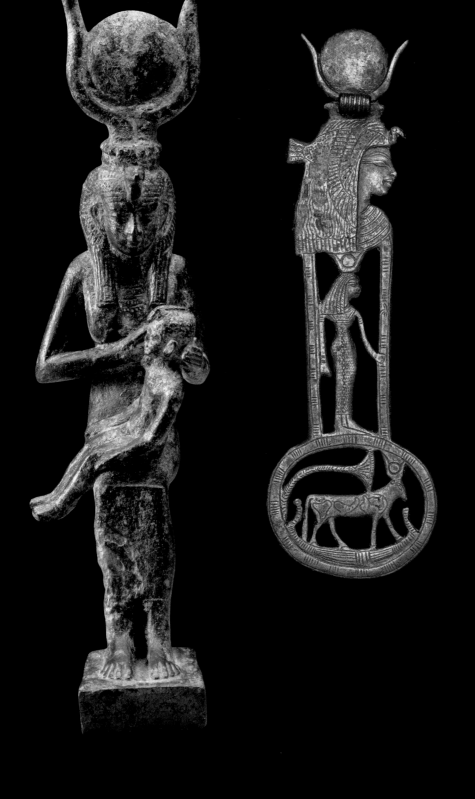

Late Period, about 684–332 B.C.
Bronze
H. 20.5 cm (8 1/16 in.)
(cat. no. 7)

Necklace counterpoise (menat)
Egyptian, from Semna, Sudan
New Kingdom, Dynasty 18,
1390–1352 B.C.
Bronze
H. 13.8 cm (5 7/16 in.)
(cat. no. 6)

Figurine of *Aphrodite* seated and
wearing a high polos
Cypriot
Cypro-Classical period,
4th century B.C.
Terracotta
H. 13 cm (5⅛ in.)
(cat. no. 14)

*T*he island of Cyprus at the far eastern end of the Mediterranean has been known since antiquity as the birthplace and beloved home of the Greek goddess Aphrodite. Homer in the eighth century B.C.—a time when Aphrodite was not yet worshipped on mainland Greece—called the goddess Kypris, the goddess of Cyprus, and already knew about her sanctuary in Paphos, where according to a later tradition she first washed ashore. Cypriots called their goddess simply the Deity or the Paphian, adopting the name Aphrodite only at the end of the fourth century B.C., once they had become conscious of their Greek identity.

The writings of the Greek poet Hesiod, from the late eighth century B.C., offer the earliest account of the origin of the Greek gods. In his *Theogony*, Aphrodite is born before all the other Greek gods, including Zeus. Ancient Greeks called her Ourania (Heavenly) because she descended from Ouranos (Sky). Incited by his mother, Kronos, one of the twelve Titans born to Ouranos and Gaia (Earth), treacherously cut off the genitals of his father. Aphrodite was born from the foam, or white sperm, of Ouranos that collected around his mutilated genitals, which had fallen into the sea: "from that foam a girl was born—she first to Kythera did come, to sacred Kythera, and then to sea-girt Kypris [Cyprus] came, and stepped upon the shore a lovely goddess with a claim to reverence, and grass sprang up beneath her feet; her name is Aphrodite—gods and men both call her this (since from the *aphros* [foam] she was nurtured—yes, within the frothy foam)."[1]

In the southwestern part of Cyprus, around Paphos, at the end of the fourth millennium B.C., a sudden flowering of female figure making occurred. Limestone statuettes with prominent sexual features and clay figurines of pregnant women and of women in the process of giving birth, together with many smaller schematized figurines made of a soft, local stone, revealed an intense worship of fertility for the survival of the living and perhaps the regeneration of the dead. The fact that these figures originate from the Paphos region, where the cult of Aphrodite later developed, is significant. According to Edgar Peltenburg, the excavator of these Chalcolithic sites, "the location of the cult of the Paphaia may prove to be not so much an historical accident as the resurgence of flourishing earlier traditions."[2] Cult places may be humbly revered for centuries, then brought to prominence when circumstances are right. The ancient fertility cult of the fourth–third millennia B.C. may have lin-

Page 28
Over-lifesize female head, possibly Aphrodite or a priestess of the goddess
Cypriot
Cypro-Archaic period, late 6th or early 5th century B.C.
Limestone
H. 50.8 cm (20 in.)
Worcester Museum of Art, Massachusetts
(cat. no. 11)

Stater of Salamis with the bust of Aphrodite wearing a diadem (obverse)
Greek, struck under Nikokreon
Late Classical or Early Hellenistic period, about 331–311 or 310 B.C.
Gold
Diam. 17 mm (11/16 in.)
(cat. no. 12)

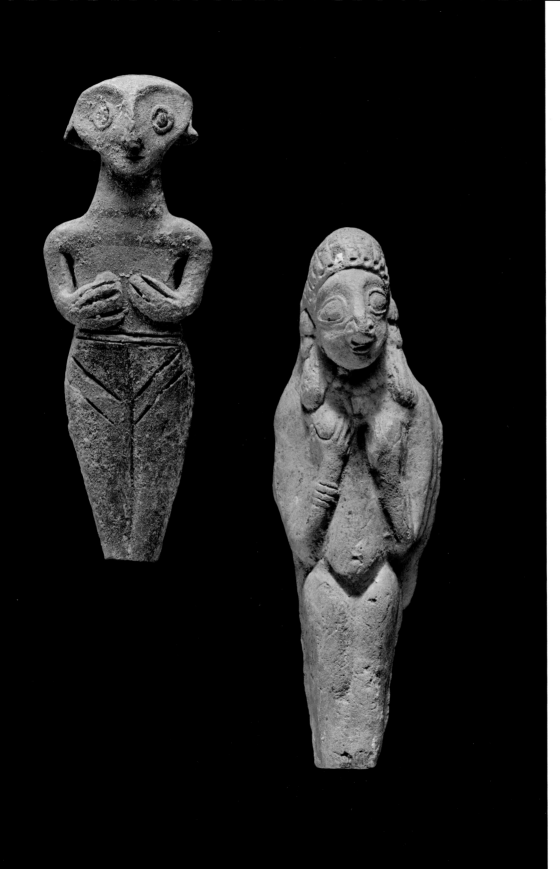

Figurine of a goddess or woman
Cypriot
Late Cypriot II period, about
1450–1200 B.C.
Terracotta
H. 11.1 cm (4⅜ in.)
(cat. no. 8)

Figurine of Cypriot *Aphrodite-Astarte*
Cypriot
Cypro-Archaic period,
late 7th century B.C.
Mold-made terracotta
H. 11.8 cm (4¹¹⁄₁₆ in.)
(cat. no. 9)

gered until the mid-second millennium B.C., when it was reinforced by strong Eastern religious influences and emerged as the cult of a goddess akin to the Akkadian Ishtar or her Levantine counterpart Astarte.

By the end of the third millennium B.C., waves of foreigners had settled in Cyprus. Newcomers from Anatolia brought to the island's northern region fertility rites based on the worship of horned animals. But the Cypriots maintained a deep attachment to the worship of fertility in human females, as evidenced by the reappearance of figurines representing women with prominent breasts and especially mothers holding infants, sometimes shown in their cradles. In the second millennium B.C., Cyprus mined and exported its rich reserves of copper, thereby developing close connections with the Near East, which exposed Cypriots to different religious systems that had already been flourishing for millennia. Among a pantheon of gods, the Sumerian Inana in Mesopotamia and her Akkadian cognate, Ishtar, were the dominant goddesses of love, fertility, war, and power. Kings were devoted to them and common people worshipped them as small clay idols with emphasized sexual attributes. The Cypriots, probably under the influence of Near Eastern religion, began to use similar idols representing naked goddesses with their hands on their breasts, birdlike faces with large eyes, and pierced ears with hanging earrings (cat. no. 8).

The period from the end of the thirteenth century B.C. to the beginning of the twelfth was crucial for the establishment of the cult of Aphrodite. Ancient sources contain information—though contradictory—about the foundation of the famous temple of Aphrodite in Paphos. Tacitus says that it was founded by Kinyras, a mythical figure of Eastern origin, known as the beloved priest of Aphrodite.[3] According to Herodotus, the Cypriots themselves believed their temple derived from the temple of Aphrodite Ourania in Ascalon in Palestinian Syria.[4] In another tradition, transmitted by Pausanias, after the end of the Trojan War, Agapenor, the leader of the Arcadians, and his ships were caught in a storm that threw them on the shore of Cyprus, where he built the city of Paphos and the temple of Aphrodite.[5]

What is left of the ancient temple of Aphrodite in Paphos is an open space about 50 meters (164 feet) square, enclosed by the remains of huge walls made of enormous monoliths, and traces of a covered hall that most likely contained the holy of holies. Depictions of the sanctuary on Hellenistic seals, Roman coins, and pieces of jewelry indicate that there was a tripartite structure, the cellar of which contained a conical stone that seems to have been the most ancient image of Aphrodite. This enclosure brings to mind the *temenos*, a sacred space described in the *Odyssey* consisting of a large, walled yard with an open-air altar and covered hall, where Aphrodite went to have her

bath, be anointed with divine oil, and be dressed with beautiful garments and jewelry by her sacred servants, the Charites (Graces).[6] The open-air sanctuary, similar to those found in Kition and Enkomi, seems to be of a type known, for instance, at Kamid el-Loz in the Southern Bekaa in Lebanon.[7] Votive monuments such as horns of consecration and stepped capitals undoubtedly connote the presence of Greeks; however, the special status of the king-priest in the kingdom of Paphos and the worship of the goddess in the shape of a sacred stone are Near Eastern features.

Though information about the foundation of Aphrodite's temple is scant and contradictory, we can surmise that a wealthy kingdom existed in Paphos in the Late Bronze Age, with a sanctuary dedicated to a Near Eastern deity akin to Ishtar, as would befit a country so deeply influenced by the Near East during the second millennium B.C. The Mycenaeans, called Achaeans by Homer, landed in Cyprus in search of new territory after the fall of the Mycenaean empire and conquered Paphos. Most likely, they respected the cult of the mighty goddess. They may have added architectural grandeur to the earlier sanctuary, but they maintained the sacred stone as a cult object. The Mycenaeans called the goddess *anassa* (the sovereign), in keeping with Near Eastern tradition. They may have adopted and adapted her Semitic name, something like Attorit, into Aphrodite. Poets may then have invented the myth of the birth of the goddess from the foam (*aphros*) of Ouranos's sperm in order to clarify the name Aphrodite and her epithet Ourania.

A rich mythology grew out of Aphrodite's many, often local, attributes. The goddess was probably the patroness of copper (appropriate for a deity from an island so rich in the mineral), as we know from bronze figurines depicting a naked goddess and an armed consort god standing on a base shaped like a copper ingot. From that association the Greeks may have derived the strange marriage of the beautiful Aphrodite to the unattractive smith god Hephaistos. Reflecting her warrior nature, in the tradition of the Mesopotamian goddess Ishtar, Aphrodite was sexually linked with Ares, the Greek god of war. As a goddess of fertility, she also had an affair with Adonis, the god of vegetation who dies and revives. Cypriot poets may have played an instrumental role in the dissemination of the myths of Aphrodite's many love affairs in the Greek world. From the sources that have survived through these myths, although often confusing and contradictory, it seems that Cyprus, and especially Paphos, played a major role in the genesis of the Greek Aphrodite.

We know from literary sources and archaeological evidence that the cult of Paphian Aphrodite continued to be practiced actively in Paphos and elsewhere in Cyprus (Idalion, Golgoi, Amathous) throughout the first millennium B.C., as the mixed population of locals and Greeks continued to shape

her identity. Cretans had reached the island in the eleventh or tenth century B.C. and bequeathed to Cyprus the image of the goddess as an imposing and respectable figure with uplifted arms, dressed in a long robe and wearing a tall, decorated headdress. Near Eastern influences in the eighth–sixth centuries B.C. changed her image again when Phoenicians founded the city of Kition and established the worship of their goddess Astarte. In this incarnation, the Cypriot Aphrodite was once again depicted as naked with exaggerated sexual features (cat. no. 9, p. 30). But the Hellenized Cypriots soon abandoned this crude representation for a more majestic image, with the goddess clad in hieratic garments and heavy jewelry that still mirrored her earlier, Eastern style of adornment. We can gauge just how widespread worship of the goddess was from the hundreds of terracotta and limestone statuettes and figurines depicting her, her priestesses, or her worshippers in the eighth–sixth centuries B.C. (cat. no. 10, p. 34; cat. no. 25, p. 58). Images on Archaic amphorae, jugs, and precious bronze and silver bowls of priestesses or worshippers standing near trees of life, or holding flowers, birds, or goats, may represent scenes of sacred dances and ritual practices relating to Aphrodite.

Most scholars now accept that Aphrodite descended from a Near Eastern divinity and was later Hellenized. Cyprus provided the link between the Near East and the Aegean world; it is likely that in Cyprus, due to the Greek presence on the island, the Near Eastern goddess of war and fertility was gradually transformed into the refined "Western," Greco-Roman deity of beauty and love. The Cypriots continued to worship her as the Greek Aphrodite and depicted her in an idealized Classical form. Yet, in the fourth and third centuries B.C., the goddess is sometimes shown wearing heavily ornamented garb in a style that expresses an Eastern taste for rich ornaments (cat. nos. 11–12, pp. 28–29). Because of her long association with fertility, she never ceased to be the *Kourotrophos*, or nursing goddess, the patroness of young children, and was often represented with an infant who was later identified as Eros (cat. no. 13, p. 35). In the Hellenistic and Roman periods she was completely identified with the Greek Aphrodite and was depicted in Cyprus by statues in the Greek style. The Romans accorded her great importance, since she was considered the founder of the dynasty of Roman emperors through her son Aeneas; her sanctuary in Paphos remained her main place of worship in the Mediterranean until the fourth century A.D., despite the spread of Christianity. Worshipped as Venus by the Romans, she was bequeathed to Europe as one of the main cultural values of Western civilization. It seems probable that the island of Cyprus lies at the origin of this valuable offering to humanity.[8]

— J.K.

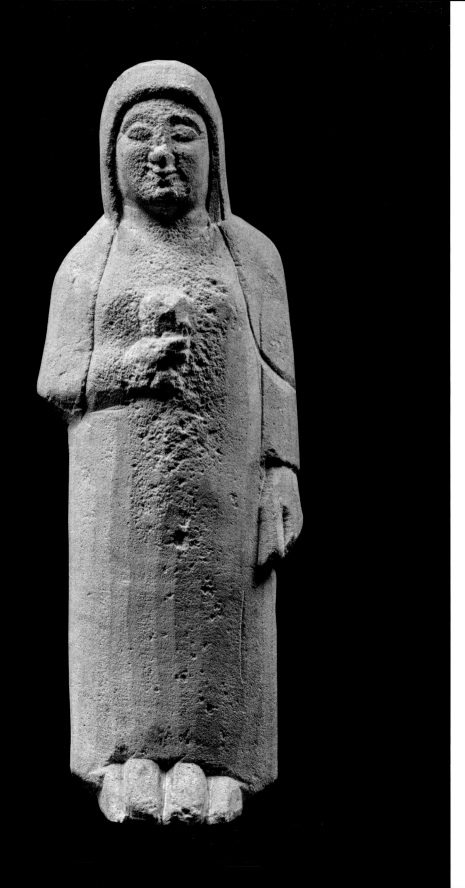

Figurine of a female carrying a bunch
of flowers
Cypriot
Cypro-Archaic II period,
600–475 B.C.
Limestone
H. 14.5 cm (5 11/16 in.)
(cat. no. 10)

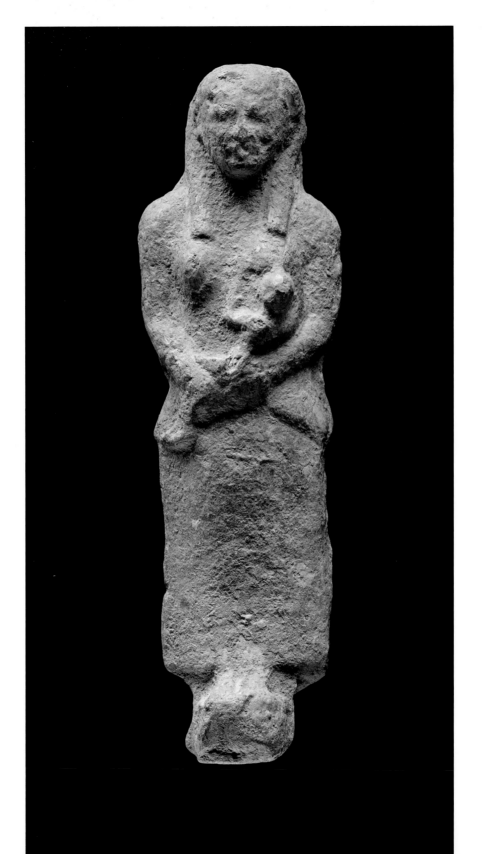

Figurine of a woman nursing a child
(*Aphrodite Kourotrophos*)
Cypriot
Cypro-Archaic period, 600–480 B.C.
Limestone
H. 17.8 cm (7 in.)
(cat. no. 13)

Fig. 2
Jim Dine (American, born
in 1935)
Nine Views of Winter (4), 1985
Woodcut, hand-painted with
floral-patterned rollers
H. 133.4 cm (52½ in.)

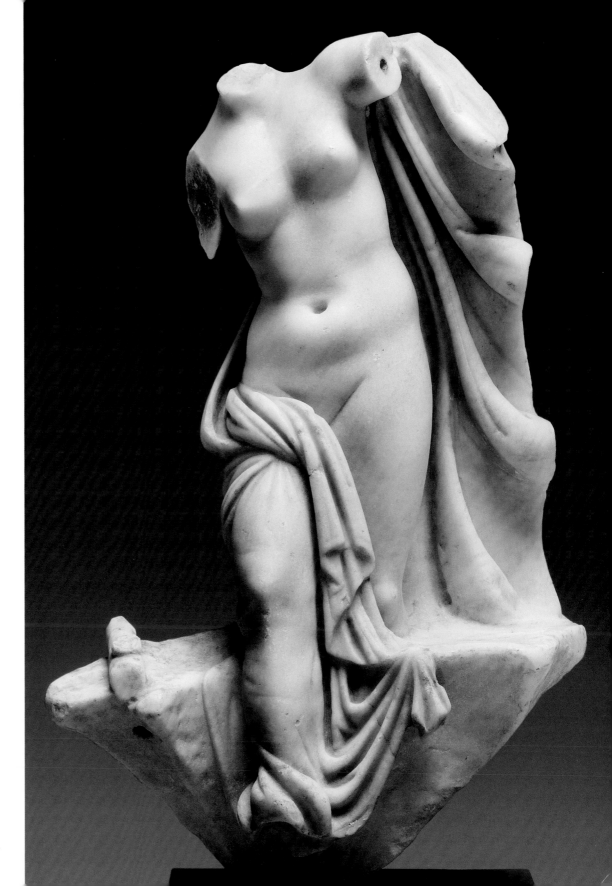

Statuette of Aphrodite emerging from the sea
Greek or Roman, Eastern Mediterranean
Hellenistic or Imperial period,
1st century B.C.–1st century A.D.
Marble
H. 43 cm (16 15/16 in.)
(cat. no. 18)

Oil bottle (lekythos) in the form
of *Aphrodite at her birth*
Greek, made in Athens
Late Classical period, about
380–370 B.C.
Ceramic
H. 21.3 cm (8⅜ in.)
(cat. no. 15)

Oil bottle (lekythos) in the form
of *Aphrodite at her birth*
Greek, made in Athens
Late Classical period,
4th century B.C.
Ceramic
H. 19 cm (7½ in.)
(cat. no. 16)

GREEK CULTS OF APHRODITE

.

Vinciane Pirenne-Delforge and Gabriella Pironti

lthough the Greek gods are familiar to all of us, much of their original significance, rooted in the religious context of the cults that were performed in their honor, has been lost.[1] In the modern world, they are fictional beings and objects of cultural curiosity. But for the ancient Greeks, the deities were powerful entities whose presence was a vital and daily fact, and not simply supernatural protagonists of a set of myths or the personifications of abstract concepts.

While their anthropomorphism made them more accessible to their worshippers, the gods are not easily circumscribed by a single personality type. Rather, they are divine powers whose aspects may be manifested in different ways at various levels: individual, societal, and natural. Accordingly, the gods cannot be reduced to a single domain, and this is certainly true of Aphrodite—even though the beautiful goddess that Botticelli showed emerging from the sea is closely related, in our modern minds, to such basic ideas as feminine beauty, the joys of love, and the art of seduction. This standard portrait has long satisfied our desire for simple definitions and clear boundaries for the Greek gods. Archaeological evidence and literary sources for Aphrodite's cults from different Greek cities, however, convey a more complex and varied image of the goddess.

An important challenge for those studying ancient societies is avoiding the misapplication of concepts laden with modern meanings. "Love" and "sexuality" are perfect examples of culturally determined terms that do not fit neatly into an ancient Greek context; unless we consider the ancient way of thinking about Aphrodite's powers, we risk falling into anachronism. In the Greek language, the phrase *ta aphrodisia* refers to all things of or pertaining to Aphrodite, and her powers are closely related to *eros*, which we often translate as "love" but which more accurately refers to sexual drive and physical desire. Aphrodite arouses eros in human beings and leads them to sexual union— *mixis* in Greek, the "mixing" of bodies. These powers, which fit poorly with modern romantic notions of love, are not the only abilities her worshippers attributed to the goddess. Greek communities also paid homage to her for matters connected with political life, war, civic authority, and seafaring.

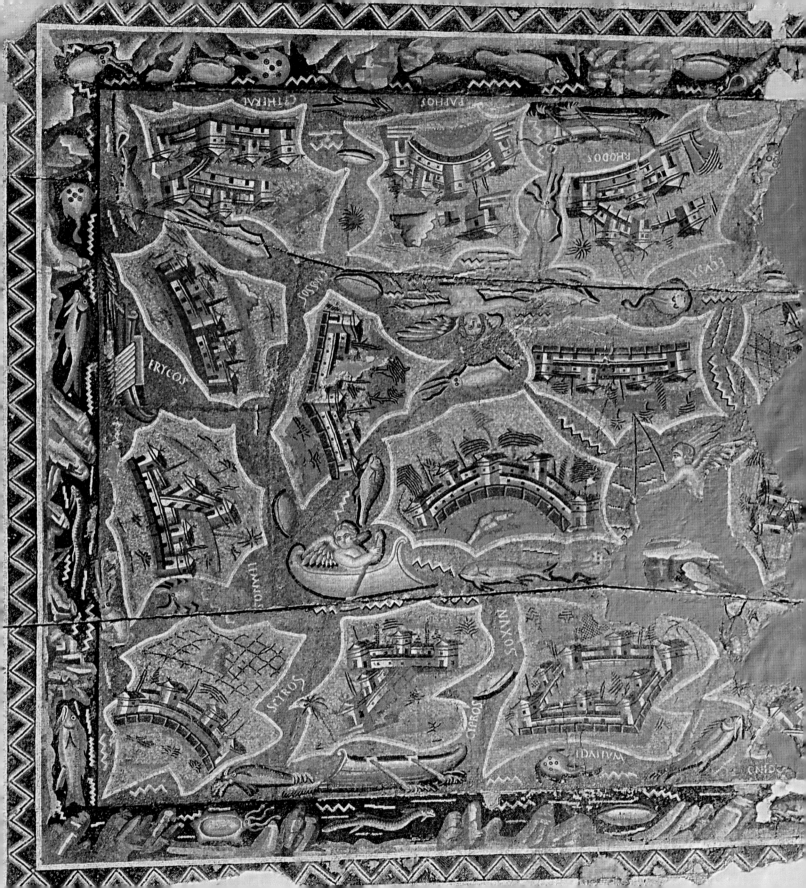

The Greeks used myths and cults to represent the divine world as they conceived it and to create effective communication with the gods. A comparison of Aphrodite's depiction in myth with archaeological evidence of her cult worship reveals her unique combination of powers. In various myths, Aphrodite is the daughter of Ouranos, the primordial Sky god, which sheds light on the link between the goddess and the inseminating power of the raining heavens. This mythical conception helps deepen our understanding of Aphrodite, who in most Greek cities was called Ourania and whose cults are related to marriage and the birth of legitimate children. Aphrodite also appears in both Greek myth and art as a couple (legitimate or not) with Ares, the god of war. This is not merely a mythical "love affair"; the cultic association of the two deities is well attested in several Greek cities where they are variously associated with battle and defense. Information provided by the cults helps to mark out particular aspects of Aphrodite that illuminate her various representations in literature and iconography.

The cults of Aphrodite were performed throughout the Greek world from at least the early first millennium B.C. until the end of the Roman Empire (fig. 3). Over that time, they adapted to historical and cultural forces and assumed various local characteristics. However, surviving evidence rarely allows for a precise diachronic analysis. The matter of Aphrodite's "origin" is a complex historical process, as Jacqueline Karageorghis discusses in this volume. Despite all the uncertainties, however, the Greek conception of Aphrodite and the expectations of her worshippers appear consistent throughout the cult's long history and justify a synchronous treatment of her domains and the functioning of her cult. In the Hellenistic period (323–31 B.C.), when rulers were worshipped as gods, Aphrodite's attributes were often used in the depiction of queens; even so, the traits remain recognizably hers.

Across the Greek world, Aphrodite was honored above all as presiding over sexuality. For the Greeks, as for most peoples, the continuity of their communities through the production of legitimate heirs was one of the main aims of sexuality. Many official cults devoted to Aphrodite are related to sexuality and marriage. In Argolis, the epithet Nymphia assigned to the goddess makes her the protector of the *numphe*, both the young woman of marriageable age and the young wife prior to the birth of her first child.[2] In Athens, Aphrodite was called Ourania and was honored in a matrimonial context, receiving offerings before marriage. Athenians also paid tribute to the primordial couple Ouranos and Gaia (Sky and Earth) as a wedding rite. The Athenian cult of Aphrodite Ourania, mythical daughter of the Sky god, thus appears to have been quite coherent.[3] Aphrodite was prayed to not only by young girls

Fig. 3
Mosaic depicting cult places of Aphrodite on Mediterranean islands
Roman, from Haïdra (ancient Ammaedara), Tunisia
Imperial period, 4th century A.D.
Limestone, marble
H. 533–536 cm (209 13/16–211 in.)
Haïdra Museum

but by all women seeking matrimony. In Naupactus, for example, in a cave outside the city, widows prayed to the goddess to contract a new marriage. Marriage was not the only situation for sexuality, however; in Hermione, every woman on the point of having sexual relations with a man, whatever her age or marital status, was supposed to offer a sacrifice to the goddess.[4] Aphrodite's protection extended to courtesans and prostitutes as well; epithets such as Hetaira (courtesan) and Porne (prostitute) show Aphrodite as the official patroness of these professional groups. But this protection does not imply an official link between prostitution and temples; there is no reliable evidence to support the old hypothesis that "sacred prostitution" was practiced in some sanctuaries of Aphrodite.[5]

Sexuality involved seduction, and the beauty related to Aphrodite and her powers is an active and irresistible grace that the Greeks call *charis*. But seduction may be deceptive, and the power of eros is often thought of as destructive. Ambiguity attends the actions of Greek divinities and, as far as Aphrodite is concerned, this ambiguity is found in *mixis* and in what John Winkler calls the constraints of desire.[6] These notions are far removed from our tender vision of romantic love. Aphrodite's destructive powers are evident in mythical figures such as Helen, whose beauty instigated the Trojan War, and Pandora, whose seduction was planned by the gods to deceive men.[7] In cults, the goddess's benevolence was obtained by paying her honors, but this was also a way of placating her potential for destruction.

In the minds of the Greeks, human fertility and the prosperity of the land were inextricably linked. In a fragment attributed to an Athenian tragedy that asserts the obligation for young people to submit to marriage, Aphrodite herself emphatically asserts her power over the prosperity of the land by encouraging the sexual union, or *mixis*, of Ouranos and Gaia. This sexual metaphor evokes heavenly rain falling onto the longing soil.[8] It also explains a scene on a red-figure classical vase found in Rhodes of a female figure rising from the soil between the gods Pan and Hermes, which had puzzled scholars for some time.[9] The female figure is identified by an inscription as Aphrodite, even though this iconography was typically associated with Kore/Persephone, whose emergence from the soil is well known. The image from Rhodes clearly links Aphrodite with the growth of plants and the black fertile soil. A red-figure skyphos, this one without an inscription, might be interpreted in the same way (cat. no. 17). Such iconography probably echoes the fact that the goddess is called the "black one" in some of her sanctuaries.[10]

In keeping with this association of sexual desire and terrestrial fertility, young people are often characterized in Greek literature as beautiful

flowers who blossom into sexual maturity. *Anthos hebes* (the blossom of youth) and *charis* (irresistible grace) are the hallmarks of the transition from childhood to adulthood and are related to sexual drive. Aphrodite's powers pertain not only to the world of females but also to young mythical heroes, such as Theseus and Jason. The discovery of offerings in the shape of male organs at the sanctuaries of Aphrodite clearly indicates the belief in her power to affect virility. Her control over male potency is attested in the myth related to the foundation of Aphrodite Ourania's cult in Athens, in which the king Aegeus was unable to father children because of the goddess's anger.[11]

Skyphos with goddess emerging between two goat-headed satyrs
Greek, made in Athens; painted by the Penthesilea Painter
Classical period, about 450 B.C.
Ceramic, red-figure technique
H. 23 cm (9 1/16 in.)
(cat. no. 17)

Young people, female *and* male, were concerned with Aphrodite's powers—all the more so since the males were also involved in the military defense of the homeland. Athenian ephebes, for instance, underwent military training near the Attic frontier in the fortress of Rhamnous, where Aphrodite was honored with the name Hegemone (leader)[12]—a qualification that probably referred both to the military leaders of the place and to the young men they led. There is ample evidence of the link between Aphrodite and civic authority. In many inscriptions, she is depicted as the protector of various magistrates, notably military leaders. Cult titles such as Stratagis and Strateia indicate that her protection extended both to specific military magistrates and to the army (*stratos*) as a whole.[13]

Contrary to the common opinion that Aphrodite's is a peaceful world, far removed from the realm of war (in which Ares and Athena alone would be active), Greek cult evidence indicates that the so-called goddess of love in fact straddles both spheres. In some of her temples, such as in Corinth, in Sparta, and on the island of Cythera, she is depicted with weapons; a Hellenistic gold ring features an intaglio of Aphrodite armed with Ares's shield (cat. no. 72, p. 86).[14] Soldiers prayed to her on the battlefield; a supplication was addressed to the Aphrodite of the Acrocorinth (Corinth) just before the battle of Salamis in 480 and at a thanksgiving ceremony held afterward (cat. no. 24). The women of the city had asked the goddess to rouse their husbands' military drive, called the "*eros* of the battle,"[15] which here refers to warlike energy. Furthermore, the term *mixis*, which lies at the core of the goddess's activities, also describes the infighting of the soldiers on the battlefield, a place where Aphrodite meets Ares himself (cat. no. 22, pp. 48–49). These two deities have formed a divine couple at least since Archaic times (700–480 B.C.). They are frequently celebrated in art and poetry and may be found in several Greek cities, such as the city of Argos and the Cretan city of Lato, where Aphrodite and Ares were worshipped in temples with a double inner chamber.[16] On the acropolis of Sparta, Aphrodite receives the cult title Areia (she of Ares) next to the sanctuary of Athena Poliouchos (protector of the city), reflecting both her closeness to Ares and her ability to take part in the city's defense with Athena.[17]

The future of the community was an essential part of worshippers' concerns when they paid homage to Aphrodite (cat. no. 19, p. 53). Sex and matrimony led to the birth of legitimate children, moisture fertilizing the earth ensured the prosperity of the land, and the physical growth of young people helped build soldiers to protect the community. Also key to the collective survival was the cohesion of the civic body. On the southwest slope

of the Athenian acropolis stood a sanctuary of Aphrodite Pandemos (literally, "who brings people together"), where Aphrodite was worshipped with Peitho (the personification of divine persuasion).[18] The cult was supposedly founded by Theseus, once he had united all the people through persuasion. Peitho is an appropriate companion for the goddess of sexual desire and matrimony and assists her in "mixing" couples as well as ensuring the harmonious commingling of individuals within their communities. In this case, the commingling is not specifically sexual. Rather, Aphrodite is being called upon to promote the cohesion of the body politic, as well as the unity of the military corps and of boards of magistrates. While the realms of sex and civic unity might not at first appear to overlap, they share a common theme, *mixis*, and thus are both governed by Aphrodite.

Drachm of Corinth with the head of Aphrodite (reverse)
Greek
Late Classical or Early Hellenistic period, about 350–300 B.C.
Silver
Diam. 16 mm (⅝ in.)
(cat. no. 24)

Aphrodite's influence was also felt in the realm of seafaring, a vital activity for the Greeks, as evidenced by cult titles such as Pontia (of the sea), Euploia (of fair sailing), and Limenia (of the harbor). As daughter of Ouranos, Aphrodite was said to be born in the sea, from the foam of the castrated Sky god.[19] Aphrodite is sometimes depicted as carried by frothy waves along the surface of the Aegean (cat. nos. 15–16, pp. 38–39; cat. no. 18, p. 37) or else riding a swan or goose above the water (cat. no. 20, p. 50). Cults, myths, and images illuminate Aphrodite's maritime functions from different angles, and the marine nature of her birth helps us to understand her association with maritime trade, travel, and naval battles. Her influence in matters of the sea and the civic body was metaphorically linked, as the Greeks believed her to be capable of creating harmony out of changeable, often conflicting elements. For sailors, the harmony between sea and sky was just as crucial as was civic cohesion for public officials.

On the island of Cos, in her harbor sanctuary, Aphrodite bears two cult titles: Pandemos refers to social cohesion, and Pontia to her oversight of seafaring.[20] Married women, civic leaders, and sailors all paid honor to her in her twin temples. All the women of the island, whatever their social status, had to offer a sacrifice to the goddess Aphrodite Pandemos in the year following their marriage, most likely in thanks for successful sexual interaction with their husbands. The demes, or local civic districts, of Cos apparently celebrated Aphrodite on a specific date each year. Sailors who served on warships were

Oil bottle (squat lekythos) with Nike sacrificing a bull to Aphrodite and Ares
Greek, made in Athens
Classical period, about 394–390 B.C.
Ceramic, red-figure technique with added white, added clay lines, dilute glaze, and traces of gilding
H. 15.2 cm (6 in.)
(cat. no. 22)

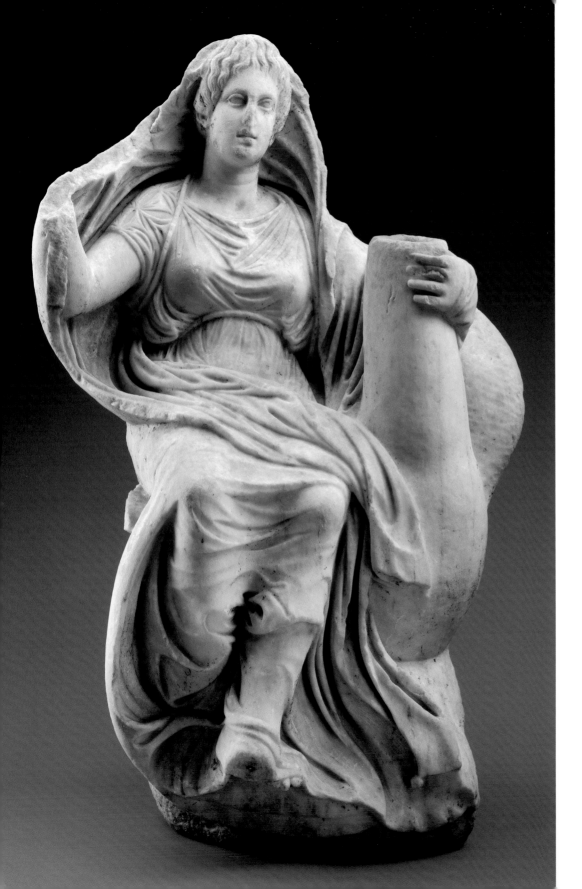

Statue of Aphrodite riding a goose
Greek, possibly made in Athens
Late Classical period, 4th century B.C.
Marble
H. 68.6 cm (27 in.)
(cat. no. 20)

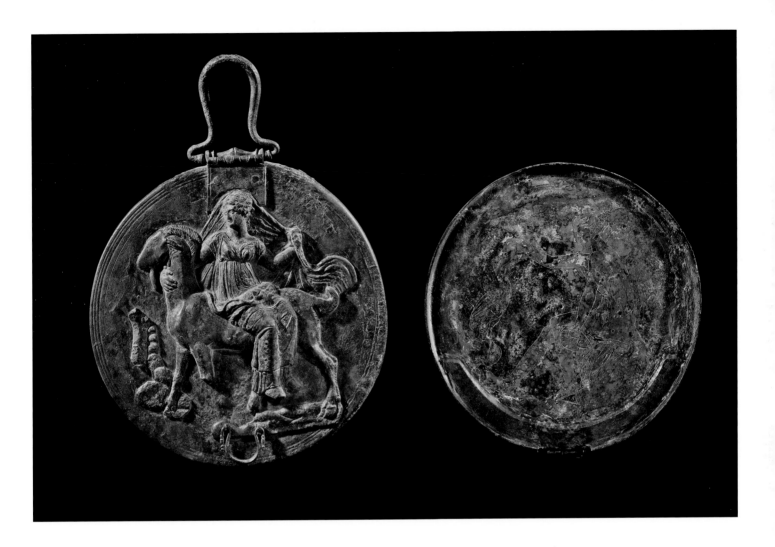

required to sacrifice to Aphrodite Pontia at the end of their expedition. Such honors demonstrate once again that Aphrodite's powers reached beyond the "feminine" sphere of sexuality and seduction.

Hellenistic dedications indicate that holders of political and military offices increasingly honored Aphrodite and presented offerings to her. Sometimes she was worshipped with Hermes, a god also associated with Peitho (Persuasion) in civic contexts. Because boards of officials made dedications to the goddess, she came to bear their names in her cult titles—such as Aphrodite Nomophylakis from the "guardians of laws" (*nomophylakes*) and Aphrodite Stratagis from the generals (*stratagoi*).[21] Such a dedicatory practice attests to the goddess's link to authority and power, and also her dominion

Mirror with Aphrodite riding a goat (exterior) and feeding a goose (interior)
Greek, possibly made in Corinth
Hellenistic period, about 280 B.C.
Bronze
Diam. 22 cm (6 ¾ in.)
Anonymous loan
(cat. no. 21)

over the harmonious "mixing" of potentially conflicting elements, as seen above. We cannot draw a firm distinction between the expectations of all these specific groups of dedicators and the traditional core of Aphrodite's domain. For instance, a metric Cretan inscription refers to the dedication of a temple to the goddess by magistrates of the city of Lato, asking Aphrodite for a prosperous old age.[22] This dedication illuminates Aphrodite's abilities in preserving the life force even in old age, as well as her close relations with civic officials. Both powers were invoked by the Cretan magistrates.

In the Hellenistic period, queens aspired to possess many aspects of Aphrodite in their personas, cults, and depictions, as the cult of the leader became an increasingly common way of addressing authority. Deification often implied relating a ruler to a traditional god. One of the most illuminating examples of this assimilation to Aphrodite is the cult of the queen Arsinoe Philadelphus of Egypt (316–270 B.C.), whose faithful admiral Callicrates built a temple for her near Alexandria. The queen was honored as an Aphrodite Zephyritis, after the name of the cape where the sanctuary was located, but her cult title was often Euploia, in reference to her power to calm the waves.[23] Not only sailors but a whole civic community might pay her homage; during the festival celebrating the divine queen, private individuals offered sacrifices in front of their houses along the procession route. Moreover, the assimilation of the deified queen Arsinoë with Aphrodite echoes not only the oversight of harbors and seafaring but all the functions and domains of the goddess. The queen's beauty as wife of Ptolemy II, for instance, refers to matrimonial sexuality, while the status of the cult founder (an admiral) refers to the military and maritime sphere (fig. 4). Beauty, marriage, kingship, and, more widely, the Ptolemaic power over the Eastern Mediterranean—all these characteristics may explain why Callicrates chose to identify Arsinoë with Aphrodite rather than with Hera, Demeter, or Artemis.

Mythological dictionaries have artificially recomposed a biography of each divinity and often reduce their personalities to static labels. In the process, Aphrodite has been simplified to the "goddess of love." Such a label, with its anachronistic vision of love, cannot encompass the complex archaeological, epigraphic, and literary evidence concerning the goddess. Aphrodite's multivalent domain ranges from harmony to conflict, appeasement to vio-

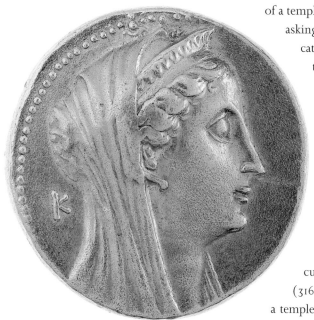

Fig. 4
Oktadrachm of the Kingdom of Egypt with the head of Arsinoë II (obverse)
Greek, Ptolemaic, struck under Ptolemy II
Hellenistic period, 261 B.C.
Gold
Diam. 27 mm (1 1/16 in.)

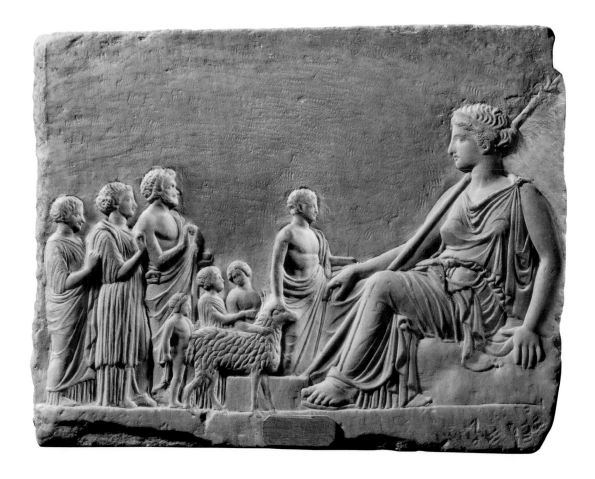

lence, sexual encounters to civic institutions. She is involved in *mixis*, *eros*, moisture, life force, genesis, bodies, and divine persuasion, among other realms. Her complex world is a network whose elements are interconnected and adaptable in various historical and religious contexts. Men and women, young and old, sought her protection. Her worshippers came from both the public and private spheres. The traditional views of Aphrodite as the "goddess of love and sex," or as a goddess for women only, are therefore restrictive and inaccurate. Images of Aphrodite are likewise multivalent. Cults, myths, and art do not depict exactly the same image of Aphrodite; each delivers, in its own language, its own picture of the goddess. However, the vast range of evidence demonstrates that these images are various facets of a single deity and provides a useful tool for properly situating Aphrodite within the multifarious world of Greek divinities.

Relief with Aphrodite and devotees
Greek, made in Athens
Late Classical or Early Hellenistic
period, 4th century B.C.
Marble
H. 45 cm (17 11/₁₆ in.)
Naples, Museo Archeologico
Nazionale
(cat. no. 19)

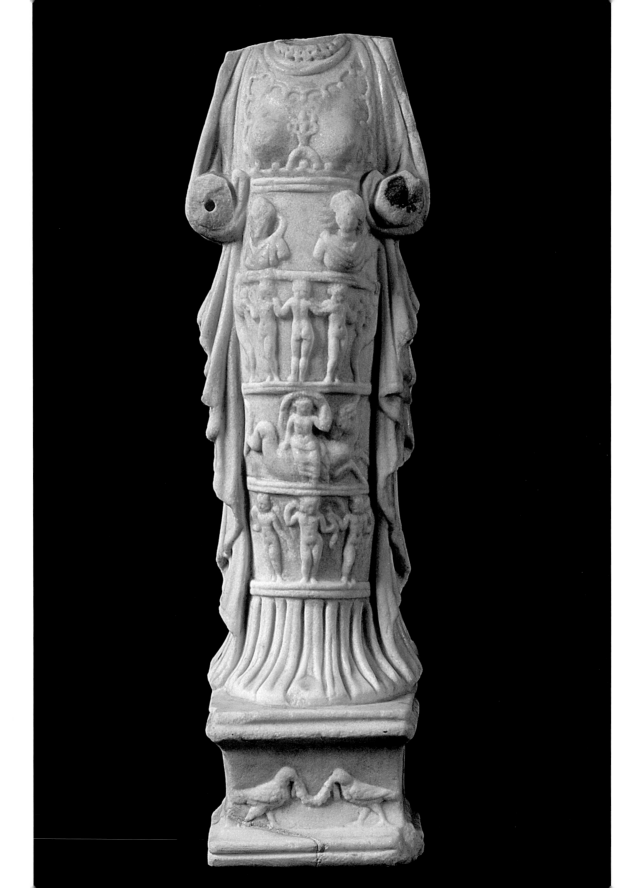

Statuette of Aphrodite of Aphrodisias
Roman
Imperial period, 2nd century A.D.,
perhaps Antonine, A.D. 138–93
Marble
H. 36 cm (14³⁄₁₆ in.)
Rome, Palazzo Massimo alle Terme,
Museo Nazionale Romano
(cat. no. 28)

*Statuette of Aphrodite with elaborate
headdress*
Roman
Imperial period, late 1st century
B.C. or later
Terracotta
H. 28 cm (11¹⁄₁₆ in.)
(cat. no. 29)

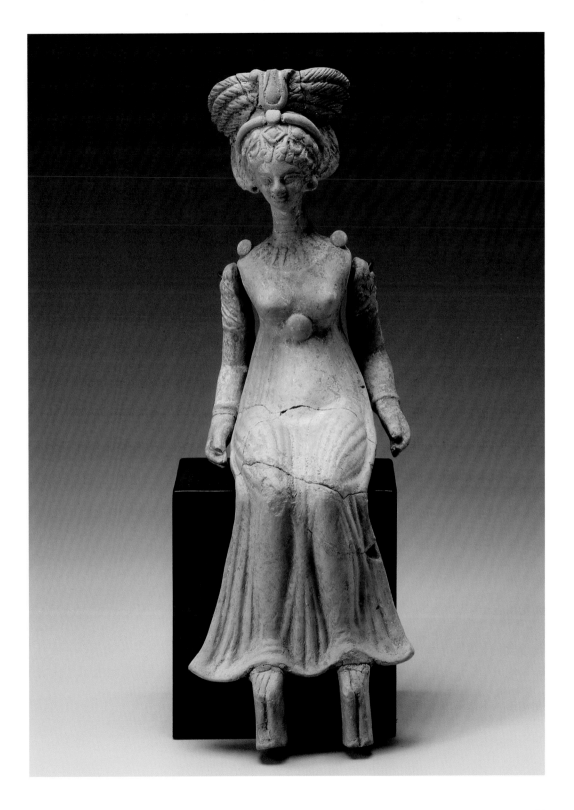

Coin of Hierapolis in alliance with
Aphrodisias with the cult statues of
Apollo and Aphrodite (reverse)
Roman Provincial
Imperial period, A.D. 186–91
Bronze
Diam. 36 mm (1 7/16 in.)
(cat. no. 30)

Tetradrachm of Cyprus with the
sanctuary of Aphrodite at Paphos
(reverse)
Roman Provincial
Imperial period, A.D. 77–78
Silver
Diam. 25.5 mm (1 1/16 in.)
(cat. no. 31)

Coin of Cyprus with the sanctuary
of Aphrodite at Paphos (reverse)
Roman Provincial
Imperial period, about
A.D. 206–7
Bronze
Diam. 33.5 mm (1 5/16 in.)
(cat. no. 32)

Coin of Aphrodisias with the cult statue
of Aphrodite (reverse)
Roman Provincial
Imperial period, A.D. 255–68
Bronze
Diam. 30 mm (1 3/16 in.)
(cat. no. 33)

Coin of Saitta with the cult statue of
Aphrodite (reverse)
Roman Provincial
Imperial period, A.D. 253–68
Bronze
Diam. 29.5 mm (1 3/16 in.)
(cat. no. 34)

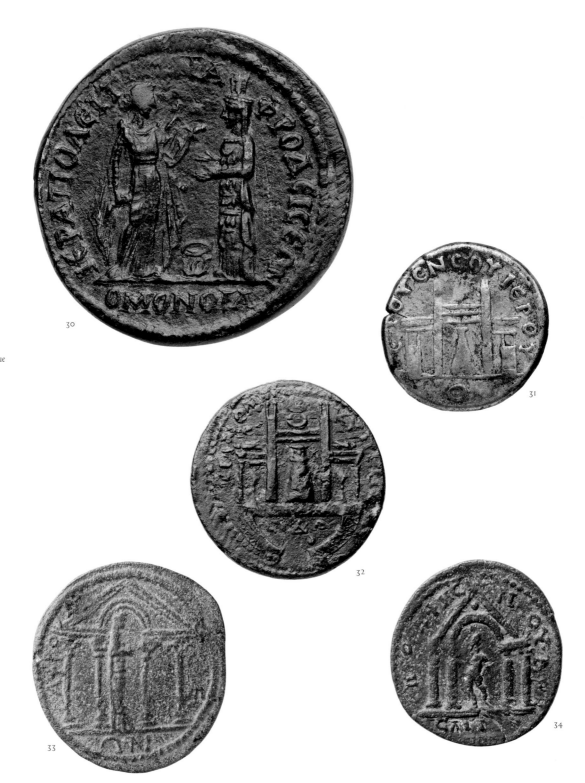

Tetradrachm of Knidos with the head of
Aphrodite (obverse)
Greek, struck under Kalliphron
Late Classical period, 360–340 B.C.
Silver
Diam. 25.5 mm (1¹⁄₁₆ in.)
(cat. no. 124)

Tetradrachm of Eryx with *Aphrodite seated
with Eros (reverse)*
Greek
Classical period, about 410–400 B.C.
Silver
Diam. 24 mm (¹⁵⁄₁₆ in.)
(cat. no. 39)

Coin of Aphrodisias with *Aphrodite
holding an apple and a scepter (reverse)*
Roman Provincial
Imperial period, A.D. 200–250
Bronze
Diam. 26.5 mm (1¹⁄₁₆ in.)
(cat. no. 35)

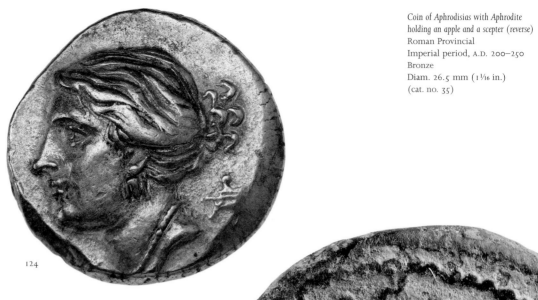

124

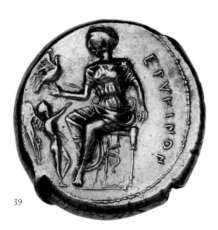

39

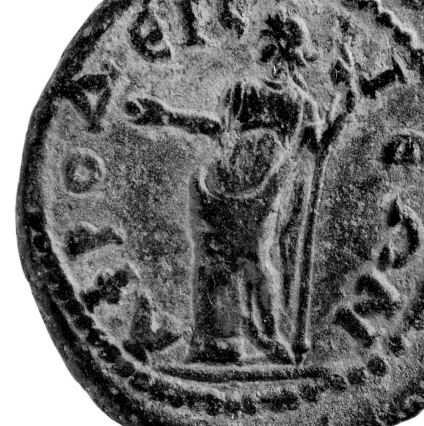

35

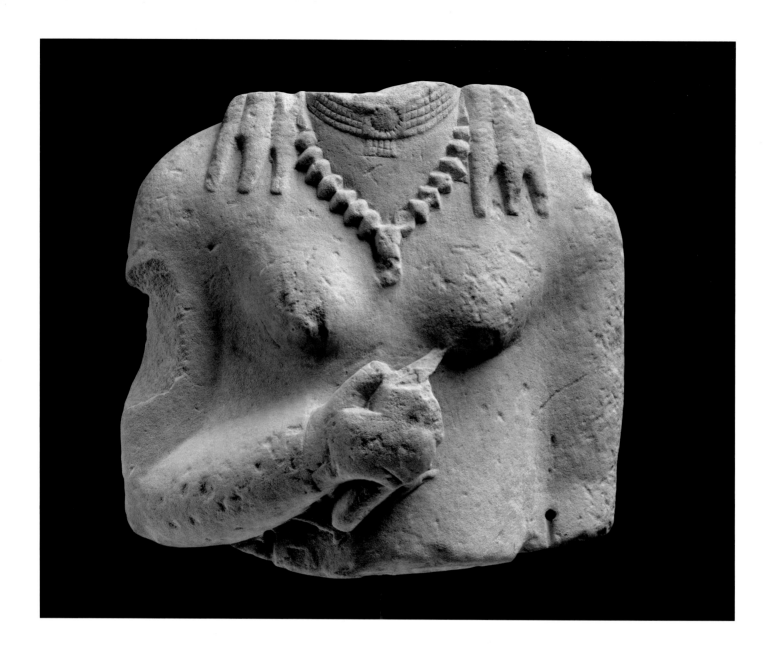

Statue of a female holding a dove
Cypriot
Cypro-Archaic period,
about 575 B.C.
Limestone
H. 23.5 cm (9¼ in.)
(cat. no. 25)

Figurine of Aphrodite
Egyptian
Roman Imperial period,
30 B.C.–A.D. 364
Faience
H. 5.9 cm (2 5/16 in.)
(cat. no. 27)

Figurine of Isis-Aphrodite Anasyromene
Egyptian
Hellenistic period,
3rd–2nd century B.C.
Terracotta
H. 20 cm (7⅞ in.)
(cat. no. 26)

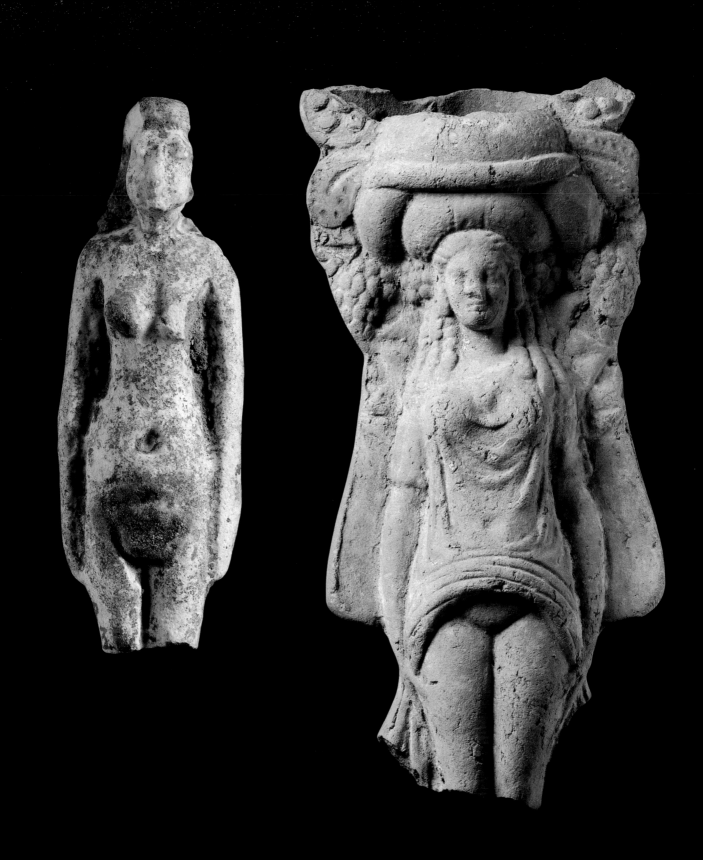

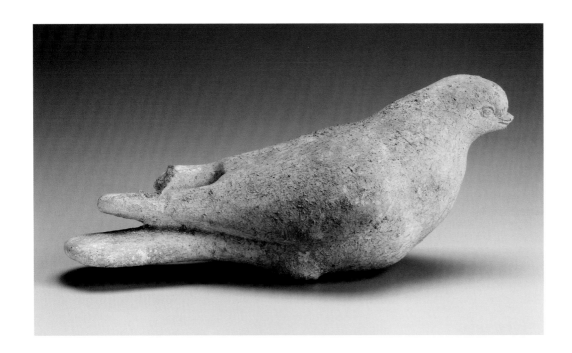

Statuette of a dove
Italic, Etruscan
Hellenistic period,
late 3rd–2nd century B.C.
Terracotta
L. 24.1 cm (9½ in.)
(cat. no. 37)

Gem with a dove
Greek, made in East Greece
Late Classical period,
early 4th century B.C.
Rock crystal, scaraboid intaglio
L. 2.3 cm (¹⁵∕₁₆ in.)
(cat. no. 38)

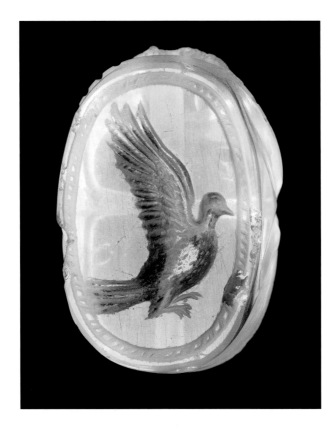

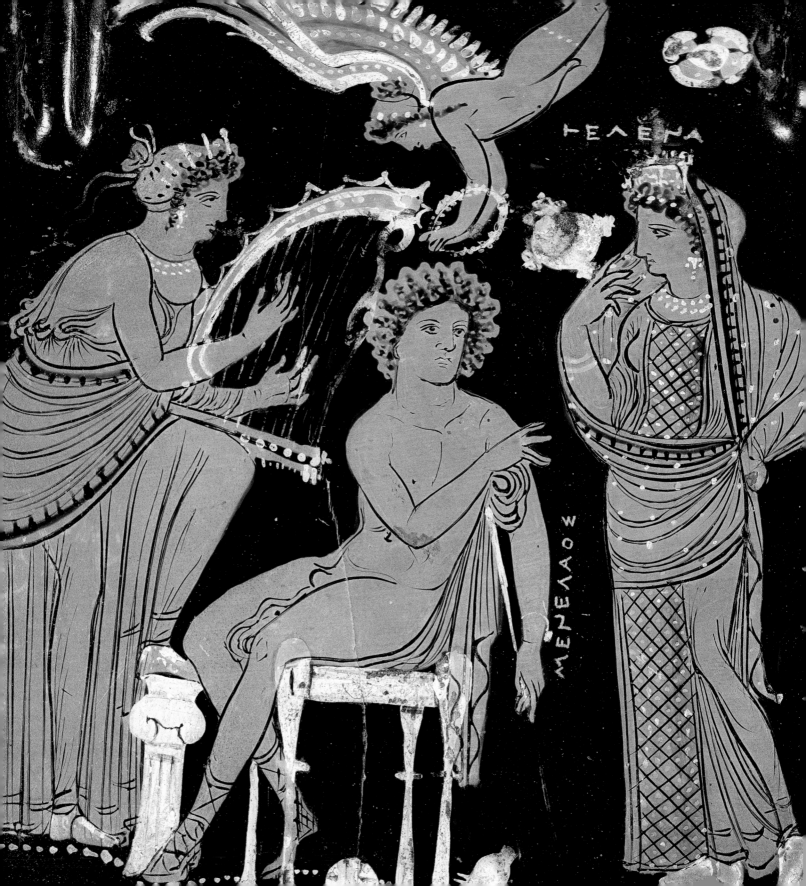

THE PARADOX OF APHRODITE:
A PHILANDERING GODDESS OF MARRIAGE

Phoebe C. Segal

F ollowing Aphrodite's skirmish with the Greek hero Diomedes in Homer's *Iliad*, Zeus tenderly (or condescendingly, depending on one's perspective) encourages the goddess to concern herself with the lovely secrets of marriage and to leave warfare to Athena and Ares.[1] As Vinciane Pirenne-Delforge and Gabriella Pironti point out elsewhere in this volume, the multivalent goddess's sphere of influence was not as neatly configured as the ruler of Olympus would have us believe. But Zeus's remark is all the more puzzling because even in myth Aphrodite is depicted as particularly inattentive to the constraints of marriage, preferring the arms of her lover Ares to those of her husband, Hephaistos, and setting in motion Helen's abandonment of her husband, Menelaos. The question, then, is: if Aphrodite is portrayed in myth as a lousy wife and an agent of home wrecking, why is she so closely associated in Greek cult and art with brides and marriage?[2]

In *Moralia*, the first-century-A.D. Greek writer Plutarch remarks that married couples need five deities: Zeus Teleios, Hera Teleia, Aphrodite, Peitho, and Artemis.[3] The Olympian pair Zeus Teleios and Hera Teleia, whose epithets roughly translate as "the finishers," ensured the completion of the rite of passage of the Greek wedding and guaranteed the legitimacy of the marriage. Women in labor, Plutarch explains, invoked Artemis, the virgin hunter worshipped by young girls, whom the Greeks likened to wild animals. Peitho, at once a goddess with divine lineage and the personification of persuasion, promoted marital harmony and aided in the bride's transition from the house of her father to that of her husband. By contrast, Aphrodite's involvement in marriage, which goes unmentioned (perhaps because Plutarch thought it to be so well understood), focused on sexuality, the single most important aspect of an institution aimed at promoting the continuity of Greek society through the production of legitimate heirs.[4]

Aphrodite's skilled employment of her unparalleled beauty to seduce her lovers, whether marital or extramarital, provided a model for brides and wives. Aphrodite set the example for women of how to enhance their beau-

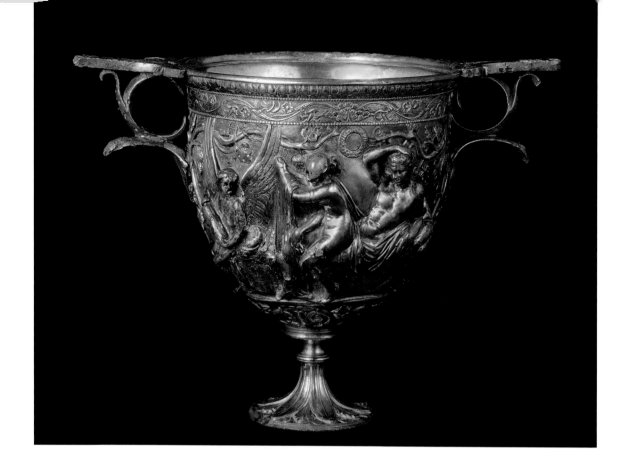

Cup with Mars and Venus
Roman, from the House of the
Menander, Pompeii
Late Republican or Early Imperial
period, second half of the 1st
century B.C.
Gilt silver
H. 12.5 cm (4¹⁵⁄₁₆ in.)
Naples, Museo Archeologico
Nazionale
(cat. no. 40)

ty with sumptuous clothing, jewelry, perfume, and cosmetics. After all, even
Hera, a deity of marriage herself, had to borrow Aphrodite's magical girdle
(*kestos*) to seduce Zeus in the *Iliad*.[5] As the literary, visual, and archaeological
sources demonstrate, Aphrodite's influence in the sphere of sexuality was
crucial to the stability of both individual marriages and Greek communities
as a whole.

The myth of Aphrodite's infidelity poses the goddess as a treacher-
ous wife and the object of ridicule among her fellow Olympians. Through
the voice of the blind poet Demodokos, Homer recounts in the *Odyssey* the
story of Aphrodite's affair with Ares, god of war, and the shame it caused to
her Olympian husband, the master craftsman Hephaistos (cat. no. 40).[6] After
the all-seeing Sun god, Helios, reported to Hephaistos that Aphrodite and
Ares were secretly making love in his house every day while he was at his
forge, Hephaistos fashioned a chain-link trap so fine that even the gods could
not see it and spread it out across his marriage bed. The next time Aphrodite
and Ares lay together, Hephaistos, sick with humiliation, trapped the couple

and displayed them before the Olympian gods, who burst into laughter at the sight. In contrast to the comparatively mild punishment of mere embarrassment the goddess endured, Athenian wives who committed adultery faced divorce, excommunication, and social ostracism, although interestingly they fared better than their lovers, whose offense was punishable by death.

The *Homeric Hymn to Aphrodite*, a hymn celebrating Aphrodite composed by an unknown poet in the seventh or sixth century B.C., tells how Aphrodite had made a habit of bringing about sexual unions between gods and mortals and then bragging about it to her fellow gods, and how Zeus ignited her passion for the Trojan hero Anchises to give her a taste of her own medicine (cat. no. 42). Many have argued that by leading her to lie with a mortal and feel ashamed of it, Zeus's larger goal was to bring about the end of the commingling between gods and men and thus to create a wider and more enduring separation between the two races, a familiar theme in Greek myth.[7] In the hymn, Aphrodite alighted on Mount Ida, where Anchises was tending cattle, and, concealing her true identity, seduced him. The result of their union, Trojan Aeneas, while a mortal, would become the founder of the Roman race and act as the crucial link in the divine ancestry of Julius Caesar and his adopted son Augustus.

Oil flask (squat lekythos) with Aphrodite and Anchises
Greek, made in Athens
Classical period, about 410–400 B.C.
Ceramic, red-figure technique
H. 13.3 cm (5¼ in.)
(cat. no. 42)

Aphrodite's love affair with the beautiful youth Adonis, as told by the Roman poet Ovid in the *Metamorphoses*, began at his birth and continued after his death. The goddess warned Adonis not to attack a fearless animal, but he dismissed her and was fatally wounded by a boar—some say sent by jealous Ares, others by Artemis. His premature death gave rise to an Athenian festival known as the Adonia. Each summer, Athenian women, among them concubines and courtesans, planted "gardens of Adonis"—with barley, fennel, and lettuce, plants that bloomed easily but died quickly—on the rooftops of their houses, burned incense, and lamented the youth's passing. Variants of this cult continued well into late antiquity and were practiced especially in Egypt.[8] Just as Aphrodite and her female Athenian adherents mourned Adonis, the Greeks lamented the death of an unmarried girl or youth as an unfulfilled promise, a theme frequently depicted in Greek funerary art.

Medallion of Tarsus with the Judgment
of Paris (reverse)
Roman Provincial
Imperial period, A.D. 235–38
Bronze
Diam. 40 mm (1 9⁄16 in.)
(cat. no. 47)

Painting of the Judgment of Paris
Roman, from Pompeii
Imperial period, 4th style,
A.D. 45–79
Fresco
H. 60.5 cm (23 13⁄16 in.)
Naples, Museo Archeologico
Nazionale
(cat. no. 46)

In addition to Aphrodite's aforementioned love affairs, she is also notorious for her role in the Judgment of Paris, who conferred on her the status of the most beautiful goddess, a title attributed to her even today. The myth, which Homer alludes to briefly but was known primarily in antiquity from the *Cypria*, a lost epic composed in the Archaic period (700–480 B.C.), begins at the wedding of Peleus and Thetis, where Eris (Strife), upset because she was the only Olympian deity excluded from the guest list, stormed out and left behind a golden apple inscribed "to the most beautiful." Soon after, a quarrel broke out among Hera, Athena, and Aphrodite, each goddess believing that she deserved the title. To settle the dispute, Zeus selected an impartial judge, a Trojan prince named Paris. Hermes led the three goddesses to Mount Ida, outside Troy (in present-day Turkey), where each presented Paris with a bribe: Hera offered political stability in Asia Minor; Athena guaranteed military supremacy; and Aphrodite promised Helen, the most beautiful woman in Greece and the wife of Menelaos of Sparta (cat. nos. 47 and 46). Paris, a man swayed more by love and pleasure than war, chose Aphrodite and left for Troy, with Helen in tow. In response, Menelaos rallied the Greeks and sailed for Troy, where after ten years of war and bloodshed he recovered Helen and took her back to Sparta.[9]

The Judgment of Paris and the ensuing Trojan War are widely regarded as part of Zeus's master plan to lighten the earth's load by bringing about the large-scale destruction of the human race.[10] But despite the knowledge that Aphrodite and Helen were themselves subject to Zeus's agenda, the

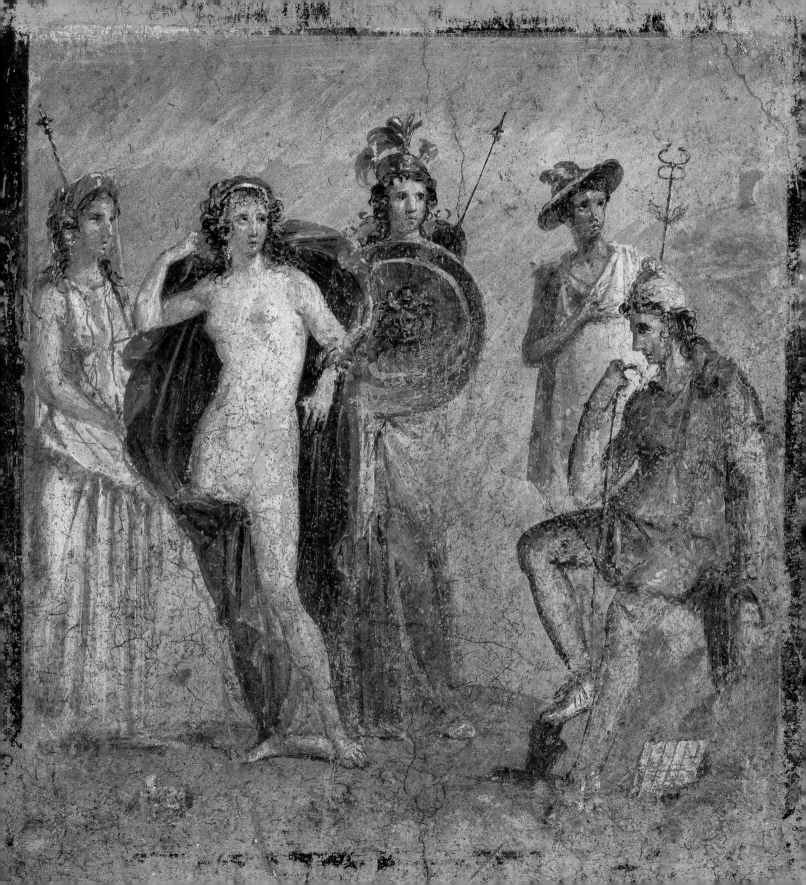

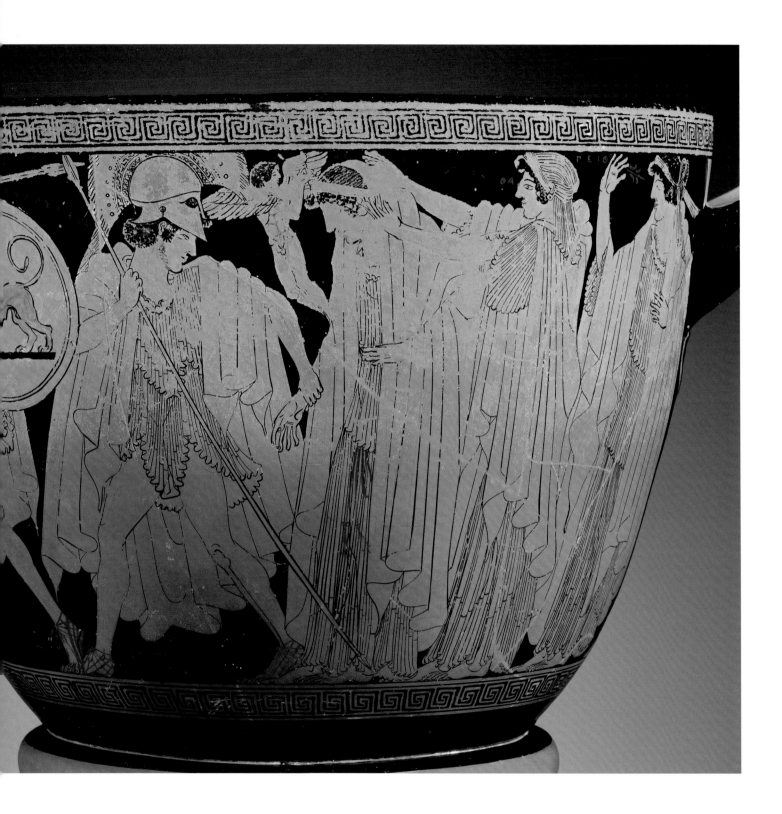

Greeks held the goddess and the heroine accountable for their involvement in these events. Homer's presentation of Helen and her role in the Trojan War, itself varied in outlook, is the acknowledged reference point for all Archaic and Classical poetic attitudes toward her, and in the Archaic period an entire tradition of blame poetry grew up, aimed at excoriating Helen. Alcaeus casts her as a treacherous adulteress, while his fellow Mytilenean Sappho is more sympathetic but still refuses to accept Helen's abandonment of her family in Sparta. Stesichorus's famous reversal of his opinion of Helen, after his harsh words for her caused him to lose his vision, signaled a watershed moment and may have initiated a more positive reception of the Spartan beauty.[11]

Fifth-century-B.C. Athenian visual depictions of Helen demonstrate that the Athenian attitude toward her had softened by that time. A large red-figure drinking cup painted by Makron about 490 B.C. features a rare depiction of Paris's abduction of Helen from Sparta and Menelaos's recovery of her in Troy (cat. no. 49). Ready to depart, Paris turns toward Helen and leads her by the wrist, in a possessive gesture the Greeks called *cheir' epi karpo* (the hand on the wrist). Helen's limp, lifeless hand and hunched shoulders signal hesitance, a state of mind frequently exhibited by nervous young brides. But Aphrodite, in the role of the mother of the bride, arranges Helen's veil and, with the help of Peitho and her son Eros, who flutters between the couple, encourages her to leave with Paris.[12] On the other side of the vase, set in Troy, Menelaos attempts to punish his unfaithful wife, only to be disarmed by her beauty. Aphrodite fixes Helen's gaze so that she can seduce Menelaos and be protected from his murderous rage. In both scenes, Makron portrays Aphrodite as Helen's protector and patroness.

Although Aristotle remarks in the *Politics* that there was in fact no Greek word for "marriage," it is believed to have been a political institution in Athens by the end of the sixth century B.C.[13] Men arranged marriages for their sisters and daughters, always with political alliances and the acquisition of wealth and land in mind. Greek history is full of famous mergers; Megacles, for instance, of the notoriously wealthy Athenian Alcmaeonid family, married Agariste, the daughter of the tyrant Cleisthenes of Sicyon, a prosperous neighboring city-state, and in turn he betrothed their daughter to the Athenian tyrant Peisistratos, a political rival.[14] It was customary for girls to marry at age fourteen and men at thirty. Athenians tended to marry within their social class, and while in the Archaic period it was common for elite Athenians to seek alliances with notable foreign families, by the mid-fifth century Athenian citizens were legally prohibited from marrying for-

Drinking cup (skyphos) representing the departure and the recovery of Helen
Greek, made in Athens; signed and made by Hieron; signed and painted by Makron
Late Archaic period, about 490 B.C.
Ceramic, red-figure technique
H. 21.5 cm (8 7/16 in.)
(cat. no. 49)

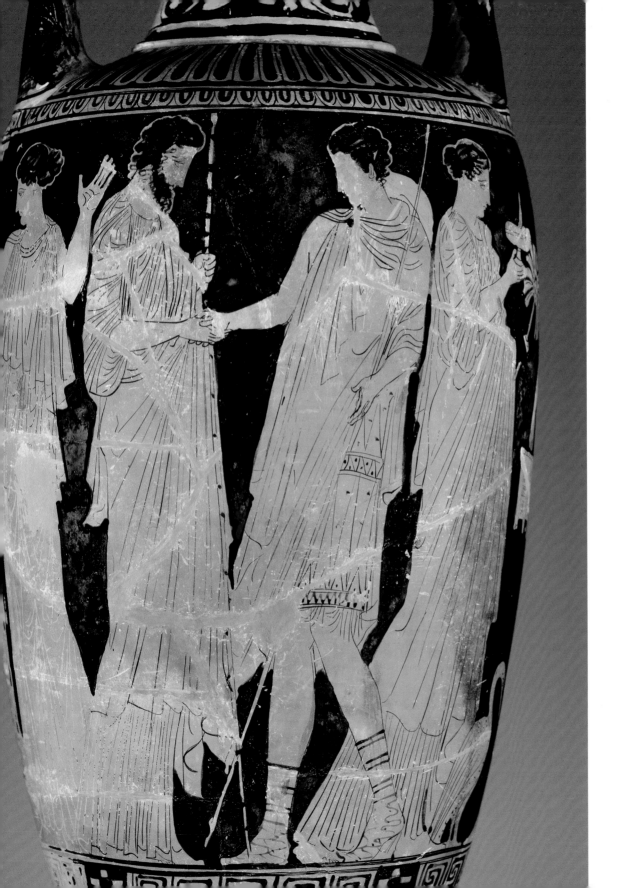

Bathing vessel (loutrophoros) with
a bridal procession
Greek, made in Athens
Classical period, about
450–425 B.C.
Ceramic, red-figure technique
H. 75.3 cm (29 11/16 in.)
(cat. no. 51)

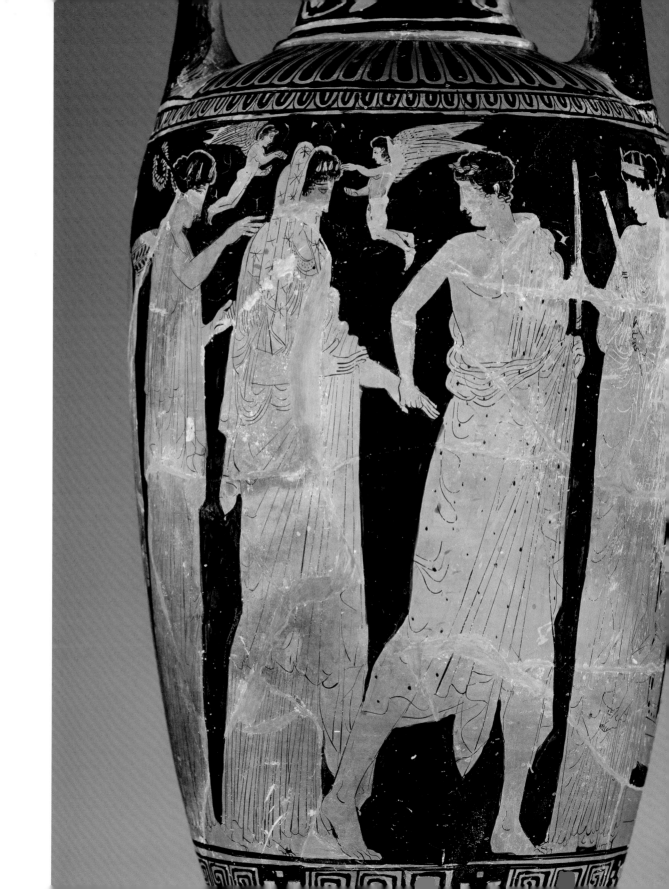

eigners, a measure that aimed to preserve the national purity of its future citizens and warriors.[15]

The Athenian wedding festival lasted three days: the first day (*proaulia*) for sacrifices, offerings, ritual bathing, and the beautification of the bride; the second day (*gamos*) for the procession and feasting; and the third day (*epaulia*) for gift exchange. The wedding commenced with the betrothal (*engye*) of the bride by her father (or brother) to the groom, which is signified in visual terms by a handshake between the two men, as seen on a rare red-figure bathing-vessel type ordinarily used in the prenuptial bath (cat. no. 51, pp. 70–71).[16] On the reverse, echoing Makron's skyphos, the groom leads the bride by the wrist to his family's home, where his mother awaits the couple with blazing torches; the bridal chamber, an allusion to the consummation of the marriage, peeks out from behind the doors.[17] This vase, which preserves an extraordinary visual record of Athenian nuptial rituals, exposes the contrast between the two marriage gestures: one willing and equitable, the other possessive and potentially violent.

Aphrodite's crucial influence was felt in all these events, evident in the cult offerings she received from brides and in her presence, and that of her children, in Greek nuptial imagery. Her devotees believed in her ability to control their marital harmony and ensure a fertile and fulfilling marriage, as evidenced by an inscription on a fourth-century-B.C. marble *thesauros* (treasury box) that reads, "Thesauros, first-fruits to Aphrodite Ourania as proteleia for marriage: one drachma."[18] She and Eros are most frequently depicted in Athenian scenes of the bridal toilette on the very oil and perfume containers used to anoint the bride, where the goddess modeled irresistibility for women and her son incited desire in them. On an acorn lekythos (cat no. 52, p. 75), the bride, adorned with earrings, bracelets, and a necklace, pulls her veil over the bridal crown (*stephane*) as Eros ties her sandals (*nymphides*). On a squat lekythos (cat. no. 53, p. 74), Eros hands a tray of fruit to the bride in the presence of her groom, and on a neck amphora (cat. no. 54, p. 75), the love god offers Hippodameia a bunch of grapes as she prepares to wed Pelops.[19] On a South Italian alabastron depicting Helen and Menelaos as bride and groom (cat. no. 55, p. 74), Eros swoops in to place a lover's crown on Menelaos's head. In all these scenes, Eros acts as his mother's agent and arouses desire in the bride and groom as they prepare for their first sexual encounter together.

The activities and tools used in these scenes of the bridal toilette mirror Aphrodite's own beauty habits. The *Homeric Hymn to Aphrodite* tells how the goddess prepared herself to seduce Anchises:

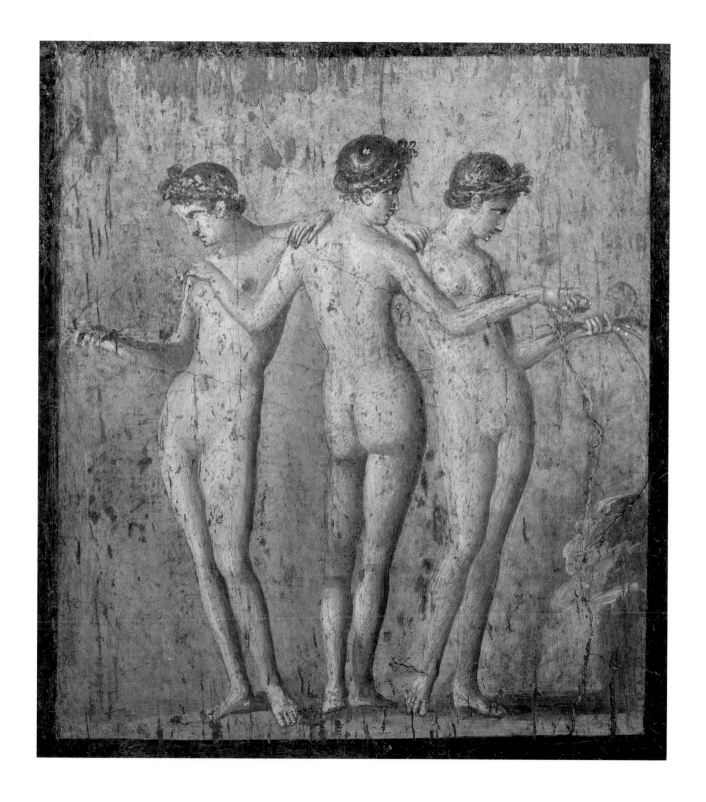

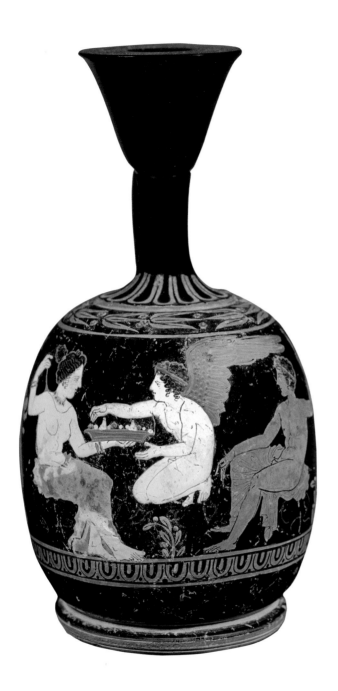

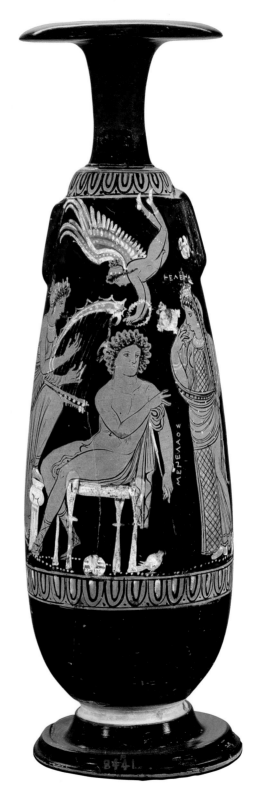

Oil bottle (squat lekythos) with Eros,
a man, and a woman
Greek, made in Athens; attributed to
the Meidias Painter
Classical period, about 410–400 B.C.
Ceramic, red-figure technique with
gilt relief
H. 11.7 cm (4⅝ in.)
(cat. no. 53)

Perfume flask (alabastron) depicting Menelaos
and Helen as bride and groom
Greek, made in Apulia; attributed
to the V. and A. Group
Late Classical period, about 350 B.C.
Ceramic, red-figure technique
H. 28.2 cm (11⅛ in.)
(cat. no. 55)

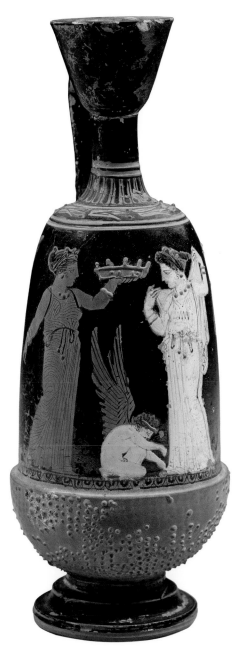

Oil bottle (lekythos) in the form of an
acorn with a scene of bridal preparations
Greek, made in Athens; attributed to
the Manner of the Meidias Painter
Classical period, about 410–400 B.C.
Ceramic, red-figure technique
H. 15.3 cm (6 1/16 in.)
(cat. no. 52)

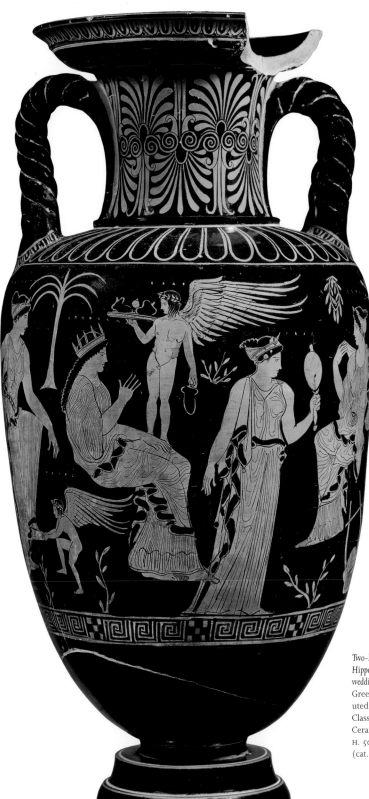

Two-handled jar (amphora) with
Hippodameia preparing for her
wedding
Greek, made in Athens; attrib-
uted to the Kadmos Painter
Classical period, about 425 B.C.
Ceramic, red-figure technique
H. 50 cm (19 11/16 in.)
(cat. no. 54)

She went to the island of Cyprus and entered her fragrant shrine
at Paphos, the place where her precinct and fragrant altar are
found; there, having gone inside, she closed the gleaming doors.
The Graces washed her, anointed her there with oil, with the
deathless oil that covers the gods who always exist, heavenly,
sweet-smelling oil which had been perfumed for her. And when
she had clothed herself well with fair robes all about her flesh, and
was decked with golden adornments, on toward Troy then rushed
Aphrodite, lover of smiles.[20]

If the most beautiful of goddesses had need of perfume, cosmetics, fine gar-
ments, and jewelry, all the more did Greek brides. The Greeks were so con-
vinced that the process of *kosmesis* (adornment) enhanced a woman's powers
to arouse desire in their grooms that Greek families even employed a special-
ist, called a *nymphokomos* (a woman who prepares the bride), to oversee the
bride's beautification.[21]

As with nuptial vases, images of Aphrodite and Eros often decorated
the tools of beautification used by Greek, Etruscan, and Roman women. With
their reflective quality, mirrors functioned as ideal surfaces onto which elite
women of antiquity projected their aspirations of beauty. An Etruscan woman
holding a mirror with a depiction of Aphrodite hiding Adonis in a lettuce
patch (cat. no. 43) would have pondered the goddess's seduction of the hand-
some youth and his premature death. A Greek woman grasping a mirror stand
in the form of Aphrodite would have seen the goddess's image reflected back
at her beneath her own and might have imagined her own beauty enhanced
in the process. Women wore images of Aphrodite and Eros in gold and silver
rings and earrings as echoes of the precious jewelry worn by the goddess and
her cult statues and as invocations of her powers and those of her son (cat.
nos. 69, 71, and 73, p. 96; cat. nos. 86 and 95, p. 138).

The images of Aphrodite and Eros on perfume and cosmetic contain-
ers reminded women of the fragrant altars of Aphrodite's sanctuary at Paphos
and how the Graces (cat. no. 59, p. 73) anointed her with perfumes. An unusu-
al bronze Etruscan perfume jar (balsamarium) in the shape of the head of
Turan, Aphrodite's counterpart in Etruria, bedecked with jewels and doves, the
signature attribute of the goddess, was a fitting well from which an elite
Etruscan woman might have enhanced her allure (cat. no. 64, pp. 78–79). As
Marcel Detienne points out, ancient literary sources present a varied outlook
on the appeal of perfume and cosmetics. While Xenophon's Socrates encour-
ages brides that their natural fragrance is sufficiently alluring, Plutarch notes a
male preference for women who are perfumed and made-up.[22] The luxury
trade of perfume in Corinth and the industrial production of roses in

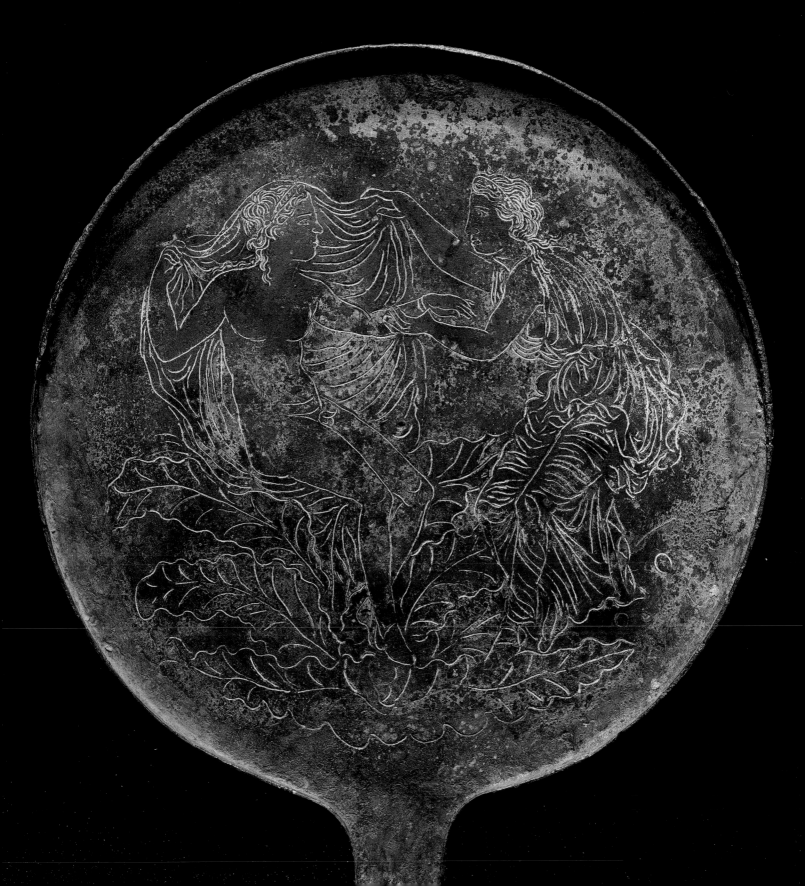

Campania and North Africa in the Roman period, emblematized in a mosaic of about A.D. 200 from North Africa (cat. no. 65, pp. 80–81), which features erotes gathering roses, demonstrate the erotic power and economic significance of perfume in antiquity.

Vases with nuptial imagery and mirrors, perfume, and jewelry served an additional function in the context of the final rite of passage in a woman's life—death. They were used in the preparation of the bodies of deceased women, which were, as with brides, bathed, anointed, and elegantly dressed, and then were buried with the women in their tombs.[23] A group of late-fifth-century objects, said to be from a tomb in the northern Peloponnese, includes the acorn lekythos described above (cat. no. 52, p. 75); a squat lekythos with Aphrodite, Anchises, and Eros (cat. no. 42, p. 65); and two gold pins decorated with sphinxes, bees, and lions. This rich collection of objects indicates the elite status of the interred woman and highlights the connection the Greeks

Perfume jar (balsamarium) in the shape of Aphrodite/Turan
Etruscan
Hellenistic period, late 3rd or early 2nd century B.C.
Bronze with inlaid glass (?) eyes
H. 10.5 cm (4⅛ in.)
(cat. no. 64)

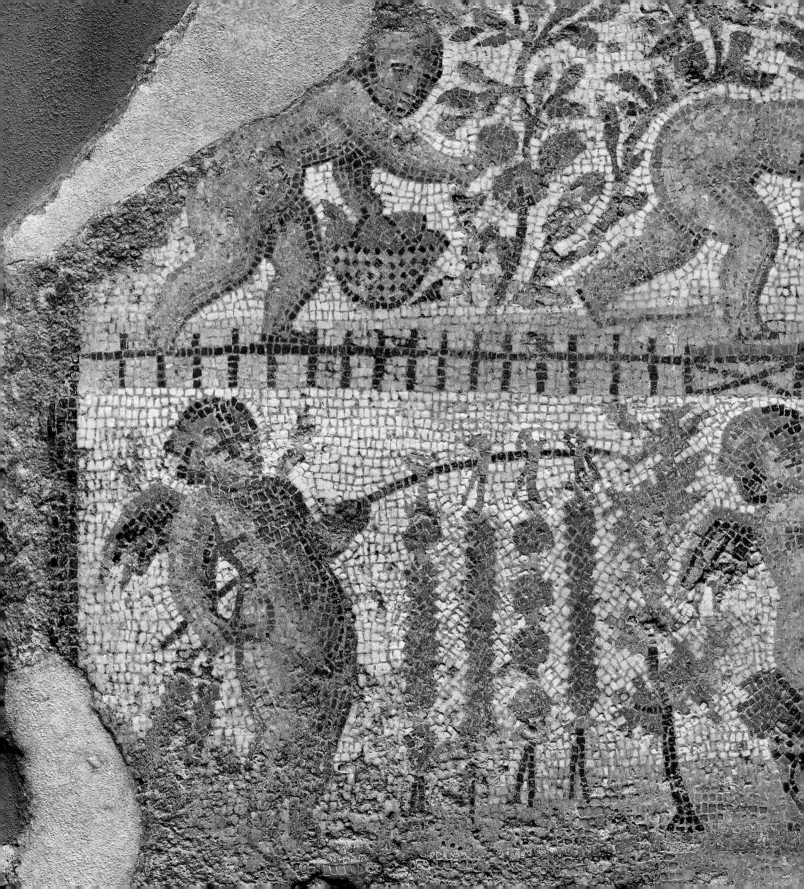

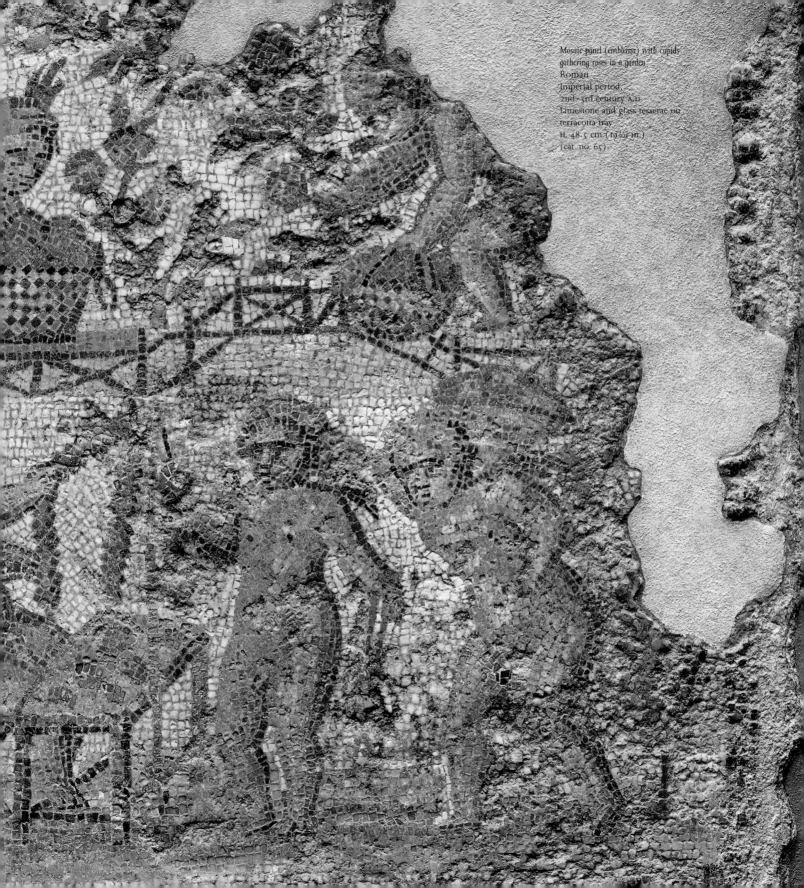

Mosaic panel (emblema) with cupids
gathering roses in a garden
Roman
Imperial period,
2nd–3rd century A.D.
Limestone and glass tesserae on
terracotta tray
H. 48.5 cm (19⅛ in.)
(cat. no. 65)

made between images of adornment and the objects of adornment in the context of the grave. An Athenian grave marker in the form of a marble lekythos (fig. 5), made about 420 B.C., further illustrates these associations. Accompanied by an attendant, the deceased, a young woman seated on a chair (klismos), looks sadly into a mirror below.

Sometimes Greek vases served an exclusively funerary function, particularly in the funerals of unmarried girls or women, who were mourned as the brides of Hades, ruler of the Underworld.[24] Mourners would have placed such vessels, an example of which is the loutrophoros discussed above (cat. no. 51, pp. 70–71), on top of the funerary mound of the deceased girl or woman and honored her by pouring libations of oil through a hole in the bottom of the vase. In this context, the images of the betrothal, the wedding procession, and the bridal chamber on the vase—the entire narrative of the Greek wedding, in effect—would have alluded to the would-be wedding of the deceased and conferred upon her the metaphorical status of a bride. This example demonstrates that nuptial images on vases functioned on at least three levels: as reflections, recollections, and projections of the wedding.

Many of the Greek funerary arts demonstrate the close association between these two rites of passage, marriage and death, for girls and women.[25] Objects of beautification, such as a fourth-century terracotta imitation mirror cover with Aphrodite cradling a young female figure (cat. no. 77, p. 84), also at times served wholly funerary purposes. This unusual mirror cover, said to be from Corinth, imitates contemporary bronze mirrors (cat. no. 75, p. 85), with relief decoration and even a molded hinge with two holes. Its pristine condition suggests that the mirror was made expressly for a woman's tomb. A nude, young bride rests in the lap of Aphrodite, who is identified by the goose at her feet; Peitho (Persuasion) stands close by as Eros flies above carrying a victor's fillet. While this iconography appears only on terracotta rather than bronze mirrors, depictions of a bride in the lap of Aphrodite, or of a member of her bridal party, are found in Athenian vase painting of the second half of the fifth century.[26] One example, a red-figure amphoriskos by the Heimarene Painter,[27] features the meeting of Helen and Paris: Aphrodite reassures a preoccupied Helen who sits in her lap, with Peitho standing nearby for additional support. As Alan Shapiro notes, Helen is not a young bride here but rather a married woman about to commit adultery. The Boston mirror exemplifies how this composition of figures later came to epitomize a nervous bride seeking reassurance on her wedding day.[28] As on the Heimarene Painter's amphoriskos, Aphrodite acts as the young bride's divine protector, and in turn the bride probably holds a dove in her left hand to honor the goddess, as was the habit of young Greek girls, who offered the goddess her favorite attribute in

Fig. 5
*Grave marker in the form of an oil bottle
(lekythos)*
Greek
Classical period, 420–410 B.C.
Marble, Pentellic
H. 76 cm (29 15/16 in.)

her sanctuaries (cat. no. 36, p. 61). This imagery would have been particularly appropriate for the tomb of an unmarried girl, as the would-be fulfillment of her greatest achievement, marriage, and the use of terracotta strongly suggests that the Boston mirror was intended for such a tomb.

As the terracotta mirror demonstrates, the reciprocal relationship between the bride and Aphrodite, with the bride as devotee and Aphrodite as mentor, provided a model for that of young women and the goddess of sexuality. The worship of Aphrodite by brides preparing for their first sexual experience and the goddess's image as a philandering temptress in fact do not contradict each other. If anything, the myths of Aphrodite's own amorous con-

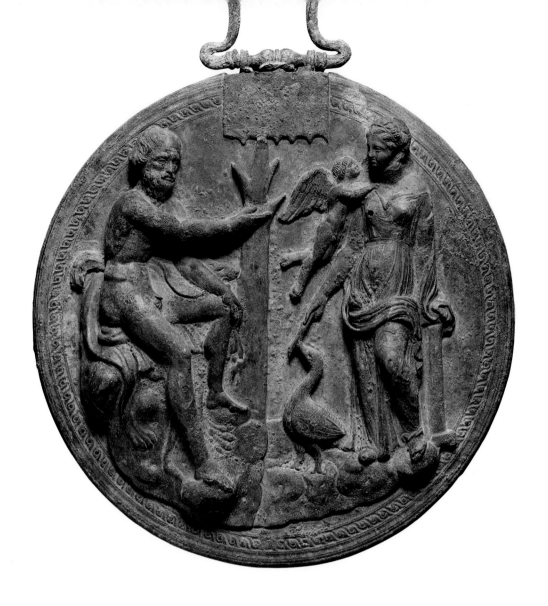

quests served as exemplars for Greek brides, wives, concubines, and courtesans. In particular, the *Homeric Hymn to Aphrodite*'s description of the goddess's bathing, anointing, and adornment functioned as a how-to guide for Greek women as they prepared for erotic encounters with their husbands, as sweet smells, soft textures, and pleasing sights aroused the senses and rendered women irresistible to men. It was the duty of the Greek wife to tease procreation out of her husband, to engage him in the sexual act, and to provide him with legitimate heirs. It is only fitting that as Greek girls themselves prepared to become seductresses, they should have invoked the guidance of, and sought to emulate, Aphrodite, the most irresistible of all goddesses.

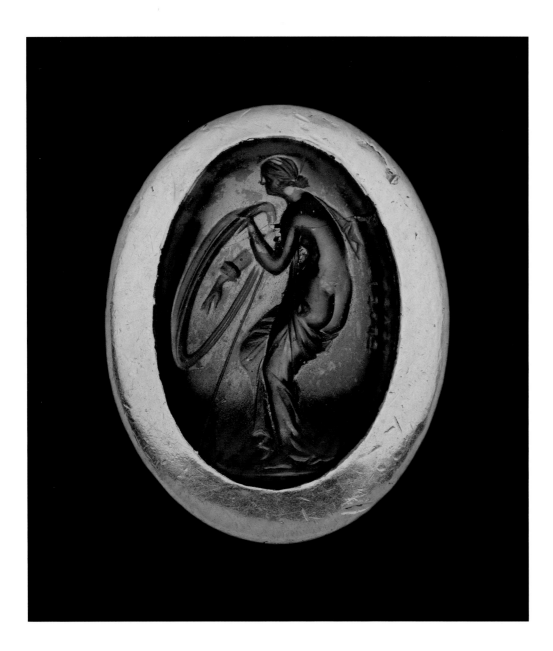

Ring with Aphrodite taking up arms
Greek; signed by Gelon
Hellenistic period, about 200 B.C.
Gold with garnet intaglio
L. 2.9 cm (1⅛ in.)
(cat. no. 72)

Plaque with a bust of Ares
Roman
Imperial period, A.D. 25 or 135
Silver
Diam. 12 cm (4¹¹⁄₁₆ in.)
(cat. no. 41)

Two-handled jar (amphora) depicting the Judgment of Paris and the recovery of Helen
Greek, made in Athens; attributed to the Group of Würzburg 199
Late Archaic period, about 510–500 B.C.
Ceramic, black-figure technique
H. 44 cm (17 5/16 in.)
(cat. no. 44)

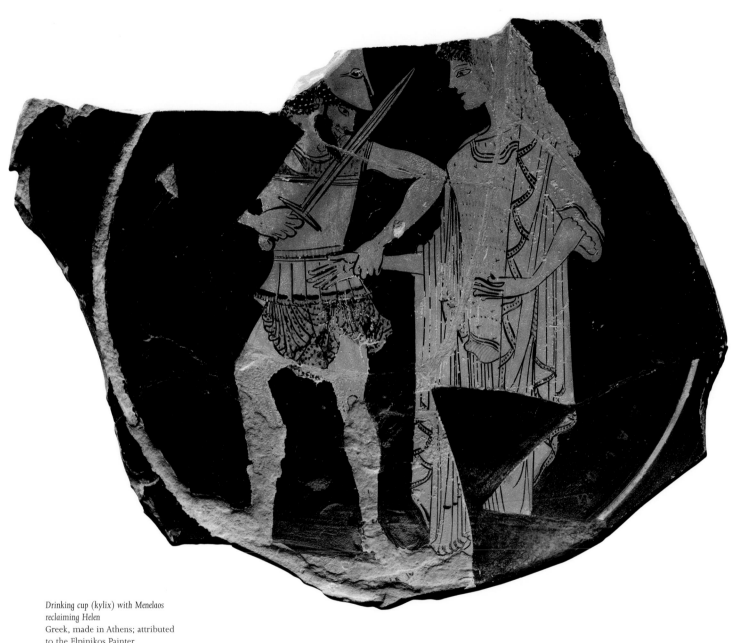

*Drinking cup (kylix) with Menelaos
reclaiming Helen*
Greek, made in Athens; attributed
to the Elpinikos Painter
Late Archaic period, about 500 B.C.
Ceramic, red-figure technique
L. 13.9 cm (5 7/16 in.)
(cat. no. 50)

*Textile depicting the Judgment
of Paris*
Egyptian
Late Roman or Early Byzantine
period, 6th century A.D.
Linen and wool tapestry weave
33 x 30.5 cm (13 x 12 in.)
(cat. no. 48)

*Drinking cup (skyphos) parodying the
Judgment of Paris*
Greek, made in Boeotia
Classical period, about 420 B.C.
Ceramic, black-figure technique
H. 20.5 cm (8 1/16 in.)
(cat. no. 45)

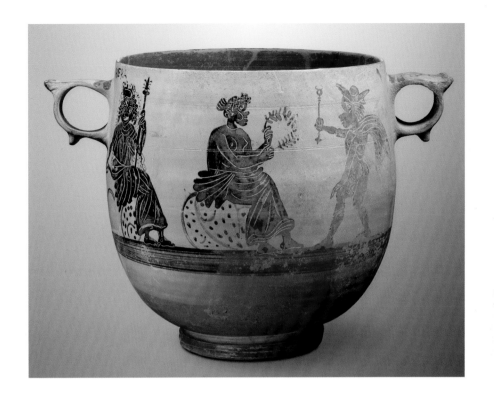

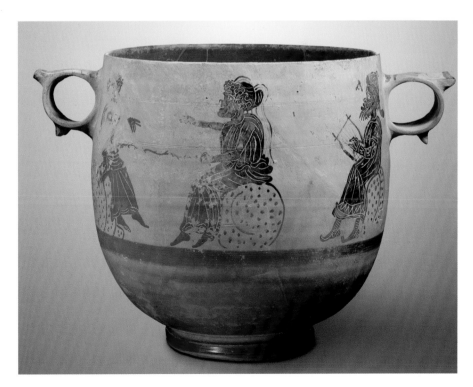

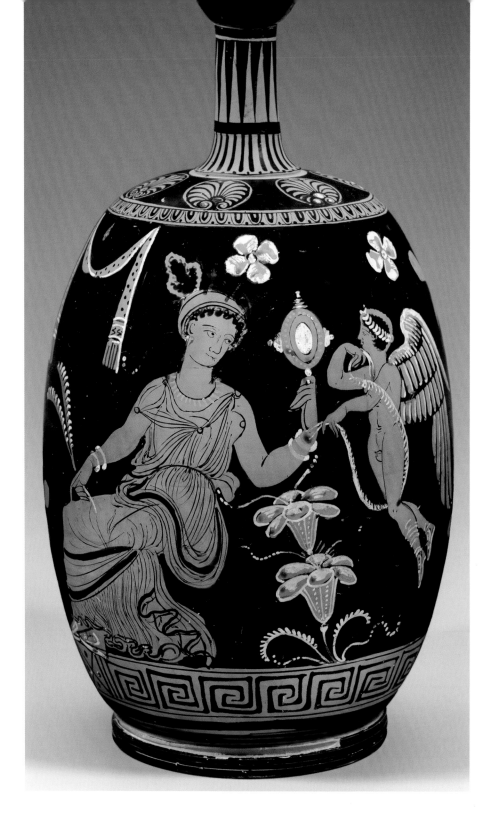

Oil bottle (lekythos) with a woman
looking in a handheld mirror
Greek; attributed to the
Primato Painter
Late Classical period, about
350–340 B.C.
Ceramic, red-figure technique with
added white and yellow
H. 36 cm (14 3/16 in.)
(cat. no. 76)

Jar (pelike) with amorous scenes
Greek, made in Apulia (South Italy);
attributed to the Circle of the
Darius Painter (Egnazia Group)
Late Classical period, about
340–320 B.C.
Ceramic, red-figure technique
H. 43.2 cm (17 in.)
(cat. no. 58)

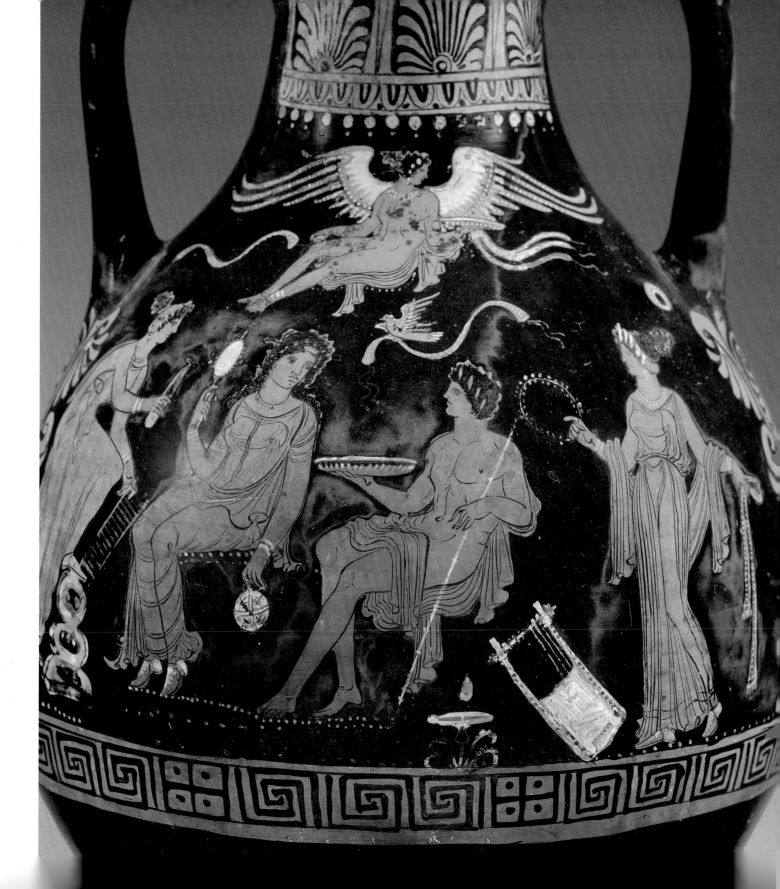

Two-handled jar (amphoriskos) with Eros and a woman
Greek, made in Athens; attributed to the Eretria Painter
Classical period, about 425 B.C.
Ceramic, red-figure technique
H. 19 cm (7 7/16 in.)
(cat. no. 56)

Marriage bowl (lebes gamikos) with prenuptial scene
Greek, made in Euboia (probably Chalkis)
Classical period, late 5th or early 4th century B.C.
Ceramic, red-figure technique
H. 24.6 cm (9 11/16 in.)
(cat. no. 57)

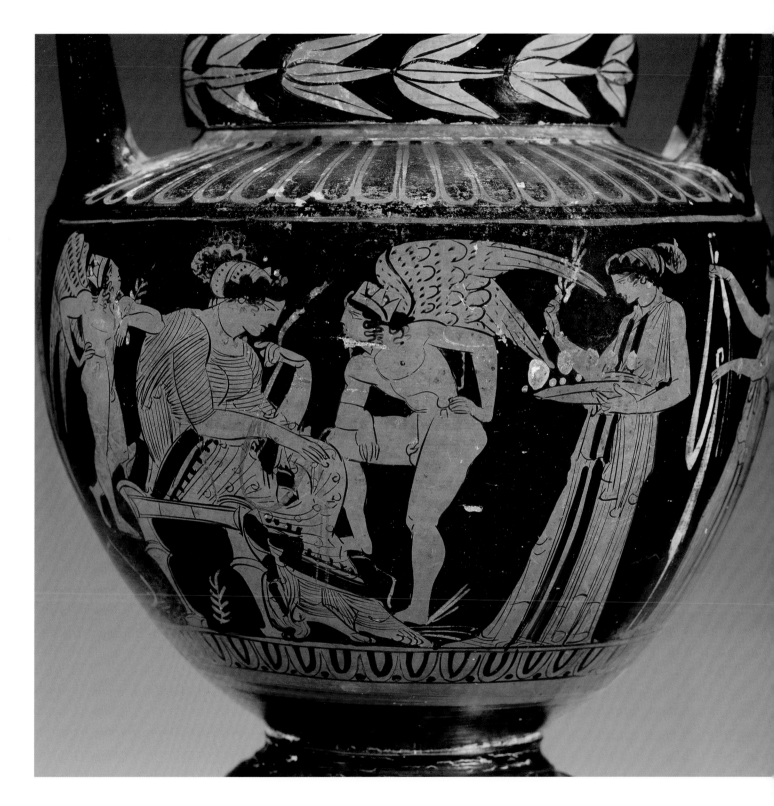

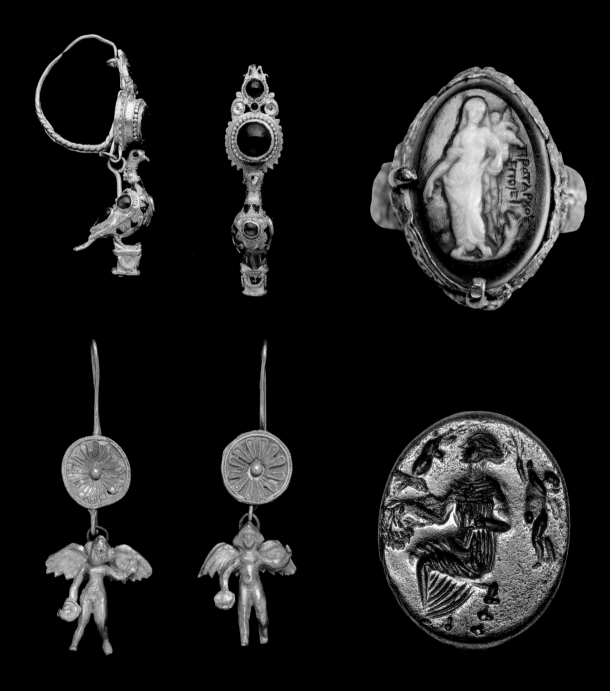

*Pair of earrings with a dove standing on
an altar*
Greek
Hellenistic period, 150–100 B.C.
Gold, garnet, glass paste
L. 5.2 cm (2 1/16 in.)
(cat. no. 70)

Pair of earrings with a pendant Eros
Greek
Early Hellenistic period,
3rd century B.C.
Gold
L. 5.2 cm (2 1/16 in.)
(cat. no. 69)

Ring with Aphrodite and Eros
Greek; signed by Protarchos
Hellenistic period, 2nd century B.C.
Sardonyx cameo
H. 2.1 cm (13/16 in.)
(cat. no. 73)

*Ring with seated woman (probably
Aphrodite) crowned by two erotes*
Greek
Late Classical period, about 350 B.C.
Silver
L. of bezel 2.1 cm (13/16 in.)
(cat. no. 71)

*Mirror and stand in the form of a female
figure (possibly Aphrodite) holding a dove*
Greek, made in Corinth or possibly
Sikyon
Early Classical period, about 460 B.C.
Bronze
H. 45 cm (17 11/16 in.)
(cat. no. 74)

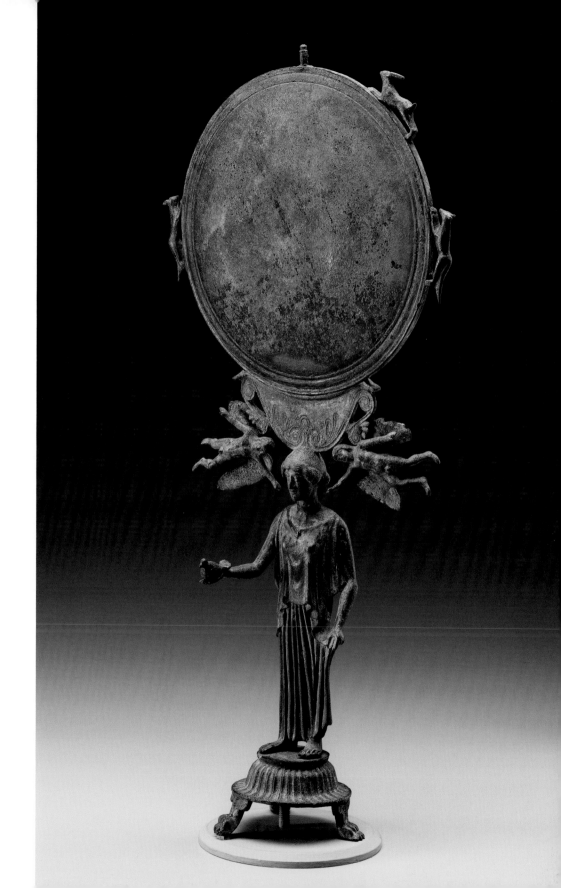

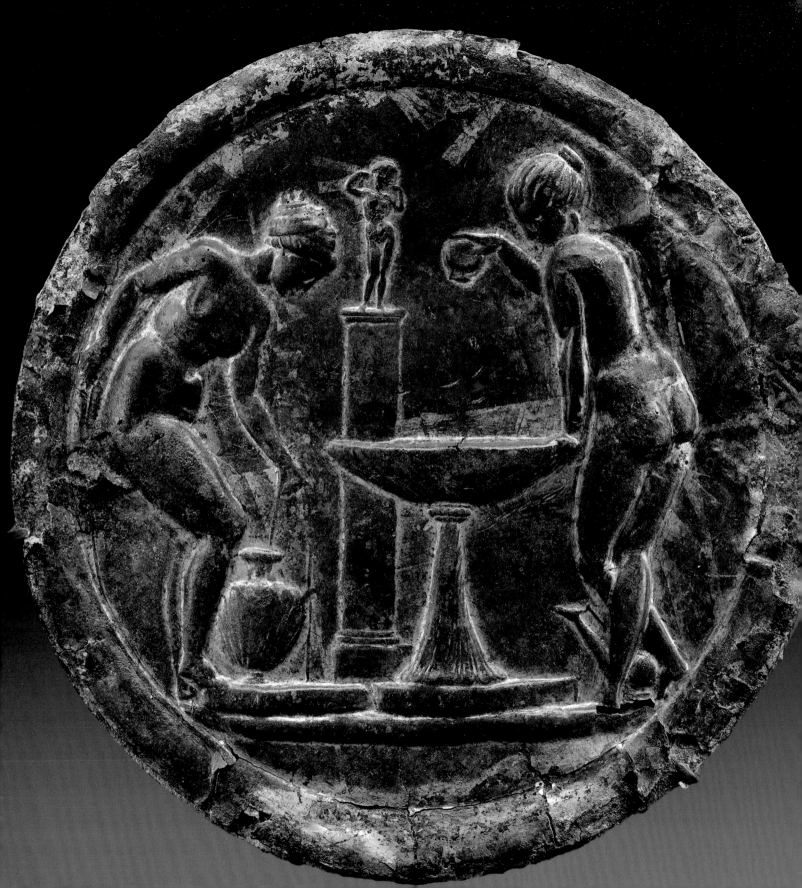

*Mirror with women bathing before
a statue of Aphrodite on a pillar*
Roman, Eastern Mediterranean
Imperial period, A.D. 110–17
Silvered and gilt bronze
Diam. 13 cm (5⅛ in.)
(cat. no. 60)

*Mirror with three cupids with
garlands and fruits*
Roman, Eastern Mediterranean
Imperial period, about A.D. 200
Gilded bronze
Diam. 8.9 cm (3½ in.)
(cat. no. 79)

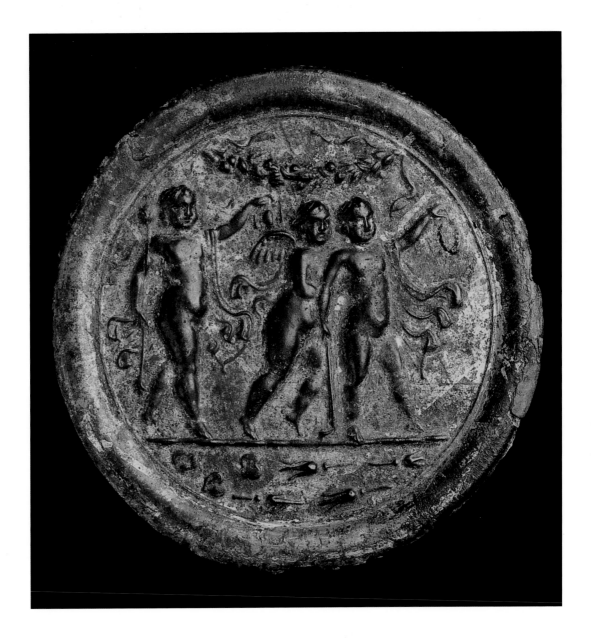

Fig. 6
Francisco Botero
(born in Colombia, 1932)
Venus, 1971
Charcoal on canvas
H. 182.9 cm (72 in.)

Figurine of Eros holding a box mirror
Greek
Hellenistic period, 2nd century B.C.
Terracotta
H. 13.4 cm (5 5⁄16 in.)
(cat. no. 78)

Round box (pyxis) with two cupids fishing
Roman
Imperial period, 1st century A.D.
Bone
H. 4.5 cm (1¾ in.)
(cat. no. 67)

Round box (pyxis) with two cupids
and a butterfly
Roman
Imperial period, 1st century A.D.
Bone
H. 5 cm (1¹⁵⁄₁₆ in.)
(cat. no. 68)

Gem with cupids making perfume
Roman
Imperial period, 1st century A.D.
Glass, intaglio
L. 3.6 cm (1⁷⁄₁₆ in.)
(cat. no. 66)

Covered unguent bowl with tall foot
(*exaleiptron*)
Greek
Classical period, 450–425 B.C.
Marble
H. 19.7 cm (7¾ in.)
(cat. no. 63)

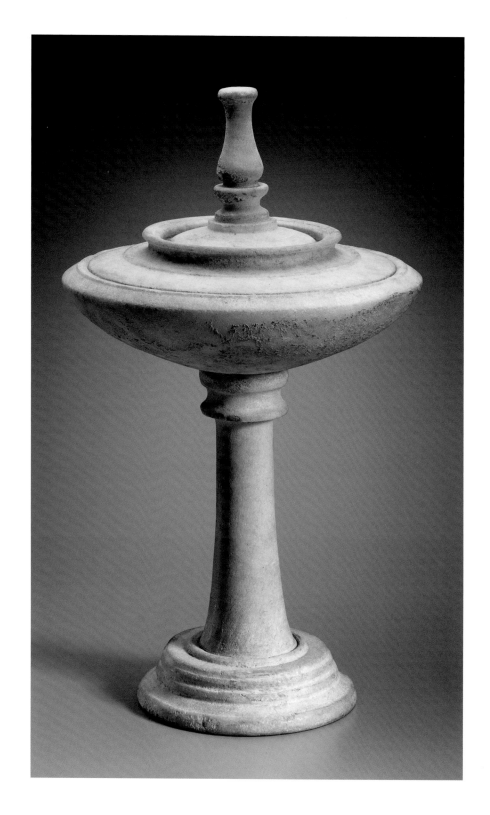

Perfume flask (alabastron) with siren
Greek, made in Corinth
Early Archaic period, 620–590 B.C.
Ceramic, black-figure technique
H. 8.9 cm (3½ in.)
(cat. no. 62)

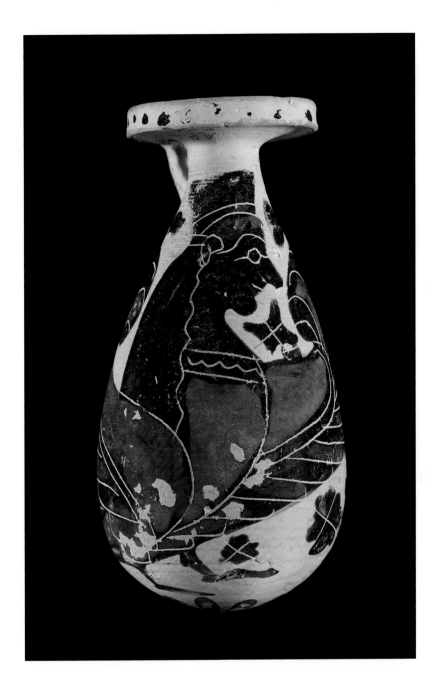

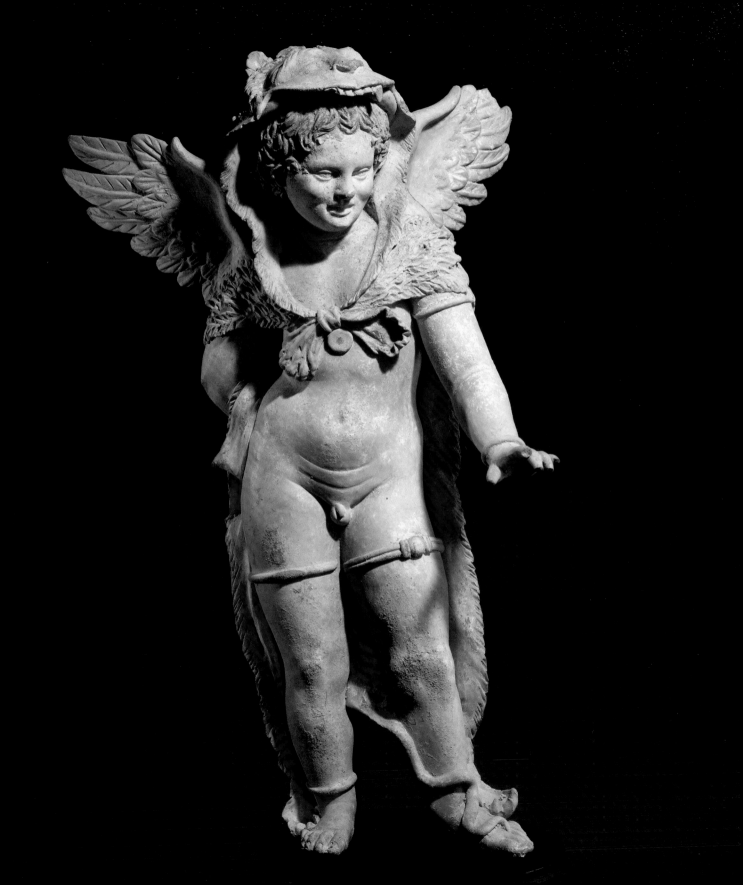

EROS, CHILD OF APHRODITE

■ ■ ■ ■ ■

Christine Kondoleon

*A*phrodite's offspring are a complicated lot. Some take on distinctive personalities, attributes easily recognized by the Greeks and Romans. Hermaphrodite and Priapos, her children by Hermes and Dionysos, respectively, were fully realized deities worshipped in their own right, especially in the Roman period. Others were more like companions than offspring and served as erotic personifications of Aphrodite. Still others remain elusive and subject to the whims of poets for their character. But her most famous child, Eros, or Cupid, offers perhaps the greatest challenge of them all.

Statistically there are far more representations of Eros than any of Aphrodite's other children, which may be explained by the fact that his youth and charm appealed to a wider audience than her other offspring. Whatever the reasons, the archaeological record leaves us no choice but to focus much of our attention on the many manifestations of Eros in Greek and Roman art. The interpretation of his various guises often depends on the cultural milieu in which he appears, which in turn can offer unexpected sexual and psychological insights into the ancients.

While visual images of Eros abound in wide variety, there are remarkably few written references in the ancient sources, epigraphic or literary.[1] The only mythological account of the birth of Eros is found in Plato's *Symposium*, where we learn that he was conceived by two lesser deities (Poros, or Plenty, and Penia, or Poverty) at the feast celebrating the birth of Aphrodite;[2] the early Greek texts are otherwise obscure about his origins. Indeed, depending on the source, he is said to have been born of no parents, cosmic parents, or Olympian parents, with potential fathers that included Ares, Ouranos, Hermes, and Zeus. One Hellenistic epigram humorously sums up the problem: "Eros is such an exhausting child that nobody wants to be his father."[3] As to his mother, it was not until the seventh century B.C. that the poet Sappho first called Eros the son of Aphrodite. Of the major early sources for the Olympian gods, only Hesiod writes about Eros, and then only as an attendant at Aphrodite's birth, where he is joined by Himeros, the personification of desire or longing;[4] Homer, normally the primary source for such information, omits mention of Eros altogether.

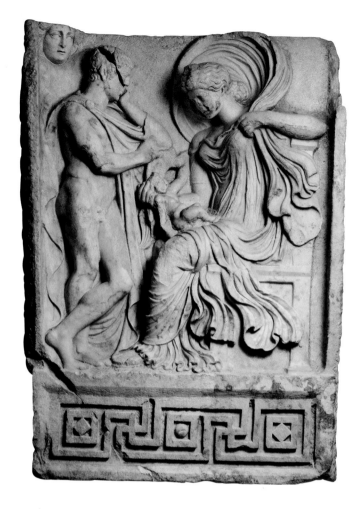

The texts indicate that the worship of Eros was not highly organized. The playwright Aristophanes, in his speech in the *Symposium*, laments how mankind has failed to realize the power of desire and neglected to build great sanctuaries and altars for Eros.[5] Likewise, the chorus in Euripides's play *Hippolytus* intones: "Eros, however, the tyrant of men, the key holder of Aphrodite's dearest chambers, we do not worship."[6] In terms of art history, the oldest visual trace of the relationship between Aphrodite and Eros is on the Parthenon frieze (fifth century B.C.), where the winged boy lounges against his mother's knees while tucking his right hand under her outer garment. Two important Roman reliefs echo this intimate maternal scene and forge a thematic and artistic link between the Greek Aphrodite and the Roman Venus. The Augustan sculptors of the *Ara Pacis* altar in Rome (13–9 B.C.) were clearly inspired by the Parthenon model when they carved a matronly goddess in

classical drapery, seated with two babies reaching for her breast. While the figure's identity has been debated, it is clear her domain is growth and fertility, and that the evocation of Aphrodite/Venus was present as a necessary mythical link between the Augustan family and Aeneas. These links are underscored by another, highly similar seated draped mother with a baby Eros on her lap, depicted on a marble relief panel from the south portico of the Sebasteion in the ancient city of Aphrodisias (present-day western Turkey) (fig. 7).

Because of its association with Aphrodite, the city of Aphrodisias enjoyed a special connection with Rome and the Julian family, which claimed direct descent from Venus, and as such benefitted from generous endowments. One of these was the Sebasteion, a building complex dedicated to the cult of the deified emperor Augustus (in Greek, Sebastos) and his successors. The marble relief panel showing Aphrodite and Eros also includes a standing male figure, perhaps Aphrodite's mortal lover Anchises, as well as their child Aeneas. Does the scene allude to the birth of Eros, otherwise unparalleled in ancient art? Or does the baby Eros serve as a reminder of the love encounter between Aphrodite and Anchises? Whichever the case, the Sebasteion seems to have been part of an innovative sculptural program, developed for the worship of the Roman emperor in the Greek East, that invokes both Imperial Augustan and earlier Classical Greek models and that puts special emphasis on Aphrodite and Eros. Undoubtedly, in this region of Turkey the representation of a mother goddess holding an infant recalled an earlier Near Eastern type generally known as the *Kourotrophos*, or nursing goddess, found in the form of small terracotta figurines manufactured for local worship (cat. no. 80).

Statuette of Aphrodite with child Eros on her knee
Greek, made in Myrina (Asia Minor)
Hellenistic period, late 1st century B.C.
Painted terracotta
H. 24.1 cm (9 ½ in.)
(cat. no. 80)

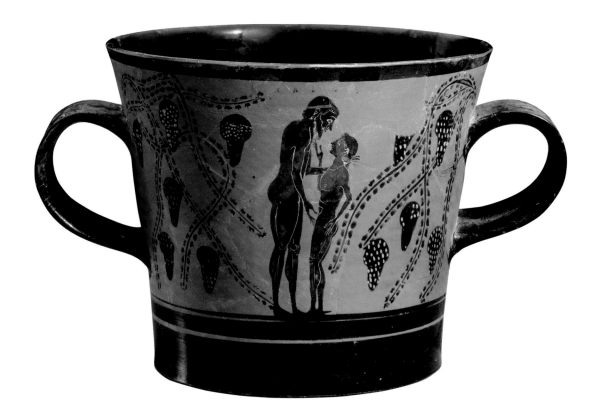

While official monumental compositions of Aphrodite and her son are rare, there are many representations of Eros on his own that were created for private use. Eros as we know him today made his earliest artistic and literary appearance in the context of Greek symposia held in Athens from the late seventh century B.C. onward; it was the Greek lyric poets, performing in male aristocratic banquets, who shaped Eros into a comely anthropomorphic deity. In the previous century, Hesiod, in *Theogony*, had presented him as a primal entity, an abstraction like Chaos, related to cosmic desire—though even here, Eros takes on the qualities of an attractive being with the power to dominate all. Writes Hesiod: "Eros is the most beautiful (*kallistos*) among the immortal gods, the limb-loosener, who overcomes the mind and thoughtful will of gods and men in their hearts."[7] Seventh-century-B.C. poets such as Sappho and Archilochos took up the poetic epithet "limb-loosener" to describe the overwhelming physical reaction to the power of desire. Later poets also applied the term to Dionysos, and it is indeed in the realm of wine that Eros assumed a major role in Greek society. Appropriately, he is frequently depicted on the

painted ceramic vases used in male drinking parties, a visual complement to the words sung by poets at these same gatherings.

More than likely, the homoerotic culture expressed in the art and poetry of these banquets helped fashion the image of Eros as a handsome adolescent—the projection of an ideal, the first stirrings of passion for male youth.[8] The sixth-century-B.C. elegiac and lyric poets most likely inspired a fashion for painting courting scenes between older men and young boys, such as are found on Athenian drinking vessels (cat. no. 81), and early depictions of winged erotes on red-figure vases late in that same century also relate to this cultural trend. On these vases, Eros can be found pursuing boys, sometimes even in an overt sexual encounter (cat. no. 82). He is always shown with wings and often as impish, playful, and youthful. In Greek homoerotic relationships, the *erastes*, or lover, usually pursues the fleeing *eromenos*, or beloved, and vases showing Eros flying after the object of his desire seem to mirror this. His wings give him power to inflict longing on gods and mortals alike, while Eros himself remains immune.[9]

Drinking cup (kylix) with an erotic scene with Eros and a youth
Greek, made in Athens;
signed by Douris
Late Archaic period, about
490–485 B.C.
Ceramic, red-figure technique
H. 7.9 cm (3⅛ in.)
(cat. no. 82)

*Oil flask (lekythos) with Eros holding
a fawn*
Greek, made in Athens; attributed
to the Pan Painter
Early Classical period,
about 470–460 B.C.
Ceramic, red-figure technique
H. 31.4 cm (12 ⅜ in.)
(cat. no. 83)

Depictions of Eros tend to emphasize both his boyish qualities and his major importance in the sphere of love. He is often shown holding or playing a flute, underscoring his connection to the symposium setting (cat. no. 85, p. 132). To demonstrate his childlike nature and playfulness, vase painters also depicted him holding toys, such as balls, hoops, spinning tops, and bird traps (cat. no. 87, p. 133). Some of these toys also functioned as love tokens in courtship scenes, and in some cases Eros is shown bearing gifts typically exchanged between Greek male lovers, such as hares, cocks, fawns, and birds (cat. no. 83; cat. no. 84, p. 133). The implication is that erotes were stand-ins for the handsome boys so admired at the symposia; on these vases, in fact, it is often only their wings that distinguish them from good-looking young mortals. In the poetry of this period, when Eros is described as playing, especially with balls, it is clear that these are games of love. Throwing a ball (sphaira) is a convention for a love challenge, and a ball was a gift for the rite of passage to manhood. In the seventh century B.C., the Greek poet Alcman had already warned his readers, "It is not Aphrodite, but the wild Eros who like a boy plays his boyish games."[10]

As an abstract concept, eros expresses passionate longing for victory, beauty, fame, and philia, or friendship with fellow athletes and citizens. But in the realm of athletics, where the nude young male contestants were objects of desire, Eros played a very special role. Because the education of the Athenian elite emphasized physical training, the dedication of an altar to Eros at the entrance of the Academy of Athens, most likely about 545–535 B.C., suggests an important milestone in the linking of the god with athletes. Toward the later sixth century B.C., red-figure vase painters depicted a winged, youthful Eros with athletes on the exercise grounds, holding out honors in the form of ribbons and crowns to young victors (cat. nos. 88–89, p. 134)—the same gifts that, on other vases, bearded older men are shown giving to an admired youth (cat. no. 92, p. 136). Moreover, the athletic contest or agon served as a metaphor in literature and art for an amorous tussle. So when Eros is shown riding a horse (cat. no. 93, p. 137) or wrestling, we should imagine that the users of these vases understood the double entendre. "Horse riding," for instance, alluded to a sexual position, and an orgy was described in terms of a sports festival.[11] Indeed, the acrobatic positions assumed by the male guests and female courtesans on a drinking cup by Nikosthenes (cat. no. 94, pp. 114–15) seem more like a fantasy or parody than a realistic depiction. We can no doubt view the erotic themes on drinking vessels as part of the private entertainment; like the flute music and dancing, they enriched the atmosphere.

The interplay of word and image demonstrated by these objects reflects a long tradition of the use of riddles (in Greek, griphos, literally "net")

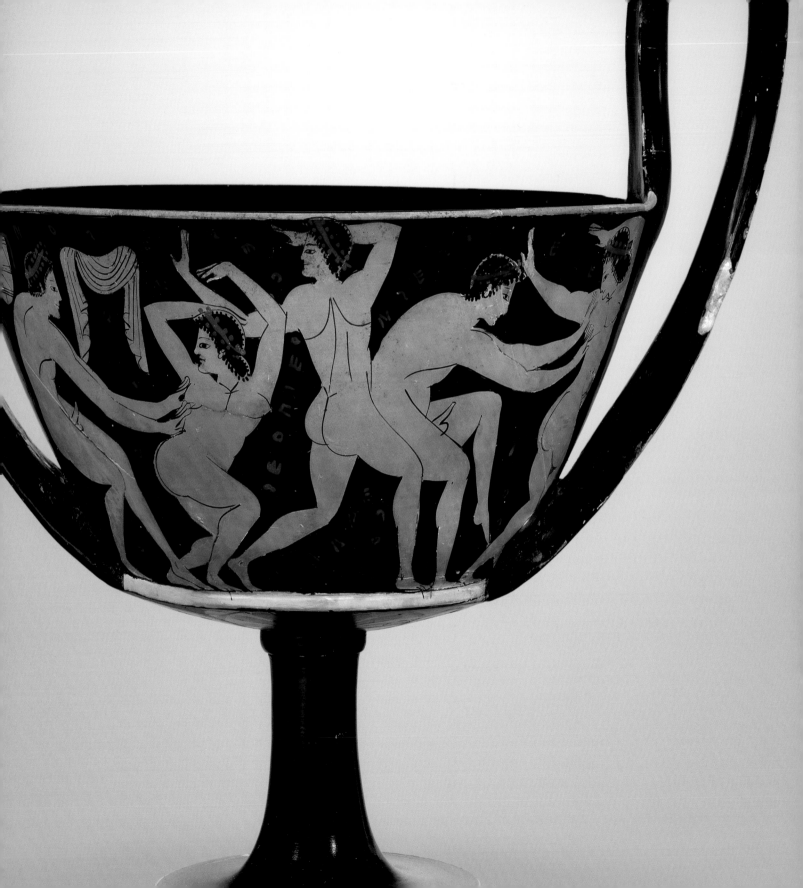

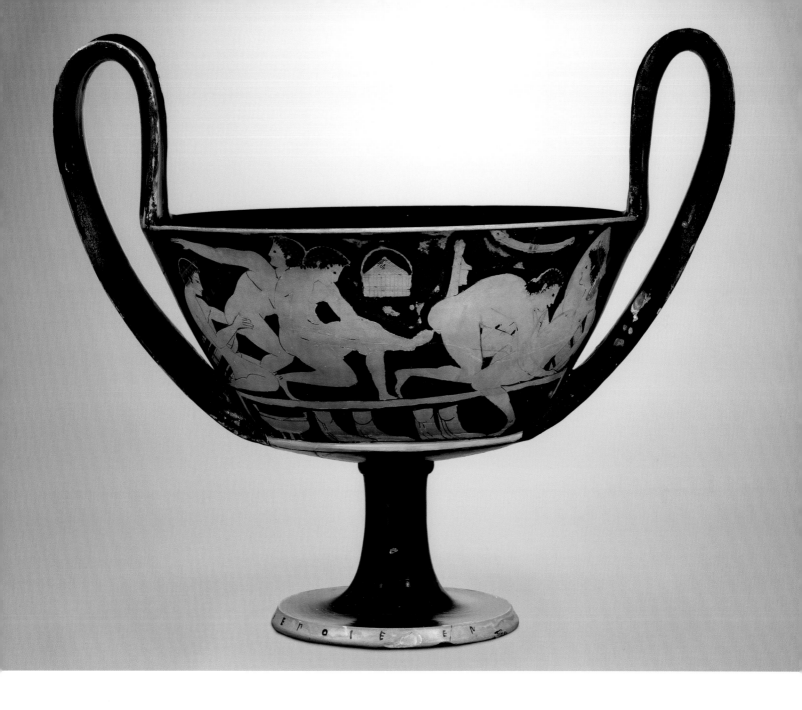

High-handled drinking cup (kantharos)
with erotic scenes
Greek, made in Athens; made and
signed by Nikosthenes; painted by
the Nikosthenes Painter
Archaic period, about 520–510 B.C.
Ceramic, red-figure technique
H. 24 cm (9 7/16 in.)
(cat. no. 94)

Fig. 8
*Signet ring with Aphrodite threatening
to slap two unruly erotes*
Roman
Late Imperial or Early Christian
period, 4th century A.D.
Gold with niello
Ring: diam. 2–2.6 cm (¹³⁄₁₆–1¹⁄₁₆ in.)
Virginia Museum of Fine Arts,
Richmond

as entertainment and competitive wordplay during symposia. Some of the peculiar imagery on red-figure drinking vessels from Athens finds its meaning in drinking songs and games that play on language to trick the ear and mind.[12] Riddles, word games, and double entendres about love were popular throughout antiquity, and are especially evident in the Hellenistic epigrams preserved in *The Greek Anthology*, a collection of poems dating from the Greek through the Byzantine periods, and on personal effects, such as rings and carved gems. The belief in the magic of love may well start with the earliest Greek epigraphic mention of Aphrodite, on the late-eighth-century-B.C. Nestor's Cup.[13] An inscription in hexametrical verse tells the drinker that the wine cup belongs to Nestor (possibly the Nestor in the *Iliad*) and that whoever drinks from it will be seized by Aphrodite's desire (*himeros*). Sexual love and desire are the devices Aphrodite uses to gain power over gods and mortals, and it is to invoke this aspect of her power or protect against it that many love charms were composed. Personal objects such as gems and rings were exchanged between lovers, or else worn as a talisman to win someone over or punish them for unrequited love.

An exceptional gold ring of the late Classical period features Aphrodite weighing erotes, which seems to be a visual pun on the age-old theme of "he loves me, he loves me not" (cat. no. 95, p. 138). The *erotostasia*, or weighing of love, is a playful variant on the more serious image of the weighing of souls (*psychostasia*). From the second century A.D., a Roman gem mixes sports metaphors and love's longing (cat. no. 96, p. 138). A winged Eros is about to shoot an arrow at a wingless youth who assumes the position of a boxer. The Greek inscription names the two men Hierokles and Jason and suggests that the man who wore the ring may have had a male lover in mind. Eros often figures in Greek literature as a metaphorical boxer: the sixth-century-B.C. poet Anacreon wrote, "I am indeed boxing against Eros!" and Sophocles in a play wrote, "Whoever challenges Eros to a match, like a boxer fist-to-fist, is out of his wits."[14]

Other instances of wrestling erotes suggest personal messages. On a Roman gold ring from the fourth century (fig. 8), word and image work together to express anxieties about desire. The square bezel features a seated Aphrodite threatening with her raised sandal two wrestling boys at her feet. They can be identified as Eros and Anteros, locked in an agonistic struggle that provides a visual gloss on the accompanying Greek inscription: "cessation for those who desire."[15] Those who wore or gifted personal items of jewelry with unusual iconography were aware of the puns and riddles, but for modern viewers it is a challenge to puzzle them out. In this case, the image of Aphrodite about to strike the "bad boys" of love expresses the plea from the

wearer to be free of love's torments. Punishment by a whack from a sandal, whether for Eros or for any young boy, is found on a number of Greek vases, where the image sometimes carries a sexual message. Eros kneeling down to tighten the sandal of a bride on a marriage jar (cat. no. 52, p. 75), for instance, connotes a sexual encounter, as does Aphrodite herself loosening her sandals (cat. no. 129, p. 153).[16]

Eros also engages in struggles with Pan and comes out the winner in a match depicted on Roman frescoes. The match speaks to the contest between bestial desire (Pan) and spiritual love (Eros), and when accompanied by Greek labels can be understood as a pun for "Love conquers all."[17] That the two types of love were well understood by several ancient cultures is evidenced by an Etruscan mirror case showing Dionysos between Pan and Eros,

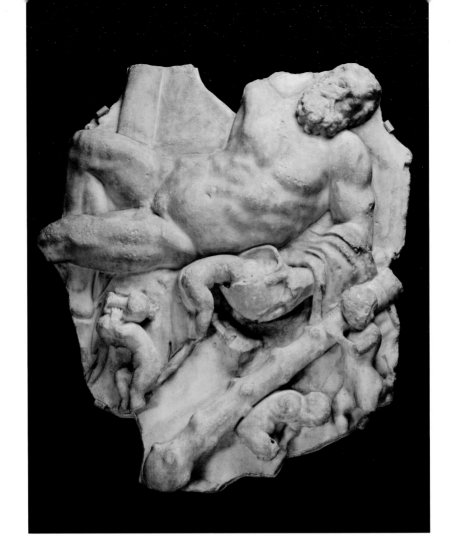

perhaps alluding to their mingling under the influence of wine (cat. no. 97, p. 139). The punishment of Eros by Aphrodite is also found on several Hellenistic and Roman rings. Far less typically, a Roman bronze disk mirror (cat. no. 98, p. 117) inverts this formula. Here, a nude woman, held down on a bed by two winged cupids, is about to be whipped by a bearded male who closely resembles Dionysos's elderly companion Silenos. With her garment pulled up to reveal her voluptuous buttocks, the woman recalls the well-known Aphrodite Kallipygos (of the beautiful buttocks) type and might well be Venus herself. In Roman art, flagellation scenes are shown in depictions of the festival of the Lupercalia where women were playfully whipped on the streets, a ritual believed to promote fertility. Whether an initiation rite or a punishment scene, the torments of love are strongly implied in this unparalleled composition.[18]

To appreciate fully how the Greeks and Romans perceived the power of Eros, we should consider how he is visually presented in association with the greatest of ancient heroes, Herakles. Eros came into his own as a deity in the fourth century B.C., when Praxiteles and Lysippos, the greatest sculptors of their day, made statues of him. It is not clear if these artists invented the conceit, but sometime later Eros began appearing with the attributes of Herakles. There is an unmistakable playfulness in the presentation of an overgrown child masquerading as the most powerful of mortals, as exceptionally realized in a terracotta from Myrina (cat. no. 99, p. 106). Eros wears over his head and shoulders the Nemean lion skin and seems to smirk as he holds his hand behind his back, perhaps (in an allusion to one of Herakles's labors) to hide the apples of the Hesperides. The reception of such imagery is poetically captured in a Hellenistic epigram: "Heracles, where is thy great club, where thy Nemean cloak and thy quiver full of arrows, where is thy stern glower?...Thou are in distress, stripped of thy arms. Who was it that laid thee low? Winged Love, of a truth one of thy heavy labors."[19] Hellenistic artists were creative in their retelling of popular myths, casting them as allegories in order to highlight moral implications— such as that, in this case, love is even mightier than Herakles. Another example of Herakles's vulnerability to love's enticements is found on a large marble relief, where the oversized hero lies asleep while four erotes steal his club and drink from his wine cup (cat. no. 100).[20]

Hellenistic artists further expand on the theme of Herakles's domination by Eros and his submission to his erotic urges when they show the hero sexually engaged with women, such as fourth-century-B.C. depictions of Herakles with Auge and Omphale. Perhaps this was a way to explore the human experience of powerlessness in the face of overwhelming desire. Indeed, the lovemaking of Herakles was an artistic strategy for the representation of erotic imagery, and as such relates closely to the far-flung sphere of Eros in ancient imagery. Among the boldest of such representations is a rare marble relief (cat. no. 101, p. 120) in which the young hero reclines on his lion skin in an erotic embrace (in Greek, *symplegma*) with a woman (a nymph?) who wears only a breast band (*strophium*). The couple is in an outdoor setting, as evidenced by the rustic shrine with Priapos (another child of Aphrodite) on a column and a large cloth draped over a tree to give them privacy. Certain elements echo Greek compositions, but this is a Roman relief that belongs to a type that once hung on a wall or stood on a pillar, most likely in a Roman bedroom. Pompeian paintings also show Herakles disarmed by cupids as part of his enslavement to Queen Omphale and thus offer a view of the hero as a captive to love.

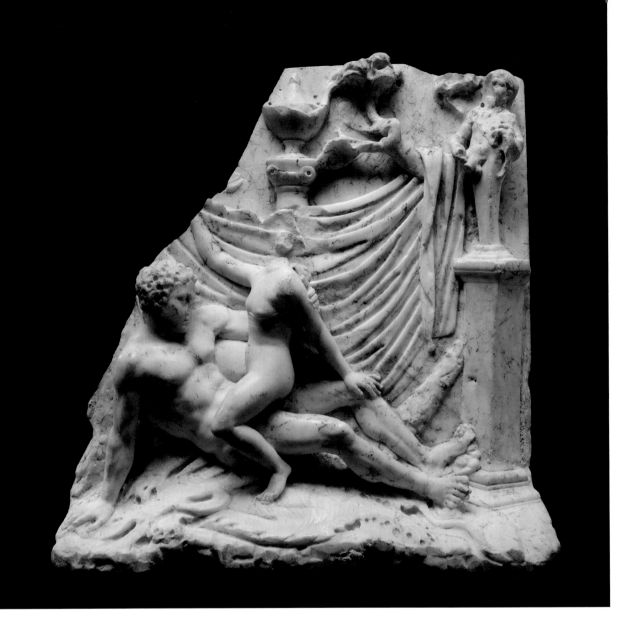

The composition of the lovemaking scene on the marble relief is close in style and detail to those found on an elegant group of terracotta drinking vessels, made in Arretium (present-day Arezzo) and called Arretine ware, from the late first century B.C. and early decades of the first century A.D. (cat. nos. 102–4). This glossy red Italian pottery was decorated with fired clay molds of erotic scenes based on the same sources as those found on much more costly silver and cameo glass vessels of the same period. The combination of man-boy couples and male-female couples on the same vessels under-

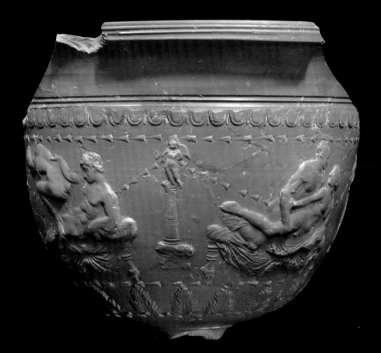

Fragment of a bowl with an erotic scene
Roman
Early Imperial period,
1st century B.C.
Ceramic, Arretine ware
H. 11.7 cm (4⅝ in.)
(cat. no. 103)

Fragment of a relief-decorated bowl
with an erotic scene
Greek
Hellenistic period, about
200–180 B.C.
Ceramic, Arretine ware
Diam. 10 cm (3¹⁵⁄₁₆ in.)
(cat. no. 104)

**Fragment of a bowl with Cupid on a
pillar between couples making love**
Roman
Early Imperial period,
late 1st century B.C.
Ceramic, mold made with red
slip decoration
H. 14 cm (5½ in.)
(cat. no. 102)

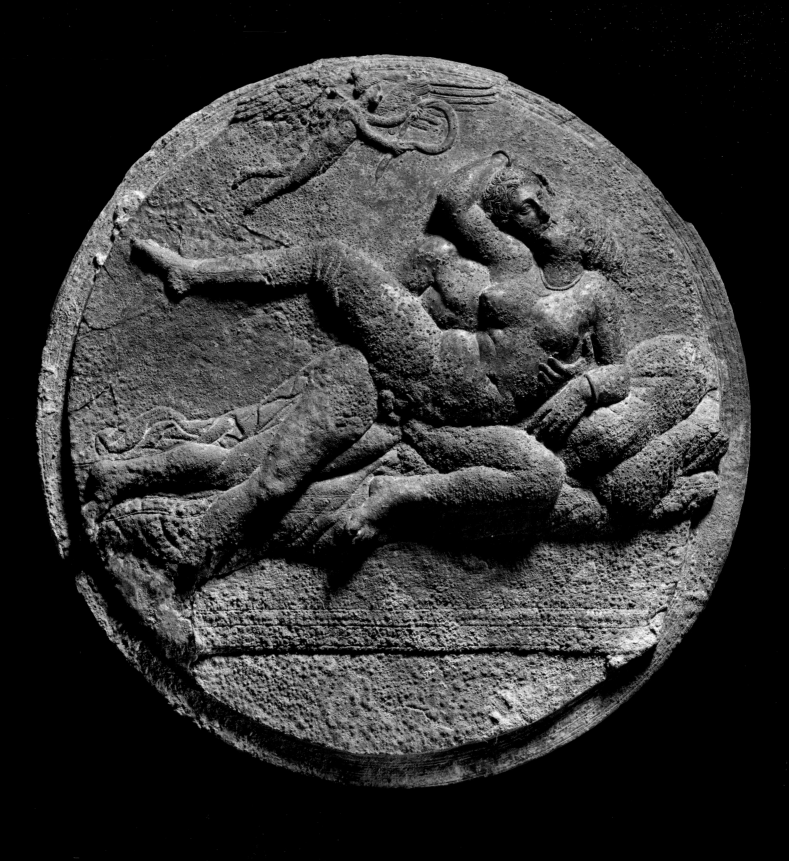

Mirror cover with Eros and an erotic scene
Greek
Late Classical or Early Hellenistic
period, about 340–320 B.C.
Bronze with silvered bronze
Diam. 17.5 cm (6⅞ in.)
(cat. no. 105)

Gem with an erotic scene
Greek
Late Classical or Early Hellenistic
period, 4th century B.C.
Chalcedony, intaglio
L. 2.9 cm (1⅛ in.)
(cat. no. 106)

lines a key point about the Arretine wares, namely that they revive the spirit of the Greek vases of the Archaic period (600–480 B.C.) in the linking of Eros and the symposium.

Most depictions of homosexual and heterosexual lovemaking in Greek art are found on painted vases, and in a similar fashion many corresponding Roman scenes also appear on ceramic drinking vessels. Such amatory imagery was acceptable in convivial settings, and for the elite male drinkers it harked back to an idealized Greek past. A notable exception, however, is found on a fourth-century-B.C. bronze box mirror with two different heterosexual intercourse scenes, one embossed in relief on the top of the cover and the other engraved in silver on its underside (cat. no. 105). Because the artist so explicitly depicted two quite athletic and complex sexual positions, scholars suggest that the mirror's owner was a courtesan, perhaps even a famous one from Corinth where the object was found.[21] The presence of Eros flying above the couple with a garland on the embossed front cover emphasizes the key role played by Aphrodite's messenger in the successful consummation of sexual unions. Whether she was a professional or a woman of rarefied tastes we cannot know, but this mirror offers an instance of an erotic scene produced for a female viewer.

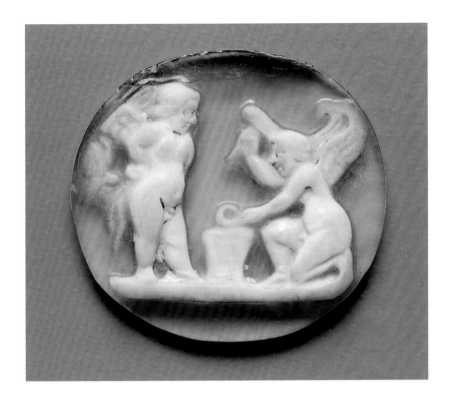

The romance of Cupid and Psyche undoubtedly stimulated writers and artists to explore the representation of loving couples (cat. no. 109). We know about the adventures and eventual triumph of the famous mortal beauty Psyche and the god Cupid only from *The Golden Ass* by Apuleius, a Latin work from the second century A.D. That their romance was already well known by the second century B.C. and traceable to a Greek source is evidenced by a large number of Hellenistic terracotta figurines from Asia Minor depicting them in a tender embrace (cat. no. 108, p. 140). The discovery of these figurines in tombs suggests that they symbolized a wish for eternal happiness and love. In the myth, Psyche's beauty is compared to that of Venus, and this naturally enrages the goddess. Some figurines show Psyche crouching and putting her hand up to protect herself, perhaps shielding herself from punishments occasioned by the goddess's wrath (cat. no. 112, p. 140). Venus sends her son to trick Psyche into falling in love with a monster, but instead it is Cupid who falls madly in love with Psyche. The trials of the pair unfold until they are accepted on Mount Olympus and bear a daughter, Voluptas (in Greek, Hedone), or sensual pleasure. The loving embrace of the pair is the key message, the union

of carnal and spiritual love, or of the body and the soul; sometimes this union is suggested by portraying Psyche with dotted butterfly wings (cat. no. 113, p. 141). The couple's embrace, sometimes called the "first kiss" in Western art, is the subject of several Roman marble sculptures that may have all derived from an original small-scale object made of silver.[22] Their embrace, curiously not treated in Greek art, appears on Roman jewelry, intaglios, and other precious objects probably intended as gifts exchanged between lovers.

By and large, Roman artists were charmed by the child Eros (Cupid), and were especially fond of multiplying him to project his ability to appear anywhere at any time. On Hellenistic and Roman carved cameos and gems, erotes forge arms, and some carry a spear and shield, perhaps as dedications to Aphrodite (cat. nos. 116–17, p. 125). These images relate to a scene popular in the Roman period in which multiple erotes disarm the war god Mars, echoing in some respects the disarming of Herakles, in preparation for his union with Venus. "Loves" are described in Hellenistic epigrams as dressing in the garb of various gods and taking on their weapons and attributes.[23] Surely, the shift from an individual god with specific powers, as favored in Hellenistic art, to groups of children (*amorini*) in the Roman period speaks to changing tastes and attitudes. In the latter period, young winged boys were favored for the decoration of children's sarcophagi, where they were represented playing various sports and games. When winged youths are shown holding seasonal fruits and prey, they represent the seasons (cat. no. 118, p. 143)—a metaphor for the cycle of life, birth, and renewal, and thus well suited to Roman funerary arts.

Many marble statues of Eros depict him as a sleeping toddler, often on a lion skin (cat. no. 119, p. 142), again referencing his power over and links to Herakles. Yet the ancients perceived an irony in the innocent slumber of childhood, evident in these words from a Hellenistic epigram: "I fear, ambitious boy, that even as you slumber, you might see a dream piercing to me," expressing Eros's ability to inflect desire even into those who sleep.[24] The link between sleep and love is dramatically made in a rare marble relief in which a winged female with bird's feet (a siren or daemon) squats over a nude man with an erect phallus (cat. no. 107). The man, bearded and bald (a shepherd or Pan, as on a Roman lamp with a similar scene),[25] is asleep on the ground with his hands behind his head. Pan pipes hang on a vine in the upper right corner, reinforcing the rusticity of the setting, which might be a cave. The female pours a mysterious liquid out of a cup in her left hand held behind her back, which may offer a clue to this mysterious composition that is not explained by any known myth. In the oldest Greek texts, Eros is described as a substance that Aphrodite pours onto gods and humans alike to bring on desire, while desire and sleep share the same descriptive language in Homer's

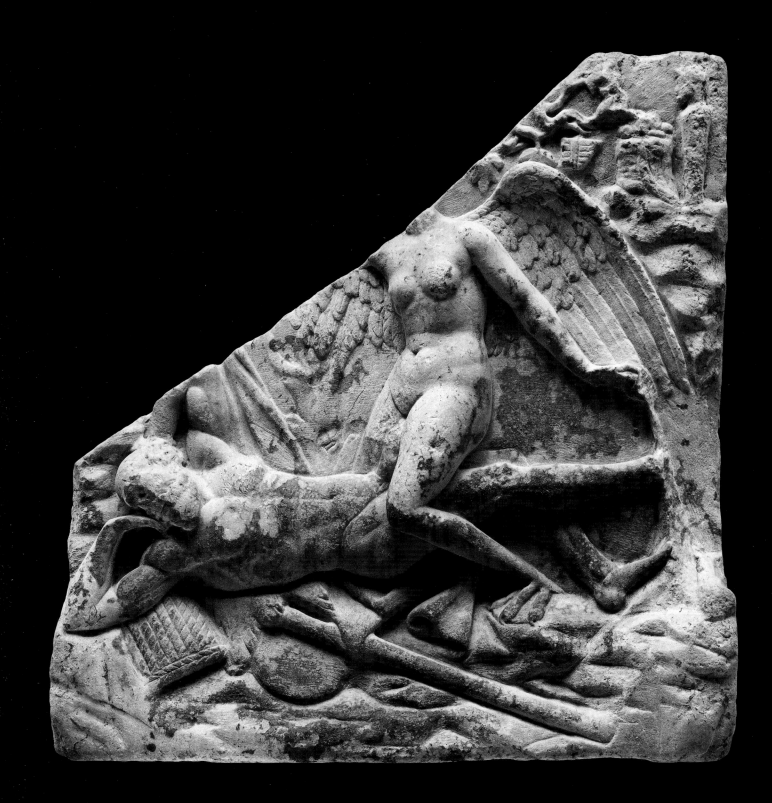

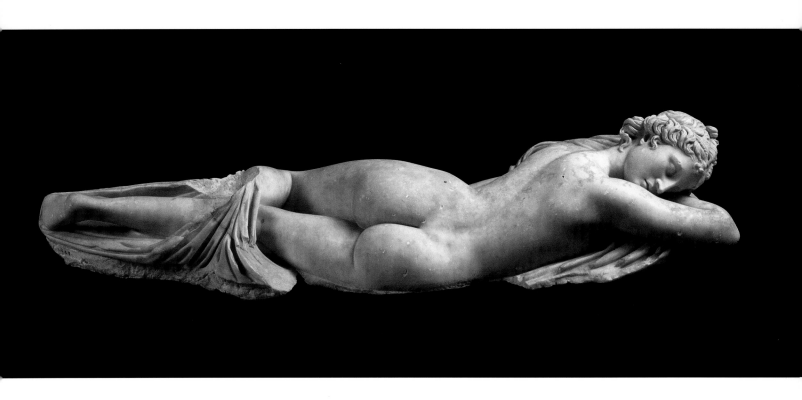

Odyssey, in that both are overwhelming and irresistible. The limb-relaxing effects of Eros and Pothos (Longing), both children of Aphrodite, are likewise produced by Hypnos (Sleep) and even Thanatos (Death). Their similar appearance in ancient art, as handsome winged youths, is no doubt due to their shared physical and mental impact on mortals.

The overlapping spheres of sleep and desire are most intriguingly presented in a work originally conceived in the late Hellenistic period but now known only through several Roman copies, namely the Sleeping Hermaphrodite (cat. no. 121). With the contemporary interest in sexual ambiguities and the gender testing of athletes, our society is acutely aware of the human condition addressed by this Greek myth. Hermaphrodite started life as Hermaphroditos, the male child of Aphrodite and Hermes, and was worshipped as a minor deity as of the fourth century B.C. We learn from Ovid that he was beloved by the water nymph Salmacis but repeatedly rejected her advances.[26] She begged the gods to join them as a couple, and in a fresh twist on the romantic ending the two were fused into a new being—one with female breasts and male genitals. The new deity was given a female name, Hermaphrodite, and was conceived in the Hellenistic era, with its taste for the

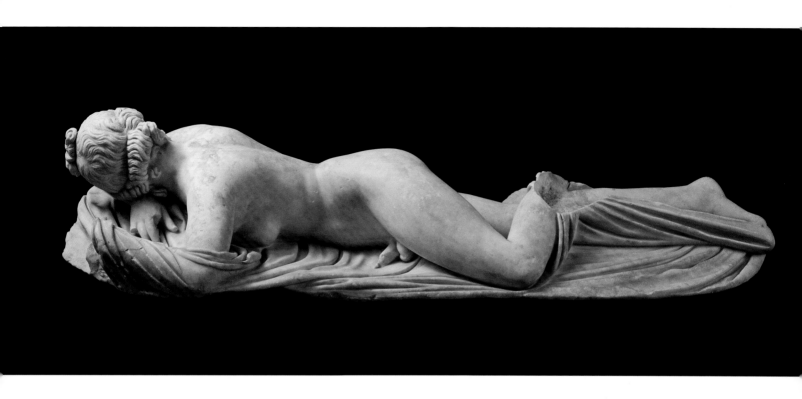

exotic and theatrical, as a sleeping nude. The composition plays on the seductive invitation of the long, sinuous curve of a woman's back, which draws the viewer in to explore and then be startled by the revelation of male genitalia on the other side. Whether the ancient artists were merely exploring a witty conceit, or whether they were expressing a deeper truth about gender and identity, is another matter.

Few things can express the range of ancient art better than juxtaposing the very subtle conceptualization of the sleeping Hermaphrodite with representations of the very unsubtle Priapos. The son of Aphrodite and Dionysos, Priapos was worshipped by both Greeks and Romans as the protector of the gardens and fields. Many of his statues were crude wood carvings set up in rustic shrines throughout the countryside and have not survived—which might explain why most extant images of Priapos date to the Roman period, even though tradition places the start of his cult in the Greek period, at the city of Lampsacus. The survival of the *Corpus Priapeorum*, a group of eighty Latin poems dedicated to the god, underscores the Roman fascination with him. A number of bronze figurines show him pouring libations on his phallus, or holding up infants in the folds of his cloak, an allusion to his role in ensuring

fertility (cat. no. 122, p. 146). One of the largest and least known marble depictions must once have adorned the garden of an elite Roman house (cat. no. 123). Seasonal fruits of the fields are gathered in his cloak, at once revealing his erect phallus and alluding to his role as protector of crops. The carver, probably working sometime in the late second century A.D., emphasized the weight of his load by throwing him slightly off-balance and creating an exaggerated curve at his back. Reproductions of *phalloi* abound in ancient art, where they functioned as sexual and humorous devices.

Still, as intriguing and conceptually rich as Priapos and Hermaphrodite might be for modern viewers, it was Eros who held first place in the hearts and minds of the Greeks and Romans—as, one might argue, he still does today. Appearing as an adorable child or a comely youth, winged or wingless, he was the darling of ancient artists, who undoubtedly projected a popular fascination with his irresistible power and his pervasive presence in their lives. No doubt the unavoidable association of Eros with such constants as erotic desire and fertility kept him very much on ancient minds. But more than this, Eros added a poetic—we might now say romantic—dimension to desire, embodying not only sexual drive but also its accompanying passion and longing, emotions to which deities and kings, citizens and slaves were subject without distinction. His interference in the daily lives of human beings, including the artists who depicted him, was as much a cause for celebration as for lamentation. Recognizing his aesthetic value as both a complicated and an appealing subject, artists throughout the centuries have embraced Eros, depicting him in every historical period and in every style, as befits his multivalent meanings and roles.

Eros's message varies with the context of his representation. When shown with Aphrodite on monumental works of art, such as the Parthenon frieze or the *Ara Pacis*, his links to his mother might have dynastic implications. If he appears on a finger ring worn every day, his role is that of medium between a lover and the person desired, both object and subject. These shifting perspectives, exploited by the ancient artists, reflected a sophisticated and knowing audience, one familiar with the characterizations of Eros in poetry as well as with his role in their daily lives. The challenge to us as modern viewers is to read Eros, as did the ancients, as part of a much larger picture of human desire, sex, and love.

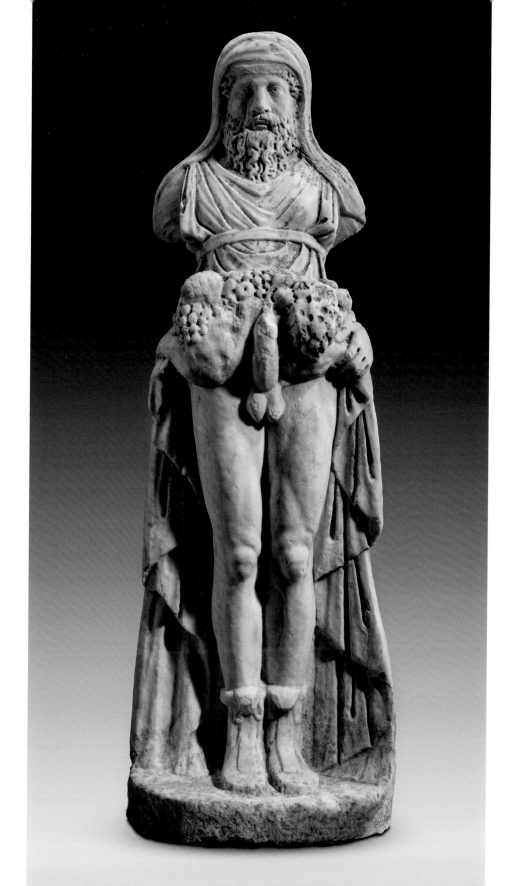

Statue of Priapos
Roman
Imperial period, A.D. 170–240
Marble
H. 159 cm (62⅝ in.)
(cat. no. 123)

Oil flask (lekythos) with Eros playing
a double flute
Greek, made in Athens; attributed
to the Providence Painter
Early Classical period,
470–460 B.C.
Ceramic, red-figure technique
H. 33.8 cm (13 5/16 in.)
(cat. no. 85)

*Drinking cup (kylix) with seated Eros holding
a scale or a bird trap*
Greek, made in Campania (South Italy);
compared to the Painter of Zurich 2633
Late Classical period, about 350–325 B.C.
Ceramic, red-figure technique
H. 8.9 cm (3½ in.)
(cat. no. 87)

*Gem with child Eros playing with a goose
and knucklebones*
Greek
Classical period, 410–400 B.C.
Chalcedony, intaglio
L. 2.2 cm (⅞ in.)
(cat. no. 84)

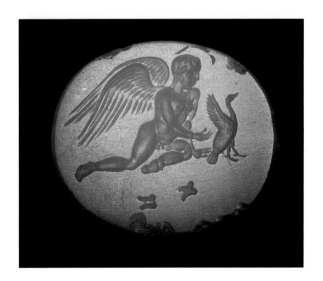

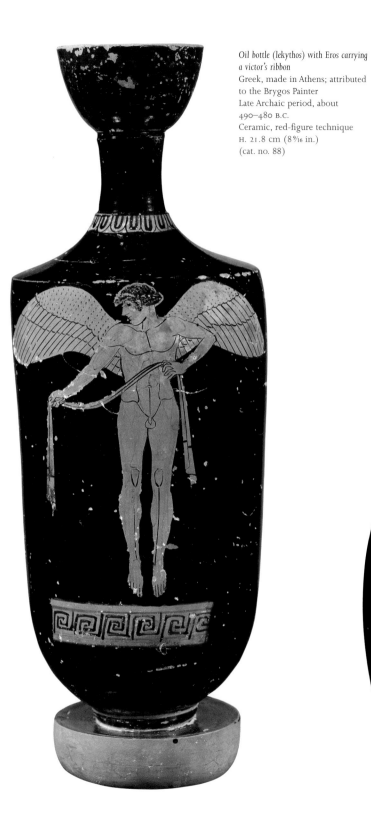

Oil bottle (lekythos) with Eros carrying
a victor's ribbon
Greek, made in Athens; attributed
to the Brygos Painter
Late Archaic period, about
490–480 B.C.
Ceramic, red-figure technique
H. 21.8 cm (8 9/16 in.)
(cat. no. 88)

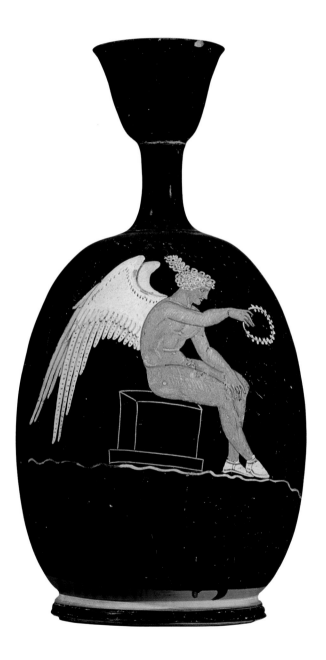

Oil flask (lekythos) with Eros seated on
an altar holding a wreath
Greek, made in Apulia (South Italy)
Late Classical period, about 350 B.C.
Terracotta
H. 21.2 cm (8 5/16 in.)
(cat. no. 89)

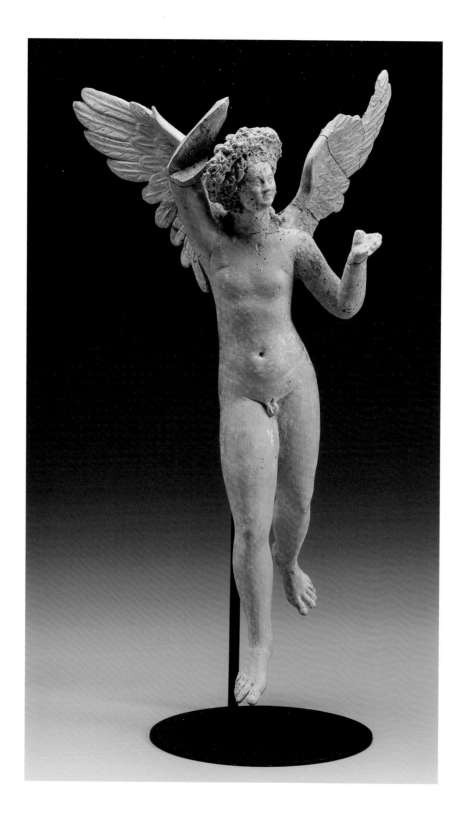

Statuette of a flying Eros
Greek, made in Myrina
(Asia Minor)
Hellenistic period,
late 2nd century B.C.
Terracotta
H. 29.1 cm (11⁷⁄₁₆ in.)
(cat. no. 91)

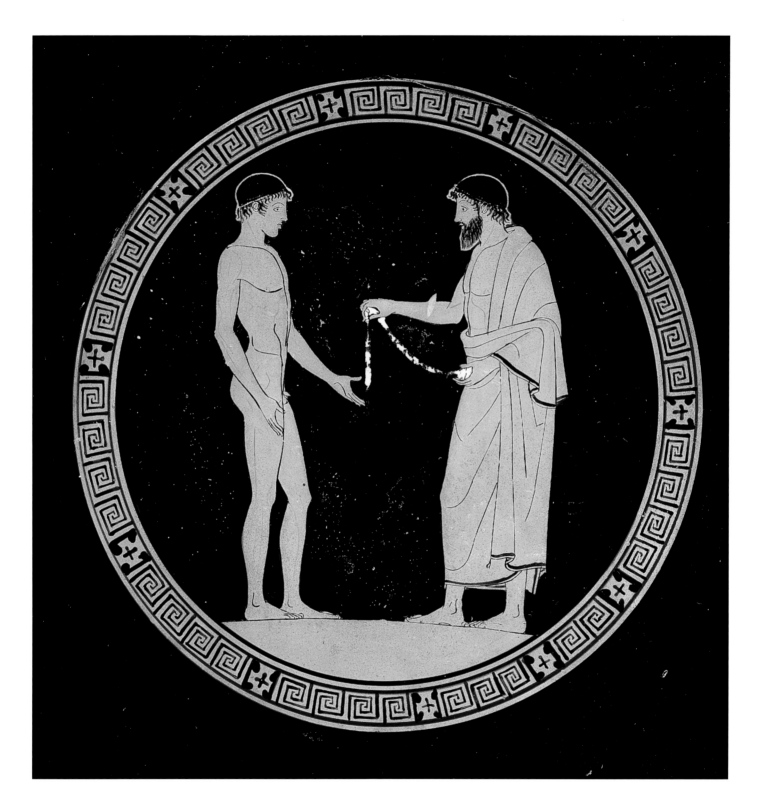

Drinking cup (kylix) with athletes and judges
Greek, made in Athens; attributed to the Euaion Painter
Early Classical period, about 460 B.C.
Ceramic, red-figure technique
H. 11.7 cm (4 5/8 in.)
(cat. no. 92)

Drinking cup (kylix) with Eros riding a horse
Greek, made in Athens; attributed to the Painter of London E 130
Classical period, about 400 B.C.
Ceramic, red-figure technique
H. 9.6 cm (3 13/16 in.)
(cat. no. 93)

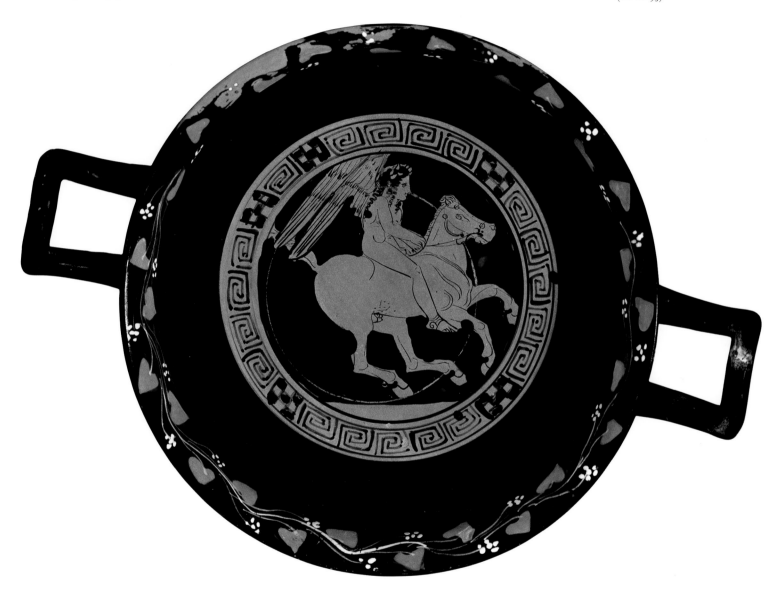

*Ring with Aphrodite weighing two erotes
with a third at her feet*
Greek
Classical period,
late 5th century B.C.
Gold
L. of bezel 1.8 cm (¹¹⁄₁₆ in.)
(cat. no. 95)

*Gem with Eros firing an arrow at a male
youth*
Roman
Imperial period, 2nd century A.D.
Sard, intaglio
L. 1.4 cm (⁹⁄₁₆ in.)
(cat. no. 96)

Gem with Eros
Greek
Late Archaic period,
early 5th century B.C.
Sard, intaglio
L. 1.2 cm (⁷⁄₁₆ in.)
(cat. no. 90)

Ring with Eros playing a double flute
Greek
Hellenistic period,
about 360–330 B.C.
Silver
L. of bezel 1.7 cm (¹¹⁄₁₆ in.)
(cat. no. 86)

Mirror case with Dionysos, Eros,
and Pan
Etruscan
Hellenistic period,
3rd century B.C.
Gold and silver with relief
appliqué
Diam. 14.1 cm (5 ⁹⁄₁₆ in.)
(cat. no. 97)

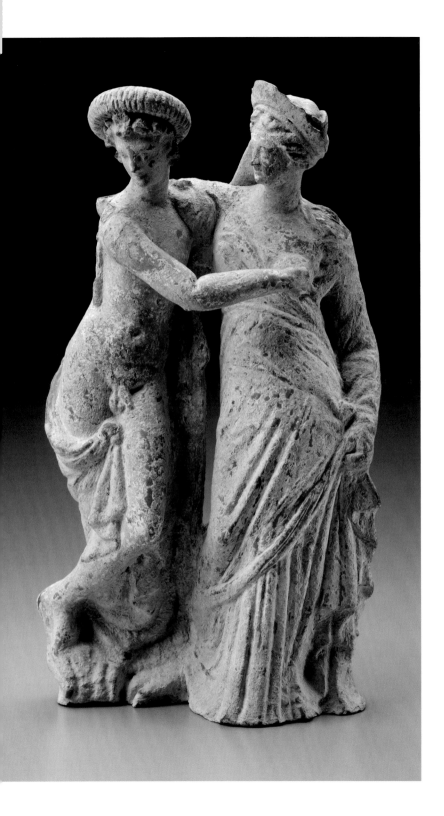

Statuette of Eros and Psyche
Greek, East Greek
Hellenistic period, 1st century B.C.
Terracotta
H. 32.1 cm (12⅝ in.)
(cat. no. 108)

Figurine of kneeling Psyche
Greek, East Greek
Hellenistic period, 3rd century B.C.
Terracotta
H. 8.9 cm (3½ in.)
(cat. no. 112)

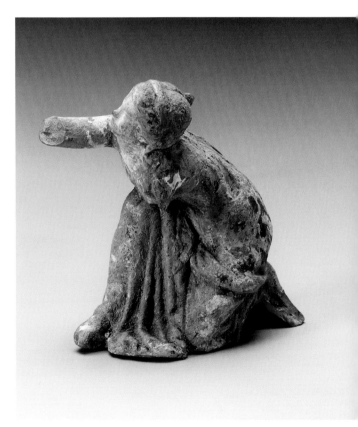

Cameo with the wedding of Cupid and Psyche or an initiation rite (Marlborough Gem)
Roman; signed by Tryphon
Late Republican or Early Imperial period, mid- to late 1st century B.C.
Layered onyx cameo
L. 4.5 cm (1¾ in.)
(cat. no. 113)

Gem with Cupid and Psyche embracing
Roman
Imperial period, 2nd century A.D.
Red jasper, intaglio
L. 1.4 cm (9⁄16 in.)
(cat. no. 110)

Pin with Cupid and Psyche
Roman
Imperial period, 2nd or 3rd century A.D.
Silver
L. 9.8 cm (3⅞ in.)
(cat. no. 111)

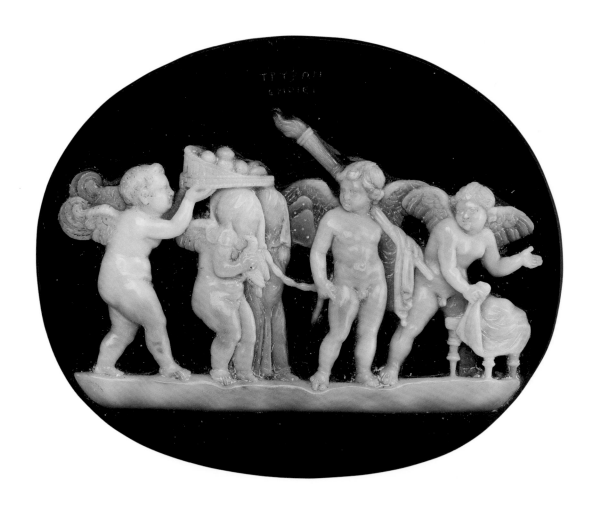

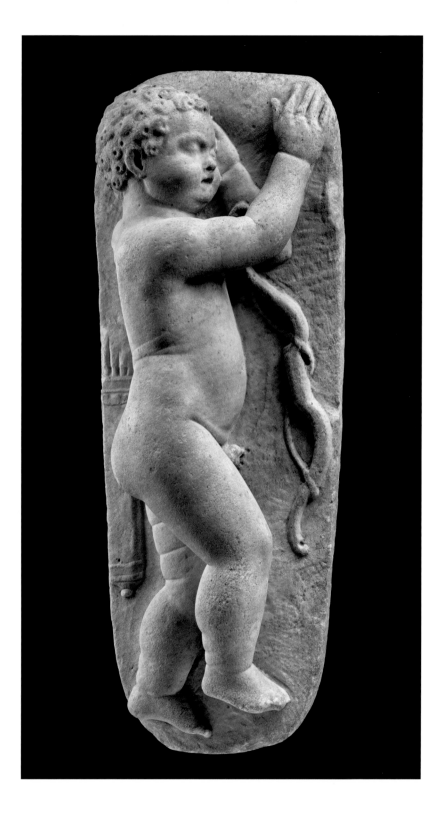

Statue of sleeping Eros
Roman
Imperial period, 2nd century A.D.
Marble
H. 12 cm (4¾ in.)
(cat. no. 119)

Fragment of a season sarcophagus with
two winged cupids
Roman
Imperial period, about A.D. 280
Marble
H. 70 cm (27 9/16 in.)
(cat. no. 118)

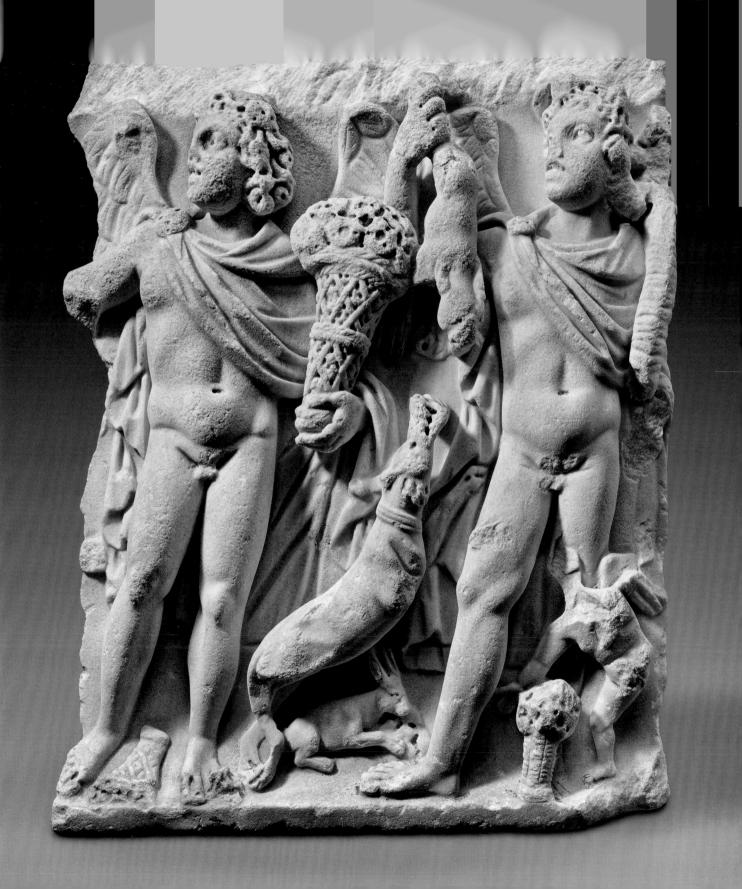

Round attachment with a man and a
woman kissing
Roman, Eastern Mediterranean
Imperial period, 1st century A.D.
Silver with gold leaf
Diam. 5.2 cm (2¹⁄₁₆ in.)
(cat. no. 115)

Drinking cup (skyphos) with a man
and a woman kissing
Greek, made in Apulia (South
Italy); attributed to the Alabastra
Group
Late Classical or Early Hellenistic
period, about 330–320 B.C.
Ceramic, red-figure technique
H. 9.7 cm (3¹³⁄₁₆ in.)
(cat. no. 114)

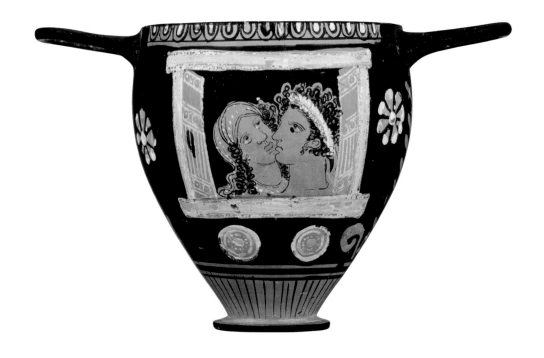

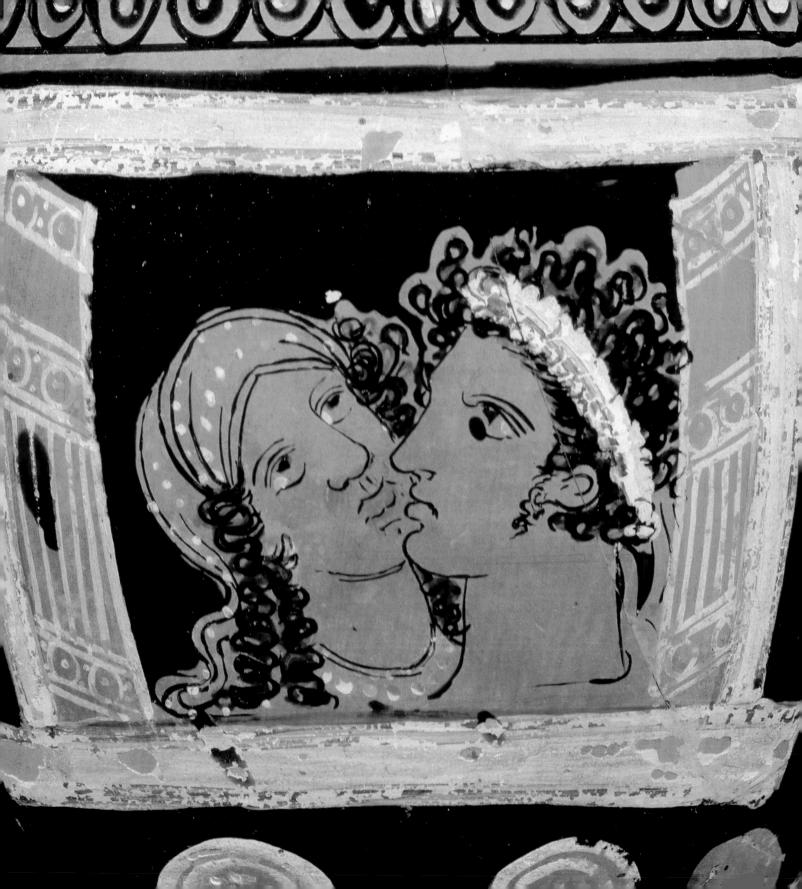

Figurine of Priapos with four infants
Greek
Hellenistic period,
2nd century B.C.
Bronze
H. 8 cm (3³⁄₁₆ in.)
(cat. no. 122)

Figurine of Eros holding up a himation between his teeth
Greek, East Greek, made in
Myrina (Asia Minor)
Hellenistic period, 150–100 B.C.
Terracotta
H. 16.5 cm (6½ in.)
(cat. no. 120)

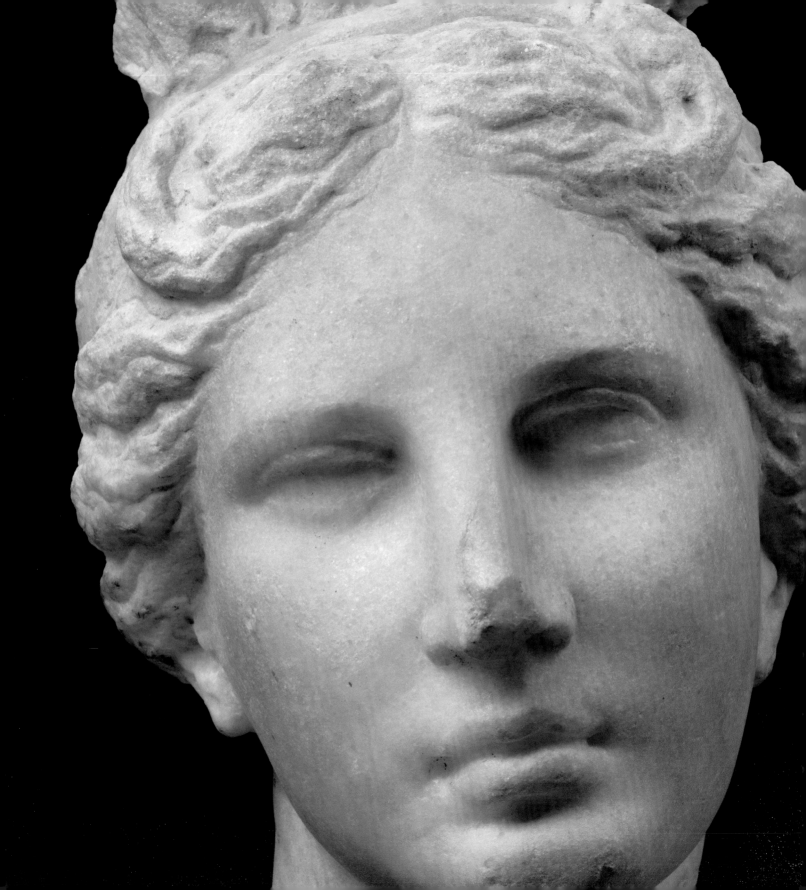

THE FEMALE NUDE IN CLASSICAL ART:
BETWEEN VOYEURISM AND POWER

■ ■ ■ ■ ■

Rachel Kousser

*T*he history of the female nude in Western art begins with Aphrodite. The goddess appeared in oversize cult statues in Greek temples and in gleaming marble sculptures decorating Roman baths. She also ornamented more modest settings, with mass-produced marble and terracotta statuettes placed in homes and tombs, creating a sensuous domestic ambience or accompanying the deceased to the afterlife. From the fourth century B.C., nude images of the goddess proliferated; they are found in every medium and every period and across the vast expanse of the Greco-Roman world. Thus, the history of the female nude and that of Aphrodite are closely intertwined; indeed, almost all nudes in ancient art are of Aphrodite, and almost all Aphrodites, from the Hellenistic and Roman periods, are wholly or partially nude.

The implications of this connection have not always been fully appreciated by scholars. Their tendency has been to interpret the genre "female nude" in light of later works—from voluptuous Renaissance paintings to *Playboy* pinups—that are thoroughly secular in nature and divorced from religious belief and cult practice.[1] But foregrounding later works of art is problematic, because such works necessarily differed in function and meaning from the nude Aphrodites of the Classical era. By focusing instead on these nudes of Classical antiquity, in relation to the goddess's cult and religious persona, we may understand better not only the representation of Aphrodite but also the early history of a major theme in Western art.

In early Greek art, it is the male nude that predominates. Athletes, heroes, and gods are shown unclothed, allowing their *kalokagathia* (beauty and goodness, conceived of as an inseparable pair) to be visibly displayed through their taut, muscular bodies and graceful poses. Women's bodies by contrast are concealed, their beauty suggested through ornate costume, complex hairstyles, jewelry, and elegant, modest gestures. A few exceptions to the rule exist: for instance, some rare early works were inspired by models from ancient Near Eastern art, where female nudity was more common

(cat. nos. 1–3, pp. 18–20). And there are occasional narrative scenes in which a woman's nakedness appears as a signal of her sexual availability or vulnerability, such as images of prostitutes at drinking parties or the rape of the Trojan princess Cassandra by the Greek warrior Ajax.

Created in the mid-fourth century B.C. by one of the era's premier sculptors, Praxiteles, the Aphrodite of Knidos was the first monumental female nude in Greek art and a radical departure from previous practice (fig. 9).[2] While the original is no longer preserved, its appearance can be reconstructed from the many extant copies. The sculpture shows Aphrodite bathing, with an urn for bathwater beside her. Praxiteles thus provided a narrative context for the goddess's nudity and also humanized her, by depicting her taking part in an everyday activity. But Aphrodite's action is not simply mundane. Rather, it alludes to the central myth of the goddess's origins in the sea; bathing returns her to that moment of birth and the watery realm. Praxiteles's sculpture, therefore, while novel in its presentation, nonetheless connects the goddess to ancient tradition and to what was most distinctive about her, mythologically speaking. This connection is particularly appropriate for a statue erected on the Greek island of Knidos, where Aphrodite was worshipped as a kind of water goddess and where her cult title was Euploia, the goddess of fair sailing.

It is with these cultic and artistic concerns in mind that we should interpret the first female nude in Greek art. In artistic terms, the Knidian Aphrodite typified the most important developments seen in fourth-century-B.C. sculpture: formal innovation and an emphatic assertion of ties to the past. Like other statues of its era, the Knidia offered a new physical ideal—that of the nude and sexually mature woman—which went beyond the rather narrow range of the preceding High Classical period. And it highlighted the human, everyday aspects of the goddess rather than her isolated grandeur. In this way, the statue responded to, and indeed encouraged, the shift

in the fourth century B.C. toward a more emotionally fulfilling religious experience for the individual worshipper; this may be seen also in the growth of healing and salvific cults, so marked a feature of the period. But while the statue appeared up-to-date, even avant-garde, in its visual form and especially its nudity, the Knidian Aphrodite at the same time represented the goddess in a manner that was anchored in Hellenic tradition. This was done above all through myth, as Aphrodite's bath functioned allusively to recall the story of her birth—her foundation myth, as it were.

Aphrodite's pose in the statue might equally relate to ancient tradition. Her right hand is held before her pubic area, in what is frequently misinterpreted as a gesture of shame or embarrassment—as though the goddess, caught unexpectedly by the viewer, were trying to hide.[3] Such an interpretation seems implausible for a cult statue, which should offer a wholly positive representation of omnipotent divinity. The gesture should be seen instead as one intended to draw attention to the part of the body most intimately connected with sexuality. For Aphrodite, goddess of sexual love, this was, after all, the source of her extraordinary power, which her nudity highlighted. As a consequence, interpretations of the statue in terms of shame or vulnerability are problematic because they do not take into sufficient account the Greek religious context. Only with the proliferation of nude Aphrodites during the Hellenistic era was there a shift toward more secular, and perhaps more voyeuristic, images.

Hellenistic artists depicted Aphrodite frequently, as demonstrated by an extensive series of original works and an even vaster array of copies. As the copies show, the Aphrodites of this period attained the greatest popularity with later viewers, in sculptures such as the Aphrodite Anadyomene (wringing out her hair) (cat. no. 130, p. 178), the crouching Aphrodite (cat. no. 132, p. 152), and Aphrodite taking off her sandal (cat. no. 129, p. 153). These images drew inspiration from the Knidian cult statue; they too depict Aphrodite engaged in everyday activities, with narratives connecting her to water and bathing. But they also move beyond the Knidia, for instance, by depicting Aphrodite in more active and complex poses and with a more distinctively feminine body type.

Although Aphrodite might appear fully clothed in these images, as she did in the conservative artistic center of Athens (cat. no. 134, p. 170), she was most often nude, the typical choice of patrons and artists throughout the Hellenistic world. Nudity functioned almost as an attribute of the goddess, allowing her identification even when other signs (such as Eros, her son, or the dove, her bird) were absent. This nearly constant nudity for Hellenistic Aphrodites effectively demonstrates the significance of the Knidia

Fig. 9
Aphrodite of Knidos ("Colonna" type)
Roman, copy of a 4th-century-B.C.
Greek original by Praxiteles
Imperial period, 1st–2nd century A.D.
Marble
H. 204 cm (80 5/16 in.)
Museo Pio Clementino, Vatican
Museums

Coin of Philadelphia with Aphrodite
arranging her hair and holding a mirror
(reverse)
Roman Provincial, struck under
Iul. Aristo Iulianus
Imperial period, A.D. 222–35
Bronze
Diam. 28.5 mm (1⅛ in.)
(cat. no. 131)

Drachm of Amisus with Aphrodite
crouching (reverse)
Roman Provincial
Imperial period, A.D. 137 or 138
Silver
Diam. 19 mm (¾ in.)
(cat. no. 132)

as the model for later works. At about this time, nude Aphrodites began to appear in a range of objects and contexts, including in small bronze and terracotta statuettes for homes or tombs (cat. no. 129; cat. no. 139, p. 186) and on gems, mirrors, and jewelry (cat. no. 72, p. 86; cat. no. 75, p. 85). Images of the female nude served a broader range of functions than was previously the case and reached a much wider audience.

Still, while Hellenistic artists were influenced by the Knidia, they also became innovators in their own right, as their facility with rendering the distinctive qualities of the nude female form increased. Praxiteles's statue was an ambitious attempt at a new subject rather than a perfect, finished achievement. It had, therefore, a somewhat awkward effect, which can be seen in the sculpture's oddly placed breasts, thick waist, and rubbery hips. Later statues such as the Capitoline Aphrodite display more clearly their creators' familiarity with sculptural techniques for rendering women's naked bodies; their proportions are more accurate and they include appropriately feminine details, such as the soft, slightly sagging flesh of the underarms and the demarcation between the swelling belly and pubic area (cat. no. 127, p. 155). The result is a more credible female nude body, which highlights and exalts its differences from the previously dominant male prototype.

A variation of the Knidia is illustrated by the statue type known as the Aphrodite of Capua (cat. no. 23, p. 156). The original sculpture was created in the late fourth century B.C. Although it is no longer preserved, we have numerous later versions of the type, where Aphrodite is depicted half nude and with a mantle draped about her hips for a more modest appearance than the Knidia's.[4] Trim and erect, she also appears more youthful and dynamic as she twists sharply to the left, originally holding a shield in both hands. Her focused gaze, down and to the left, seems to emphasize the significance of her action—even though this significance, in both the Aphrodite of Knidos and the Capuan statue type, has long been subject to debate.

Scholars have frequently claimed that Aphrodite is using the shield of Ares, her lover, as a mirror to admire her own beauty.[5] This interpretation is problematic, however, because it relies upon an extremely limited characterization of Aphrodite. It is unlikely that the goddess would be so exclusively concerned with love and beauty that she would turn the war god's shield, an important emblem of battle, into a mirror. As recent studies have shown, in Greece Aphrodite had a much more wide-ranging sphere of activity—her dominion extended not only to sexual love but also

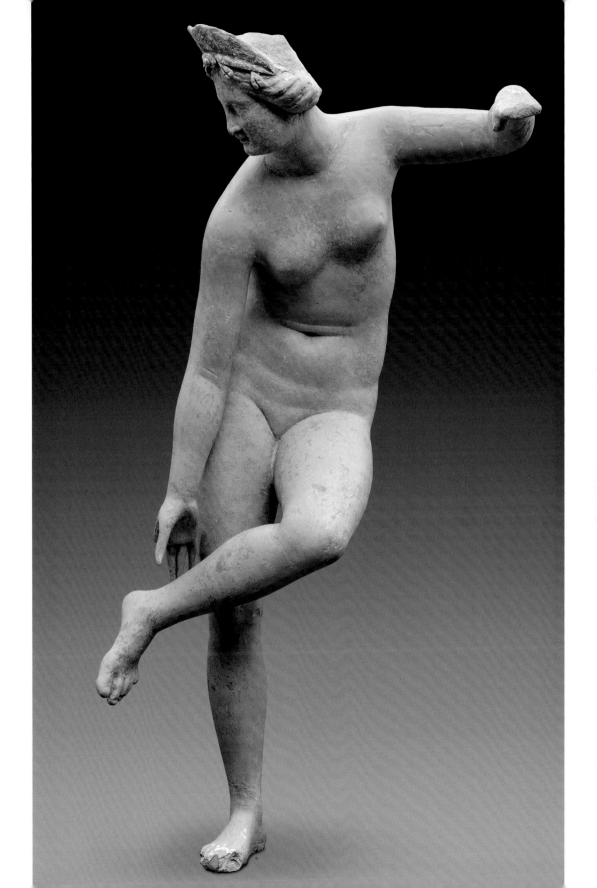

Statuette of *Aphrodite untying her
sandal* (Sandalbinder)
Greek, made in Smyrna
Late Hellenistic period,
about 1st century B.C.
Terracotta
H. 37.4 cm (14¹¹⁄₁₆ in.)
(cat. no. 129)

Fig. 10
Jim Dine (American, born
in 1935)
Nine Views of Winter (2), 1985
Woodcut, hand-painted with
floral-patterned rollers
H. 133.4 cm (52½ in.)

Statue of *Aphrodite of the Capitoline type*
Roman, made in Lazio, Italy
Imperial period, 2nd century A.D.
Marble
H. 112.4 cm (44 ¼ in.)
(cat. no. 127)

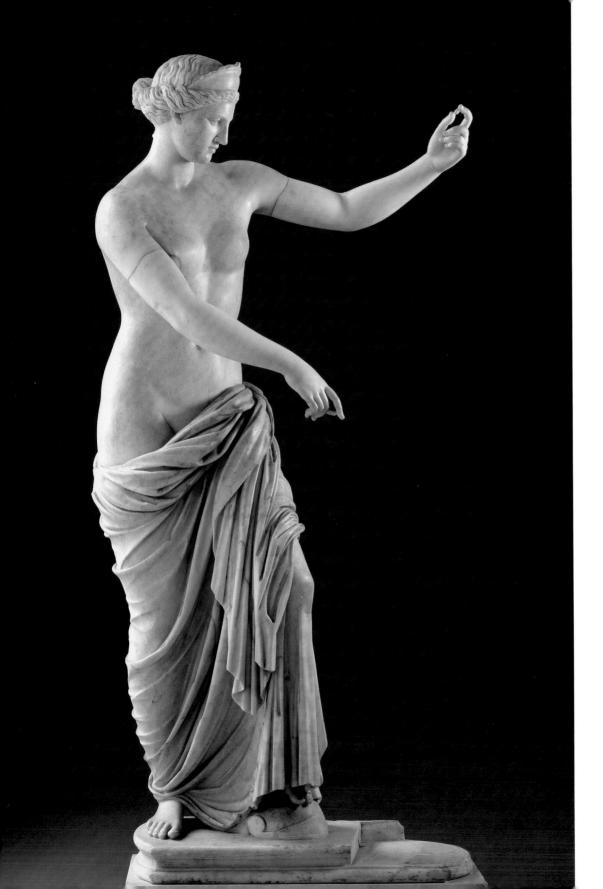

Statue of Aphrodite (Aphrodite of Capua)
Roman
Imperial period, Hadrianic,
A.D. 117–38
Marble
H. 210 cm (82⅝ in.)
Naples, Museo Archeologico
Nazionale
(cat. no. 23)

to political harmony, agricultural fertility, seafaring, and, perhaps surprisingly, war. In Corinth, where the original Capuan statue was likely erected, Aphrodite had long been venerated as a goddess of military victory; literary and archaeological sources show that she was believed to protect the city in times of danger, such as during the Persian Wars.[6]

The image of Aphrodite with a shield is best interpreted as an appropriately martial cult statue for the goddess's Corinthian temple. It represents Aphrodite as a sensuous half-nude in the most current fashion of the late fourth century B.C. but holding a shield to indicate her longstanding role as defender of the polis. Like the Knidia, the Capuan statue combines innovative representational strategies with traditional religious symbolism; while it retains the erotic appeal characteristic of the goddess of love, its sensuality has a particular meaning here: the desirability of military victory in the age of Alexander the Great, a time when such victory was ever more critical to the community's survival.[7] The statue's combination of erotic beauty and martial symbolism also ensured its popularity in later periods, especially in the heavily militarized society of imperial Rome.

The Roman goddess Venus had much in common with Aphrodite, but the two were by no means identical.[8] Like her Greek counterpart, Venus was a powerful deity associated with beauty, love, and sexuality. Venus also inherited much of Aphrodite's mythological background, such as her involvement in the Trojan War and her love affairs with Adonis and Anchises—albeit with a particular emphasis on her role as mother of Aeneas, a founding hero of Rome. But in other ways the two goddesses were quite distinct. The most significant difference was Venus's greater involvement with war and victory, as well as her connection to the imperial family. Taken together, these variations resulted in strikingly divergent patterns of worship for the Roman goddess, even when her visual form was very close to that of her Hellenic predecessor.

From the outset, the public cult of Venus in Rome was closely associated with military success and imperial expansion. Q. Fabius Gurges built the first temple to Venus in 295 B.C. at the conclusion of a war with the Samnites, Rome's formidable neighbors on the Italian peninsula. The goddess's cult title here was

Fig. 11
Mosaic with Aphrodite as a martial goddess holding a spear
Roman, from Room 2, Roman House south of the Villa of Theseus, Nea Paphos, Cyprus
Imperial period, 3rd century A.D.
Limestone, marble
Paphos Archaeological Park

157

Venus Obsequens (propitious Venus), because she had proved advantageous in the war to the temple's dedicator and to the Romans more broadly. Q. Fabius Maximus, the grandson of the previous dedicator, vowed a second temple in 217 B.C. during the Second Punic War. The dedication came in response to Rome's crushing defeat by the great Carthaginian general Hannibal at the battle of Cannae and was part of a broader attempt to garner divine support for continuing the struggle. In this case, the temple was dedicated to Venus Erycina, from the former Punic stronghold of Mount Eryx, in Sicily; its importance is signaled by its placement on the Capitoline hill, the heart of ancient Rome. L. Porcius Licinius constructed an additional temple to Venus Erycina in 184 B.C. during the Ligurian War. While these temples took on other functions as well—for example, a festival for prostitutes was held near the site of Licinius's dedication—their martial purposes were clear and highly valued by the Romans. The temples' history shows how the worship of Venus was incorporated into the public rituals of Rome, above all at times of great military peril during the wars that secured Rome's dominance over the Mediterranean.[9]

While later cults of Venus continued to connect her with war and victory, they also associated the goddess more closely with particular individuals in the contest for power that marked the Late Republic. In the early first century B.C., following his victory in the so-called Social War with Rome's Italian allies, the dictator L. Cornelius Sulla set up a colony named after Venus—the Vesuvian city of Pompeii, formally the Colonia Veneria Cornelia Pompeianorum—and constructed her temple there in a prominent location. After his military successes in the Mithridatic wars in Greece, he set up a victory monument to Aphrodite and sent gifts to the Aphrodite of Aphrodisias (in present-day western Turkey), claiming that he saw her in a dream, fighting on his side. He also took as his Latin cognomen *Felix* (lucky), which in Greek was translated as *Epaphroditos*, suggesting that he enjoyed the favor of Aphrodite. All this closely tied Sulla to Venus, whom he also promoted on his coins as a kind of patron deity of his military successes. Later aspiring generals followed his lead, including Pompey the Great, Sulla's one-time protégé and the dominant military figure of the mid-first century B.C. Throughout his career, Pompey portrayed himself as under the goddess's protection; he even dedicated the temple crowning his famous theater in Rome to her as Venus Victrix (victorious).[10]

The association of Venus with powerful military figures did not change when the Republic ended in 27 B.C. and the Principate was established. Instead, the connection intensified, although Venus also took on

other nonmilitary functions. Hellenistic rulers had already promoted Aphrodite as a divine role model for their queens; however, the Roman emperors surpassed their Greek counterparts in the many ways they aligned themselves with the deity—by sponsoring several Venusian cults and monuments, used in high-profile imperial settings and integrated within a coherent visual language of political propaganda. Much of the credit for this development must go to Julius Caesar and his heir Augustus, the first Roman emperor. Caesar's family, the Iulii, claimed descent from Venus via her son Aeneas, and already in the second century B.C. they were representing the goddess on their coins. Under Caesar and Augustus, this practice was vastly accelerated. The dictator and his grand-nephew the emperor not only put Venus on their coins but also honored her in their temples and used her imagery on their gems, historical reliefs, and portraits, thereby emphasizing their divine ancestry, crucial for the kind of charismatic leadership role to which they aspired.[11] At the same time, using the image of the goddess of love offered a sensuous and pacific way to represent their power, one particularly attractive to the Romans after a generation of civil war.

Aureus with a standing Venus Victrix (reverse)
Roman, struck under Septimius Severus
Imperial period, A.D. 193–96
Gold
Diam. 20.5 mm (13⁄16 in.)
(cat. no. 151)

Caesar's and Augustus's descendents, the Julio-Claudians, emphasized their ancestral ties especially to Venus Genetrix (the ancestress). But after the assassination of Nero and the accession of a new dynasty, the Flavians, Venus became instead a model for the Roman empresses, as she had for Hellenistic queens. Her image was coupled with that of the empress, particularly on coins and gems, where it metaphorically suggested the beauty of her mortal counterpart or the marital concord of the dynasty (cat. no. 145, p. 172; cat. no. 151). She was also honored in a temple constructed by the emperor Hadrian to Venus Felix and Roma Aeterna (Venus of Good Fortune and Eternal Rome). This immense religious structure, atop the Velian hill at the eastern end of the Roman Forum, was the last major public temple to the goddess in Rome; but even into the Late Empire, Venus continued to adorn the great public buildings, such as baths, theaters, and amphitheaters, that the emperors patronized so lavishly. In such locations, her statues offered an attractive representation of imperial power for those who were subject to it.[12] Her public, nude images perhaps also alluded to her role as guarantor of fertility and as embodiment of *felicitas temporum* (the good fortune of the era)—both critical to the flourishing of the empire.

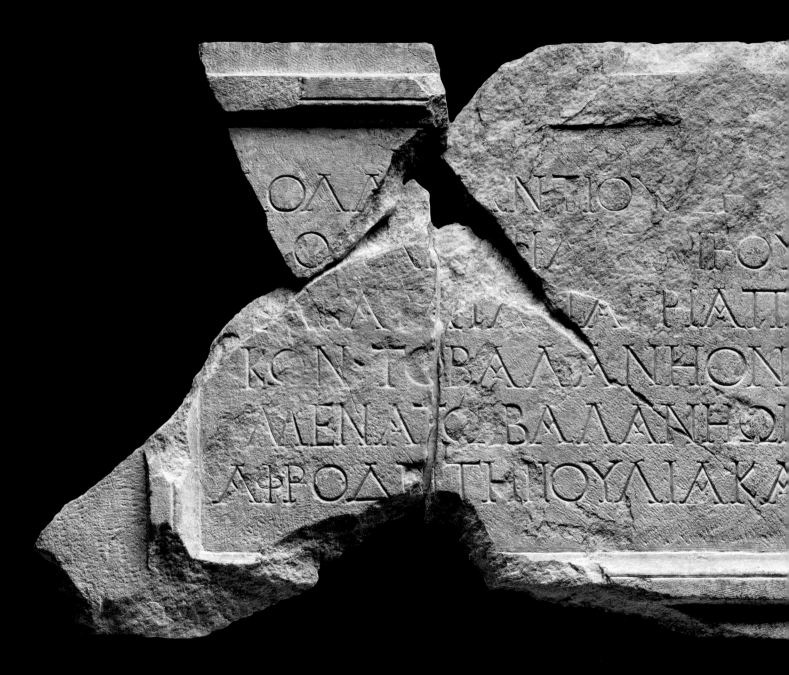

ΟΛΑ ΝΤΙΟΥ
Ο ΟΝ
 Α ΤΑ ΡΙΑΠ
ΚΟΝΤΟ ΒΑΛΑΝΗΟΝ
ΜΕΝΑΤΟ ΒΑΛΛΑΝΗΟ
ΑΦΡΟΔ ΤΗ ΙΟΥΛΙΑΚΑ

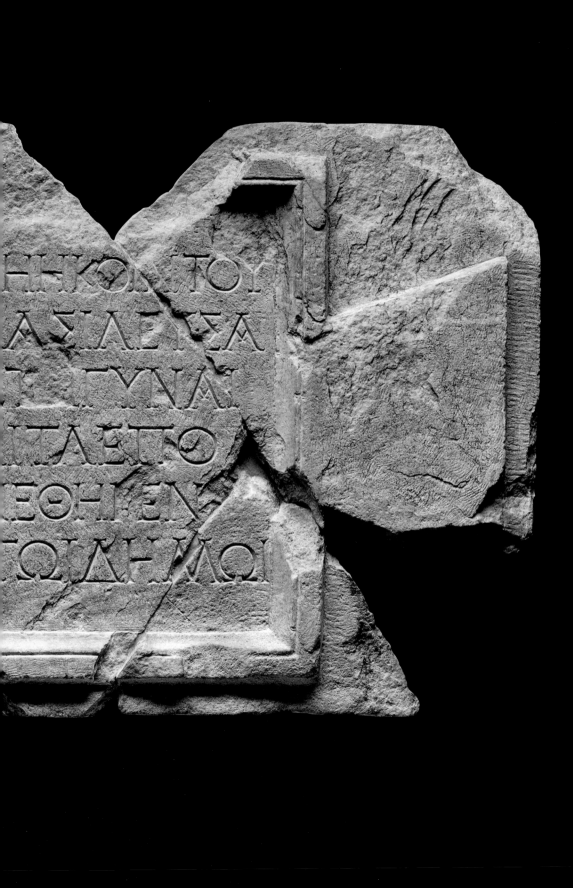

Inscription commemorating Lollia Antiochis's dedication of a bath to Aphrodite
Greek, East Greek
Roman Imperial period,
before 2 B.C.
Marble
L. 94 cm (37 in.)
(cat. no. 61)

Venus was popular in private worship as well. Her connection to sexuality made her an important deity for women, including brides, matrons, and prostitutes, and gave her a particular place of honor in the home. Venus also appeared in gardens—perhaps in acknowledgment of her power over agricultural fecundity, further underscored by the appearance of her son, the fertility god Priapos—and her presence there emphasized the garden's status as a zone of pleasure within the multifunctional Roman home.[13] As all these public and private cults of Venus suggest, the goddess was thoroughly integrated into Roman life. Her worship was emphatically different from that of Aphrodite; her images, by contrast, were closely linked.

Roman nudes tend to look Greek.[14] That is, the Romans used Greek styles, and often established Hellenic types, to represent the female nude in their art; they also appropriated earlier works of Greek art for their own uses. This emulation of Greek art also extended to heroic male nudes (frequently deployed for portraits), images of the gods, narratives of courage and romance derived from Greek myth, and the decoration of Roman houses and tombs. As this list suggests, the Romans used Greek styles selectively for particular artistic genres, while others, such as realist portraiture, remained emphatically Roman in form. Overall, one might say that the Romans dreamed in Greek, deploying Greek visual formats and styles to represent their pleasures, fantasies, and ideals.

These Greek-style works have often been described as derivative copies,[15] yet such a description does not do justice to what is distinctively Roman about them: their contexts.[16] Monumental images derived from Greek cult statues were erected in eminently Roman settings such as baths, theaters, and gladiatorial arenas. Miniaturized versions were also created to adorn the Romans' beloved villa gardens, while models with portrait heads were used as a characteristic form of Roman funerary commemoration (cat. no. 146). In such settings, Greek-style nudes were seen by broad new audiences and thus understood in new ways. So while the Roman period saw few changes to the female nude in visual terms, its meanings were dramatically altered.

Among the most significant of these alterations was the deployment of Greek-style Aphrodites throughout the great civic spaces of the Roman world. Public architectural complexes boasted an immense population of sculptures in marble and bronze. Gods and mythological heroes rubbed shoulders with local benefactors and the reigning emperor, result-

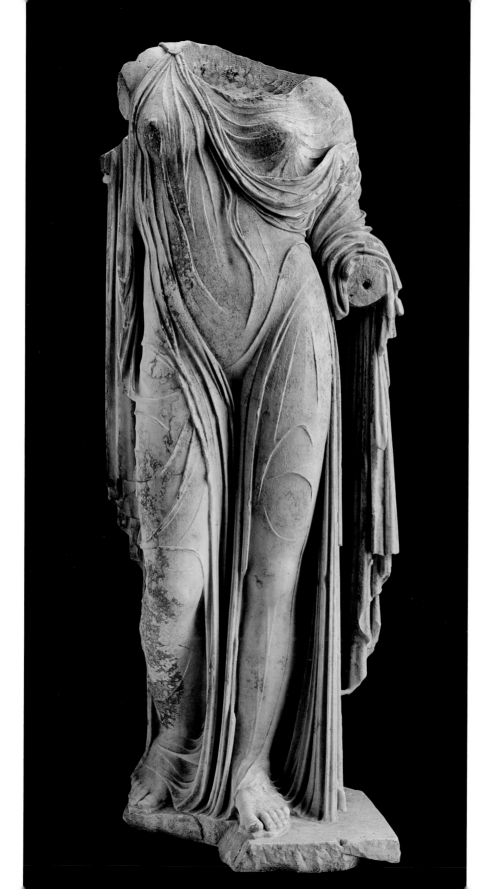

Statue of a woman in the guise of Venus
Roman
Imperial period, mid-1st to
early 2nd century A.D.
Marble
H. 145 cm (57 1/16 in.)
(cat. no. 146)

Fig. 12
Statue of Aphrodite
Roman, from the baths of Cyrene
Imperial period,
about A.D. 100–150
Marble
H. 150 cm (59¹⁄₁₆ in.)
Rome, Museo Nazionale Romano

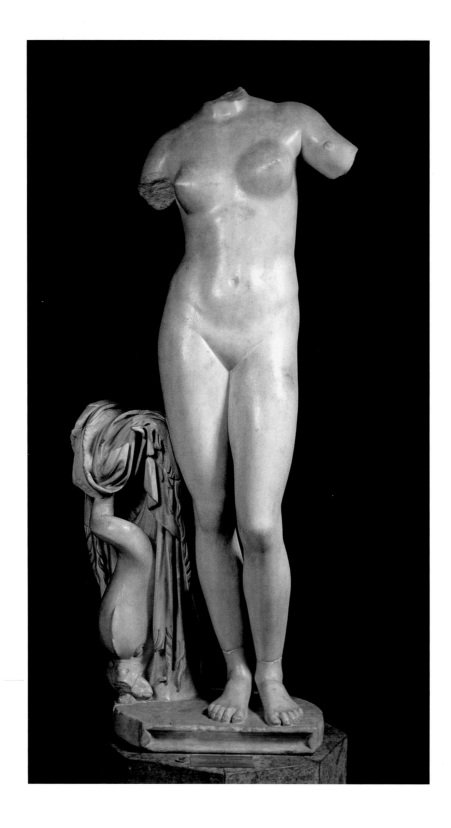

ing in a dazzling showcase of Roman wealth and imperial power. While the goddess of love appeared in all these civic spaces, she was particularly popular within Roman baths.[17] The myth of her birth and her cultic connection to water may partly account for her popularity there; more important, however, was her association with beauty, love, and pleasure. These were the baths' promise, so it is not surprising that Aphrodite (together with the wine god Dionysos and perhaps the healing deities Asklepios and Hygeia) predominates there.

A statue from Cyrene, a Greco-Roman city on the coast of North Africa, demonstrates very effectively what made Aphrodite so appropriate for the baths (fig. 12).[18] The statue depicts the goddess as a full-bodied and graceful nude, with her discarded costume and a small dolphin to her right as a support. Her arms are not preserved below the shoulders, but copies of the type suggest that they were raised, perhaps wringing out wet hair or binding it with a ribbon. In this statue, the treatment of the nude body is adept and sensuous. It puts to good use some five centuries of sculptors' experience with the rendering of the unadorned female form, and—with the softly modulated planes of the body and strong light-shadow contrasts on the support—shows the high level of artistic achievement attained in civic sculpture during the Roman Empire.

The North African bath complex in which the Aphrodite stood testifies to the scale and ambition of such buildings in the provinces. At the same time, the site's inscriptions show that the bath was initiated during the emperor Trajan's reign and with his assistance, making clear its connection to Rome.[19] The complex was restored by his successor, Hadrian, after the Jewish revolt of A.D. 115, known as the Bar Kochba War; he was also likely responsible for the sculptures here. These elegantly carved and high-profile works of art testified to the artistic taste and cultivation of Hadrian and to the benefits for the local population of the empire he ruled.

A second important development of the Roman era was the predominance of Venus, and Venusian imagery, in the private sphere of house and tomb. In Pompeii, for example, Venus was the divinity most frequently depicted in domestic statuettes and wall paintings, often shown wholly or partly nude, as were her companions, Cupid, Psyche, and the Three Graces. Compared with the nudes used in public monuments, these private works of art were more diverse in appearance and meaning, while retaining a consistent connection to beauty and sexual love. The private nudes also began earlier and continued longer, becoming popular in the early first century B.C. and keeping their hold on Roman viewers well into the Late Antique peri-

od, as the Roman Empire became Christian. Unlike large-scale public commissions, private works of art were more economical. They were also less ostentatiously at odds with the new religious dispensation and consequently tended to escape the destruction meted out to, for example, statues and temples of Venus.[20]

Funerary contexts also provided a rich and varied private production of Venusian imagery. In tombs, women were often shown in the manner of the Capitoline Aphrodite as a means to commemorate and idealize the deceased. The dead woman's assimilation to Venus was surely meant to praise her beauty; this central aspect of the goddess's character was enhanced by her depiction as a nude (cat. no. 146, p. 163). The nudity was metaphorical, functioning as a kind of costume that indicated the virtues being commemorated in the funerary monument. It removed the deceased from the sphere of everyday life and connected her to the gods and to high art, especially through its allusion to a familiar statue type. Thus, here as elsewhere, nudity had a religious meaning and also an aesthetic one, exalting the deceased through the medium of Greek art.

The Aphrodite of Knidos was influential not simply as the first but indeed as the definitive female nude throughout antiquity. Reproduced in hundreds of copies from the Hellenistic through Late Roman periods, the Knidia set the standard for later images. Given the striking differences between the Hellenic worship of Aphrodite and the Roman cult of Venus—with her close connection to war, imperial expansion, and the ruling dynasty—the Knidia's influence, and that of Greek art more generally, becomes especially noteworthy. We might expect the goddess to look more explicitly martial, or at any rate more sober and restrained, than is generally the case.[21] Instead, she was represented as sensuous and alluring, and the revered traditions of Greek art were deployed to enhance her attractiveness rather than her formidable divinity. At the same time, when viewed in the correct light, it is precisely the alluring physical form of Aphrodite that emerges as the concrete, effective expression of her divine power—making these ancient images of her very different indeed from the female nudes of later periods, when the realms of the sensual and the religious and political spheres were considered wholly separate, even antithetical.

*Denarius with the head of Venus (obverse)
and Aeneas, Anchises, and Ascanius (reverse)*
Roman, struck under Julius Caesar
Late Republican period,
about 47–46 B.C.
Silver
Diam. 18.5 mm (¾ in.)
(cat. no. 147)

Denarius with a standing Venus (reverse)
Roman, struck under L. Flaminius
Chilo
Late Republican period, 43 B.C.
Silver
Diam. 20.5 mm (¹³/₁₆ in.)
(cat. no. 148)

Sestertius with a seated Venus (reverse)
Roman, struck under Commodus
Imperial period, about A.D. 180–82
Bronze
Diam. 31 mm (1³/₁₆ in.)
(cat. no. 149)

Aureus with a standing Venus (reverse)
Roman, struck under Marcus Aurelius
Imperial period, A.D. 164–82
Gold
Diam. 21 mm (¹³/₁₆ in.)
(cat. no. 150)

*Aureus with a standing Venus Victrix
(reverse)*
Roman
Imperial period, about A.D. 284
Gold
Diam. 21 mm (¹³/₁₆ in.)
(cat. no. 152)

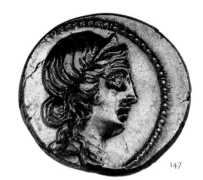
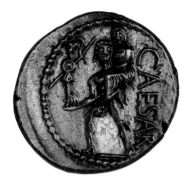

147

148

149

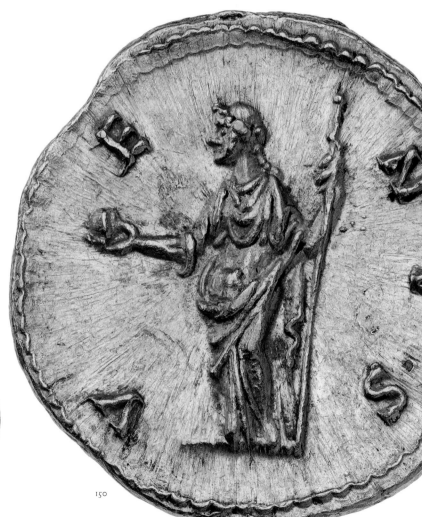

150

152

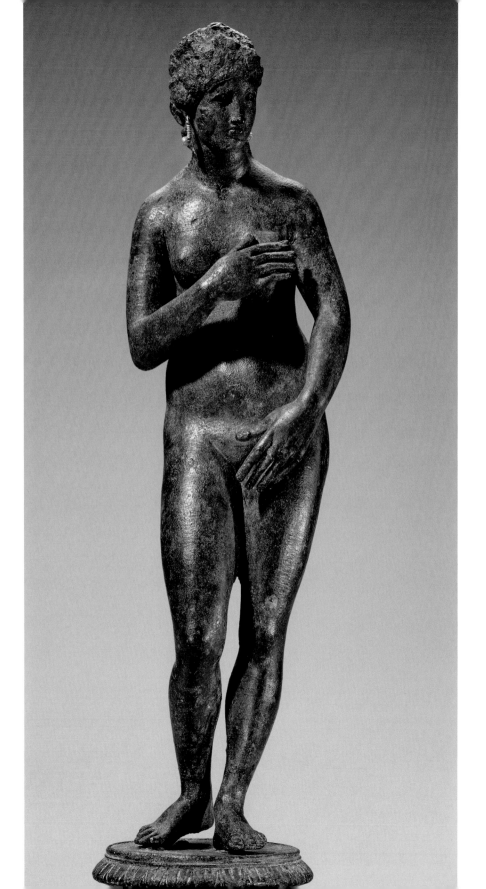

Statuette of Aphrodite
Greek or Roman
Late Hellenistic or Roman Imperial
period, 1st century B.C. or
1st–2nd century A.D.
Bronze
H. 31.3 cm (12⁵⁄₁₆ in.)
(cat. no. 138)

Fig. 13
Pablo Picasso (Spanish, worked
in France, 1881–1973)
*Sculptor Reclining and Model with
Mask*, 1933
Etching
H. 44.6 cm (17 9/16 in.)

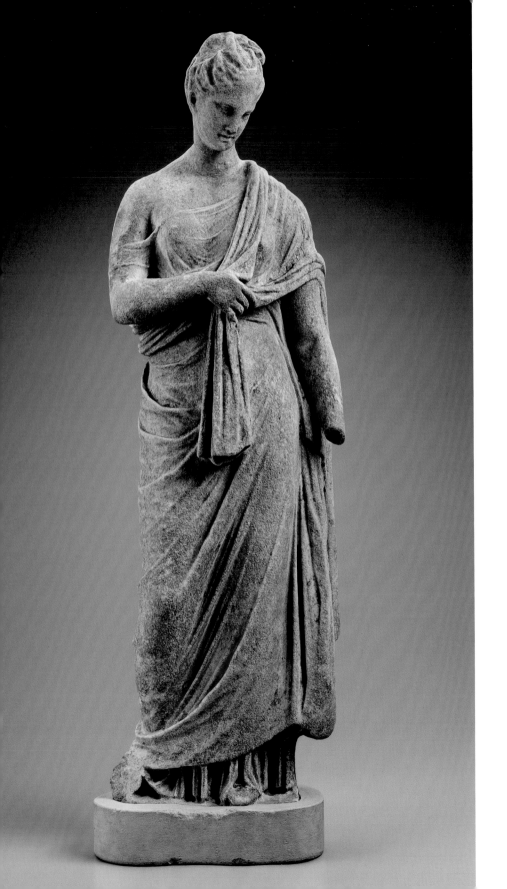

Statuette of Aphrodite
Greek
Early Hellenistic period, about
325–300 B.C.
Marble
H. 54.6 cm (21½ in.)
(cat. no. 134)

Statuette of Aphrodite leaning on a column
Greek
Early Hellenistic period, end of the
4th century B.C.
Terracotta
H. 23.1 cm (9 1/16 in.)
(cat. no. 137)

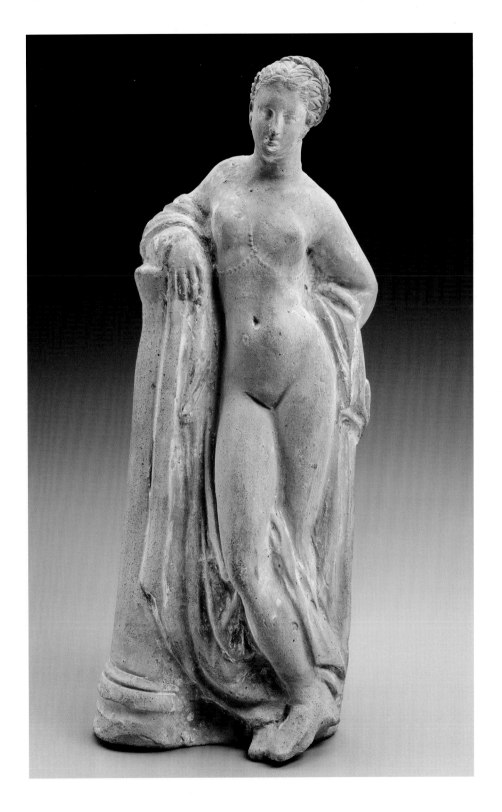

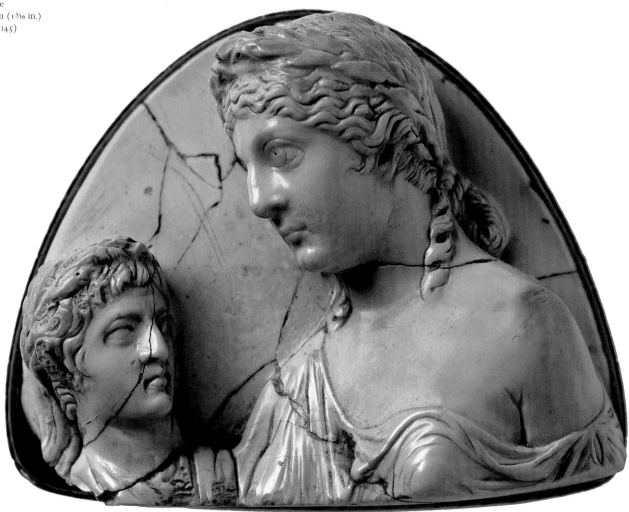

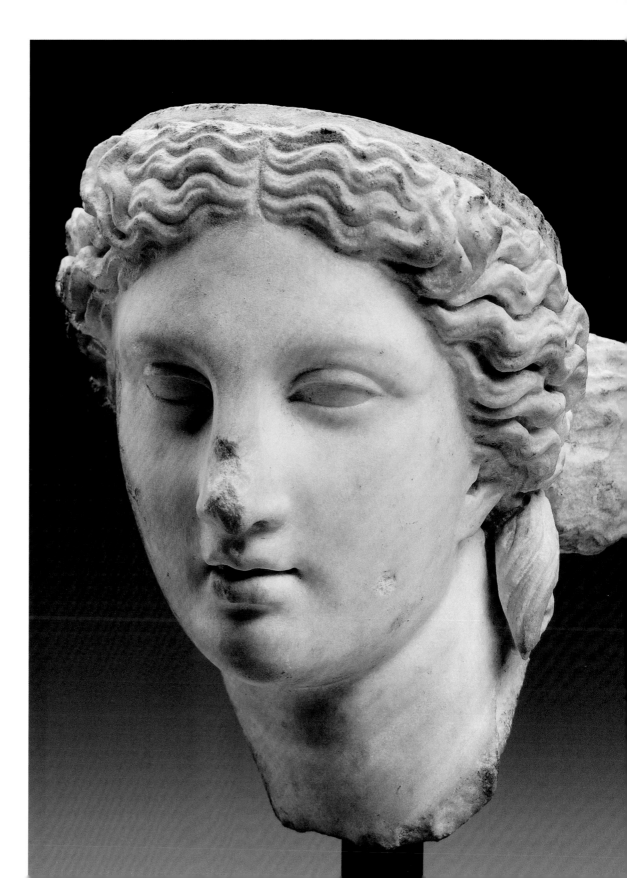

Head of Aphrodite
Roman
Imperial period, Antonine,
A.D. 138–92
Marble
H. 22 cm (8 11/16 in.)
(cat. no. 126)

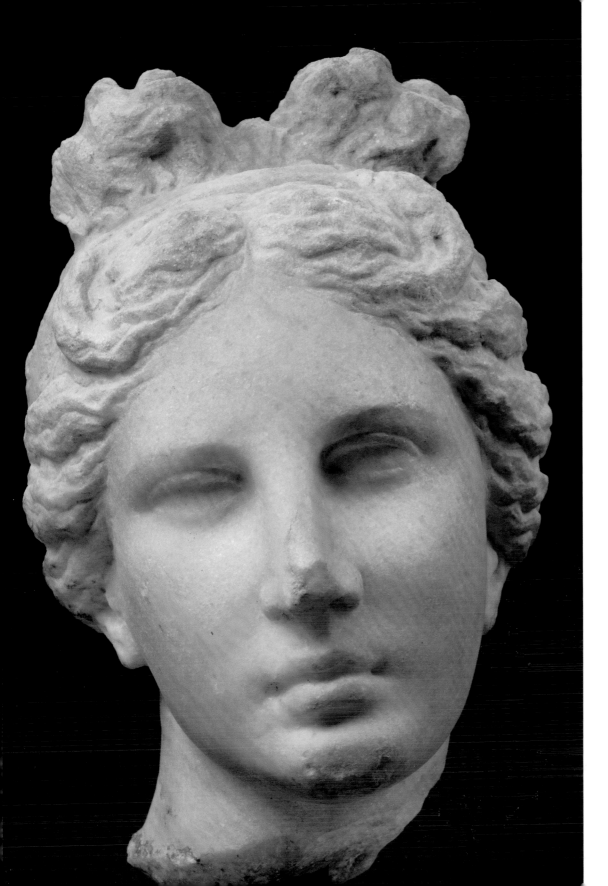

Head of Aphrodite (Bartlett Head)
Greek, made in Athens
Late Classical or Early Hellenistic
period, 330–300 B.C.
Marble
H. 28.8 cm (11 5/16 in.)
(cat. no. 125)

Head of Aphrodite of the Capitoline type
Roman, made in Lazio, Italy
Imperial period, 2nd century A.D.
Marble
H. 29.5 cm (11⅝ in.)
(cat. no. 128)

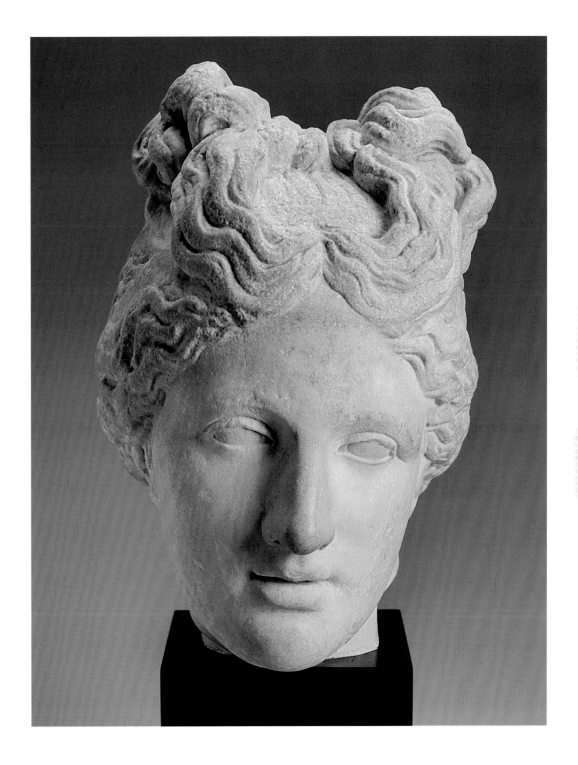

Mixing bowl (calyx krater) with
dueling scenes from the Trojan War
Greek, made in Athens; attrib-
uted to the Tyszkiewicz Painter
Late Archaic period, 490–
480 B.C.
Ceramic, red-figure technique
H. 45.2 cm (17 13/16 in.)
(cat. no. 144)

Fig. 14
Luca Giordano
(Italian, 1634–1705)
Venus Giving Arms to Aeneas,
1680–82
Oil on canvas
H. 227.3 cm (89½ in.)

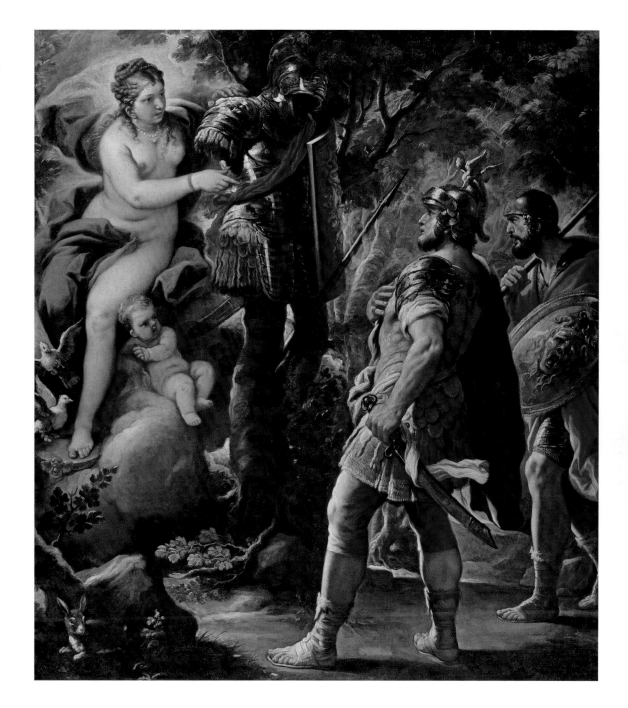

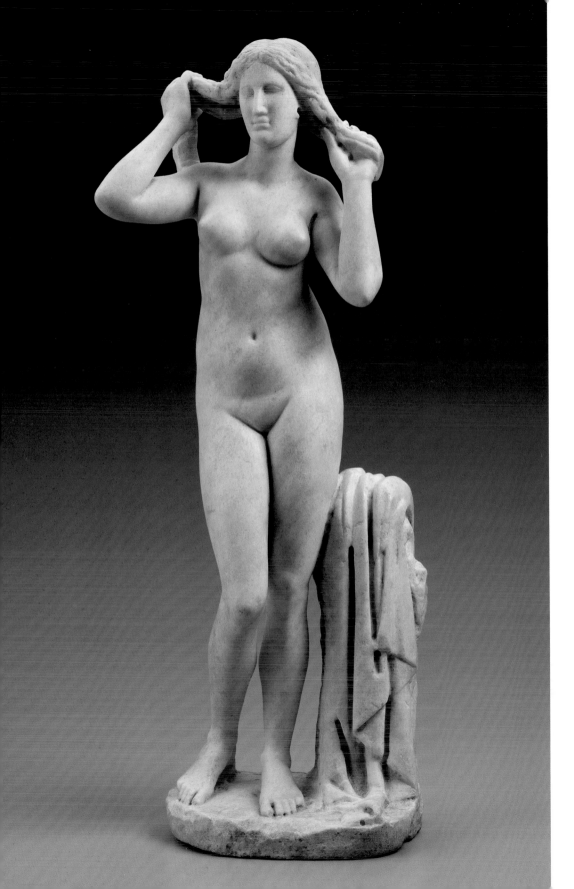

Statuette of *Aphrodite Anadyomene*
Greek or Roman, Eastern
Mediterranean
Hellenistic or Imperial period,
100 B.C.–A.D. 70
Marble
H. 55 cm (21 11/16 in.)
(cat. no. 130)

Fig. 15
Théodore Chassériau
(French, 1819–1856)
Venus Rising from the Sea, 1839
Crayon lithograph with scraping
and tan tint stone
H. 46.8 cm (18 7/16 in.)

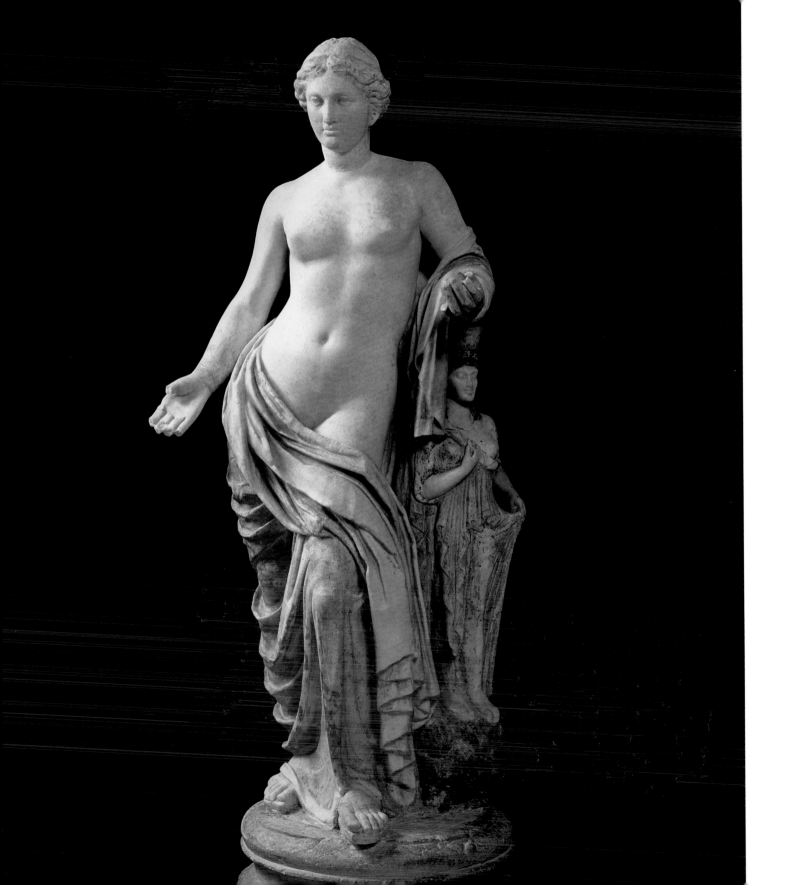

*Statue of Aphrodite leaning on a statue
of herself*
Roman
Late Hellenistic period,
2nd or 1st century B.C.
Marble with polychromy
H. 104 cm (40 15/16 in.)
Naples, Museo Archeologico
Nazionale
(cat. no. 142)

*Statuette of Aphrodite leaning on a
statue of herself*
Greek, from Myrina (Asia Minor);
signed by Aglaophon
Hellenistic period, 150–100 B.C.
Terracotta
H. 33.4 cm (13 3/16 in.)
(cat. no. 143)

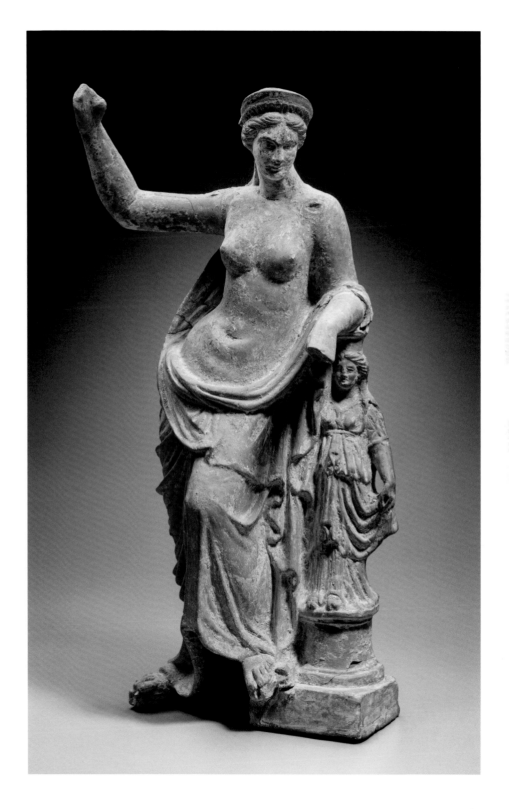

Statuette of Aphrodite leaning on a column
Greek or Roman, Eastern
Mediterranean
Late Hellenistic or Early Roman
period, 100 B.C.–A.D. 50
Marble
H. 42.9 cm (16⅞ in.)
(cat. no. 133)

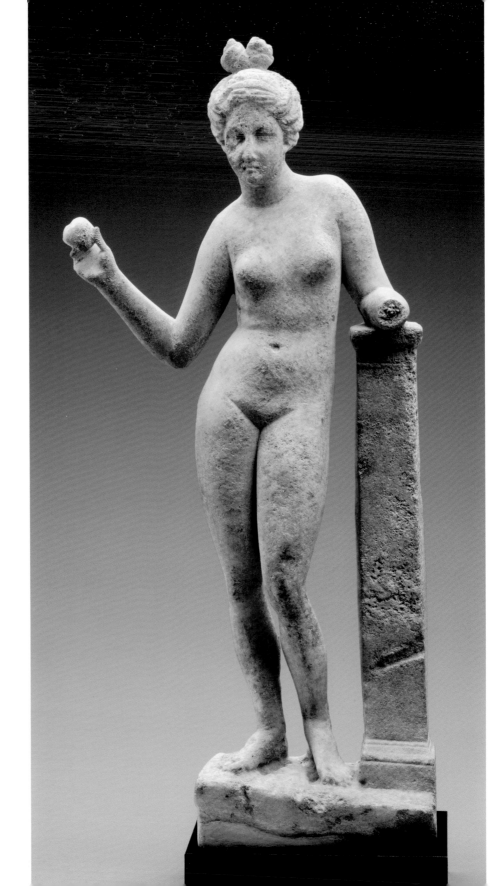

Fig. 16
Pablo Picasso (Spanish, worked
in France, 1881–1973)
*Sculptor and His Model before a
Window*, 1933
Etching
H. 34.1 cm (13 7/16 in.)

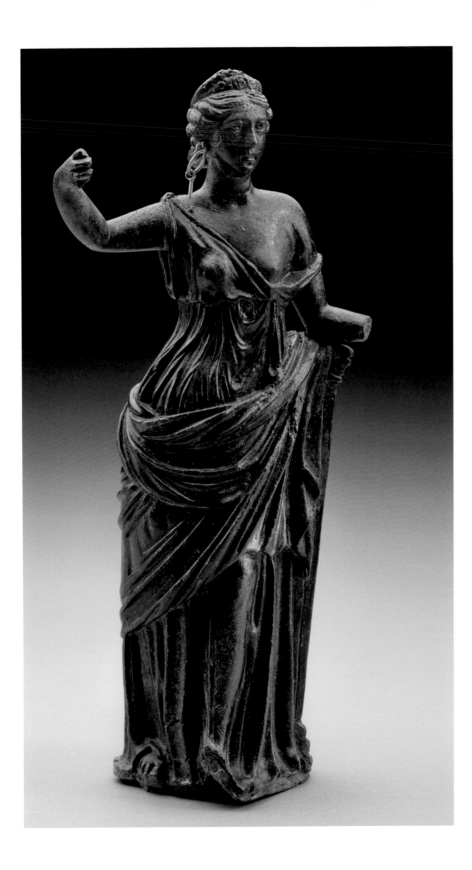

Figurine of Aphrodite
Roman Provincial
Imperial period, 2nd century A.D.
Bronze, gold
H. 17.7 cm (6 15/16 in.)
(cat. no. 140)

Figurine of Aphrodite
Greek or Roman
Late Hellenistic or Roman
Imperial period, 1st century B.C.
or 1st century A.D.
Silver with gold leaf
H. 12.4 cm (4⅞ in.)
(cat. no. 141)

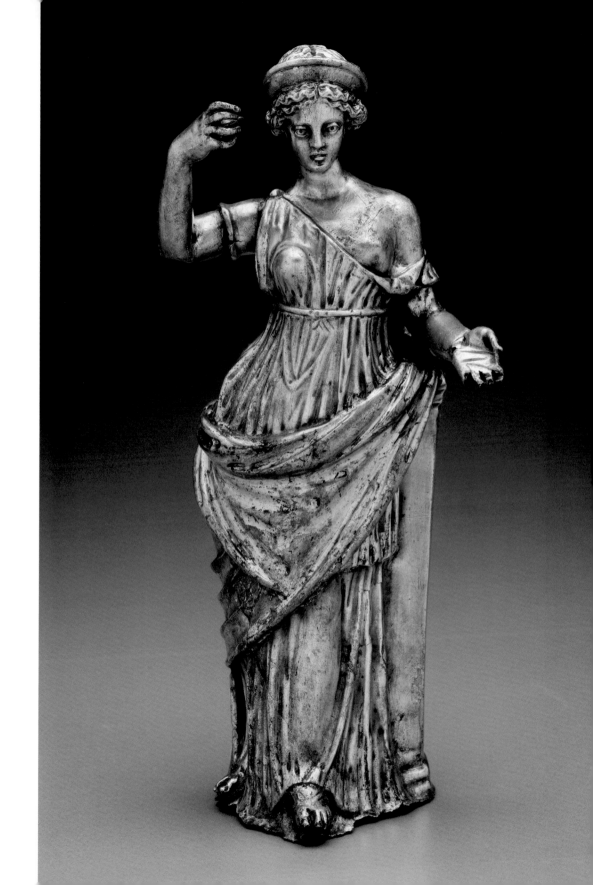

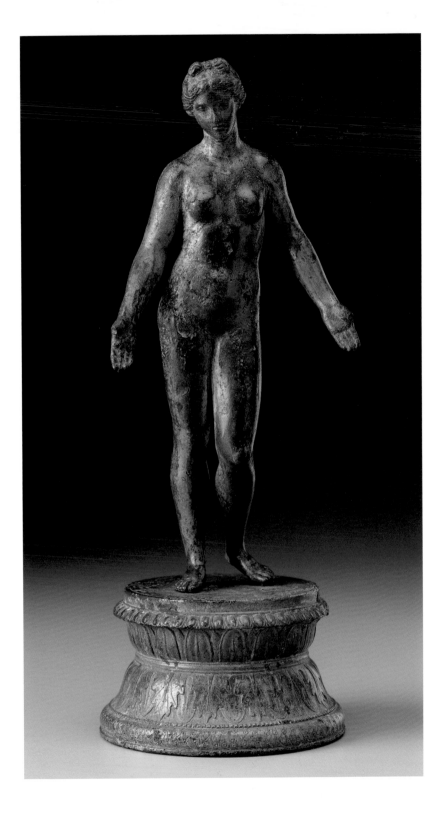

Figurine of Aphrodite with open palms
Greek
Late Hellenistic period,
1st century B.C.
Bronze
H. 18.6 cm (7 5/16 in.)
(cat. no. 139)

Mold of the face of a woman (possibly
Aphrodite)
Greek, East Greek
Hellenistic period, 3rd or 2nd
century B.C.
Terracotta
H. 5.5 cm (2 3/16 in.)
(cat. no. 135)

Statuette of Aphrodite or a Muse leaning
on a pillar
Greek
Hellenistic period, about
300–250 B.C.
Terracotta
H. 39.4 cm (15½ in.)
(cat. no. 136)

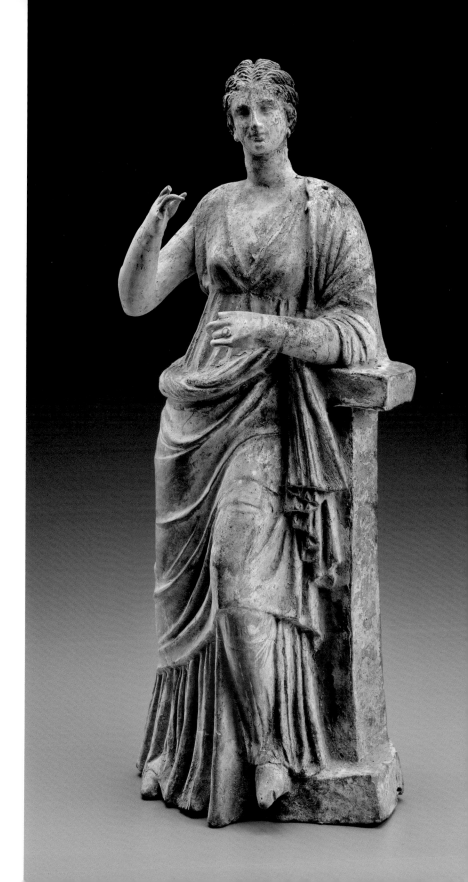

ANNOTATED CHECKLIST

·····

Christine Kondoleon, Phoebe C. Segal, and David Saunders

The checklist organization follows the section divisions in the exhibition. Provenance information for MFA objects can be found through the Collections search at the MFA Web site: http://www.mfa.org.

APHRODITE'S ANCESTORS
Ancient Near East

The Greek conception of Aphrodite as a goddess of sexuality is firmly rooted in the goddesses of the ancient Near East, in particular Mesopotamian Ishtar and Syro-Phoenician Astarte.

1
"Mother Goddess" figurine (p. 18)
Near Eastern, Anatolian
Neolithic period, about 6000–5500 B.C.
Terracotta
H. 2 cm (13/16 in.), w. 2.3 cm (15/16 in.)
Gift of Brig. Gen. (ret.) and Mrs. Eric H. F.
Svensson 64.2052

With its squat, corpulent body, this miniature figurine finds its closest parallel in the much-debated "mother goddess" type found at Çatal Höyük in central Anatolia (present-day Turkey). Some argue that this type of figurine represents a fertility goddess, while others maintain that its identity and function remain unknown.

2
Figurine of a nude female holding her breasts (p. 19)
Near Eastern, Levantine, from Tell Judeidah
(Syria)
Early Bronze Age, 3200–2800 B.C.
Bronze with silver
H. 19 cm (7 7/16 in.)
Gift of the Marriner Memorial Syrian Expedition
49.119

This cast-bronze figurine was discovered in a cache with five others at Tell Judeidah, a settlement that was occupied from the Neolithic to the Byzantine period. The figurines, including males and females, are widely regarded as among the earliest examples of bronze casting and feature additions in silver and gold. The sexual organs of all the figurines are very clearly defined. The male

figurines (including MFA 49.118, not illustrated) once carried weapons, and the females, such as this one, hold their breasts, a gesture that dates back to the late fourth millennium B.C.

3
Statuette of a nude female holding her breasts (p. 20)
Near Eastern, Central Anatolian
Early Hittite, about 2000 B.C.
Copper
H. 25.4 cm (10 in.)
Gift of Mrs. Frederick M. Stafford in memory of
Mr. Frederick M. Stafford 1984.993

Many believe that this statuette and the figurine from Tell Judeidah (cat. no. 2) depict fertility goddesses.

4
Model shrine with nude goddess (p. 22)
Eastern Mediterranean
6th–3rd century B.C.
Terracotta
H. 26 cm (10¼ in.), w. 14.3 cm (5⅝ in.)
Gift of Alan M. and Marcia May 1990.605

The origins of this terracotta shrine are not well known. Its hybrid iconography suggests Phoenician (frontal nudity) and Egyptian (recumbent lions, Hathor wig, Bes capitals) influences. Similar plaques in the British Museum have been found at Naukratis, where Egyptian, Phoenician, and Greek populations, gods, and artistic ideas mixed together.

Egypt

Hathor and Isis are the Egyptian goddesses most closely associated with love, procreation, and nurturing and are the best parallels for Aphrodite. The writings of Herodotus demonstrate that, as early as the fifth century B.C., Hathor and Aphrodite were considered by the Greeks to be interchangeable. Like Aphrodite, Hathor was a celestial goddess invoked as "the beautiful one" and "golden one." Isis, the Egyptian goddess of motherhood, was later associated with Aphrodite by Greeks living in Egypt.

5
Sistrum (p. 21)
Egyptian
Late period, Dynasty 26–30, 664–332 B.C.
Bronze
H. 44.5 cm (17½ in.), w. 14.5 cm (5 11/16 in.),
l. 10 cm (3 15/16 in.)
Edward J. and Mary S. Holmes Fund 1970.572

The sistrum is a percussive instrument that was used to accompany singing and dancing in both secular contexts and religious ceremonies, particularly those honoring Hathor. The rustling sound of the sistrum, similar to that made by reeds, was believed to appease and placate the gods. Egyptian reliefs frequently depict priestesses, princesses, and other beauties carrying the instrument in procession. About 2000 B.C., the two-sided sistrum acquired the distinctive female face, curled hairstyle, and bovine ears of Hathor.

This sistrum, of the loop type, features three rearing cobras, Egyptian symbols of kingship and power. Two are seated on Hathor's shoulders and wear headdresses associated with Upper and Lower Egypt, and the third wears a sun disk. The side of the loop carries a representation of Mut, an Egyptian war goddess and wife of Amen-Ra, shaking a pair of sistra before a ram, the sacred animal of her husband. Mut and Amen-Ra were worshipped in the temple precinct at Karnak and, thus, the sistrum is suspected to have originated there.

6
Necklace counterpoise (menat) (p. 26)
Egyptian, from Room R, Semna, Sudan
New Kingdom, Dynasty 18, 1390–1352 B.C.
(reign of Amenhotep III)
Bronze
H. 13.8 cm (5 7/16 in.), w. 4.5 cm (1¾ in.),
d. 0.2 cm (1/16 in.)
Harvard University–Boston Museum of Fine Arts
Expedition 29.1199

This counterpoise, a device used to balance heavy necklaces worn in ritual ceremonies, depicts Hathor in three guises. In the center, a standing

Hathor holds a scepter; below, she appears in the form of a cow riding a papyrus boat; above, the goddess wears a vulture headdress and characteristic horned solar disk and bears facial features recognized as those of Queen Tiye, the wife of Amenhotep III.

7
Statuette of Isis and Horus (p. 26)
Egyptian
Late period, about 664–332 B.C.
Bronze
H. 20.5 cm (8¹⁄₁₆ in.), w. 5.1 cm (2 in.),
d. 5 cm (1¹⁵⁄₁₆ in.)
Gift of Mrs. Horace L. Mayer 1974.575

Isis's role as model wife and devoted mother is well known from the myth of Osiris, in which the goddess assembled her husband's scattered remains and posthumously conceived their child, Horus. Wearing her characteristic horned sun disk, Isis holds Horus in her lap and reaches for her breast to nurse him. A similar Greek statue type depicting Aphrodite and her son Eros is known as the Aphrodite Kourotrophos.

Cyprus

As the mythical birthplace of Aphrodite, Cyprus is the home of many cults of the goddess and findspot of numerous types of figurines that depict her and her devotees.

8
Figurine of a goddess or woman (p. 30)
Cypriot
Late Cypriot II period, about 1450–1200 B.C.
Terracotta
H. 11.1 cm (4⅜ in.)
General Funds 72.154

This type of figurine, decorated in the style of Cypriot "Base-ring" ware, is among the earliest images that were mass produced in Cyprus. It is thought to represent an indigenous fertility deity often known as the Great Goddess. The figure holds her breasts in her hands, and her pubic area is embellished with incised lines and paint, which also encircle the neck and shoulders.

9
Figurine of Cypriot Aphrodite-Astarte (p. 30)
Cypriot
Cypro-Archaic period, late 7th century B.C.
Mold-made terracotta
H. 11.8 cm (4¹¹⁄₁₆ in.)
General Funds 72.155

This mold-made figurine was manufactured in Cyprus and fuses the iconography of the Phoenician goddess Astarte, typically seen holding her breasts, with a distinctively Cypriot style, notably in the so-called ear caps. The closest parallels for this figurine are found at Amathous and Lapithos in Cyprus.

10
Figurine of a female carrying a bunch of flowers (p. 34)
Cypriot
Cypro-Archaic II period, 600–475 B.C.
Limestone
H. 14.5 cm (5¹¹⁄₁₆ in.)
Gift in memory of Emily Dickinson Townsend Vermeule 2001.173

Flowers and doves are among the most popular offerings to Aphrodite, and votive figurines dedicated to the goddess are often depicted carrying them. The broad, round face of this flower bearer points to Golgoi as its place of origin.

11
Over-lifesize female head, possibly Aphrodite or a priestess of the goddess (p. 28)
Cypriot
Cypro-Archaic period, late 6th or early 5th century B.C.
Limestone
H. 50.8 cm (20 in.), w. 34.9 cm (13¾ in.),
d. 41.2 cm (16³⁄₁₆ in.)
Worcester Museum of Art, Massachusetts
Museum Purchase 1941.49
Photograph courtesy of Worcester Museum of Art

This over-lifesize head of the goddess or a priestess wears a headdress (*polos*) elaborately decorated with silens and maenads, who joyfully dance through a rosette-ornamented colonnade. The head's prominent cheekbones, almond-shaped eyes, and archaic smile are characteristic of Cypro-Archaic style, and the head is similar in style and iconography to those found at the sanctuaries of Golgoi and Arsos, which had the oldest tradition of limestone sculpture in Cyprus.

12
Stater of Salamis with the bust of Aphrodite wearing a diadem (obverse, not illustrated) and the bust of Aphrodite wearing a turreted crown (reverse) (p. 29)
Greek, struck under Nikokreon
Late Classical or Early Hellenistic period, about 331–311 or 310 B.C.
Gold
Diam. 17 mm (¹¹⁄₁₆ in.)
Theodora Wilbour Fund in memory of Zoë Wilbour 49.1905

This gold coin from Salamis, a wealthy city in Cyprus with an important Aphrodite cult, features images of the Paphian goddess on both sides. On the obverse, the goddess wears a turreted crown, echoing the headdresses worn by the limestone head (cat. no. 11) and terracotta figurine (cat. no. 14). This crown, which imitates the walls of a city and may be derived from the iconography of Aphrodite's Near Eastern predecessors, symbolized in concrete visual terms the goddess's role as protector of the city.

13
Figurine of a woman nursing a child (Aphrodite Kourotrophos) (p. 35)
Cypriot
Cypro-Archaic period, 600–480 B.C.
Limestone
H. 17.8 cm (7 in.)
General Funds 72.158

Kourotrophos is the Greek adjective used to describe images of nursing women and was applied to a wide range of goddesses associated with fertility, childbirth, and motherhood. Depictions of Aphrodite Kourotrophos, usually enthroned and often wearing an elaborate headdress (*polos*), were popular in the Cypro-Archaic period and hark back to Egyptian representations of Isis nursing Horus (e.g., cat. no. 7). This figurine belongs to the less-common standing type and bears remarkable similarity to terracotta examples from Lapithos, Cyprus.

14

Figurine of Aphrodite seated and wearing a high polos
(p. 27)
Cypriot
Cypro-Classical period, 4th century B.C.
Terracotta
H. 13 cm (5⅛ in.)
General Funds 72.165

Enthroned figurines of Aphrodite continued to be popular in the Classical period in Cyprus. As with other Aphrodite figurines of its type, this example wears a headdress (*polos*) shaped like a basket (*kalathos*), rests her feet on a base, and touches her breasts, which are visible through her chiton. With its emphasis on the breasts and fertility, this type is related to Kourotrophos figurines (see cat. no. 13).

BIRTH OF APHRODITE

15

Oil bottle (lekythos) in the form of Aphrodite at her birth
(p. 38)
Greek, made in Athens
Late Classical period, about 380–370 B.C.
Ceramic
H. 21.3 cm (8⅜ in.)
Catharine Page Perkins Fund 96.722

In the early fourth century B.C., Athenian ceramic artists invented figurative oil vessels illustrating Aphrodite's emergence from the sea. Such representations relate to the account of her birth, first preserved in Hesiod's *Theogony* (173–206). The original polychromy (blue, pink, white) and gilding are well preserved on this example, where the goddess rises from a seashell. She wears an elaborate diadem, and her bare breasts are embellished with a gilded chain.

16

Oil bottle (lekythos) in the form of Aphrodite at her birth
(p. 39)
Greek, made in Athens
Late Classical period, 4th century B.C.
Ceramic
H. 19 cm (7½ in.)
Museum purchase with funds donated by Mrs.
Samuel Torrey Morse 00.629

Aphrodite emerges with billowing drapery from a seashell, as two erotes herald her arrival. The original polychromy of this ornate vessel is well preserved, with pink for the interior of the shell and traces of yellow, gold, and blue for the figures. The vase was found in a tomb with other perfume and cosmetic vessels decorated with related images of erotes and women.

17

Skyphos with goddess emerging between two goat-headed satyrs (p. 45)
Greek, made in Athens; painted by the Penthesilea Painter
Classical period, about 450 B.C.
Ceramic, red-figure technique
H. 23 cm (9 1/16 in.), diam. 23 cm (9 1/16 in.)
Henry Lillie Pierce Fund 01.8032

A female figure rises from the ground between two surprised goat-headed satyrs on this skyphos. Early interpretations of this enigmatic scene took the woman to be Persephone; a vase in the Rhodes Archaeological Museum (inv. no. 12454), however, shows a similar female figure, identified as Aphrodite by an inscription, emerging from the ground in the presence of Pan. There are other scenes that show a woman rising up from the earth (*anodos*) before satyrs, and some have thought such images to be related to a satyr play parodying Aphrodite's birth.

18

Statuette of Aphrodite emerging from the sea (p. 37)
Greek or Roman, Eastern Mediterranean
Hellenistic or Imperial period,
1st century B.C.–1st century A.D.
Marble, probably from Paros, Greece
H. 43 cm (16 15/16 in.), w. 29 cm (11 7/16 in.)
Frank B. Bemis Fund 1986.20

This unique, dynamic sculpture depicts Aphrodite bursting forth from a shell, with her drapery, still wet, swirling behind her. The immediacy of this lively portrayal of the goddess's birth places the viewer at the shore of Paphos, where the goddess is said to have emerged from the sea. This statuette from the Eastern Mediterranean was likely intended for a bath, where images of Aphrodite bathing were appropriate, or a garden, where images of sea gods were often incorporated into fountains.

GREEK CULTS OF APHRODITE

Cult of Aphrodite in Athens

Aphrodite had many cults in Athens, where she was worshipped as Ourania (heavenly) and Hegemone (leader) in the Agora; Pandemos (who brings people together) on the southwest slope of the Acropolis; en Kepois (in the gardens) near the Ilissos River; and Euploia (of fair sailing) in Piraeus, the port of Athens.

19

Relief with Aphrodite and devotees (p. 53)
Greek, made in Athens, discovered in Pompeii
(V, 3, 10)
Late Classical or Early Hellenistic period,

4th century B.C.
Marble
H. 45 cm (17 11/16 in.), w. 62 cm (24 7/16 in.)
Naples, Museo Archeologico Nazionale 126174
Ministero per i Beni e le Attività Culturali / Soprintendenza Speciale per i Beni Archeologici di Napoli e Pompei
Photograph © Luciano Pedicini / Archivio dell'Arte

Votive reliefs were set up in Greek sanctuaries as prayers and offerings of thanks, and the images represented on them acted both as reflections and as reminders of the rituals that took place there. They were usually displayed on pillars and bore inscriptions identifying the people who dedicated them. In this example, seven worshippers, perhaps an extended family or household, bring a ram to sacrifice before a large statue of a goddess, possibly Aphrodite, seated with her right hand outstretched. This relief was discovered in a Roman house in Pompeii, attesting to the Roman custom of collecting Athenian votive reliefs and displaying them alongside the neo-Attic reliefs of the first century B.C. and first century A.D. they inspired.

20

Statue of Aphrodite riding a goose (p. 50)
Greek, possibly made in Athens
Late Classical period, 4th century B.C.
Marble, Pentelic
H. 68.6 cm (27 in.), w. 43.2 cm (17 in.),
d. 34.3 cm (13½ in.)
Francis Bartlett Donation of 1900 03.752

This marble statue of Aphrodite riding on a goose probably originally functioned as an acroterion and likely surmounted the corner of a small shrine in Athens. Images of Aphrodite riding a goose or a swan depict the goddess as Ourania, "the heavenly one," and her connection with these sea birds probably refers to her marine birth. Aphrodite Ourania was a particularly appropriate subject for temple acroteria, which were seen against the backdrop of the blue sky. As with the votive relief (cat. no. 19), this statue was discovered in a Roman context where it had been reused in a fountain.

21

Mirror with Aphrodite riding on a goat (exterior) and feeding a goose (interior) (p. 51)
Greek, possibly made in Corinth
Hellenistic period, about 280 B.C.
Bronze
Diam. 22 cm (6¾ in.)
Anonymous Loan
Photographs by Stefan Hagen. Courtesy of Robert Haber and Associates, Inc.

This box mirror depicts Aphrodite riding a goat through a rocky, pastoral landscape on the cover

and a seated, nude Aphrodite feeding a goose on the interior. In contrast to scenes of Aphrodite riding sea birds (geese, swans) that refer to the cult of the goddess as Ourania (heavenly), the goat is associated with the cult of Aphrodite Pandemos (who brings people together). The juxtaposition of the draped Aphrodite Pandemos and the nude Aphrodite Ourania on this mirror demonstrates that a single utilitarian object could incorporate multiple Greek cults into daily life.

22
Oil bottle (squat lekythos) with Nike sacrificing a bull to Aphrodite and Ares (pp. 48–49)
Greek, made in Athens, said to have been found in Eretria, Euboia
Classical period, about 394–390 B.C.
Ceramic, red-figure technique with added white, added clay lines, dilute glaze, and traces of gilding
H. 15.2 cm (6 in.), diam. 8.4 cm (3 5⁄16 in.)
Henry Lillie Pierce Fund 98.884

Ares and Aphrodite, depicted with a spear and a shield, watch as Nike draws back a bull's head in a rare depiction of animal sacrifice. This martial representation would be fitting for the goddess as she was worshipped at the Piraeus, where, as recounted by Pausanias (1.1.3), the Athenian admiral Konon built a temple to Aphrodite Euploia (of fair sailing) following his 394 B.C. naval victory over the Spartans off Knidos, of which Aphrodite was the patron goddess.

Cult of Aphrodite in Corinth

Aphrodite had an important cult in Corinth from the eighth century B.C. through the Roman Imperial period and was worshipped there on a rocky outcrop called Acrocorinth.

23
Statue of Aphrodite (Aphrodite of Capua) (p. 156)
Roman, from *summa cavea* of amphitheater, found 1750
Imperial period, Hadrianic, A.D. 117–38
Marble
H. 210 cm (82 5⁄8 in.)
Naples, Museo Archeologico Nazionale 6017
Ministero per i Beni e le Attività Culturali / Soprintendenza Speciale per i Beni Archeologici di Napoli e Pompei
Photograph © Luciano Pedicini / Archivio dell'Arte

Discovered in 1750 in the amphitheater of Capua, near Naples, this commanding statue of Aphrodite is the finest and most complete Roman example of a type inspired by a fourth-century-B.C. Greek cult statue from Corinth. In her role as Venus Victrix (victorious), Aphrodite, half-draped and diademed, twists to her left and rests her left foot on a helmet, perhaps that of Ares. In her left hand

she held a shield, and she is thought to be inscribing the names of victors in battle with her right hand. Part of the base, where a statue of Eros had probably been inserted, has been cut away. Sculptures of Psyche and Adonis were also found in the amphitheater of Capua.

24
Drachm of Corinth with Pegasos (obverse, not illustrated) and the head of Aphrodite (reverse) (p. 47)
Greek
Late Classical or Early Hellenistic period, about 350–300 B.C.
Silver
Diam. 16 mm (5⁄8 in.)
Catharine Page Perkins Fund 01.5469

This fourth-century-B.C. Corinthian drachm depicts the bejeweled head of Aphrodite opposite an image of the mythical horse Pegasos. According to myth, Acrocorinth was the hill where the winged horse Pegasos was tamed by the hero Bellerophon.

Cult of Aphrodite in Naukratis

The cult and sanctuary of Aphrodite at Naukratis, a trading emporium in the Nile Delta, were established in the late seventh or early sixth century B.C. and continued into the Roman period.

25
Statue of a female holding a dove (p. 58)
Cypriot, discovered in the Temple of Aphrodite at Naukratis (Egypt)
Cypro-Archaic period, about 575 B.C.
Limestone
H. 23.5 cm (9 1⁄4 in.)
Egypt Exploration Fund by subscription 88.735

This small statue is one of many archaic votive statues that were found in Aphrodite's temple at Naukratis, along with thousands of Greek pottery sherds. Many of these statuettes bear striking resemblance to those found in Cyprus; however, the extent to which their style ought to be labeled "Cypriot"—and the corresponding assumption that there was a significant Cypriot population living in Naukratis—is debated. This painted statue is bedecked with jewels and carries a dove, Aphrodite's sacred bird.

26
Figurine of Isis-Aphrodite Anasyromene (p. 59)
Egyptian, discovered in the Temple of Aphrodite at Naukratis (Egypt)
Hellenistic period, 3rd–2nd century B.C.
Terracotta
H. 20 cm (7 7⁄8 in.), w. 8.8 cm (3 7⁄16 in.)
Egypt Exploration Fund by subscription 88.919

In Hellenistic and Roman times, Aphrodite's identity was often fused with those of Egyptian fertility goddesses: Isis, Hathor, and Bubastis. This figurine represents Isis-Aphrodite Anasyromene (revealing the womb) or Isis-Bubastis. The figure lifts her short-sleeved tunic to reveal her pubic area and wears an elaborate *kalathos*-shaped (basket-shaped) headdress, reminiscent of those worn by Cypriot Aphrodite. This figure and others of its type were found in a terracotta workshop on the eastern side of Naukratis.

27
Figurine of Aphrodite (p. 59)
Egyptian, found in the Temple of Aphrodite at Naukratis (Egypt)
Roman Imperial period, 30 B.C.–A.D. 364
Faience
H. 5.9 cm (2 5⁄16 in.), w. 2 cm (13⁄16 in.), d. 1.5 cm (9⁄16 in.)
Egypt Exploration Fund by subscription 88.1110

Made of a medium native to Egypt, this faience statuette of Aphrodite displays a fusion of artistic ideas characteristic of the material culture of Naukratis. The rigidly posed goddess wears a headdress, possibly a *polos*, and features an enlarged belly and breasts, as with other fertility goddesses.

Cult of Aphrodite in the Roman East

Roman emperors seeking to emphasize their ancestral ties with Venus actively promoted the ancient cults of Aphrodite in the Eastern Mediterranean. As a result, Paphos, the legendary birthplace of the goddess, and Aphrodisias, where the goddess had an important cult as early as the sixth century B.C., thrived in the Roman period.

28
Statuette of Aphrodite of Aphrodisias (p. 54)
Roman, probably found in the region of Siena
Imperial period, 2nd century A.D., perhaps Antonine, A.D. 138–93
Marble
H. 36 cm (14 3⁄16 in.)
Rome, Palazzo Massimo alle Terme, Museo Nazionale Romano 67556
Courtesy of the Ministero per i Beni e le Attività Culturali—Soprintendenza Speciale per i Beni Archeologici di Roma

The cult statue of Aphrodite of Aphrodisias—a city located in ancient Caria, present-day Turkey—is recognizable for its unique overgarment, which is divided into four figural zones decorated in relief (from top to bottom) with the Three Graces, Selene (Moon) and Helios (Sun), Aphrodite rid-

ing on a sea goat, and erotes gathered around an altar. This canonical cult image, which displays Hellenistic iconography in an indigenous Carian format, is represented at Aphrodisias in both large- and medium-scale marble sculpture and in architectural reliefs from monumental civic buildings. Images of the cult statue are also found on the coinage of Aphrodisias; gems; and about thirty marble statuettes, many of which have been found in Italy. This marble version is believed to have been found in the region of Siena, Italy, and was later transferred to Rome.

29
Statuette of Aphrodite with elaborate headdress (p. 55)
Roman, said to be from Myrina (Asia Minor)
Imperial period, late 1st century B.C. or later
Terracotta
H. 28 cm (11 1/16 in.)
Gift of Martin Brimmer 87.397

Terracotta statuettes with moveable limbs first became popular in the eighth century B.C. and remained so throughout antiquity. Long thought to have been toys for children, recent scholarship has shown that these figures probably served as guardians and had magical functions. This Roman Imperial statuette of Aphrodite wears an Egyptianizing wiglike headdress and platform sandals (kothornoi) often associated with Hellenistic theater actors.

30
Coin of Hierapolis in alliance with Aphrodisias with the bust of Commodus (obverse, not illustrated) and the cult statues of Apollo and Aphrodite (reverse) (p. 56)
Roman Provincial
Imperial period, A.D. 186–91
Bronze
Diam. 36 mm (1 7/16 in.)
Theodora Wilbour Fund in memory of Zoë Wilbour 61.1058

Reproduced in large numbers and widely circulated, ancient coins were the bearers of important messages from the cities and rulers that issued them. In many cases, coins featured images of recognizable cult statues framed within architectural enclosures, intended as shorthand representations of temples, and these came to act as symbols of cities and bespeak a process of visual extrapolation on the part of ancient viewers.

Among the different types of political messages Roman cities and emperors communicated with their coinage, the formation of an alliance between two cities was a popular subject, particularly in the second and third centuries A.D. Minted by Hierapolis under Commodus, this coin illus-

trates the city's alliance with nearby Aphrodisias through the recognizable cult statues of the respective cities, Apollo and Aphrodite.

31
Tetradrachm of Cyprus with the head of Vespasian (obverse, not illustrated) and the sanctuary of Aphrodite at Paphos (reverse) (p. 56)
Roman Provincial
Imperial period, A.D. 77–78
Silver
Diam. 25.5 mm (1 1/16 in.)
Theodora Wilbour Fund in memory of Zoë Wilbour 60.1435

32
Coin of Cyprus with the bust of Septimius Severus (obverse, not illustrated) and the sanctuary of Aphrodite at Paphos (reverse) (p. 56)
Roman Provincial
Imperial period, about A.D. 206–7
Bronze
Diam. 33.5 mm (1 5/16 in.)
Theodora Wilbour Fund in memory of Zoë Wilbour 63.423

Aphrodite's sanctuary at Paphos remained her primary sanctuary in the Mediterranean until the advent of Christianity in the fourth century A.D. Beginning with Julius Caesar, who traced his family's lineage back to Aphrodite through Aeneas, Roman emperors held the sanctuary in especially high regard and supported it financially. Many emperors, including Septimius Severus, depicted the sanctuary on their coins as evidence of their devotion to the goddess and respect for the antiquity of her cult.

33
Coin of Aphrodisias with the bust of Gallienus (obverse, not illustrated) and the cult statue of Aphrodite (reverse) (p. 56)
Roman Provincial
Imperial period, A.D. 255–68
Bronze
Diam. 30 mm (1 3/16 in.)
Theodora Wilbour Fund in memory of Zoë Wilbour 63.1129

34
Coin of Saitta with the bust of Salonina (obverse, not illustrated) and the cult statue of Aphrodite (reverse) (p. 56)
Roman Provincial
Imperial period, A.D. 253–68
Bronze
Diam. 29.5 mm (1 3/16 in.)
Theodora Wilbour Fund in memory of Zoë Wilbour 63.2920

In the absence of literary evidence and copies, coins often provide the basis of our knowledge of

ancient cult statues. On the coin from Aphrodisias (cat. no. 33), the oversize statue of Aphrodite of Aphrodisias stands in profile, while in this example from Saitta, a nude statue of the goddess is depicted contrapposto.

35
Coin of Aphrodisias with the head of Senate (obverse, not illustrated) and Aphrodite holding an apple and a scepter (reverse) (p. 57)
Roman Provincial
Imperial period, A.D. 200–250
Bronze
Diam. 26.5 mm (1 1/16 in.)
Theodora Wilbour Fund in memory of Zoë Wilbour 64.1369

This coin depicts the personification of the Senate (Synkletos) as a handsome youth. Synkletos was an important figure in Aphrodisias, a Roman city in Asia Minor that had obtained special rights and privileges from a *Senatus Consultum* in the first century B.C. While the majority of Aphrodite images in the coinage of Aphrodisias depict the city's unusual cult statue, this example features the goddess holding an apple and a scepter and highlights her role as a civic goddess.

Doves

One aspect of Aphrodite's cult is that, as with her Near Eastern predecessors, she was worshipped with dove sacrifices; bone remains found in her sanctuaries indicate that she was the only Greek deity to receive these gifts. In fact, dove sacrifices constituted a major ritual component of the worship of Aphrodite from the early Archaic through the Hellenistic period. The goddess's affinity for doves is usually attributed to their benevolent, tender nature and predilection for lovemaking.

36
Figurine of a girl with a dove (p. 61)
Greek, said to have been found at Achaia, Peloponnesos
Classical period, about 430 B.C.
Bronze
H. 8.3 cm (3 1/4 in.)
Museum purchase with funds donated by contribution 01.7497

Bronze and terracotta statuettes of young girls offering doves to Aphrodite were popular gifts to the goddess and are often found in her sanctuaries. Statuettes of this kind functioned as lasting acts in place of the ephemeral sacrifices made in the goddess's honor.

37

Statuette of a dove (p. 60)
Italic, Etruscan, said to have been found at
Cerveteri
Hellenistic period, late 3rd–2nd century B.C.
Terracotta
L. 24.1 cm (9½ in.)
Everett Fund 88.363

Terracotta doves acted as substitutes for the real
doves that were sacrificed in Aphrodite's honor.
This dove was discovered along with hundreds of
other terracotta statues in a votive deposit in
Cerveteri, the ancient Etruscan city of Caere.

38

Gem with a dove (p. 60)
Greek, made in East Greece
Late Classical period, early 4th century B.C.
Rock crystal, scaraboid intaglio
L. 2.3 cm (15/16 in.)
Henry Lillie Pierce Fund 98.723

This rock-crystal scarab features a dove flying to
the right, encircled by a cabled border; the
reverse is carved in the shape of a beetle. The
large size of the scarab suggests that it may have
been worn as a pendant, perhaps by a devotee of
Aphrodite. Although scarabs were popular in the
Archaic period, they became less common in the
Late Classical period.

39

Tetradrachm of Eryx with a victorious chariot (obverse, not
illustrated) and Aphrodite seated with Eros (reverse) (p. 57)
Greek
Classical period, about 410–400 B.C.
Silver
Diam. 24 mm (15/16 in.)
Henry Lillie Pierce Fund 04.442a

The ancient Sicilian city of Eryx possessed one of
the wealthiest and most celebrated sanctuaries of
Aphrodite in the Mediterranean, known as that of
Aphrodite Erycina. Although Eryx was not itself a
Greek city, it was heavily influenced by the Greek
cities with which it regularly interacted. This tetra-
drachm features Aphrodite seated with her son
Eros and may depict her cult statue. She holds a
large dove or a pigeon, which recalls Aelian's
report in his Historical Miscellany (1.15) that pigeons
were said to accompany the goddess on her year-
ly migration from Eryx to Libya.

APHRODITE AND LOVE, MARRIAGE, AND FEMALE BEAUTIFICATION

Aphrodite's Husbands and Lovers

40

Cup with Mars and Venus (p. 64)
Roman, from the House of the Menander,
Pompeii
Late Republican or Early Imperial period, second
half of the 1st century B.C.
Gilt silver
H. 12.5 cm (4 15/16 in.), diam. 10 cm (3 15/16 in.)
Naples, Museo Archeologico Nazionale 145515
Ministero per i Beni e le Attività Culturali / Soprintendenza
Speciale per i Beni Archeologici di Napoli e Pompei
Photograph © Luciano Pedicini / Archivio dell'Arte

This richly embellished drinking cup is one of a
pair representing the union of Venus and Mars
discovered in the House of the Menander, one
of the grandest and most important houses in
Pompeii and home to one of the finest Roman
silver hoards ever discovered: jewelry, coins, and
a 118-piece silver service used for sumptuous
banquets and display.

The cup was probably intended to be viewed
side by side with its twin (Naples, Museo Archeo-
logico Nazionale, inv. no. 145516) and together
the four scenes (two on each cup) narrate an
intimate encounter between Mars and Venus. On
both sides of this cup, Mars reclines on a sump-
tuous couch (kline) and gazes at Venus. On one
side, the goddess is seated on the couch with her
back to Mars and her legs over the side, wearing
nothing but a mantle draped over her right arm
and a bracelet on her left. Eros is seated to the left
and holds a large nuptial vessel. On the other side,
Venus, seated and fully dressed, draws her dress
up to reveal her legs. Eros stands to the right of
Mars and raises a sword and in the other hand
holds a perfume flask.

41

Plaque with a bust of Ares (p. 87)
Roman, said to have been found in southwestern
Turkey
Imperial period, A.D. 25 or 135
Silver
Diam. 12 cm (4 11/16 in.)
Theodora Wilbour Fund in memory of Zoë
Wilbour 58.352

This rare silver votive plaque with the bust of
Ares was found, along with a silver plaque with
the bust of Zeus and fragments of a gilded bronze
diadem, in southwestern Turkey, where Ares had a
prominent oracular cult from the early Archaic
period to late antiquity. The plaque was most

likely attached to a loose chain that, with the
other items, adorned the robe of the priest of the
cult of Ares or that of the cult statue of the god.
The dedication and maintenance of the plaque by
several priests over seventy years is recorded in
partially preserved inscriptions around the bust of
Ares. Ares is depicted wearing a helmet and
corselet and holding a spear.

42

Oil flask (squat lekythos) with Aphrodite and Anchises
(p. 65)
Greek, made in Athens
Classical period, about 410–400 B.C.
Ceramic, red-figure technique
H. 13.3 cm (5¼ in.)
Anonymous gift 95.1403

On this lekythos, a seated woman, breast exposed,
looks back to a youth who is accompanied by
Eros. The young man's Phrygian costume invites a
specific identification. Some have named the pair
as Aphrodite with one of her beloveds—Anchises
or Adonis; others believe the couple to be Helen
and Paris.

43

Mirror with Aphrodite and Adonis (p. 77)
Etruscan
Late Classical or Early Hellenistic period,
400–350 B.C.
Bronze
H. 19 cm (7 7/16 in.)
Gift of Horace L. Mayer 61.1258

Mirrors were first used in Etruria about 540–530
B.C. and depicted Etruscan and Greek mythologi-
cal themes. Engraving was the favored method of
decoration, allowing for a freer line and more
expression than relief technique. This mirror
depicts Aphrodite attempting to hide Adonis in a
lettuce patch, a scene described in Hellenistic
poetry. Of course her attempt was futile, and he
was finally devoured by a boar. Aphrodite and
Adonis were worshipped together at Gravisca, the
port city of Tarquinia, a powerful Etruscan city. It
has been noted that Adonis was viewed as an
ideal love object by elite Etruscan women.

Judgment of Paris

44

Two-handled jar (amphora) depicting the Judgment of Paris
and the recovery of Helen (p. 88)
Greek, made in Athens; attributed to the
Group of Würzburg 199
Late Archaic period, about 510–500 B.C.
Ceramic, black-figure technique
H. 44 cm (17 5/16 in.), diam. 27.7 cm (10 15/16 in.)
Seth Kettell Sweetser Fund 60.790

The two sides of this vase depict the beginning and the end of the story of Helen, Paris, and Menelaos. On one side, Hermes leads the three goddesses (Athena, Hera, and Aphrodite) to be judged by Paris (not shown). On the other, Menelaos and another warrior lead Helen away from Troy. Both scenes occur regularly in extant Athenian black-figure vase painting, but to find them paired together is relatively unusual.

45
Drinking cup (skyphos) parodying the Judgment of Paris (p. 91)
Greek, made in Boiotia
Classical period, about 420 B.C.
Inscriptions: HERA; A (Alexandros)
Ceramic, black-figure technique
H. 20.5 cm (8 1/16 in.), diam. 21.6 cm (8 1/2 in.)
Henry Lillie Pierce Fund 99.533

Kabeiric vases—so called for their association with the sanctuary of the Kabeirioi near Thebes—are often decorated with caricature-like figures and what seem to be humorous scenes. On one side of this skyphos, Hermes stands before Hera (named in an inscription) and Aphrodite, whose breasts are exposed, as they prepare for their beauty contest. On the other side, a rather rustic Paris—identifiable by his Eastern attire, lyre, and the letter A (for Alexandros, as Paris was sometimes known)—is present at a contest between two women seated on rocks who play a hand game of chance known as *morra*. An ancient text cites Helen as the inventor of this game, which was used by women to predict their success in love.

46
Painting of the Judgment of Paris (p. 67)
Roman, from Pompeii (V 2, 15, triclinium I, west wall)
Imperial period, 4th style, A.D. 45–79
Fresco
H. 60.5 cm (23 13/16 in.), w. 58.5 cm (23 1/16 in.), d. 6.5 cm (2 9/16 in.)
Naples, Museo Archeologico Nazionale 119691
Ministero per i Beni e le Attività Culturali / Soprintendenza Speciale per i Beni Archeologici di Napoli e Pompei
Photograph © Luciano Pedicini / Archivio dell'Arte

Depictions of the Trojan War are among the most popular in Pompeian wall painting, and the Judgment of Paris was especially frequently shown. This vividly painted fresco from Pompeii adheres to canonical representations of the myth, in which the judgment takes place on Mount Ida with Paris seated upon a rock before Hera, Aphrodite, Athena, and Hermes. Set against the blue sky, each goddess is easily recognized by her posture, dress, and attributes: Hera carries a scepter, Aphrodite is nude, and Athena is fully armed. The fresco displays an impressive diversity of pigments—Paris's sea-green tunic and yellow Phrygian cap and undergarments, Hera's white tunic with green accents, Aphrodite's violet mantle, and Athena's rose-colored peplos. While Paris looks down pensively, the three goddesses and Hermes look over his head, which may suggest that the painting was originally positioned to the left of a threshold, window, or niche and/or that it functioned as a pendant to another fresco with an unknown but presumably related or complementary subject.

47
Medallion of Tarsus with a bust of Maximinus I (obverse, not illustrated) and the Judgment of Paris (reverse) (p. 66)
Roman Provincial
Imperial period, A.D. 235–38
Bronze
Diam. 40 mm (1 9/16 in.)
Theodora Wilbour Fund in memory of Zoë Wilbour 59.243

As with coins, medallions are made of precious metal and carry images on both sides; however, they are larger than coins and usually have no currency value but are instead purely commemorative. This bronze medallion from Tarsus, a Roman city in southeastern Turkey, depicts the head of Maximinus I, a barbarian emperor who ruled Rome from A.D. 235 to 238. On the reverse is the Judgment of Paris with (from left to right) Athena, Hera, Aphrodite, and Paris. Seated on a rocky outcrop, Paris holds an apple out before the goddesses; Aphrodite is represented as Anadyomene (wringing out her hair), while Hera is enthroned and diademed and Athena is fully armed. Even though these goddesses do not depict statues per se, they quote sculptural types that had become so closely associated with these goddesses in the minds of ancient artists and their audiences that they double in pictorial art as representations of artistic moments or ideas and of the goddesses themselves.

48
Textile depicting the Judgment of Paris (p. 90)
Egyptian
Late Roman or Early Byzantine period, 6th century A.D.
Linen and wool tapestry weave
33 x 30.5 cm (13 x 12 in.)
Gift of Thomas S. Buechner 55.577

Originally one of a pair, this woven linen and wool textile was made in Egypt in the sixth century A.D. and probably decorated the skirt or the shoulders of a woman's tunic. The roundel, which may have been made specifically for export, features the Judgment of Paris, and the choice of subject speaks to the ongoing fascination with Greek culture in the domestic art of late Roman and early Byzantine Egypt. The figures are depicted with their characteristic attributes: (moving clockwise) enthroned and bearded Zeus, winged-foot Hermes, helmeted Athena, cloaked Paris, nude Aphrodite, and crowned Hera. The size and centrality of Zeus may refer to his key role in provoking the Judgment of Paris and the ensuing Trojan War. The large heads and hollowed eyes of the figures and the running wave pattern along the border indicate that the roundel was made in the sixth century.

Helen of Troy

49
Drinking cup (skyphos) representing the departure and the recovery of Helen (p. 68)
Greek, made in Athens; signed and made by Hieron; signed and painted by Makron
Late Archaic period, about 490 B.C.
Ceramic, red-figure technique
Inscriptions: HIERON EPOIESEN (Hieron made [it]); MAKRON EGRAPHSEN (Makron painted it)
H. 21.5 cm (8 7/16 in.), diam. 27.8 cm (10 15/16 in.)
Francis Bartlett Donation of 1912 13.186

This drinking cup depicts the departure of Helen with Paris, the catalyst for the Trojan War, and Menelaos's recovery of his wife after the fall of Troy. On one side, Paris grasps Helen by the wrist, in a gesture of marriage, as Aphrodite fixes the heroine's wedding veil, assisted by Eros (Desire) and Peitho (Persuasion). On the other side, Aphrodite fixes Helen's gaze on Menelaos, who attempts to punish his adulterous wife but is literally disarmed by her beauty. Aphrodite's highlighted presence in both scenes reminds the viewer that it was she who set these events in motion when she offered Helen to Paris in exchange for victory in the Judgment of Paris.

50
Drinking cup (kylix) with Menelaos reclaiming Helen (p. 89)
Greek, made in Athens; attributed to the Elpinikos Painter
Late Archaic period, about 500 B.C.
Ceramic, red-figure technique
Inscription: ELPINIKOS KALOS (Elpinikos is beautiful)
L. 13.9 cm (5 7/16 in.)
Francis Bartlett Donation of 1912 and Gift of the Archaeological Institute, University of Leipzig 13.190

Menelaos's recovery of Helen is rendered here in a fashion that combines two separate moments, a manner typical for Athenian vase painting. Menelaos brandishes his sword at his wife—indicating his wrath on finally finding her at Troy—but at the same time is shown grasping his wife's wrist. The gesture is also seen in marriage scenes and points to her return to her rightful husband.

Nuptial Imagery

51
Bathing vessel (loutrophoros) with a bridal procession (pp. 70–71)
Greek, made in Athens
Classical period, about 450–425 B.C.
Ceramic, red-figure technique
H. 75.3 cm (29¹¹⁄₁₆ in.)
Francis Bartlett Donation of 1900 03.802

Loutrophoroi are often decorated with wedding scenes and were used in such contexts. Here a young man grasps his wife's wrist and leads her to her new home. His mother awaits them at the door of the marriage chamber with torches—this phase of the wedding ceremony took place at night—and a tiny Eros appears to beckon them inside. The bride's beauty is indicated by the fluttering pair of erotes who tend to her crown, while her attendant (the *nympheutria*) adjusts her veil. On the other side, a young man shakes the hand of an elder man: this is the pledge of betrothal (*engye*) between the bride's father and the groom. The neck of the vase features two women: one holds a wreath and a loutrophoros hydria, and the other carries a torch and a wicker basker on her head.

52
Oil bottle (lekythos) in the form of an acorn with a scene of bridal preparations (p. 75)
Greek, made in Athens; attributed to the Manner of the Meidias Painter
Classical period, about 410–400 B.C.
Ceramic, red-figure technique
H. 15.3 cm (6¹⁄₁₆ in.)
Anonymous gift 95.1402

Rendered prominently on this oil jar with both white skin and a white peplos, a bride dresses herself. She is attended by a crouching Eros who fastens her sandal. Another woman presents her with her crown (the *stephane*), while a second looks on, fingering her necklace. The lower part of the vase is molded in the form of an acorn with gilding. The lekythos is said to have been found in the same grave as another lekythos that also depicts Eros (cat. no. 42), along with two gold pins.

53
Oil bottle (squat lekythos) with Eros, a man, and a woman (p. 74)
Greek, made in Athens; attributed to the Meidias Painter
Classical period, about 410–400 B.C.
Ceramic, red-figure technique with gilt relief
H. 11.7 cm (4⅝ in.)
Henry Lillie Pierce Fund 00.353

In the late fifth century B.C, certain Athenian red-figure vase painters made extensive use of added color and gilding. Such luxurious treatment befitted perfume vessels for personal adornment. On this oil bottle, Eros, his wings once gilded, selects an item from a tray probably filled with fruits (see cat. no. 56), held by the woman; a seated nude male, perhaps the future bridegroom, looks on.

54
Two-handled jar (amphora) with Hippodameia preparing for her wedding (p. 75)
Greek, made in Athens; attributed to the Kadmos Painter
Classical period, about 425 B.C.
Ceramic, red-figure technique
Inscriptions: HIPPODAME; ASTERIA; EROS; POTHOS; EURYNOE; IASO
H. 50 cm (19¹¹⁄₁₆ in.)
Francis Bartlett Donation of 1900 03.821

A woman sits with her bridal crown sit in an outdoor setting, accompanied by Eros. The inscription "Hippodame" suggests that she is Hippodamia, wife of Pelops, one of the most renowned mythical brides. Among the women who accompany her is Euryonoe (Broad of Thought) whose sandal is bound by a second winged figure named Pothos (Desire). The theme of desire is continued on the other side, where an unnamed male pursues a female.

55
Perfume flask (alabastron) depicting Menelaos and Helen as bride and groom (p. 74)
Greek, made in Apulia; attributed to the V. and A. Group
Late Classical period, about 350 B.C.
Ceramic, red-figure technique
Inscriptions: MENELAOS; HELENA
H. 28.2 cm (11¹⁄₁₆ in.)
Henry Lillie Pierce Fund 00.360

Identified by inscriptions, a nude Menelaos is crowned with a wreath by Eros as he gestures toward his richly attired bride, Helen. The conjugal atmosphere is underscored by the woman at the left, playing a harp. Given Menelaos's beardless appearance, he is to be thought of as young, and thus the scene shows the early and celebratory stage of the marriage.

56
Two-handled jar (amphoriskos) with Eros and a woman (p. 94)
Greek, made in Athens; attributed to the Eretria Painter
Classical period, about 425 B.C.
Ceramic, red-figure technique
Inscription: EROS
H. 19 cm (7⁷⁄₁₆ in.)
Henry Lillie Pierce Fund 00.355

A woman ties a ribbon around her head while Eros looks on from the other side, holding a box. The four white spheres on the box are difficult to identify—perhaps fruit such as quince or apples, which Plutarch in his *Moralia* (183 d) notes were eaten by women before entering the wedding chamber. The scene is apposite for the vessel, for amphoriskoi such as these were used for precious perfumes and ointments.

57
Marriage bowl (lebes gamikos) with prenuptial scene (p. 95)
Greek, made in Euboia (probably Chalkis)
Classical period, late 5th or early 4th century B.C.
Ceramic, red-figure technique
H. 24.6 cm (9¹¹⁄₁₆ in.)
Anonymous gift 93.107a–b

Vases of this shape are closely associated with marriage. They are regularly depicted in scenes that show wedding preparations, and they are typically decorated with such scenes themselves. Here the women are interspersed with erotes and Nikai under the handles, indicating the celebratory atmosphere. With her downcast glance and pensive gesture, the bride here recalls representations of Helen as a bride from the third quarter of the fifth century.

58
Jar (pelike) with amorous scenes (p. 93)
Greek, made in Apulia (South Italy); attributed to the Circle of the Darius Painter (Egnazia Group)
Late Classical period, about 340–320 B.C.
Ceramic, red-figure technique
H. 43.2 cm (17 in.)
Gift of Mrs. S. V. R. Thayer 10.234

A young woman holding a mirror and a ball of wool looks towards the youth seated beside her. The pair is flanked on either side by a woman presenting a wreath and another presenting a gift of an oil jar (alabastron). A bird flies toward the seated female clutching a white ribbon in its feet. Eros overlooks the whole scene; although nude, he is richly adorned with a fillet, necklace, earrings, and anklets. The grouping suggests a bride and groom about to wed.

Bathing

The poet of the *Homeric Hymn to Aphrodite* sang of Aphrodite's bath at Paphos, but only centuries later did the sculptor Praxiteles give visual expression to her customary habit. By the Archaic period, purification through bathing had become an important feature of Greek cult, and individuals undertook ritual baths before initiations into mystery cults and wedding ceremonies. Prenuptial bathing was observed by both brides and grooms but was especially crucial for brides as they prepared for their first sexual encounter. Bridal attendants drew water from a sacred spring and carried it in vessels known as loutrophoroi to the bride's parents' home the night before the wedding. In the Hellenistic and Roman periods, bathing became more public and social. Large-scale bath-gymnasium complexes were key civic monuments and often were generously donated by local elites, such as Lollia Antiochis of Assos.

59

Painting of the Three Graces (p. 73)
Roman, from Pompeii, Regio IV?, Insula Occidentalis (VI, 17, west 31?)
Imperial period, 3rd style,
1st century B.C.–1st century A.D.
Fresco
H. 53 cm (20⅞ in.), w. 47 cm (18½ in.)
Naples, Museo Archeologico Nazionale 9231
Ministero per i Beni e le Attività Culturali / Soprintendenza Speciale per i Beni Archeologici di Napoli e Pompei
Photograph © Luciano Pedicini / Archivio dell'Arte

The Three Graces (Charites), Euphrosyne, Aglaia, and Thalia, daughters of Zeus and Eurynome, had a special relationship with Aphrodite and are often referred to as her handmaidens. The *Homeric Hymn* tells that when the goddess arrived at her sanctuary in Paphos, the Graces washed and anointed her in preparation for her seduction of Anchises (58–66). The Three Graces are depicted nude, in an interlocking horizontal embrace, with the central figure turning her back to the viewer. This iconography, with approximately 140 examples in Roman art, emphasizes the beauty and sensuality of the Graces and probably derives from a Hellenistic sculpture itself influenced by Praxiteles's Knidia and its followers. Although Pausanias himself did not know the author of such a work, he hints at its transformative significance by remarking that that in earlier times the Three Graces were represented draped (9, 35, 6). A very close parallel noted for its richly articulated landscape setting was also found in Pompeii (Naples, Museo Archeologico Nazionale, inv. no. 9236).

60

Mirror with women bathing before a statue of Aphrodite on a pillar (p. 98)
Roman, Eastern Mediterranean
Imperial period, A.D. 110–17
Silvered and gilt bronze
Diam. 13 cm (5⅛ in.)
Museum purchase with funds donated by Dr. Ernest and Virginia Lewisohn Kahn 1978.158

This gilt bronze mirror with a bathing scene belongs to a group made during the Hadrianic period, probably in Asia Minor. In the foreground, two women stand beside a wash basin (louterion); the woman on the left reaches down to pick up a water jar (kalpis) by its strap while the woman on the right pours what is probably perfumed oil from a vessel into the basin. Behind them stands a pillar with a small statue of Aphrodite Anadyomene (wringing out her hair). Here, the explicit visual parallel between the bathing women and their divine patron bather, together with the elegant poses of the bathing women, which themselves evoke Hellenistic statues of Aphrodite, demonstrates that ancient women sought to emulate the goddess.

61

Inscription commemorating Lollia Antiochis's dedication of a bath to Aphrodite (pp. 160–61)
Greek, East Greek
Roman Imperial period, before 2 B.C.
Marble
H. 58.5 cm (23¹¹⁄₁₆ in.), l. 94 cm (37 in.), d. 12.9 cm (5¹⁄₁₆ in.)
Gift of the Archaeological Institute of America 84.58a–f

This monumental marble inscription, dedicated by a woman, Lollia Antiochis, before 2 B.C., was discovered at the ancient city of Assos, in present-day Turkey. It reads "Lollia Antiochis, the wife of Quintus Lollius Philetairos, cultic queen according to ancestral customs, and first among women, dedicated the bath and its annexes to Aphrodite, Iulia and the people." The inscription thus publicized and memorialized the identity of the patroness and demonstrated the intimate connection between Aphrodite and ancient bathing customs.

Discovered during excavations carried out by the Archaeological Institute of America in 1881 and 1882, the inscription was found in six pieces in the street between a market building (probably Hellenistic) that ran along the south flank of the Agora and the Roman baths. The findspot would seem to suggest that the inscription was set into the wall facing the street and was encountered as one entered the bath from the Agora. Another

larger but heavily restored epistyle inscription was also found inside the baths and probably surmounted a colonnade in a large room. What remains of the text seems to expand on the wording of the Lollia Antiochis inscription.

Perfume and Cosmetics

The *Homeric Hymn to Aphrodite* tells how Aphrodite bathed and anointed herself with perfumed oils before she prepared to seduce Anchises, and other literary sources attest that her worshippers honored her with offerings of balms and frankincense in her sanctuaries. Greek, Etruscan, and Roman women hoping to seduce their husbands and lovers also indulged in the luxury of wearing perfume, which became an important commodity in Mediterranean trade throughout antiquity. The bronze, marble, and ceramic perfume containers used by ancient women in their daily lives thus very often carry images of Aphrodite and Eros. Ancient women also applied cosmetics to enhance their natural beauty. The discovery of a multitude of cosmetic implements such as brushes and pencils and jars and compacts, some preserving traces of pigments, attests to their frequent use in antiquity.

62

Perfume flask (alabastron) with siren (p. 105)
Greek, made in Corinth
Early Archaic period, 620–590 B.C.
Ceramic, black-figure technique
H. 8.9 cm (3½ in.)
Everett Fund 91.211

Vessels such as this, with a constricted neck and flat mouth to assist in careful dispensing, were typically used as containers for precious perfumed ointments. The siren, a hybrid creature who in Greek mythology seduces men, is a fitting image for a receptacle of perfume.

63

Covered unguent bowl with tall foot (exaleiptron) (p. 104)
Greek
Classical period, 450–425 B.C.
Marble, possibly from Paros, Greece
H. 19.7 cm (7¾ in.), diam. 16.2 cm (6⅜ in.)
Gift of Henry P. Kidder 81.355a–c

This tall stemmed perfume vessel, originally painted, is one of very few marble exaleiptra that survive. Taking their name from the Greek meaning "to anoint" and associated exclusively with the world of women, these perfume jars are often carried by women on white-ground lekythoi, oil bottles that were used to pour libations at the grave (e.g., MFA 00.359, not illustrated). The

turned-in rims of these vessels were designed to prevent their contents from spilling out. Made of a less-expensive material, ceramic exaleiptra are found in greater numbers than their marble counterparts.

64

Perfume jar (balsamarium) in the shape of Aphrodite/Turan (pp. 78–79)
Etruscan
Hellenistic period, late 3rd or
early 2nd century B.C.
Bronze with inlaid glass (?) eyes
H. 10.5 cm (4⅛ in.)
Henry Lillie Pierce Fund 98.682

This bronze Etruscan perfume jar (balsamarium) in the shape of a female head was discovered in a tomb on the road between Ferentinum and Bomarzo in central Italy. Two additional bronze vessels were found in the tomb: a small amphora with spiral handles and a pear-shaped vase with a cover. Perfume jars in the shape of female heads were popular items in the toilettes of elite Etruscan women from about 300 to 125 B.C. Many of these jars have evidence of round attachments from which they were hung. This elegant example has softly modeled facial features and inlaid eyes, and wears a diadem crowned by a pair of doves, drop earrings, and a necklace. These female heads are usually interpreted as representations of Turan, the Etruscan equivalent of Aphrodite, or Lassae, winged spirits that assisted mortal women and goddess in their beauty routines. In this case, the pair of doves suggests that she is Aphrodite/Turan.

65

Mosaic panel (emblema) with cupids gathering roses in a garden (pp. 80–81)
Roman, said to have been found at Sousse, Tunisia
Imperial period, 2nd–3rd century A.D.
Limestone and glass tesserae on terracotta tray
H. 48.5 cm (19⅟₁₆ in.), w. 61.1 cm (24⅟₁₆ in.), d. 12.3 cm (4 13/16 in.)
Museum purchase with funds donated by Jeffrey and Pamela Dippel Choney 2003.340

This mosaic is a portable panel that was once inserted either into a floor or wall of a Roman house. Originally there were three registers (of which two remain) depicting winged cupids harvesting roses and making them into garlands. At the top, three cupids gather roses in the garden bordered by a wooden fence and place them in wicker baskets. In the middle register, five cupids are stringing roses for garlands. At the center, a garland maker sits on a basket of roses and works at a table covered with roses. He is assisted by a

cupid who wears a rose pomander hanging from a ribbon around his left wrist. At the left, a cupid holds a long pole from which are suspended four garlands—he may be about to set out to sell them.

Rose garlands were placed on Roman dining tables for their sweet scent and were worn around the neck for religious festivals and sacrifices. Romans celebrated the rose harvest with the spring festival of the Rosalia. The harvest of roses was an important Roman industry related to the production of perfume; Roman Tunisia, the purported origin of this mosaic, was famous for its rose industry. The close association of Venus with sweet smells and perfumed unguents was widely understood by Romans. According to Ovid (*Fasti* 4.135–138), Roman brides and matrons brought fresh roses to cult statues of Venus. In Greek times, the association of Aphrodite with the rose can be traced back to Homer and the Archaic poets.

66

Gem with cupids making perfume (p. 103)
Roman
Imperial period, 1st century A.D.
Glass, intaglio
L. 3.6 cm (1⁷⁄₁₆ in.)
Henry Lillie Pierce Fund 98.746

This glass gem is carved with six winged cupids enacting the various stages of perfume production. At the top, two cupids raise their mallets to hammer wedges for the oil press (a so-called wedge press) designed explicitly for extracting fine oils needed in the production of perfumes. The oil pours out of the press into a large bowl. In the middle register, two other cupids are off to the side pounding flowers in a mortar. At the bottom, a seated cupid stirs a large cauldron, while another crouches beside a cauldron heating on a brazier. To the right, a large herm overlooks the scene and suggests it is taking place outdoors. The details of these scenes follow closely those of several wall paintings from Pompeian houses. The specific depiction of a wedge press, so far only attested in Campania, suggests a connection to this region, where Capua was the center of the perfume industry. Fittingly, the children of Venus work on making perfumed oils for Roman ladies.

67

Round box (pyxis) with two cupids fishing (p. 102)
Roman
Imperial period, 1st century A.D.
Bone
H. 4.5 cm (1¾ in.)
Bequest of Dora Pintner and Gift of Visitors to the Department of Classical Art 1981.86a–b

68

Round box (pyxis) with two cupids and a butterfly (p. 102)
Roman
Imperial period, 1st century A.D.
Bone
H. 5 cm (1¹⁵⁄₁₆ in.)
Bequest of Dora Pintner and Gift of Visitors to the Department of Classical Art 1981.87a–b

These two cylindrical pyxides made of bone belong to a type known from Egypt, Pompeii, and Herculaneum. The boxes found in Pompeian houses still bear traces of pigments that attest to their daily use as cosmetic jars. Typically these boxes are carved with erotes at play. In one example, a pair of erotes are depicted fishing, and in the other, a pair chase a butterfly, which may represent Psyche.

Jewelry

The many items of ancient jewelry that have survived, and the many representations of Greek, Roman, and Etruscan women bedecked with earrings, necklaces, finger rings, and bracelets, demonstrate that objects of personal adornment functioned as symbols of status and tools of seduction in the ancient world. Pieces of jewelry were offered as gifts to the gods and often adorned cult statues of goddesses, but they are usually found in tombs, where they were buried with deceased women, who wore them in life or received them as grave gifts. Aphrodite, her sacred bird the dove, and Eros are often portrayed on items of personal adornment, particularly earrings, gems, and finger rings, many of which were exchanged as lovers' gifts.

69

Pair of earrings with a pendant Eros (p. 96)
Greek
Early Hellenistic period, 3rd century B.C.
Gold
L. 5.2 cm (2⅟₁₆ in.)
Anonymous gift 90.177, 90.178

Each earring of this pair features a winged Eros hanging from a circular disk with a twelve-petal rosette design. In both, Eros has his left hand raised and holds a phiale (a shallow dish for wine used in religious ceremonies) in his right hand. Along with other flying figures such as Nike and Ganymede, Eros was a popular subject in Greek jewelry from the late fourth century B.C. through the Hellenistic period. Such fine gold earrings are usually found in the graves of elite women, and parallels of this type are known from royal tombs at Pella and at Kato Paphos in Cyprus. Eros was a fitting subject for objects of

adornment for women, and the presence of a phiale may suggest a connection with the celebration of a rite of passage such as marriage or death.

70
Pair of earrings with a dove standing on an altar (p. 96)
Greek
Hellenistic period, 150–100 B.C.
Gold, garnet, glass paste
L. 5.2 cm (2 1/16 in.)
Harriet Otis Cruft Fund 68.5a, 68.5b

This pair of elegant gold earrings in the shape of a dove standing on an altar probably refers to the cult of Aphrodite. Made of gold, and embellished with garnet, glass-paste accents, and gold granulation, this exquisite example of Hellenistic jewelry must have belonged to an elite woman, perhaps a priestess of Aphrodite, or may have even adorned a bronze or marble statuette of the goddess used for worship. The top of the earring is decorated with an Egyptian-inspired Isis crown that features a sun disk and two feathers. Isis crowns became a popular decorative motif in Greek earrings in the middle of the second century B.C. The connection between Isis and Aphrodite was probably not lost on the wearer or the viewer.

71
Ring with seated woman (probably Aphrodite) crowned by two erotes (p. 96)
Greek
Late Classical period, about 350 B.C.
Silver
L. of bezel 2.1 cm (13/16 in.)
Museum purchase with funds donated by contribution 01.8183

This silver ring features a flat, oval bezel engraved with a seated woman, probably Aphrodite, attended by two erotes. She holds a wreath in her right hand, and the erotes crown her with leafy fronds. This type of flat bezel is a development of the Classical period, and parallels for this ring are known from ancient western Greece (present-day South Italy).

72
Ring with Aphrodite taking up arms (p. 86)
Greek, said to have been found in the Tomb of the Erotes, Eretria, Euboia; signed by Gelon
Hellenistic period, about 200 B.C.
Gold with garnet intaglio
L. 2.9 cm (1 1/8 in.), w. 2.4 cm (15/16 in.)
Francis Bartlett Donation of 1912 21.1213

This gold ring with a garnet intaglio features Aphrodite arming herself with the shield and

lance of her lover, Ares—a scene portrayed in book five of Homer's *Iliad*. Here, the goddess is depicted in three-quarter view from the back, as she struggles to keep at least her lower half draped. This is one of few ancient gems to preserve the signature of the gem cutter, Gelon, which is inscribed to the right of the figure. It was discovered, along with a painted terracotta statuette of Aphrodite or a Muse (cat. no. 136) and many small figurines of winged erotes in a tomb in Eretria, Greece. *Chaire*, the Greek word for "farewell," is scratched inside the setting of the ring and preserves the human dimension of this grave offering.

73
Ring with Aphrodite and Eros (p. 96)
Greek; signed by Protarchos
Hellenistic period, 2nd century B.C.
Sardonyx cameo
Inscription: PROTARXOS EPOIEI (Protarchos made it)
H. 2.1 cm (13/16 in.), w. 1.6 cm (5/8 in.)
Francis Bartlett Donation of 1912 27.750

This sardonyx cameo, set in a modern gold ring, depicts Aphrodite and Eros. The goddess stands on a thin ground line beside a tree stump and turns to look at Eros fluttering over her left shoulder. Aphrodite's stance and drapery—a thin, gauzelike chiton that slips off her right shoulder to reveal her breast—may have been inspired by a fourth-century-B.C. sculpture. An inscription beneath Eros identifies the gem carver and the style of the letters suggests a date in the second century B.C.

Mirrors

Mirrors were first used in Greece in the beginning of the sixth century B.C. and adhere to three types: the grip mirror, the stand mirror, and the covered mirror (sometimes called a box mirror). The grip and stand types were both popular from the early sixth into the fifth century B.C.; the grip type continued to be popular into the fourth century B.C., although the stand type was abandoned after the fifth century B.C. The covered type was first used in the fifth century B.C. and became the mirror of choice in the Hellenistic period. Major centers for the production of mirrors in Greece were Corinth, Argos, Sikyon, Sparta, Athens, Aegina, Rhodes, Samos, and Locri (South Italy).

A large percentage of ancient mirrors feature representations of Aphrodite and Eros, and recently scholars have emphasized the associative value of these images. Seeing her reflection above or opposite an image of Aphrodite, a woman in antiquity

might have felt her own beauty enhanced by association with the goddess. Similarly, the presence of Eros might have encouraged her sense of her desirability.

74
Mirror and stand in the form of a female figure (possibly Aphrodite) holding a dove (p. 97)
Greek, made in Corinth or possibly Sikyon
Early Classical period, about 460 B.C.
Bronze
H. 45 cm (17 11/16 in.)
Henry Lillie Pierce Fund 98.667

Made in Corinth or possibly Sikyon, this elaborate stand mirror belongs to a special type known as a caryatid mirror, of which there are more than one hundred examples from the beginning of the sixth to the middle of the fifth century B.C. A young female figure wears a Doric peplos and holds a dove in her right hand as she picks up her skirt with her left. She is flanked by fluttering, winged erotes, who dangle like charms from the mirror above. Around the edge of the disk, two foxes chase two hares, one of which is missing. The identity of the young female caryatids that are the primary feature of this type of mirror is a matter of debate. While most interpret them as Aphrodite, others favor Helen, and some interpret them as mortal devotees of the goddess.

75
Mirror cover and handle with Aphrodite and satyr (p. 85)
Greek
Early Hellenistic period, about 320 B.C.
Bronze
Diam. 20.3 cm (8 in.)
Museum purchase with funds donated by contribution 01.7494b, 01.7494c

This early Hellenistic bronze mirror cover depicts an encounter between Aphrodite and a bearded satyr whose facial features show the influence of Hellenistic portraiture, in this case a philosopher type, which is characteristic of luxury arts of the period. The satyr sits on a rock with a panther skin beneath him and reaches his left hand out toward Aphrodite. Leaning on a pillar, the goddess offers a stick to a goose, one of her traditional accompanying animals (see cat. nos. 20–21). Her son Eros flies close to her as if in conversation.

76
Oil bottle (lekythos) with a woman looking in a handheld mirror (p. 92)
Greek, Lucanian (South Italy); attributed to the Primato Painter

Late Classical period, about 350–340 B.C.
Ceramic, red-figure technique with added white and yellow
H. 36 cm (14 3/16 in.)
Gift of Edward Austin 76.455

This lekythos from South Italy depicts a woman, perhaps a bride, seated amid flowering plants looking at a mirror that she holds in her left hand. She is richly adorned in a chiton and himation and wears bracelets, a necklace, and earrings. Eros flies toward her with a white ribbon, a prize for her beauty.

77
Imitation mirror cover with Aphrodite, Peitho, Eros, and a bride (p. 84)
Greek, said to be from Corinth
Hellenistic period, about 300–250 B.C.
Terracotta
Diam. 19.8 cm (7 13/16 in.)
Henry Lillie Pierce Fund 99.821

More than a dozen terracotta imitations of bronze mirror covers date from the late fourth century through the third century B.C. Of these, six examples, including this one, show Aphrodite with a small female figure, a bride, in her lap, attended by Peitho (Persuasion) and Eros (Desire). While this scene is not found on bronze mirrors of this period, depictions of a young bride in the lap of Aphrodite, or of a member of her bridal party, are found in Athenian vase painting of the second half of the fifth century B.C.

Although there is no conclusive proof of the context or function of these mirror imitations, in all likelihood they served as grave goods for women, which typically focus on nuptial imagery including items from the female toilette. This example bears traces of fiber on its surface, indicating that it was wrapped in cloth before it was buried.

78
Figurine of Eros holding a box mirror (p. 101)
Greek, said to be from Myrina (Asia Minor)
Hellenistic period, 2nd century B.C.
Terracotta
H. 13.4 cm (5 5/16 in.)
Museum purchase with funds donated by contribution 01.7681

Depictions of Eros at his mother's toilette became popular in fifth-century-B.C. Athenian vase painting; the tradition continued into the Hellenistic period, as evidenced by the popularity of the subject in terracotta statuettes from Myrina. By holding up a box mirror to Aphrodite for her contemplation, Eros validates his mother's beauty.

Located between Pergamon and Smyrna, Myrina (Asia Minor) became a major center for the manufacture of terracotta figurines and statuettes from the 3rd century B.C. to the early second century A.D., after coroplasts from Athens and Tanagra (Boiotia) are believed to have settled there. French excavators in the five thousand tombs of the Hellenistic cemetary of Myrina unearthed two thousand figurines and statuettes between 1880 and 1883. Of these, Aphrodite and Eros are the most popular subjects.

79
Mirror with three cupids with garlands and fruits (p. 99)
Roman, Eastern Mediterranean
Imperial period, about A.D. 200
Gilded bronze
Diam. 8.9 cm (3 1/2 in.)
Gift of Esther D. Anderson, Nancy A. Claflin, Suzanne R. Dworsky, and Josephine L. Murray 1988.232

The inclusion of Eros in the sphere of the female toilette underlines the purpose of female beautification. Here, three youthful cupids dance below a garland; the one on the left carries a thyrsus and a wine pitcher (oinochoe), while the one in the center props up his companion, who displays a wreath. They seem to be celebrating in the sphere of Dionysos. They are reminiscent of similar cupids found on Roman sarcophagi of the same date.

EROS, CHILD OF APHRODITE

80
Statuette of Aphrodite with child Eros on her knee (p. 109)
Greek, East Greek, made in Myrina (Asia Minor)
Hellenistic period, late 1st century B.C.
Painted terracotta
H. 24.1 cm (9 1/2 in.)
Museum purchase with funds donated by contribution 01.7722

The image of Aphrodite holding Eros on her lap dates back to the Kourotrophos (nursing mother) type in the terracotta figurines of Cyprus (see cat. no. 13). Here, a seated Aphrodite holds a double cornucopia, a symbol of abundance created as an attribute in the third century B.C. for Arsinoë II, a Ptolemaic queen, and commonly associated in Greek art with Tyche (Fortune), an important goddess in the Hellenistic period. The overlay of this symbol of prosperity on an image of motherhood emphasizes Aphrodite's role as a fertility goddess.

Eros and Homoerotic Culture: The Symposium and Athletics

81
Two-handled cup with male couples (p. 110)
Greek, made in Athens or Boiotia
Late Archaic period, about 520 B.C.
Ceramic, black-figure technique
Inscriptions: KALOS (beautiful); KA...
H. 11.4 cm (4 1/2 in.), diam. 13.5 cm (5 5/16 in.)
Gift of Edward Perry and Fiske Warren 08.292

In a bountiful vineyard, a bearded man fondles a young boy's penis. The youth acquiesces to his advances, touching the man's beard on one side of this vessel, and leaping up to embrace him in the similar scene on the other side. The depiction of the *erastes* (lover) and his *eromenos* (beloved) is inscribed *kalos* (beautiful). This relationship is more than simply sexual; within aristocratic society, the mature male served as a role model for the youth.

82
Drinking cup (kylix) depicting an erotic scene with Eros and a youth (p. 111)
Greek, made in Athens; signed by Douris
Late Archaic period, about 490–485 B.C.
Ceramic, red-figure technique
Inscription: DORISEGRAPHSEN: XAIRESTRATOS KALOS (Douris painted it: Chairestratos is beautiful)
H. 7.9 cm (3 1/8 in.), diam. 21 cm (8 1/4 in.)
Catharine Page Perkins Fund 95.31

Formerly interpreted as the beautiful youth Hyakinthos and Zephyros, the god of the West Wind, this kylix depicts Eros hovering above ground level in an erotic embrace with a nude youth. Eros presses himself onto the Athenian youth as he lifts him skyward. This rape scene is more visually violent than others in Greek art, notably the rape of Cassandra by Ajax and Ganymede by Zeus, and is not strictly mythological but rather addresses itself to a living person. A parallel for this scene (MFA 13.94, not illustrated) is also inscribed "Chairestratos is beautiful" and even more graphically depicts Eros penetrating the youth. This cup is said to have been found in Tarquinia and might reflect a particular Etruscan taste.

83
Oil flask (lekythos) with Eros holding a fawn (p. 112)
Greek, made in Athens; attributed to the Pan Painter
Early Classical period, about 470–460 B.C.
Ceramic, red-figure technique
Inscription: KALE

H. 31.4 cm (12⅜ in.)
Henry Lillie Pierce Fund 01.8079

Eros is shown mid-flight, holding a fawn. Vase painters regularly show men wooing youths with gifts of animals. Not only are they signs of affection and desire, an offering with which to persuade the beloved, but they also suggest the beloved's innocence and need to be trained.

84
Gem with child Eros playing with a goose and knucklebones (p. 133)
Greek, East Greek (?), said to be from Asia Minor
Classical period, 410–400 B.C.
Chalcedony, intaglio
L. 2.2 cm (⅞ in.)
Francis Bartlett Donation of 1912 27.700

This blue-gray gem is carved with a seated Eros as he plays with a goose, a pair of knucklebones (*astralagoi*) on the floor in front of him. Greek children used knucklebones, usually of a sheep or a goat, in a variety of games similar to dice or jacks, in which each side of the knucklebone had a different numerical value; the values resulting from different throws were added up to keep score. Eros's childlike and playful nature was an increasingly popular theme in the Classical period.

85
Oil flask (lekythos) with Eros playing a double flute (p. 132)
Greek, made in Athens; attributed to the Providence Painter
Early Classical period, 470–460 B.C.
Ceramic, red-figure technique
H. 33.8 cm (13⁵⁄₁₆ in.)
Henry Lillie Pierce Fund 00.341

Eros is depicted here flying to the right, playing the double flute. The god of love is often shown with musical instruments, connecting him with the world of youths, for music was a key element in education and in the all-male symposium.

86
Ring engraved with Eros playing a double flute (p. 138)
Greek
Hellenistic period, about 360–330 B.C.
Silver
L. of bezel 1.7 cm (¹¹⁄₁₆ in.)
Museum purchase with funds donated by contribution 01.8184

As with the red-figure lekythos (cat. no. 85), this silver ring features Eros playing the double flute.

87
Drinking cup (kylix) with seated Eros holding a scale or a bird trap (p. 133)

Greek, made in Campania (South Italy); compared to the Painter of Zurich 2633
Late Classical period, about 350–325 B.C.
Ceramic, red-figure technique
H. 8.9 cm (3½ in.), diam. 18.9 cm (7⁷⁄₁₆ in.)
Henry Lillie Pierce Fund 01.8118

Eros crouches on a rock, as if ready to act. He holds an unusual object in his left hand, perhaps a bird trap, possibly alluding to a snare for a lover.

88
Oil bottle (lekythos) with Eros carrying a victor's ribbon (p. 134)
Greek, made in Athens; attributed to the Brygos Painter
Late Archaic period, about 490–480 B.C.
Ceramic, red-figure technique
Inscription: KALOS HO PAIS (The boy is beautiful)
H. 21.8 cm (8⁹⁄₁₆ in.)
James Fund and Museum purchase with funds donated by contribution 10.180

Hovering above the ground line, Eros bears a ribbon—often shown offered to victors of Greek games. The inscription "The boy is beautiful" occurs regularly on contemporary Athenian vases but is clearly pertinent here. It could relate directly to the appearance of the youthful love god, or more broadly, to the young men in the social milieu of the gymnasium or the symposium.

89
Oil flask (lekythos) with Eros seated on an altar holding a wreath (p. 134)
Greek, made in Apulia (South Italy)
Late Classical period, about 350 B.C.
Ceramic, Gnathia technique
H. 21.2 cm (8⁵⁄₁₆ in.)
Henry Lillie Pierce Fund 01.8106

Eros sits on an altar, his blonde hair tied in a top-knot. He is nude save for his yellow shoes; his flesh is rendered with pink-brown paint, shaded with lighter strokes. He holds a wreath, an honor for a victor in the games, in his outstretched hand.

90
Gem with Eros (p. 138)
Greek
Late Archaic period, early 5th century B.C.
Sard, intaglio
L. 1.2 cm (⁷⁄₁₆ in.)
Francis Bartlett Donation of 1912 27.680

On this sard intaglio, set in a modern ring, Eros flies to the right holding sprigs or branches and looks over his right shoulder; the reverse is carved in the form of a beetle. By the sixth century B.C.,

Eros was commonly associated with plants and flowers: the Megarian poet Theognis describes Eros bringing spring flowers and seed to earth (vv. 1275–79), and Athenian vase-painting features numerous depictions of Eros carrying flowers and wreaths. This ring is said to have been purchased in Paphos and may originate from Aphrodite's birthplace.

91
Statuette of a flying Eros (p. 135)
Greek, East Greek, made in Myrina (Asia Minor)
Hellenistic period, late 2nd century B.C.
Terracotta
H. 29.1 cm (11⁷⁄₁₆ in.)
Gift of Martin Brimmer 87.374

Three-dimensional images of Eros flying were first created in Myrina in the middle of the third century B.C. and remained popular for centuries. As Athenian vase painting demonstrates (see cat. nos. 83 and 88), Eros had been suspended in mid-air in pictorial art since the early fifth century B.C. This nude example wears a wreath and has a small hole in the back, from which it probably hung. Its arms, now broken, most likely held either a wreath or a ribbon overhead.

92
Drinking cup (kylix) with athletes and judges (p. 136)
Greek, made in Athens; attributed to the Euaion Painter
Early Classical period, about 460 B.C.
Ceramic, red-figure technique
H. 11.7 cm (4⅝ in.), diam. 28.8 cm (11⁵⁄₁₆ in.)
James Fund and Museum purchase with funds donated by contribution 10.181

Crucial to the homosexual relationships between youths and older men in ancient Athens were occasions for leisure, education, and training. Alongside the symposium, where a cup such as this may have been used, the gymnasium served as a primary context for such interaction. Here, bodily beauty and physical prowess could be tested, admired, and celebrated. A white ribbon, here given by the bearded man, probably a judge, was a traditional gift for an admired athlete or handsome youth.

93
Drinking cup (kylix) with Eros riding a horse (p. 137)
Greek, made in Athens; attributed to the Painter of London E 130
Classical period, about 400 B.C.
Ceramic, red-figure technique
H. 9.6 cm (3¹³⁄₁₆ in.)
Francis Bartlett Donation of 1900 03.819

Eros rides a galloping horse in the center of this red-figure drinking cup. The pair is encircled by a meander and check-pattern border, and the lip of the cup is decorated with an ivy wreath. In the context of the symposium—the elite male drinking party—the image of Eros on horseback probably carried a sexual connotation, as horse riding was used as a metaphor for a sexual position in Athenian comedy. The vase is reported to have been found in Campania (South Italy), where this Athenian import must have been used alongside locally made Greek vases.

94

High-handled drinking cup (kantharos) with erotic scenes
(pp. 114–15)
Greek, made in Athens; made and signed by Nikosthenes; painted by the Nikosthenes Painter
Archaic period, about 520–510 B.C.
Ceramic, red-figure technique
Inscriptions: NIKOSTHENES EPOIE[S]EN (Nikosthenes made [it]); nonsense inscriptions
H. 24 cm (9 7/16 in.), diam. 28 cm (11 in.)
Catharine Page Perkins Fund 95.61

Eros and Aphrodite are nowhere to be found on this drinking cup—the focus is on human and physical activity. On one side, aroused youths cavort and try to fondle two nude courtesans (*hetairai*); on the other, we see a full orgy. At the left, a youth takes another from behind, and a woman is likewise penetrated while she performs fellatio for a fourth youth. He brandishes a sandal at her—a popular sexual allusion in Greek art. This vase is said to be from Vulci and may reflect a preference of the Etruscan market.

Eros and Love Riddles

95

Ring with Aphrodite weighing two erotes with a third at her feet (p. 138)
Greek
Classical period, late 5th century B.C.
Gold
L. of bezel 1.8 cm (11/16 in.)
Francis Bartlett Donation of 1912 23.594

This exceptional gold ring depicts Aphrodite weighing two erotes, with a third crouching at her feet. The weighing of love, *erotostasia*, is an uncommon image in ancient art but is found on several gold rings indicating that it was understood as a personal message for the wearer.

96

Gem with Eros firing an arrow at a male youth (p. 138)
Roman, with Greek inscription
Imperial period, 2nd century A.D.
Sard, intaglio

Inscription (in Greek): IEROKLES IASONI (Hierokles and Jason, or Hierokles, son of Jason)
L. 1.4 cm (9/16 in.), w. 1.1 cm (7/16 in.)
Theodora Wilbour Fund in memory of Zoë Wilbour 62.1146

On this sard gem, a winged Eros raises his bow and an arrow to shoot a male figure. The figure adopts a boxing stance, which highlights his powerlessness—even athletic victors cannot escape Eros's arrow. A retrograde Greek inscription, "Hierokles, son of Jason," could refer to either the wearer or the recipient of the gem.

97

Mirror case with Dionysos, Eros, and Pan (p. 139)
Etruscan, found in a tomb near Chiusi
Hellenistic period, 3rd century B.C.
Gold and silver with relief appliqué
Diam. 14.1 cm (5 9/16 in.)
Francis Bartlett Donation of 1912 13.2875a–b

This well-preserved gold and silver mirror case features the wine god Dionysos flanked by Pan and Eros. On the left, a frontal, bearded Pan plays the double pipes. Dionysos, nude except for his boots, wraps his left arm around Eros, who is winged and holds a torch, indicating that the scene takes place at night. The position of the three pairs of feet, with one foot frontal and the other diagonal on its toes, suggests that the threesome is in motion, possibly in a state of revelry. The mirror case was discovered along with other luxury items in a tomb belonging to five female members of an elite Etruscan family, the Velsi.

98

Mirror with erotes and Silenos punishing a nude female
Roman (p. 117)
Imperial period, 1st or 2nd century A.D.
Gilt bronze
Diam. 10.7 cm (4 3/16 in.)
William E. Nickerson Fund 1986.750

This gilt-bronze disk mirror depicts Silenos and three erotes punishing a nude female. Silenos stands in the center, bearded, and raises a whip in his right hand as two winged erotes hold their female victim, possibly Venus, face down on a bed by her wrists and ankles. Her garment is pulled up to her waist, leaving her buttocks exposed. On the right, a third eros records the number of blows on a *titulus*—a practice imitating public punishments. A *pinax* with an image of a winged Victory hangs on the wall above the action. Flagellation scenes such as this one usually take place in schoolrooms, during initiations into mystery cults, and in connection with the Lupercalia, a pastoral festival in which whipping was thought to promote fertility.

Eros and Herakles

99

Statuette of Eros wearing the lion skin of Herakles
(p. 106)
Greek, East Greek, said to be from Myrina (Asia Minor)
Hellenistic period, late 1st century B.C.
Terracotta with traces of pigment
H. 40 cm (15 3/4 in.)
Henry Lillie Pierce Fund 00.321

Eros is depicted as a youthful god wearing the lion skin of Herakles, the mighty hero who achieved immortality through his labors. The unusually large terracotta statuette may have been inspired by a bronze original attributed to the early Hellenistic sculptor Lysippos, depicting Herakles missing his attributes. Such a playful image exemplifies the universal theme *amor vincit omnia*: "love conquers all," even the strongest and most accomplished of heroes.

100

Relief of a sleeping Herakles (p. 118)
Greek
Late Hellenistic period, 2nd or 1st century B.C.
Marble
H. 91.5 cm (36 in.), w. 76.5 cm (30 1/8 in.), d. 14 cm (5 1/2 in.)
Bowdoin College Museum of Art, Brunswick, Maine
Gift of Edward Perry Warren, Esq., Honorary Degree, 1926 1906.2
Photograph courtesy of Bowdoin College Museum of Art

This large marble relief depicts the hero Herakles asleep as four erotes steal his club and drink his wine. The theft of Herakles's attributes was represented in Greek art as early as the Archaic period and was a popular subject in the Hellenistic and early Roman periods. Over the centuries, the identity of the thieves evolved from the Kerkopes (Archaic Athenian vase painting), to satyrs (Classical Athenian vase painting), Pan (fourth-century-B.C. South Italian vase painting), and finally to erotes (Hellenistic reliefs and Roman wall paintings). The fourth-century-B.C. painter Aetion's *Marriage of Alexander and Roxanna* seems to have been the first representation of erotes as thieves (of Alexander's arms) and is believed to have inspired their presence in scenes with Herakles. While Roman wall paintings of this subject tend to depict the hero in his youth, this relief shows him bearded, mature, and vulnerable. Among the parallels for this representation of Herakles is a relief in the Villa Albani (inv. no. 27641).

101

Relief of Herakles and Omphale or possibly a nymph
(p. 120)
Roman
Imperial period, mid- to late 1st century A.D.
Marble, probably from Carrara, Italy
H. 40 cm (15¾ in.), w. 45 cm (17¹¹⁄₁₆ in.)
Gift of Fiske Warren and Edward Perry Warren
RES.08.34d

In this rare, highly polished marble relief, Herakles engages in sexual intercourse with Omphale, or possibly a nymph. The hero is identified by the lionskin on which he rests and the club propped up on a nearby pillar. Omphale, whose head is missing, wears a band below her breasts that is similar to the girdle (*kestos*) Aphrodite famously lent to Hera to seduce Zeus in the *Iliad* (14.190–221). The couple is situated in a rustic, makeshift bedchamber, where they are hidden from view by a large curtain draped over the bough of a tree. Behind the curtain, an Ionic column acts as a pedestal for a vase, and in front, a pillar supports a priapic herm. This relief was probably displayed in a bedchamber; similar images of sexual congress between Herakles and Omphale are found on Roman gems.

Erotic Scenes

102

Fragment of a bowl with Cupid on a pillar between couples making love (p. 121)
Roman
Early Imperial period, late 1st century B.C.
Ceramic, Arretine ware
H. 14 cm (5½ in.)
Gift of Edward Perry Warren 13.109

Arretine ware is a type of Roman red-gloss pottery (terra sigillata) manufactured from the first century B.C. through the third century A.D. in Arretium, present-day Arezzo, about fifty miles southeast of Florence, Italy. The use of molds allowed this pottery to be mass produced, and, as a result, a large industry developed around its production and export across the Roman Empire and beyond its frontiers.

　　This Arretine bowl fragment depicts a heterosexual couple (left) and a homosexual male couple (right) making love. Between the two pairs a statue of Eros stands on a pillar, demonstrating that Desire himself overwhelms the scene.

103

Fragment of a bowl with an erotic scene (p. 121)
Roman
Early Imperial period, 1st century B.C.
Ceramic, Arretine ware

H. 11.7 cm (4⅝ in.)
Gift of Edward Perry Warren RES.08.33e

The male couple preserved on this fragment repeats one of the sexual pairings found on another Arretine bowl (cat. no. 102). However, the ornamental patterns and the figure at the left differ: here, a draped woman stands in place of Eros on a pillar.

104

Fragment of a relief-decorated bowl with an erotic scene (p. 121)
Greek
Hellenistic period, about 200–180 B.C.
Ceramic, mold made with red slip decoration (proto–terra sigillata)
Diam. 10 cm (3¹⁵⁄₁₆ in.)
Gift of Edward Perry Warren RES.08.33h

On the tondo of this cup fragment, a young man, hand on hip, penetrates a woman as she reclines. In contrast to his apparently casual pose, her right leg is raised nearly upright, so that it rests against her lover's left shoulder. Beneath the couch are a pitcher and a basin, suggesting perhaps a banquet or brothel.

105

Mirror cover with Eros and an erotic scene (p. 122)
Greek, found in Corinth
Late Classical or Early Hellenistic period, about 340–320 B.C.
Bronze with silvered bronze
Diam. 17.5 cm (6⅞ in.)
Gift of Edward Perry Warren RES.08.32c.2

This bronze mirror features erotic scenes on both its cover and interior. The cover depicts in relief a pair of heterosexual lovers on an elaborately upholstered couch. The woman turns her head back to kiss her male partner—an unusual scene in ancient art—as he pulls her toward him and penetrates her from behind. Eros flies above the couple, about to crown the man with a victory ribbon (*taenia*). The interior of the mirror is engraved with a pair of lovers in a complicated sexual position known to have been the specialty of a famous Corinthian courtesan, Leania.

106

Gem with an erotic scene (p. 123)
Greek
Late Classical or Early Hellenistic period,
4th century B.C.
Chalcedony, intaglio
L. 2.9 cm (1⅛ in.)
Gift of Edward Perry Warren 23.597

As with the bronze mirror above, this chalcedony gem depicts a man and a woman engaged in sex-

ual intercourse. Decked out with jewelry—earrings, necklace, bracelets, and a diadem—a woman reclines on an elegant, cushioned couch as her lover lifts her legs in the air and penetrates her. Both participants cast their gaze toward the center of the action. The gem, from which a large chip is missing, is pierced on the sides and was probably strung. Erotic images are not common on gems of this period.

107

Relief with an old man and a siren (p. 127)
Roman
Imperial period, 2nd century A.D.
Marble, probably from Mount Hymettos,
near Athens, Greece
H. 40 cm (15¾ in.), w. 39 cm (15⅜ in.)
Gift of Fiske Warren and Edward Perry Warren
RES.08.34c

This damaged marble relief depicts a winged female, identified as a siren by her webbed feet, as she lowers herself onto a sleeping nude man with an erect phallus and pours an unknown liquid from a cup in her left hand. The bald and bearded man lies on a cloak, with his head in his hands and a basket, sack, and staff beside him. In the upper right corner is a herm opposite a small altar and a tree with panpipes hanging from it— all indications of the rustic setting in which this episode takes place. A noted parallel for this scene is found on a plaster circular relief from Begram (National Museum, Afghanistan); a similar scene also appears on a Roman lamp (MFA 1991.1020, not illustrated).

Cupid and Psyche

The love story of Eros and Psyche, as told by the second-century-A.D. Latin writer Apuleius in *The Golden Ass* (4.28–6.24), for which he most likely drew on Hellenistic poetic sources, is a tale of love, jealousy, deceit, vengeance, repentance, and forgiveness. Psyche, a mortal maiden, had become so famous for her beauty that people began to refer to her as a new Venus and neglected the goddess's temples. Jealous and indignant, Venus enlisted her son Cupid to punish Psyche by causing her to fall in love with the most hideous, wretched creature on earth. But Cupid mistakenly pricked himself with his arrow and fell in love with Psyche, whom he invited into his golden house, married, and impregnated—all while concealing his true identity. At the news that her son had married her enemy, Venus flew into a jealous rage and became determined to punish pitiable Psyche with a series of seemingly insurmountable tasks. But Psyche—with a good deal of help—

triumphed, and in the end Jupiter called all the gods together to witness and celebrate in the official marriage of Cupid and Psyche, whose child would be known as Voluptas (Pleasure).

The pair appears together for the first time in the terracotta statuettes of the Hellenistic Greek East, which predate the Latin literary source; in the Roman period, they were represented in a wide variety of media, ranging from marble sculpture and wall painting to personal items such as gems and jewelry, probably exchanged as love gifts. With few exceptions (e.g., cat. no. 112), these images focus on the happy union of Eros and Psyche that comes at the end of the story.

108

Statuette of Eros and Psyche (p. 140)
Greek, East Greek, said to be from Myrina (Asia Minor)
Hellenistic period, 1st century B.C.
Terracotta
H. 32.1 cm (12⅝ in.)
Museum purchase with funds donated by contribution 01.7700

Eros and Psyche, identified here by holes on their backs for wings, were first represented as a pair in terracotta statuettes in the third century B.C. and became more and more affectionate in pose and gesture over time.

109

Painting of Cupid and Psyche (p. 124)
Roman, from the House of Terentius Neonis, Pompeii (VII 2, 6, exedra g, north wall, or tablinium 10, exedra b)
Imperial period, 4th style, A.D. 45–79
Fresco
H. 55.5 cm (21¹³⁄₁₆ in.), w. 41 cm (16⅛ in.), d. 6 cm (2⅜ in.)
Naples, Museo Archeologico Nazionale 9195
Ministero per i Beni e le Attività Culturali / Soprintendenza Speciale per i Beni Archeologici di Napoli e Pompei
Photograph © Luciano Pedicini / Archivio dell'Arte

This vibrant fresco depicts Cupid and Psyche in an affectionate embrace. Cupid is seated on a rock with Psyche splayed across his lap, her rear end exposed to the viewer. A strong wind sends their wings and drapery fluttering in the air and reminds the viewer of the fleeting nature of physical love. The scene is staged on a thick red ground line and framed within a yellow and green aedicule with a violet canopy.

110

Gem with Cupid and Psyche embracing (p. 141)
Roman
Imperial period, 2nd century A.D.

Red jasper, intaglio
L. 1.4 cm (⁹⁄₁₆ in.)
Mary L. Smith Fund 65.3

This red jasper gem depicts Cupid (left) and Psyche (right) embracing, about to exchange a kiss. To the right of Psyche, very faint traces of a butterfly wing are preserved.

111

Pin with Cupid and Psyche (p. 141)
Roman
Imperial period, 2nd or 3rd century A.D.
Silver
L. 9.8 cm (3⅞ in.), w. 2.5 cm (1 in.)
Gift of Jonathan Kagan and Sallie Fried
1991.1035

Like the red jasper gem (cat. no. 110), this slightly worn silver pin features Cupid and Psyche in a lovers' embrace. Both Cupid and Psyche are winged, and her lower half is draped. Roman pins such as this one were worn in the hair and used to fasten drapery.

112

Figurine of kneeling Psyche (p. 140)
Greek, East Greek, said to be from Myrina (Asia Minor)
Hellenistic period, 3rd century B.C.
Terracotta
H. 8.9 cm (3½ in.)
Anonymous gift 06.2369

In contrast to images of Eros and Psyche embracing, this small, unusual figurine of Psyche kneeling with an outstretched hand depicts a specific yet ambiguous moment in the myth of the young lovers. Some believe that this image depicts Psyche begging for mercy, while others suggest that she awaits a reward from Eros for having completed the last of Venus's tasks.

113

Cameo with the wedding of Cupid and Psyche or an initiation rite (Marlborough Gem) (p. 141)
Roman; signed by Tryphon
Late Republican or Early Imperial period, mid- to late 1st century B.C.
Layered onyx cameo
Inscription: TRYPHON EPOIEI (Tryphon made [it])
L. 4.5 cm (1¾ in.), h. 3.7 cm (1⁷⁄₁₆ in.)
Henry Lillie Pierce Fund 99.101

This cameo, known as the Marlborough Gem after the Duke of Marlborough who once owned it, is noted for its unusual representation. A veiled young couple clings to each other as they are led by three erotes—one holds a woven tray of fruit over their heads, another pulls them by a cord as he carries a blazing torch, and the third removes drapery from a stool. These iconographic features

have led to the recent reinterpretation of this scene as an initiation rite rather than the marriage of Cupid and Psyche, as was traditionally thought. The signature of the gem carver, Tryphon, hovers above the figures and may in fact be a later addition.

114

Drinking cup (skyphos) with a man and a woman kissing (pp. 144–45)
Greek, made in Apulia (South Italy); attributed to the Alabastra Group
Late Classical or Early Hellenistic period, about 330–320 B.C.
Ceramic, red-figure technique
H. 9.7 cm (3¹³⁄₁₆ in.), diam. 16 cm (6⁵⁄₁₆ in.)
Mary L. Smith Fund 69.28

A loving couple are about to kiss before an open window on this skyphos. Scenes of such tender, and apparently domestic, intimacy between men and women are unusual in Greek vase painting. On the other side, Eros signals his approval, flying with a wreath in his hand.

115

Round attachment with a man and a woman kissing (p. 144)
Roman, Eastern Mediterranean
Imperial period, 1st century A.D.
Silver with gold leaf
Inscription: O PHILON TI PHILOUSI (The lover to the beloved)
Diam. 5.2 cm (2¹⁄₁₆ in.)
Helen and Alice Coburn Fund 1977.752

This gilded circular relief depicts a man and woman in a passionate embrace and kiss, a rare scene in ancient art. It probably decorated the center of a drinking bowl; similarly shaped reliefs dated to the Hellenistic period feature Dionysos and his consort Ariadne. Beside the couple, a wreath encircles a Greek inscription, "The lover to the beloved." The gender of the nouns indicates that it was a gift from a man to a woman.

The Child Eros

116

Cameo with two erotes making arms (p. 125)
Roman
Imperial period, 1st–3rd century A.D.
Sardonyx
L. 1.7 cm (¹¹⁄₁₆ in.)
Francis Bartlett Donation of 1912 27.751

This sardonyx cameo depicts two winged erotes making arms. One kneels down before an anvil, about to strike a piece of metal with his hammer, while the other stands over him with his hands

behind his back. This imagery is close to scenes found on Pompeian frescoes.

117

Gem with winged youth Eros holding a spear and a shield (p. 125)
Greek; signed by Kallippos
Late Classical period, about 350–300 B.C.
Carnelian, intaglio
Inscription: KALLIPPOS EPOIEI (Kallippos made [it])
L. 2.9 cm (1⅛ in.)
Francis Bartlett Donation of 1912 27.761

This oval carnelian intaglio depicts Eros advancing with a spear and a shield. His hair is pulled back in a bun, a hairstyle he also wears on fourth-century-B.C. coins and vase paintings from Taras in South Italy. The gem is inscribed with the name of the carver, Kallippos, and originally would have been set in a bezel ring similar to the ring with Aphrodite taking up arms (cat. no. 72).

118

Fragment of a season sarcophagus with two winged cupids (p. 143)
Roman
Imperial period, about A.D. 280
Marble
H. 70 cm (27⁹/₁₆ in.), w. 57 cm (22⁷/₁₆ in.), d. 17 cm (6¹¹/₁₆ in.)
Gift of Mrs. Abraham C. Webber in memory of Mr. Abraham C. Webber 58.584

This fragment of a season sarcophagus, a type popular in Rome in the third and fourth centuries, features two winged youths who hold the attributes of their seasons. On the left, Summer holds a basket of flowers, with another basket at his feet, and on the right, Autumn, accompanied by a hunting dog, displays a hare he has just brought back from the hunt. Both figures look up and over to their companions, Winter and Spring, now lost. Undoubtedly, a portrait tondo of the deceased was set between them. The seasons in sepulchral art are usually interpreted as symbolizing the cycle of life, death, and rebirth, and their often-close resemblance to cupids plays on their connection through Venus to the fertility and regeneration of the earth.

119

Statue of sleeping Eros (p. 142)
Roman
Imperial period, 2nd century A.D.
Marble
H. 12 cm (4¾ in.), w. 22 cm (8¹¹/₁₆ in.), l. 57 cm (22⁷/₁₆ in.)
Gift of J. M. Lewis 2009.2522

This marble sculpture depicts Eros sleeping on his left side with his bow and quiver beside him. It belongs to a type that was invented in the Hellenistic period for funerary use and later adapted by the Romans as garden statuary. Eros's representation as a chubby toddler in the funerary sculpture of the Hellenistic period functioned as a visual link for parents and other family members who mourned deceased children. Yet the inclusion of his bow and arrow demonstrates that he remained a mischievous and dangerous boy, who could awake at any moment and strike the viewer.

120

Figurine of Eros holding up a himation between his teeth (p. 147)
Greek, East Greek, made in Myrina (Asia Minor)
Hellenistic period, 150–100 B.C.
Terracotta
H. 16.5 cm (6½ in.)
Museum purchase with funds donated by contribution 01.7685

This flying, shrouded Eros belongs to a type known as the "funerary Eros." The gesture of Eros holding his himation between his teeth is interpreted as a symbol of silence and was appropriate to the funerary context in which these statuettes were discovered.

Hermaphrodite and Priapos

121

Statue of a sleeping Hermaphrodite (pp. 128–29)
Roman
Imperial period, Antonine, 2nd-century-A.D. copy of a 2nd-century-B.C. original
Marble
H. 25 cm (9¹³/₁₆ in.), l. 148 cm (58¼ in.)
Rome, Palazzo Massimo alle Terme, Museo Nazionale Romano 1087
Courtesy of the Ministero per i Beni e le Attività Culturali—Soprintendenza Speciale per i Beni Archeologici di Roma

The physiognomy of the Hermaphrodite has long fascinated ancient and modern audiences. First mentioned in Greek literature in the fourth century B.C. (Theophrastus *Characters* 16.10), by the first century B.C., Hermaphrodite was known as the offspring of Hermes and Aphrodite (Diodorus 4.5.6). While an older tradition ascribes Hermaphrodite's bisexual identity to his parentage, Ovid tells of a myth of transformation in which the male youth acquired his female traits from the forceful embrace of Salmacis, a nymph of a spring near Halicarnassus (*Metamorphoses* 4.285–

388). Hermaphrodite became a popular subject in Hellenistic art and was depicted standing and reclining, nude and seminude. The most popular type is the recumbent or sleeping Hermaphrodite, believed to derive from a second-century-B.C. bronze original by Polykles, the group to which this Roman example belongs. This statue, discovered in 1880, is considered to be one of the best examples of its type; the other is the Borghese Hermaphrodite (now in the Musée du Louvre, Paris), for which the seventeenth-century sculptor Gian Lorenzo Bernini created a marble mattress.

122

Figurine of Priapos with four infants (p. 146)
Greek
Hellenistic period, 2nd century B.C.
Bronze
H. 8 cm (3³/₁₆ in.)
Gift of Edward Perry Warren RES.08.32p

This small bronze figurine of Priapos, the ithyphallic son of Aphrodite and Dionysos, cradles four infants, possibly erotes, in his garment. Together with his gigantic phallus, these infants allude to Priapos's role as a fertility god. This figurine probably functioned as a votive offering intended as a prayer for fertility.

123

Statue of Priapos (p. 131)
Roman
Imperial period, A.D. 170–240
Marble
H. 159 cm (62⅝ in.), w. 53 cm (20⅞ in.), d. 32 cm (12⅝ in.)
Gift of Fiske Warren and Edward Perry Warren RES.08.34a

This lifesize marble statue, formerly in the Ludovisi Collection in Rome, stands frontally with his long, muscular legs pressed tightly together and his feet tucked into high boots. He wears a cloak over his head and pulls back his belted chiton to reveal his enormous, erect phallus and carries a large basket overflowing with fruit. From the side, one can see that Priapos leans backward and appears as if he might tip over from the weight he carries on the front of his torso, which is augmented and supported by his phallus. The size of his phallus and its function emphatically declare Priapos's identity as a fertility god and a protector of crops. For these reasons, statues of Priapos, including this one, were usually placed in gardens, where they were believed to encourage procreation and to ward off disease and evil spirits.

124

*Tetradrachm of Knidos with the head of Aphrodite (obverse)
and the head of a lion (reverse, not illustrated)* (p. 57)
Greek, struck under Kalliphron
Late Classical period, 360–340 B.C.
Silver
Diam. 25.5 mm (1 1/16 in.)
Theodora Wilbour Fund in memory of Zoë
Wilbour 61.601

Aphrodite was worshipped as Euploia (of fair
sailing) in Knidos, a Greek city in southwestern
Asia Minor. About 350 B.C., the Knidians pur-
chased a nude sculpture of the goddess from the
Athenian sculptor Praxiteles, henceforth known
as the Aphrodite of Knidos, or the Knidia. The
appearance of the head of Aphrodite on Knidian
coinage of the same years may indicate that the
goddess's image had by that point come to func-
tion as a symbol of the city.

125

Head of Aphrodite (Bartlett Head) (p. 174)
Greek, made in Athens
Late Classical or Early Hellenistic period,
330–300 B.C.
Marble, from Paros, Greece
H. 28.8 cm (11 5/16 in.), w. 18.1 cm (7 1/8 in.),
d. 24.8 cm (9 3/4 in.)
Francis Bartlett Donation of 1900 03.743

The Bartlett Head, named for Francis Bartlett, who
donated the funds for its acquisition, was made
shortly after the Aphrodite of Knidos and is one
of a few Greek originals that approximate the
subtle carving style of Praxiteles's lost masterpiece.
With her fleshy, blurred features, finely carved
hair, and remote quality, the Bartlett Head is itself
one of the most admired faces of Aphrodite.
Recent scholarship suggests that, in contrast to
the full nudity of the revolutionary Knidia, the
Bartlett Head was originally inserted into a full-
length draped statue.

126

Head of Aphrodite (p. 173)
Roman
Imperial period, Antonine, A.D. 138–92
Marble, Pentelic
H. 22 cm (8 11/16 in.), l. 13 cm (5 1/8 in.)
Museum purchase with funds donated by
Mr. Clement S. Houghton 01.8200

This idealized head of Aphrodite was made with
Athenian marble by Athenian sculptors living
under Roman rule. The softness of her facial fea-

tures recalls the Bartlett Head (cat. no. 125),
which was also sculpted in Athens about five cen-
turies earlier. The deep carving and the style of
the hair, worn in a low bun, date this head to the
Antonine period.

127

Statue of Aphrodite of the Capitoline type (p. 155)
Roman, made in Lazio, Italy
Imperial period, 2nd century A.D.
Marble, probably Parian
H. 112.4 cm (44 1/4 in.), w. 45.4 cm (17 7/8 in.)
Henry Lillie Pierce Fund 99.350

128

Head of Aphrodite of the Capitoline type (p. 175)
Roman, made in Lazio, Italy
Imperial period, 2nd century A.D.
Marble, Thasian and Pentelic
H. 29.5 cm (11 5/8 in.), d. 19.1 cm (7 1/2 in.)
Henry Lillie Pierce Fund 99.351

Although this head and torso of Aphrodite do not
belong to the same statue, taken together they
represent one of the Hellenistic and Roman
sculptural types that most closely emulates the
Aphrodite of Knidos. The Capitoline type, named
for a nude statue of Aphrodite discovered in
Rome in the seventeenth century and housed in
the Capitoline Museum, covers her pubic area
with one hand and her breasts with the other.
The position of the shoulders indicates that the
MFA sculpture made the same gesture as the
Capitoline Aphrodite. The features of the head
and hairstyle also bear a striking resemblance to
that of the Capitoline Aphrodite.

129

Statuette of Aphrodite untying her sandal (Sandalbinder)
(p. 153)
Greek, made in Smyrna
Late Hellenistic period, about 1st century B.C.
Terracotta
H. 37.4 cm (14 11/16 in.)
Catharine Page Perkins Fund 97.357

This elegant, effortlessly balanced terracotta stat-
uette is one of hundreds of examples of this type,
which developed in response to the innovation of
the nude Aphrodite of Knidos. Like the Knidia,
Aphrodite is depicted nude (save for an elaborate-
ly ornamented diadem), at her bath, but here she
reaches for her sandal. Traditionally, this type was
understood as Aphrodite binding her sandal, hence
the term "Sandalbinder"; however, the current
interpretation is that she is in fact removing it,
perhaps seductively.

130

Statuette of Aphrodite Anadyomene (p. 178)
Greek or Roman, Eastern Mediterranean
Hellenistic or Imperial period, 100 B.C.–A.D. 70
Marble
H. 55 cm (21 11/16 in.)
Classical Department Exchange Fund 1982.286

This fleshy nude statuette belongs to a type known
as Aphrodite Anadyomene (wringing out her hair)
that became popular in the Hellenistic period and
refers to the goddess's perpetual rebirth through
bathing. Having just stepped onto land for the first
time, the goddess wrings out her hair; beside her,
a cloth for drying is draped over a tree stump.

131

*Coin of Philadelphia with the bust of Severus Alexander
(obverse, not illustrated) and Aphrodite arranging her hair
and holding a mirror (reverse)* (p. 152)
Roman Provincial, struck under Iul. Aristo
Iulianus
Imperial period, A.D. 222–35
Bronze
Diam. 28.5 mm (1 1/8 in.)
Theodora Wilbour Fund in memory of Zoë
Wilbour 63.1121

A variation on the Anadyomene (wringing out
her hair) type popular in the Hellenistic period,
the statue of Aphrodite depicted on this Roman
Provincial coin holds up a mirror with one hand
and arranges her hair with the other. The shrine-
like niche in which she is enclosed confirms that
this image represents a cult statue of Aphrodite
from Philadelphia.

132

*Drachm of Amisus with the bust of Sabina (obverse,
not illustrated) and Aphrodite crouching (reverse)* (p. 152)
Roman Provincial
Imperial period, A.D. 137 or 138
Silver
Diam. 19 mm (3/4 in.)
Theodora Wilbour Fund in memory of Zoë
Wilbour 63.1497

On the reverse of this Hadrianic silver coin from
the Black Sea region, Aphrodite is depicted in a
crouching, bathing position, echoing one of the
most inventive and popular Hellenistic sculptural
types that developed in response to Praxiteles's
nude Aphrodite of Knidos. The goddess reaches
around and, with a phiale (shallow cup), pours
water over her diademed head. The position of
Aphrodite opposite the bust of Sabina, the
beloved wife of the Roman emperor Hadrian,
draws a parallel between the empress and the
goddess of matrimony.

133

Statuette of Aphrodite leaning on a column (p. 182)
Greek or Roman, Eastern Mediterranean
Late Hellenistic or Early Roman period,
100 B.C.–A.D. 50
Marble, probably from Paros, Greece
H. 42.9 cm (16⅞ in.)
Anonymous gift 1979.304

The nude marble statuette of Aphrodite holds an apple referring to her victory in the Judgment of Paris. The Venus de Milo, a late-Hellenistic half-draped statue found in a gymnasium on Melos (now in the Musée du Louvre, Paris), is also believed to have held an apple. The scale of this statuette indicates that it probably stood in a more private setting, either in a bath or in a garden.

134

Statuette of Aphrodite (p. 170)
Greek
Early Hellenistic period, about 325–300 B.C.
Marble, probably Pentelic
H. 54.6 cm (21½ in.), w. 17.8 cm (7 in.),
d. 11.4 cm (4½ in.)
Henry Lillie Pierce Fund 00.305

This elegantly draped statue is one of many fourth-century-B.C. Athenian examples that continued to depict the goddess clothed, as opposed to the many different nude types developed in response to Praxiteles's revolutionary Aphrodite of Knidos. Here, Aphrodite pulls her mantle across her breast with her right hand in emulation of the philosopher type, a fourth-century-B.C. invention in Greek sculpture.

Aphrodite Statuary in Domestic and Funerary Contexts

Large and small statues of Aphrodite were given as votive gifts to the goddess in her sanctuaries, but they were also placed on household altars and in graves. Romans included images of Venus on their household altars and in their gardens. Statuettes of Aphrodite were made in a range of sizes, types, and media—from modest terracotta replicated in molds to expensive metals.

135

Mold of the face of a woman (possibly Aphrodite) (p. 187)
Greek, East Greek, probably from Smyrna
Hellenistic period, 3rd or 2nd century B.C.
Terracotta
H. 5.5 cm (2³⁄₁₆ in.)
Museum purchase with funds donated by contribution 01.7932

This mold of a female face, possibly Aphrodite, exemplifies the subtractive process of terracotta

figurine manufacture. The earliest evidence for molds dates back to the seventh century B.C. The process began with a solid handmade prototype around which wet clay was pressed to produce a mold in two pieces, front and back. The indentations around the edges of the mold seen here helped the coroplast (modeler of small figurines) align the front with the back. More complex figurines, such as the flying figures invented in the third century B.C., could require up to fourteen additional molds. The use of molds allowed coroplasts to mass produce their designs, which were extremely popular in Greek religious, domestic, and funerary contexts.

136

Statuette of Aphrodite or a Muse leaning on a pillar (p. 187)
Greek, from the Tomb of the Erotes, Eretria, Euboia
Hellenistic period, about 300–250 B.C.
Terracotta
H. 39.4 cm (15½ in.)
Henry Lillie Pierce Fund 98.893

This large, polychrome terracotta statuette was discovered in a niche in the so-called Tomb of the Erotes in Eretria, Greece (along with a gold ring with an intaglio of Aphrodite armed with Ares's shield, cat. no. 72). The position of the draped figure's hands indicates that she played a lyre or a kithara, which has led some to identify her as a Muse (probably Erato, the Muse of lyric poetry). However, holes on the shoulder and the top of the pillar indicate that another figure, probably Eros, was attached, strongly suggesting that the statuette represents Aphrodite.

137

Statuette of Aphrodite leaning on a column (p. 171)
Greek, said to be from Canosa (ancient Canusium), South Italy
Early Hellenistic period, end of the
4th century B.C.
Terracotta
H. 23.1 cm (9¹⁄₁₆ in.)
Museum purchase with funds donated by contribution 01.7956

This statuette is one of many Hellenistic depictions of Aphrodite leaning on a pillar. However, unlike the heavily draped example from the Tomb of the Erotes (cat. no. 136), this Aphrodite's drapery covers only her forearms and thus acts chiefly as a frame for her nude body. The most conspicuous feature is her long, beaded breast cross-cords, which frame her breasts and heighten her sexual allure.

138

Statuette of Aphrodite (p. 168)
Greek or Roman
Late Hellenistic or Roman Imperial period,
1st century B.C. or 1st–2nd century A.D.
Bronze
H. 31.3 cm (12⁵⁄₁₆ in.)
Henry Lillie Pierce Fund 00.313

This bronze statuette belongs to the Capitoline Aphrodite type (see also cat. no. 127), also known as the Aphrodite of modesty because she covers her body with both hands. This example, which may have been a cult offering or a household object, originates from the Eastern Mediterranean, where the cult of Aphrodite remained strong in the Hellenistic and Roman periods. It is noted for the remarkable preservation of its gold and pearl earrings, a reminder that votive and cult statues of Aphrodite were adorned with precious jewelry.

139

Figurine of Aphrodite with open palms (p. 186)
Greek
Late Hellenistic period, 1st century B.C.
Bronze
H. 18.6 cm (7⁵⁄₁₆ in.)
Henry Lillie Pierce Fund 04.8a–b

The outstretched arms and upturned palms of this nude bronze statuette of the goddess present her nudity openly, in contrast to the pose of the so-called Aphrodite of modesty (see cat. no. 138). The base, richly ornamented with vegetal motifs in relief, postdates this statuette and was probably intended for a larger statue.

140

Figurine of Aphrodite (p. 184)
Roman
Imperial period, 2nd century A.D.
Bronze and gold
H. 17.7 cm (6¹⁵⁄₁₆ in.)
Gift in memory of Robert A. Kagan 1994.352

In iconographic terms, this bronze statuette is remarkably similar to the gilded-silver example discussed below (cat. no. 141). This example wears a delicately twisted gold earring. Its finely carved drapery folds hug the body underneath and create a sense of motion despite its static pose.

141

Figurine of Aphrodite (p. 185)
Greek or Roman
Late Hellenistic or Roman Imperial period,
1st century B.C. or 1st century A.D.
Silver with gold leaf

H. 12.4 cm (4⅞ in.)
Henry Lillie Pierce Fund 01.8187

This gilt-silver statuette of Aphrodite from the Eastern Mediterranean is exquisitely modeled and the most expensive of the statuettes grouped here. She wears a diadem and elaborate, layered dresses sumptuously gilded around the edges and across the waist. Her chiton has slipped off her left shoulder, sensuously revealing her bare breast, a sign of both maternity and sexuality. Originally, this statuette held a scepter, a symbol of sovereignty, in her right hand and a phiale or an apple in her left. Images of Aphrodite holding an apple, the most famous of which is the Venus de Milo, were very popular in antiquity and refer to the goddess's victory in the Judgment of Paris.

142
Statue of Aphrodite leaning on a statue of herself (p. 180)
Roman, discovered in Pompeii in 1874
Late Hellenistic period, 2nd or 1st century B.C.
Marble with polychromy
H. 104 cm (40¹⁵⁄₁₆ in.)
Naples, Museo Archeologico Nazionale 109608

Ministero per i Beni e le Attività Culturali / Soprintendenza Speciale per i Beni Archeologici di Napoli e Pompei
Photograph © Luciano Pedicini / Archivio dell'Arte

Half draped and holding an apple in her left hand, this statue of Aphrodite leans on an archaistic statue of herself fully draped and standing on rocks. In Classical art, Aphrodite is often depicted leaning on pillars and other supports, including herms, vases, and animals, but the use of an archaistic statue of herself as a prop originates in the Hellenistic period and can be seen on statues of Artemis as well. The differentiation between the two Aphrodites in dress, pose, adornment, hairstyle, and facial features may suggest that the larger Aphrodite is, in fact, visiting her own shrine represented by the smaller draped archaistic statue. The polychrome is exceptionally well preserved and bears witness to the wide range of pigments (red, orange, blue, brown) used to enliven and to enrich ancient statues. This was the largest statuette of Aphrodite found in a Pompeian garden. It was set into a marble-veneered shrine-like structure with a back wall painted to represent a blue textile hanging and a ceiling decorated as a shell, clearly designed to invoke the marine environs associated with Aphrodite.

143
Statuette of Aphrodite leaning on a statue of herself (p. 181)
Greek, from Myrina (Asia Minor); signed by Aglaophon
Hellenistic period, 150–100 B.C.

Terracotta
Inscription: AGLAOPHONTOS
H. 33.4 cm (13³⁄₁₆ in.)
Museum purchase with funds donated by contribution 01.7751

As with the painted Aphrodite from Naples (cat. no. 142), this terracotta statuette, found in the Hellenistic tombs of Myrina, depicts the goddess leaning against an archaistic statue. Its similarity to the painted Aphrodite demonstrates that the type was suitable for both funerary and decorative contexts. The back of the statuette bears the inscribed signature of the coroplast (modeler), Aglaophon, in the genitive form "Aglaophontos." Parallels have been found in the East Greek cities of Ephesus, Priene, and Miletus.

Roman Venus

Aphrodite was worshipped by the Romans as Venus and as the mother of Aeneas, the Trojan refugee who founded the Roman race. Venus became especially important at the dawn of the Imperial period as the ancestor of Julius Caesar and his nephew Augustus, who emphasized their divine lineage in the literary and visual arts.

144
Mixing bowl (calyx krater) with dueling scenes from the Trojan War (p. 176)
Greek, made in Athens; attributed to the Tyszkiewicz Painter
Late Archaic period, 490–480 B.C.
Ceramic, red-figure technique
H. 45.2 cm (17¹³⁄₁₆ in.), diam. 51.3 cm (20³⁄₁₆ in.)
Catharine Page Perkins Fund 97.368

This large bowl, used for mixing wine and water, depicts two of the most memorable duels fought in Homer's *Iliad*: Achilles and Memnon, the Ethiopian king who was an ally of the Trojans; and Diomedes and Aeneas, the son of Aphrodite and Trojan Anchises. Diomedes was known to the Greeks as one of the most valiant Greek heroes, whose wrath was so great that even Aphrodite was not exempt from it. After he wounded Aeneas, Diomedes struck the goddess with his spear as she carried her son off the battlefield (5.311–74). This vase depicts Aphrodite as a protective mother, placing her hand on Aeneas's shoulder as if to catch him from his fall.

145
Cameo with Livia holding the bust of Augustus (?) (p. 172)
Roman
Imperial period, A.D. 14–37
Turquoise
H. 3.1 cm (1³⁄₁₆ in.), l. 3.8 cm (1½ in.)
Henry Lillie Pierce Fund 99.109

This turquoise cameo, made in the years after the death of Augustus in A.D. 14, depicts Livia, the first Roman empress, holding a male portrait bust, identified as her deified husband or one of her sons—Drusus, who died in 9 B.C., or Tiberius, who succeeded Augustus. She wears the hairstyle and slipped-shoulder drapery of Venus Genetrix (the ancestress), the symbolic mother of Rome and divine ancestor of the Julio-Claudian family. The cameo thus poses Livia as a model wife and mother, roles that were crucial to the dynastic success of the imperial family.

146
Statue of a woman in the guise of Venus (p. 163)
Roman
Imperial period, mid-1st to early 2nd century A.D.
Marble, from Carrara, Italy
H. 145 cm (57¹⁄₁₆ in.)
Museum purchase as a memorial to Mrs. W. Scott Fitz with funds from the Henrietta Goddard Fitz Fund and Edward Jackson Holmes 30.543

Elite women who were not part of the imperial household also presented themselves in the guise of Venus. This sensuous, full-figured Roman statue of Venus is one of many inspired by a lost bronze of Aphrodite made by the Athenian sculptor Callimachus at the end of the fifth century B.C. The type is noted for its skilled use of wet drapery—thin gauzelike folds that cling to the body and tantalizingly reveal its contours. A portrait head of an elite Roman woman was inserted into this statue of Venus, assimilating the depicted woman with the goddess.

147
Denarius with the head of Venus (obverse) and Aeneas, Anchises, and Ascanius (reverse) (p. 167)
Roman, struck under Julius Caesar
Late Republican period, about 47–46 B.C.
Silver
Diam. 18.5 mm (¾ in.)
Deposited by The Boston Athenaeum 13.633

148
Denarius with the head of C. Julius Caesar (obverse, not illustrated) and a standing Venus (reverse) (p. 167)
Roman, struck under L. Flaminius Chilo
Late Republican period, 43 B.C.
Silver
Diam. 20.5 mm (¹³⁄₁₆ in.)
Theodora Wilbour Fund in memory of Zoë Wilbour 58.2

It was common practice in the Roman Republic for mint officials, generally young men from noble families embarking on political careers, to strike coins with images making reference to prominent

ancestors, ranging from famous figures of earlier Roman history to Trojan heroes familiar from epic poetry, and even divinities. Following in this tradition, Julius Caesar promoted his divine ancestry on coins struck on his authority, including a silver denarius with the head of Venus on the obverse and Aeneas fleeing Troy with his father, Anchises, his son, Ascanius, and the cult statue of Athena in tow. In the year following Caesar's death in 43 B.C., a mint official sympathetic to his memory, L. Flaminius Chilo, struck a silver coin with a posthumous portrait of the dictator on the obverse and an image of Venus with a caduceus and a scepter on the reverse. Even after his assassination, those loyal to Caesar continued to advertise his divine ancestry, while Caesar himself, who was formally deified in 42 B.C., in turn became a divine ancestor to be touted by his ambitious adopted son, Octavian.

149
Sestertius with a bust of Crispina (obverse, not illustrated) and seated Venus (reverse) (p. 167)
Roman, struck under Commodus
Imperial period, about A.D. 180–82
Bronze
Diam. 31 mm (1³⁄₁₆ in.)
Anonymous gift in memory of Zoë Wilbour (1864–1885) 34.1419

150
Aureus with the bust of Lucilla (obverse, not illustrated) and a standing Venus (reverse) (p. 167)
Roman, struck under Marcus Aurelius
Imperial period, A.D. 164–82
Gold
Diam. 21 mm (¹³⁄₁₆ in.)
Theodora Wilbour Fund in memory of Zoë Wilbour 67.7

151
Aureus with a bust of Julia Domna (obverse, not illustrated) and a standing Venus Victrix (reverse) (p. 159)
Roman, struck under Septimius Severus
Imperial period, A.D. 193–96
Gold
Diam. 20.5 mm (¹³⁄₁₆ in.)
Theodora Wilbour Fund in memory of Zoë Wilbour 53.2020

152
Aureus with a bust of Carinus (obverse, not illustrated) and a standing Venus Victrix (reverse) (p. 167)
Roman
Imperial period, about A.D. 284
Gold
Diam. 21 mm (¹³⁄₁₆ in.)
Anonymous gift in memory of Zoë Wilbour (1864–1885) 35.2003

Venus, the ancestral mother of all Romans through Aeneas, was a particular focus of devotion for the imperial family, for whom dynastic succession was a constant source of anxiety. As a goddess associated with fertility, Venus was a natural model for ladies of the imperial house, who were seen as ensuring the wellbeing of the empire by providing potential heirs to the throne. Three of these coins call attention to this bond through the juxtaposition of triumphant images of Venus Victrix (victorious) with portraits of imperial women: Lucilla, the daughter of Marcus Aurelius; Crispina, the wife of Commodus; and Julia Domna, the wife of Septimius Severus. A gold coin with the bust of Carinus on one face, opposite an image of the goddess holding a statue of Victory on the other, demonstrates that emperors, too, sought to legitimize their rule by association with Venus, harking back to Julius Caesar.

FIGURE ILLUSTRATIONS

■ ■ ■ ■ ■

Fig. 1
Relief with striding lion
Near Eastern, Mesopotamian, Babylonian
Neo-Babylonian period, 604–561 B.C.
Glazed bricks
H. 106 cm (41¾ in.), w. 232 cm (91⁵⁄₁₆ in.)
Maria Antoinette Evans Fund 31.898

Fig. 2
Jim Dine (American, born in 1935)
Nine Views of Winter (4), 1985
Printed by Toby Michel, Angeles Press, Santa Monica
Woodcut, hand-painted with floral-patterned rollers
H. 133.4 cm (52½ in.), w. 94 cm (37 in.)
Promised gift of the artist
© 2011 Jim Dine/Artists Rights Society (ARS), New York

Fig. 3
Mosaic depicting cult places of Aphrodite on Mediterranean islands
Roman, discovered in Haïdra (ancient Ammaedara), Tunisia
Imperial period, 4th century A.D.
Limestone, marble
H. 533–536 cm (209¹³⁄₁₆–211 in.),
w. 492 cm (193¹¹⁄₁₆ in.)
Haïdra Museum
Photograph: SJJabeur-INP

Fig. 4
Oktadrachm of the Kingdom of Egypt with the head of Arsinoë II (obverse)
Greek, Ptolemaic; struck under Ptolemy II
Hellenistic period, 261 B.C.
Gold
Diam. 27 mm (1¹⁄₁₆ in.)
Francis Bartlett Donation of 1900 03.980

Fig. 5
Grave marker in the form of an oil bottle (lekythos)
Greek
Classical period, 420–410 B.C.
Marble, Pentellic
H. 76 cm (29¹⁵⁄₁₆ in.)
Anna Mitchell Richards Fund and 1931 Purchase Fund 38.1615

Fig. 6
Francisco Botero (born in Colombia, 1932)
Venus, 1971
Charcoal on canvas
H. 182.9 cm (72 in.), w. 162.6 cm (64 in.)
Melvin Blake and Frank Purnell Collection 2003.24
© Fernando Botero, courtesy Marlborough Gallery, New York

Fig. 7
Relief with Aphrodite and the birth of Eros
Roman, from the south portico of the Sebasteion, Aphrodisias
Imperial period, about A.D. 14–68
Marble, Aphrodisian
H. 160 cm (63 in.), w. 140 cm (55⅛ in.),
d. 45 cm (17¹¹⁄₁₆ in.)
Aphrodisias Museum
Photograph courtesy of NYU Excavations at Aphrodisias

Fig. 8
Signet ring with Aphrodite threatening to slap two unruly erotes
Roman
Late Imperial or Early Christian period,
4th century A.D.
Gold with niello
Ring: diam. 2–2.6 cm (¹³⁄₁₆–1¹⁄₁₆ in.);
bezel: 1.6 cm square (⅝ in. square)
Virginia Museum of Fine Arts, Richmond
Adolph D. and Wilkins C. Williams Fund 67.52.10
Photograph by Travis Fullerton. © Virginia Museum of Fine Arts

Fig. 9
Aphrodite of Knidos ("Colonna" type)
Roman, copy of a 4th-century-B.C. Greek original by Praxiteles
Imperial period, 1st–2nd century A.D.
Marble
H. 204 cm (80⁵⁄₁₆ in.)
Museo Pio Clementino, Vatican Museums 812
Photograph: Nimatallah/Art Resource, NY

Fig. 10
Jim Dine (American, born in 1935)
Nine Views of Winter (2), 1985
Printed by Toby Michel, Angeles Press, Santa Monica
Woodcut, hand-painted with floral-patterned rollers
H. 133.4 cm (52½ in.), w. 94 cm (37 in.)
Promised gift of the artist
© 2011 Jim Dine/Artists Rights Society (ARS), New York

Fig. 11
Mosaic with Aphrodite as a martial goddess holding a spear
Roman, discovered in Room 2, Roman House south of the Villa of Theseus, Nea Paphos, Cyprus
Imperial period, 3rd century A.D.
Limestone, marble

Room: L. 332 cm (130¹¹⁄₁₆ in.),
w. 205 cm (80¹¹⁄₁₆ in.)
Paphos Archaeological Park
Reproduced with the permission of the Director of the Department of Antiquities, Cyprus

Fig. 12
Statue of Aphrodite
Roman, found in the baths of Cyrene
Imperial period, about A.D. 100–150
Marble
H. 150 cm (59¹⁄₁₆ in.)
Rome, Museo Nazionale Romano 72115
Courtesy of the Ministero per i Beni e le Attività Culturali—Soprintendenza Speciale per i Beni Archeologici di Roma

Fig. 13
Pablo Picasso (Spanish, worked in France, 1881–1973)
Sculptor Reclining and Model with Mask, 1933
Etching
H. 44.6 cm (17⁹⁄₁₆ in.), w. 34 cm (13⅜ in.)
Lee M. Friedman Fund, and Gift of William A. Coolidge 1974.348
© 2011 Estate of Pablo Picaso/Artists Rights Society (ARS), New York

Fig. 14
Luca Giordano (Italian, Neapolitan, 1634–1705)
Venus Giving Arms to Aeneas, 1680–82
Oil on canvas
H. 227.3 cm (89½ in.), w. 199.4 cm (78½ in.)
Charles Potter Kling Fund and Henry H. and Zoe Oliver Sherman Fund 1984.409

Fig. 15
Théodore Chassériau (French, 1819–1856)
Venus Rising from the Sea, 1839
Crayon lithograph with scraping and tan tint stone
H. 46.8 cm (18⁷⁄₁₆ in.), w. 39.6 cm (15⁹⁄₁₆ in.)
Gift of W. G. Russell Allen 50.3459

Fig. 16
Pablo Picasso (Spanish, worked in France, 1881–1973)
Sculptor and His Model before a Window, 1933
Etching
H. 34.1 cm (13⁷⁄₁₆ in.), w. 44.9 cm (17¹¹⁄₁₆ in.)
Lee M. Friedman Fund, and Gift of William A. Coolidge 1974.357
© 2011 Estate of Pablo Picaso/Artists Rights Society (ARS), New York

NOTES

▪▪▪▪▪

INTRODUCTION

1. Varro On *Agriculture* 1; Pliny *Natural History* 19.50; Paulus in Naevius frag. 30 a–c, translation in E. H. Warmington, ed. and trans., *Remains of Old Latin*, vol. 2, Loeb Classical Library (Cambridge, Mass.: Harvard University Press, 1967), 149.

2. "Nestor's Cup," Pithekoussai Tomb 168, Museo di Lacco Ameno, Ischia, Italy, inv. no. 166788.

3. Plato *Symposium* 203c, trans., with introduction and notes, Alex Nehamas and Paul Woodruff (Indianapolis, Ind.: Hackett Publishing, 1989), 48.

4. Nigel Spivey, *Understanding Greek Sculpture: Ancient Meanings, Modern Readings* (New York: Thames and Hudson, 1996), 176.

5. Pliny *Natural History* 36.4.20–21.

6. Lucian *Erotes* (or, "Affairs of the Heart") 11–19.

7. For the official biography of Warren, see Osbert Burdett and E. H. Goddard, *Edward Perry Warren: The Biography of a Connoisseur* (London: Christophers, 1941), and for more recent accounts, see David Sox, *Bachelors of Art: Edward Perry Warren and the Lewes House Brotherhood* (London: Fourth Estate, 1992), and Dyfri Williams, *The Warren Cup* (London: British Museum Press, 2006), 17–34.

8. Whitney Davis, "Homoerotic Art Collection from 1750 to 1920," *Art History* 24 (2001), 248.

APHRODITE'S ANCESTORS

Ancient Near Eastern Goddesses of Love

1. Jeremy A. Black, Graham Cunningham, Esther Flückiger-Hawker, Eleanor Robson, and Gábor Zólyomi, "A Hymn to Inana as Ninegala (Inana D)," *The Electronic Text Corpus of Sumerian Literature* (Oxford: The ETCSL Project, Faculty of Oriental Studies, University of Oxford, 1998–2006), lines 1–8, http://etcsl.orinst.ox.ac.uk/cgi-bin/etcsl.cgi?text=t.4.07.4# (accessed September 16, 2010).

2. In this case, it is more appropriate to refer to Ishtar alone, as the lion was mainly associated with that goddess and much less so with her earlier incarnation, Inana.

3. Stephanie Budin, *The Origin of Aphrodite* (Bethesda, Md.: CDL Press, 2003), 274ff.

4. Diane Bolger and Nancy Serwint, eds., *Engendering Aphrodite*, vol. 7 (Boston: American Schools of Oriental Research, 2002), 334ff.; see 336, fig. 9, for Qudsu stele.

5. Jeremy A. Black, Graham Cunningham, Esther Flückiger-Hawker, Eleanor Robson, and Gábor Zólyomi, "A Hymn to Inana (Inana C): Translation," *The Electronic Text Corpus of Sumerian Literature* (Oxford: The ETCSL Project, Faculty of Oriental Studies, University of Oxford, 1998–2006), lines 182–196, http://www-etcsl.orient.ox.ac.uk/section4/tr4073.htm (accessed September 16, 2010). This is a composite text translation, from tablets inscribed in cuneiform and dating to the late third or early second millennium B.C. but reflecting an earlier literary and oral tradition.

6. Claude Lévi-Strauss, *Structural Anthropology* (New York: Basic Books, 1963), 245ff.; Wendy Doniger, "The Land East of the Asterisk," *London Review of Books*, April 10, 2008, 27–29, http://www.lrb.co.uk/v30/n07/wendy-doniger/the-land-east-of-the-asterisk.

7. "A Literary Prayer to Ishtar as Venus," in A. R. George, *Babylonian Literary Texts in the Schøyen Collection*, Cornell University Studies in Assyriology and Sumerology Vol. 10 (Bethesda, Md.: CDL Press, 2009), 76–77.

8. Jeremy Black and Anthony Green, *Gods, Demons and Symbols of Ancient Mesopotamia* (Austin: University of Texas Press, 1992), 108–9.

9. Charles Penglase, *Greek Myths and Mesopotamia: Parallels and Influence in the Homeric Hymns and Hesiod* (New York: Routledge, 1994), 166ff.

10. For a striking example of the nude goddess who has been identified as Inana/Ishtar or Ereshkigal, see the Queen of the Night relief, British Museum, London, 2003-7-18, 1.

11. Walter Burkert, *The Creation of the Sacred* (Cambridge, Mass.: Harvard University Press, 1996), 54–55.

12. Irene Winter, "Sex, Rhetoric, and the Public Monument," in *Sexuality in Ancient Art*, ed. Natalie Boymel Kampen (Cambridge: Cambridge University Press, 1996), 21.

13. The Assyrian king Adad-Nirari II, for example, proclaims: "I am a lion and I am a (potent) male"; ibid., 24. Another Assyrian king, Assurnasirpal II, also proclaims himself "a lion, and … virile," and a sexual incantation recommends, "Let a lion get an erection along with you"; Chikako E. Watanabe, *Animal Symbolism in Mesopotamia*, Wiener Offene Orientalistik Vol. 1 (Vienna: Institut für Orientalistik der Universitat Wien, 2002), 51, 103–4.

14. Bolger and Serwint, *Engendering Aphrodite*, 327.

15. Zainab Bahrani, *Women of Babylon: Gender and Representation in Mesopotamia* (New York: Routledge, 2001), 153.

The Cypriot Origin of Aphrodite

1. Hesiod *Theogony* 176–206; translation in Hesiod, *Theogony; and, Works and Days*, trans. and with an introduction by Catherine Schlegel and Henry Weinfeld (Ann Arbor: University of Michigan Press, 2006), lines 191–97, 29.

2. Edgar Peltenburg, "The Beginnings of Religion in Cyprus," in *Early Society in Cyprus*, ed. Edgar Peltenburg (Edinburgh: Edinburgh University Press, 1989), 124.

3. Tacitus *Histories* 2.3.1.

4. Herodotus *History* 1.105.2.

5. Pausanias *Description of Greece* 8.5.2–3.

6. Homer *Odyssey* 8.362–63.

7. Martin Metzger, *Kamid el-Lôz 7. Die Spätbronzezeitlichen Tempelanlagen. Stratigraphie, Architektur und Installation Vol. 1*, Kamid el-Lôz, Saarbrücker Beiträge zur Altertumskunde, Band 35 (Bonn: Dr. Rudolf Habelt, 1991).

8. About the Cypriot Aphrodite in general, see Jacqueline Karageorghis, *Kypris: The Aphrodite of Cyprus* (Nicosia, Cyprus: A. G. Leventis Foundation, 2005).

GREEK CULTS OF APHRODITE

1. A more extensive treatment of the material in this essay is available in our respective works, Vinciane Pirenne-Delforge, *L'Aphrodite grecque: Contribution à l'étude de ses cultes et de sa personnalité dans le panthéon archaïque et classique*, Kernos supplement 4 (Athens and Liège: Centre International d'Etude

de la Religion Grecque Antique, 1994); Gabriella Pironti, *Entre ciel et guerre: Figures d'Aphrodite en Grèce ancienne*, Kernos supplement 18 (Athens and Liège: Centre International d'Etude de la Religion Grecque Antique, 2007); and Vinciane Pirenne-Delforge, "Something to Do with Aphrodite: *Ta Aphrodisia* and the Sacred," in *A Companion to Greek Religion*, ed. Daniel Ogden (New York: Wiley-Blackwell, 2007), 311–23. Only minimal references to ancient sources are provided here.

2. Pausanias 2.32.7.

3. Pausanias 1.14.7; Proclus Commentary on Plato's Timaeus 40; *Supplementum Epigraphicum Graecum* 41, no. 182.

4. Pausanias 2.37.2, 10.38.12.

5. For the most recent study of this controversial hypothesis, see Stephanie Budin, *The Myth of Sacred Prostitution in Antiquity* (Cambridge: Cambridge University Press, 2008).

6. See John Winkler, *The Constraints of Desire: The Anthropology of Sex and Gender in Ancient Greece* (New York: Routledge, 1990).

7. Hesiod Theogony 570–92; *Works and Days* 54–105.

8. Aeschylus frag. 44 Radt.

9. Attic red-figure pelike, Rhodes Archaeological Museum, 12454. From Cameiros; Angelos Delivorrias, "Aphrodite," *Lexicon Iconographicum Mythologiae Classicae*, vol. 2 (Zurich: Artemis Verlag, 1981), no. 1159.

10. Pausanias 2.2.4, 8.6.5, 9.27.5.

11. Pausanias 1.14.7.

12. *Supplementum Epigraphicum Graecum* 41, nos. 90–91; 51, no. 177.

13. *Inscriptiones Graecae* 9.2.1, 256 (second/first century B.C.); *Supplementum Epigraphicum Graecum* 37, no. 937 (second century B.C.). Helmut Engelmann and Reinhold Merkelbach, eds., *Die Inschriften von Erythrai und Klazomenai* (Bonn: Habelt, 1972–73), no. 207, 9–11 (Hellenistic period); Wolfgang Blümel, ed., *Die Inschriften von Mylasa* (Bonn: Habelt, 1987–88), nos. 203, 5, and 204, 3 (Hellenistic period).

14. Pausanias 2.5.1, 3.15.10, 3.23.1.

15. Plutarch De Herodoti malignitate 39 (*Moralia* 871a–b); Athenaeus 13.573c–d; see also scholiast on Pindar Olympian Odes 13.32b (Drachmann).

16. Pausanias 2.25.1; Jean Bousquet, "Le temple d'Aphrodite et Arès à Sta Lenikà," *Bulletin de Correspondance Hellénique* 62 (1938): 386–408.

17. Pausanias 3.17.5.

18. Pausanias 1.22.3; see *Inscriptiones Graecae* 2².659.

19. See Hesiod Theogony 188–200.

20. The evidence is available in Robert Parker, "The Cult of Aphrodite Pandamos and Pontia at Cos," in *Kykeon: Studies in Honour of H. S. Versnel*, ed. Herman F. J. Horstmanshoff et al. (Leiden and Boston: Brill, 2002), 143–60.

21. *Supplementum Epigraphicum Graecum* 9, no. 133. On magistrates, see Jenny Wallensten, "Demand and Supply? The Character of Aphrodite in the Light of Inscribed Votive Gifts," in *Le donateur, l'offrande et la déesse: Systèmes votifs dans les sanctuaires de déesses du monde grec*, Kernos supplement 23, ed. Clarisse Prêtre (Athens and Liège: Centre International d'Etude de la Religion Grecque Antique, 2009), 169–80.

22. *Inscriptiones Creticae* 1.16.24 (second half of the second century B.C.).

23. Strabo 7.16; Athenaeus 7.318b–d.

THE PARADOX OF APHRODITE: A PHILANDERING GODDESS OF MARRIAGE

1. Homer Iliad 5.427–30.

2. Rachel Kousser, "The World of Aphrodite in the Late Fifth Century B.C.," in *Greek Vases: Images, Contexts and Controversies. Proceedings of the Conference Sponsored by the Center for the Ancient Mediterranean at Columbia University, 23–24 March 2002* (Leiden and Boston: Brill, 2004), 97–112, esp. 109. Kousser notes the "awkward fit" between Aphrodite's cultic connection with marriage and her "literary persona as unenthusiastic wife, and indeed, as renowned adultress."

3. Plutarch Moralia 264b.

4. Vinciane Pirenne-Delforge, *L'Aphrodite grecque: Contribution à l'étude de ses cultes et de sa personnalité dans le panthéon archaïque et classique*, Kernos supplement 4 (Athens and Liège: Centre International d'Etude de la Religion Grecque Antique, 1994), 421; "Le culte de la Persuasion Peithô en Grèce ancienne," *Revue de l'histoire des religions* 208 (1991): 395–413; Jean-Pierre Vernant, "Marriage," in *Myth and Society in Ancient Greece*, trans. Janet Lloyd (New York: Zone

Books 1988), 47, 51; Demosthenes *Against Neaera* 122.

5. Homer Iliad 14.190–221.

6. Homer Odyssey 8.266–369.

7. Vinciane Pirenne-Delforge, "Conception et manifestations du sacré dans *L'Hymne Homérique à Aphrodite*," *Kernos* 2 (1989): 187–97; Jenny Strauss Clay, *The Politics of Olympus: Form and Meaning in the Major Homeric Hymns* (Princeton: Princeton University Press, 1989), 166–70, 192–93; Gregory Nagy, *The Best of the Achaeans* (Baltimore: Johns Hopkins University Press, 1979), 220. Recently, Andrew Faulkner has refined this interpretation, arguing that the greater emphasis in the poem is on the cessation of Aphrodite's boasting; Andrew Faulkner, "The Legacy of Aphrodite: Anchises' Offspring in the *Homeric Hymn to Aphrodite*," *American Journal of Philology* 129 (2008): 1–18. For the passage in question, see *Homeric Hymn to Aphrodite* 48–52.

8. Walter Burkert, *Greek Religion*, trans. John Raffan (Cambridge, Mass.: Harvard University Press, 1985), 177. This led to the association between Aphrodite, the leader of the cult, and ladders, as seen in a fifth-century red-figure kalpis in the Florence Archaeological Museum (inv. no. 81948) and on a votive relief found in the Athenian Agora. For an exploration of the symbolism of Adonis, see Marcel Detienne, *The Gardens of Adonis: Spices in Greek Mythology*, trans. Janet Lloyd (Princeton: Princeton University Press, 1994); Jane Rowlandson, *Women and Society in Greek and Roman Egypt: A Sourcebook* (Cambridge: Cambridge University Press, 1998), 27.

9. Homer Iliad 24.25–30.

10. Guy M. Hedreen, *Capturing Troy: The Narrative Functions of Landscape in Archaic and Early Classical Greek Art* (Ann Arbor: University of Michigan Press, 2001), 199–208, notes a parallel in the myths of Aphrodite's seduction of Anchises and the Judgment of Paris in that they are both motivated by Zeus's agenda.

11. William Allan, ed., *Helen/Euripides* (Cambridge: Cambridge University Press, 2008), 10, 13; H. Alan Shapiro, "The Judgment of Helen in Athenian Art," in *Periklean Athens and Its Legacy:*

Problems and Perspectives, ed. Jeffrey M. Hurwit and Judith M. Barringer (Austin: University of Texas Press, 2005), 47–62. Alcaeus frag. 42v; Sappho frag. 16v. As Plato writes in *Phaedrus* (243b), the poet recanted and promptly regained his sight.

12. Shapiro, "Judgment of Helen," 48, 53.

13. Aristotle *Politics* 1.3.2; Vernant, "Marriage," 67.

14. Herodotus *Histories* 6.129–30, 1.61. Fearing that any offspring resulting from his marriage to Megacles's daughter might threaten the inheritance of his two sons, Peisistratus reportedly refused to consummate their marriage properly.

15. By Pericles's decree of 451 B.C. See John H. Oakley and Rebecca H. Sinos, *The Wedding in Ancient Athens* (Madison: University of Wisconsin Press, 1993), 10; Vernant, "Marriage," 57.

16. In this case it was used exclusively in a funerary context.

17. The Greeks used torches in various rites of passage because light, in the presence of darkness, was believed to signal transformation. Athenian tragedy tells us that Greek mothers delighted in the privilege of raising the wedding torches of their children; Eva Parisinou, *The Light of the Gods: The Role of Light in Archaic and Classical Greek Cult* (London: Duckworth, 1996), 45, 54.

18. *Supplementum Epigraphicum Graecum* 41, no. 182; translation in Matthew Dillon, *Girls and Women in Classical Greek Religion* (London: Routledge, 2002), 217. The treasury box is in the collection of the Acropolis Museum.

19. Oakley and Sinos, *Wedding in Ancient Athens*, 40. Grapes and other fruits are often present in nuptial scenes, perhaps as symbols of fertility.

20. *Homeric Hymn to Aphrodite* 58–66; translation in Michael Crudden, ed. and trans., *The Homeric Hymns* (Oxford: Oxford University Press), 66–67.

21. Oakley and Sinos, *Wedding in Ancient Athens*, 16. She was a special kind of *nympheutria* (bridal attendant), who was hired to supervise the entire wedding.

22. Detienne, *Gardens of Adonis*, 62; Xenophon *Symposium* 2.3–4; Plutarch *Bruta ratione uti* 990 b–c.

23. A mourning scene on a phormiskos (Kerameikos Museum, inv. no. 691), a perfume bottle with an exclusively funerary use, illustrates the contrast between the elegantly dressed and crowned deceased woman on a bier and her disheveled female mourners (*prothesis*); H. Alan Shapiro, "The Iconography of Mourning in Athenian Art," *American Journal of Archaeology* 95 (1991): 637, 629–56.

24. Oakley and Sinos, *Wedding in Ancient Athens*, 6. On the theme of brides of Hades, see Christiane Sourvinou-Inwood, *"Reading" Greek Death: To the End of the Classical Period* (Oxford: Clarendon Press, 1995), 248–52.

25. John Oakley, *Picturing Death in Classical Athens. The Evidence of the White Lekythoi* (Cambridge: Cambridge University Press, 2004), 85, 103.

26. There are five known terracotta parallels: Dresden, Staatliche Skulpturensammlung, 1495; London, British Museum, 1904, 7-8, 6; J. H. Fitzhenry Collection (1904); Wurzburg, Martin von Wagner-Museum, Prov. H. 3844; Thebes Museum (inv. no. unknown). There are no known examples in bronze.

27. Berlin, Antikensammlung, 30036.

28. Shapiro, "Judgment of Helen," 50–52.

EROS, CHILD OF APHRODITE

1. The following discussion of Eros in the Greek world owes a great debt to Barbara Breitenberger's study *Aphrodite and Eros: The Development of Erotic Mythology in Early Greek Poetry and Cult* (New York: Routledge, 2007).

2. Plato *Symposium* 203b2–c1.

3. Poet Meleager, *Anth. Pal.* 5, 177; translation in Breitenberger, *Aphrodite and Eros*, 165.

4. Hesiod *Theogony* 116–20.

5. Plato *Symposium* 189c4–8.

6. Euripides *Hippolytus* 538–40; translation in Breitenberger, *Aphrodite and Eros*, 139.

7. Hesiod *Theogony* 120–23; translation in Breitenberger, *Aphrodite and Eros*, 151.

8. See "The Creation and Birth of Eros at the Symposium," in Breitenberger, *Aphrodite and Eros*, 171–94; Robert F. Sutton, Jr., "Pornography and Persuasion on Attic Pottery," and H. A. Shapiro, "Eros in Love: Pederasty and Pornography in Greece," in *Pornography and Representation in Greece and Rome*, ed. Amy Richlin (New York and Oxford: Oxford University Press, 1992), 3–35, 53–72; and H. A. Shapiro, "Courtship Scenes in Attic Vase-Painting," *American Journal of Archaeology* 85, no. 2 (April 1981): 133–43. For the view that some of these vases were produced for the Etruscan market, see Kathleen M. Lynch, "Erotic Images on Attic Vases: Markets and Meanings," in *Athenian Potters and Painters III*, ed. John H. Oakley and Olga Papagia (Oxford: Oxbow Books, 2009), 159–65.

9. The power of his wings is expressed in a Hellenistic epigram from the *Anthologia Palatina* (5.59): "'You should flee Eros': empty effort! How shall I elude on foot one who chases me on wings?" Translation in Anne Carson, *Eros the Bittersweet: An Essay* (Princeton: Princeton University Press, 1986), 157.

10. According to the Greek lyric poet Alcman of Sparta, in *Poetarum Melicorum Graecorum Fragmenta: Volumen I: Alcman, Stesichorus, Ibycus*, ed. Malcolm Davies (Oxford: Oxford University Press, 1991), frag. 58. Translation in Breitenberger, *Aphrodite and Eros*, 190–91.

11. The orgy is described in Aristophanes, *Peace* (894–905), in Thomas F. Scanlon, *Eros and Greek Athletics* (Oxford: Oxford University Press, 2002); see esp. 269–70 and n. 231 for the use of horse riding as a sexual metaphor.

12. For a full exploration of how these riddle nets, or *griphoi* and *homonymia* (double meanings), are reflected on Greek vases, see Richard Near, *Style and Politics in Athenian Vase Painting* (Cambridge: Cambridge University Press, 2002), esp. 13–14, 40–41, 46, 62–63.

13. The cup is in the collection of the Pithecousae Archaeological Museum, Italy.

14. Anacreon frag. 369; Sophocles *Trachiniae* 441, translation in Scanlon, *Eros and Greek Athletics*, 261.

15. For the interpretation of this ring, see Christine Kondoleon, *Art of Late Rome and Byzantium in the Virginia Museum of Fine Arts*, exh. cat. (Richmond: Virginia Museum of Fine Arts, 2004), cat. nos. 3, 36–37.

16. For a discussion of the sexual innuendos associated with sandals and Eros, see Marjorie Susan Venit, "Fit to Be Tied: The Punishment of Eros and Two Vases by Euphronios in the Villa Giulia," in *Essays in Honor of Dietrich von Bothmer*, ed. Andrew J. Clark and Jasper Gaunt (Amsterdam: Allard Pierson 2002), 318–22.

17. In the House of the Epigrams at Pompeii; see Bettina Bergmann, "A Painted Garland: Weaving Words and Images in the House of the Epigrams in Pompeii," in *Art and Inscriptions in the Ancient World*, ed. Zahra Newby and Ruth Leader-Newby (Cambridge: Cambridge University Press, 2007), 60–101, esp. 82–87.

18. Contrary to the "obsession with flagellation" demonstrated by eighteenth- and nineteenth-century English pornography, whipping does not appear otherwise in an erotic context in ancient art. See Catherine Johns, *Sex or Symbol: Erotic Images of Greece and Rome* (Austin: University of Texas, 1982), 113.

19. Geminus, "On a Statue of Herakles," in *The Greek Anthology*, trans. W. R. Paton, vol. 5, book 16.103, Loeb Classical Library 86 (Cambridge, Mass., and London: Harvard University Press, 1953), 217.

20. Bowdoin College Museum, inv. 1906.2, dated from 3rd–1st century B.C.; see *Lexicon Iconographicum Mythologiae* (Zurich and Munich: Artemis Verlag, 1988), vol. 4.1, 173, no. 3419.

21. Because of its uniqueness, many scholars have written on this object, most recently Andrew Stewart, "Reflections," in *Sexuality in Ancient Art*, ed. Natalie Boymel Kampen (Cambridge: Cambridge University Press, 1996), 136–54, esp. 145–50, and John R. Clarke, *Looking at Lovemaking* (Berkeley: University of California Press, 1998), 22–27. Both are open to the possibility that the female represented is the famous Corinthian *hetaira* Leaina, nicknamed the "Lioness" because she was adept at the sexual position depicted on the mirror's interior engraving.

22. See Brunilde Ridgway, *Hellenistic Sculpture*, vol. 2 (Madison: University of Wisconsin Press, 2000), 253.

23. Secundus puts it best: "What shall men's strength avail when Love has stormed heaven and…despoiled the immortals of their arms!" "On Statues of Loves," in *The Greek Anthology*, trans. W. R. Paton, vol. 5, book 16.214, 287.

24. Quoted in Jean Sorbella, "Eros and the Lizard: Children: Animals and Roman Funerary Sculpture," in *Constructions of Childhood in Ancient Greece and Italy* (*Hesperia Supplement* 41), ed. Ada Cohen and Jeremy B. Rutter (Princeton: American School of Classical Studies at Athens, 2007), 355. Sorbella provides a recent discussion (353–70) of the type represented by some 180 marble examples dating from the first through fourth centuries A.D.

25. Museum of Fine Arts, Boston, 1991.1020.

26. Ovid *Metamorphoses* 4.285.

THE FEMALE NUDE IN CLASSICAL ART: BETWEEN VOYEURISM AND POWER

1. John Berger, *Ways of Seeing* (New York: Viking Press, 1972), chap. 3, 45–64; Kenneth Clark, *The Nude: A Study in Ideal Form* (Washington, DC: Trustees of the National Gallery of Art, 1956).

2. On the Knidia, see especially Christine Mitchell Havelock, *The Aphrodite of Knidos and Her Successors: A Historical Review of the Female Nude in Greek Art* (Ann Arbor: University of Michigan Press, 1995); Kristen Seaman, "Retrieving the Original Aphrodite of Knidos," *Rendiconti delle sedute della Accademia nazionale dei Lincei, Classe di Scienze morali, storiche e filologiche* 9 (2004): 531–94, with previous bibliography.

3. Havelock, *Aphrodite of Knidos*, 36–37; Andrew Stewart, *Art, Desire and the Body in Ancient Greece* (Cambridge: Cambridge University Press, 1997), 97–106.

4. On these images, see Rachel Kousser, *Hellenistic and Roman Ideal Sculpture: The Allure of the Classical* (Cambridge: Cambridge University Press, 2008).

5. The classic example is Adolf Furtwängler, *Masterpieces of Greek Sculpture*, trans. Eugenie Sellars (New York: Charles Scribner's Sons, 1895), 387–88, followed by many later scholars.

6. Charles K. Williams, "Corinth and the Cult of Aphrodite," in *Corinthiaca* (Columbia: University of Missouri, 1986), 12–24. For the varied cults of Aphrodite, see Vinciane Pirenne-Delforge, *L'Aphrodite grecque: Contribution à l'étude de ses cultes et de sa personnalité dans le panthéon archaïque et classique*, Kernos supplement 4 (Athens and Liège: Centre Internationale d'Etude de la Religion Grecque Antique, 1994); also useful is the section on Aphrodite in Lewis Richard Farnell, *Cults of the Greek States*, vol. 2, chaps. 21–23 (Oxford: Clarendon Press, 1896); see also Pirenne-Delforge and Pironti's essay in this volume.

7. Kousser, *Hellenistic and Roman Ideal Sculpture*, 19–28.

8. On the cult of Roman Venus, see Evamaria Schmidt, "Venus," in *Lexicon Iconographicum Mythologiae Classicae*, vol. 8 (Zurich: Artemis Verlag, 1997), 192–230; G. Lloyd-Morgan, "Roman Venus: Public Worship and Private Rites," in *Pagan Gods and Shrines of the Roman Empire*, ed. Martin Henig and Anthony King (Oxford: Oxford University Committee for Archaeology, 1986), 179–88; Ariadne Staples, *From Good Goddess to Vestal Virgins: Sex and Category in Roman Religion* (London: Routledge, 1998), part 3, "Venus' Role in Roman Religion," 95–126.

9. Temple of Venus Obsequens: Livy 10.31.9. Temple of Venus Erycina: Livy 22.10.10, 40.34.4; Strabo 6.2.6; Ovid *Fasti* 4.871–76.

10. Sulla: Plutarch *Sulla* 19.5, 34.4; Appian *Civil Wars* 1.97. Pompey: Plutarch *Pompey* 68.

11. Stefan Weinstock, *Divus Julius* (Oxford: Clarendon Press, 1971), 17 (early coins of Julian family), 82–91 (Caesar and Venus). Rachel Kousser, "Augustan Aphrodites: The Allure of Greek Art in Roman Visual Culture," in *Brill's Companion to Aphrodite*, ed. Amy C. Smith and Sadie Pickup (Leiden and Boston: Brill, 2010); Paul Zanker, *The Power of Images in the Age of Augustus*, trans. Alan Shapiro (Ann Arbor: University of Michigan Press, 1988), 195–99.

12. Susan B. Matheson, "The Divine Claudia: Women as Goddesses in Roman Art," in *I, Claudia: Women in Ancient Rome*, ed. Diana E. E. Kleiner and Susan B. Matheson (New Haven: Yale University Art Gallery, 1996), 182–94, esp. 182–84. Kousser, *Hellenistic and Roman Ideal Sculpture*, 100–106.

13. Wilhelmina Jashemski, *The Gardens of Pompeii* (New Rochelle, N.Y.: Caratzas Brothers, 1979), 124–31.

14. On the nude in Roman art, see especially Eve D'Ambra, "The Calculus of Venus: Nude Portraits of Roman Matrons," in *Sexuality in Ancient Art*, ed. Natalie Boymel Kampen (Cambridge: Cambridge University Press, 1996), 219–32, and "Nudity and Adornment in Female Portrait Sculpture of the Second Century A.D.," in *I, Claudia II: Women in Roman Art and Society*, ed. Diana E. E. Kleiner and Susan B. Matheson (Austin: University of Texas Press, 2000), 101–14; Christopher Hallett, *The Roman Nude: Heroic Portrait Statuary 200 B.C.–A.D. 300* (Oxford: Oxford University Press, 2005).

15. Most influential here has been Furtwängler, *Masterpieces of Greek Sculpture*, with many later followers; for an extensive discussion of the historiography of Greek-style Roman sculptures, see Miranda Marvin, *The Language of the Muses: The Dialogue Between Roman and Greek Sculpture* (Los Angeles: Getty Publications, 2008).

16. Kousser, *Hellenistic and Roman Ideal Sculpture*, 1–8, 136–51.

17. Katherine Dunbabin, "*Baiarum grata voluptas*: Pleasures and Dangers of the Baths," *Papers of the British School in Rome* 57 (1989): 6–46.

18. Antonio Giuliano, ed., *Museo Nazionale Romano: Le sculture*, vol. 1 (Rome: De Luca Editore, 1981), 170–76.

19. Mary Boatwright, *Hadrian and the Cities of the Roman Empire* (Princeton: Princeton University Press, 2000), 173–82.

20. Jashemski, *Gardens of Pompeii*, 124; Henning Wrede, *Consecratio in formam deorum: Vergöttlichte Privatpersonen in der römischen Kaiserzeit* (Mainz am Rhein: Verlag Philipp von Zabern, 1981), 72. On the desecration and transformation of one such temple, in the ancient city of Aphrodisias (in present-day Turkey), see Robin Cormack, "Byzantine Aphrodisias: Changing the Symbolic Map of a City," *Proceedings of the Cambridge Philological Society* 216 (1990): 32–34.

21. For some martial Venuses, see Kousser, *Hellenistic and Roman Ideal Sculpture*, 58–62, 124–25.

RECENT WORKS

· · · · ·

Breitenberger, Barbara. *Aphrodite and Eros: The Development of Erotic Mythology in Early Greek Poetry and Cult.* New York: Routledge, 2007.

Brody, Lisa R. *The Aphrodite of Aphrodisias.* Aphrodisias III. Results of the Excavations at Aphrodisias in Caria conducted by New York University. Mainz am Rhein: Verlag Philipp von Zabern, 2007.

Cyrino, Monica S. *Aphrodite.* New York: Routledge, 2010.

Delivorrias, Angelos. "Aphrodite," in *Lexicon Iconographicum Mythologiae Classicae,* vol. 2, edited by L. Kahil, 2–151. Zurich: Artemis Verlag, 1981.

Havelock, Christine M. *The Aphrodite of Knidos and Her Successors: A Historical Review of the Female Nude in Greek Art.* Ann Arbor: University of Michigan Press, 1995.

Kaltsas, Nikolaos E., and H. Alan Shapiro. *Worshiping Women: Ritual and Reality in Classical Athens.* New York: Alexander S. Onassis Public Benefit Foundation (USA) in collaboration with the National Archaeological Museum, Athens, 2008.

Karageorghis, Jacqueline. *Kypris: The Aphrodite of Cyprus: Ancient Sources and Archaeological Evidence.* Nicosia, Cyprus: A. G. Leventis Foundation, 2005.

Kousser, Rachel M. *Hellenistic and Roman Ideal Sculpture: The Allure of the Classical.* Cambridge: Cambridge University Press, 2008.

Oakley, John H., and Rebecca H. Sinos. *The Wedding in Ancient Athens.* Madison: The University of Wisconsin Press, 1993.

Pirenne-Delforge, Vinciane. *L'Aphrodite grecque: Contribution à l'étude de ses cultes et de sa personnalité dans le panthéon archaïque et classique.* Kernos supplement 4. Athens and Liège: Centre International d'Etude de la Religion Grecque Antique, 1994.

Pironti, Gabriella. *Entre ciel et guerre: Figures d'Aphrodite en Grèce ancienne.* Kernos supplement 18. Athens and Liège: Centre International d'Etude de la Religion Grecque Antique, 2007.

Reeder, Ellen D., ed. *Pandora: Women in Classical Greece.* Baltimore: Trustees of the Walters Art Gallery in association with Princeton University Press, 1995.

Rosenzweig, Rachel. *Worshipping Aphrodite: Art and Cult in Classical Athens.* Ann Arbor: University of Michigan Press, 2004.

Smith, Amy C., and Sadie Pickup, eds. *Brill's Companion to Aphrodite.* Leiden and Boston: Brill, 2010.

INDEX

■ ■ ■ ■ ■

195; attributed to the Euaion Painter, 136, 200; attributed to the Kadmos Painter, 75, 195; attributed to the Manner of the Meidias Painter, 73, 75, 195; attributed to the Painter of London, 137, 200–201; attributed to the Pan Painter, 112, 199–200; Penthesilea Painter, 44, 45, 190; attributed to the Primato Painter, 92, 198–99; attributed to the Providence Painter, 132, 200; attributed to the Tyszkiewicz Painter, 176, 207; Heimarene, 82; Makron, 68, 69, 72, 194; Nikosthenes, 113, 114, 115, 201; . See also ceramic (black-figure technique); ceramic (red-figure technique)

vases: and Arretine ware, 120, 121, 123, 202; funerary function of, 65, 70, 71, 75, 79, 82, 193, 194–95; nuptial imagery on, 82; and sexual activity imagery, 123. See also specific form

vases, Kabeiric, 91, 194

Venus, cult of: associated with victory and expansion, 157–59; emperors' alignment with, 159; and empresses, 159, 159, 172, 207, 208; and funerary art, 162, 163, 165, 166, 207; origin of, in Cyprus, 33; and private worship, 162, 165–66; war and victory, 157–59; worship patterns, versus Aphrodite, 157–58

Venus, mythology of: differences with Aphrodite, 157, 162; and Herakles (see Herakles); linked to Aphrodite, 108–9; patroness and protector roles, 13, 157–59, 162; and Psyche, 125; and punishment imagery, 118; in Roman imperial ancestry, 12, 65, 109, 157. See also Aphrodite, mythology of

Venus, representations of, 207–8; bowl, mixing (calyx krater), 176, 207; cameo, 159, 172, 207; coin, 159, 167, 207–8; cup, 64, 193; Greek-style Aphrodites used for, 162, 164, 165; mixing bowl (calyx krater), 176, 207; statuette, 163, 207; Venus Giving Arms to Aeneas (Giordano), 177; Venus Rising from the Sea (Chassériau), 179

Venus (Botero), 100

Venus Erycina, 158

Venus Felix, 159

Venus Genetrix, 159, 172, 207

Venus Giving Arms to Aeneas (Giordano), 177

Venus Obsequens, 158

Venus (planet). See star, evening and morning

Venus Rising from the Sea (Chassériau), 179

Venus Victrix, 158, 167, 191, 208

victory, military: Aphrodite associated with (see Aphrodite of Capua); Venus associated with, 157–59

virility, and cult of Aphrodite, 45

Voluptas (daughter of Cupid and Psyche), 125, 202

votive relief, 53, 190

votives, 20, 32; Naukratis, 58, 191

W

war: Aphrodite associated with, 20–21, 32, 43, 46, 47–49, 86, 158, 190, 191, 198 (see also Aphrodite of Capua); and eros (warlike energy), 46; Inana/Ishtar associated with, 17, 23; Venus associated with, 157–58. See also Ares

Warren, Edward Perry, 14–15

wedding. See nuptial imagery; nuptial rituals

weighing of love (erotostasia), 116, 138, 201

wine cup. See skyphos

Winkler, John, 44

women, unmarried: and funerary art (see funerary art, unmarried women mourned in)

wrestling contests, 116, 116–17

X

Xenophon, 76

Y

youth: and age of marriage, 69; in homoerotic imagery, 110, 111, 111, 113, 136, 199, 200; and sexuality, 45

youths, winged, 126, 128; in funerary art, 126

Z

Zeus: and Aphrodite, 29, 63, 65; and Ares, 63; attributes, 90, 194; and Eros, 107; in Iliad (Homer), 64; and Judgment of Paris, 66–67; and Three Graces, 196

Zeus Teleios, 63

CONTRIBUTORS

.

JACQUELINE KARAGEORGHIS received her PhD from the University of Lyon and is an expert on the cult of Aphrodite in Cyprus. She has written numerous articles and books, including *The Coroplastic Art of Ancient Cyprus* and *Kypris: The Aphrodite of Cyprus: Ancient Sources and Archaeological Evidence*.

CHRISTINE KONDOLEON is the George D. and Margo Behrakis Senior Curator of Greek and Roman Art at the Museum of Fine Arts, Boston. A specialist in late Roman and Early Byzantine art, she has written and lectured widely on mosaics and domestic arts. She curated the exhibitions and authored the catalogues *Antioch: The Lost Ancient City* and *Games for the Gods*.

RACHEL KOUSSER is an associate professor in the Department of Art at Brooklyn College. A specialist in Greek and Roman art, she is the author of *Hellenistic and Roman Ideal Scultpure*. She is currently working on a project concerning violence towards images in Greek art.

DIANA K. MCDONALD is an art historian and lecturer at Boston College. She has a particular interest in the representation of animals in ancient art. She contributed nine essays to *The Looting of the Iraq Museum, Baghdad* and has lectured frequently at the Museum of Fine Arts, Boston, and other museums.

VINCIANE PIRENNE-DELFORGE is a senior research associate at the Fonds de la Recherche Scientifique (FNRS), a professor at the University of Liège, and the scientific editor of the journal *Kernos*. She has written extensively on Greek religion, especially Greek gods. Her publications include *L'Aphrodite grecque* and *Retour à la source: Pausanias et la religion grecque*.

GABRIELLA PIRONTI is an assistant professor and researcher in History of Religions at the University of Naples Federico II. Her research focuses on ancient Greek religion and polytheism and its representations. Her publications include *Entre ciel et guerre: Figures d'Aphrodite en Grèce ancienne* and an introduction to and commentary on Hesiod's *Theogony*.

DAVID SAUNDERS is an assistant curator of Antiquities at the J. Paul Getty Museum. He curated the travelling exhibition "The Golden Graves of Ancient Vani." His dissertation, "'Sleepers in the Valley': Athenian Vase-Painting 600–400 B.C. and Beautiful Death," examined the representation of dead and dying figures on Athenian pottery.

PHOEBE C. SEGAL is the Mary Bryce Comstock Assistant Curator of Greek and Roman Art at the Museum of Fine Arts, Boston. Her dissertation, "Soaring Votives: *Anathemata* in Archaic Greek Sanctuaries," explored the use of columns and pillars as pedestals for votive statues. She is currently working on an article concerning the representation of the Adonia in Athenian art and comedy.

MFA PUBLICATIONS
Museum of Fine Arts, Boston
465 Huntington Avenue
Boston, Massachusetts 02115
www.mfa.org/publications

This book was published in conjunction with the exhibition "Aphrodite and the Gods of Love," organized by the Museum of Fine Arts, Boston.

Museum of Fine Arts, Boston
October 26, 2011–February 20, 2012

J. Paul Getty Museum at the Getty Villa, Malibu, California
March 28, 2012–July 9, 2012

San Antonio Museum of Art, Texas
September 15, 2012–February 17, 2013

The exhibition is sponsored by United Technologies Corporation.

The exhibition is organized under the auspices of the President of the Italian Republic, in celebration of the 150th anniversary of the unification of Italy.

Generous support for this publication was provided by the A. G. Leventis Foundation.

© 2011 by Museum of Fine Arts, Boston

ISBN 978-0-87846-756-3 (hardcover)
ISBN 978-0-87846-757-0 (softcover)
Library of Congress Control Number: 2009942107

The Museum of Fine Arts, Boston, is a nonprofit institution devoted to the promotion and appreciation of the creative arts. The Museum endeavors to respect the copyrights of all authors and creators in a manner consistent with its nonprofit educational mission. If you feel any material has been included in this publication improperly, please contact the Department of Rights and Licensing at 617 267 9300, or by mail at the above address.

The MFA is proud to be a leader within the American museum community in sharing the objects in its collection via its Web site. Currently, information about more than 330,000 objects is available to the public worldwide. To learn more about the MFA's collections, including provenance, publication, and exhibition history, kindly visit www.mfa.org/collections.

For a complete listing of MFA publications, please contact the publisher at the above address, or call 617 369 4230.

Front cover: *Statuette of Aphrodite emerging from the sea*, Greek or Roman, Hellenistic or Imperial period, 1st century B.C.–1st century A.D. (cat. no. 18)

Back cover: *Statuette of Eros wearing the lion skin of Herakles*, Greek, Hellenistic period, late 1st century B.C. (cat. no. 99)

All illustrations in this book were photographed by the Imaging Studios, Museum of Fine Arts, Boston, except where otherwise noted.

Edited by Julia Gaviria and Mark Polizzotti
Production Editor: Jodi M. Simpson

Designed by Cynthia Rockwell Randall
Produced by Cynthia Rockwell Randall and Terry McAweeney
Printed and bound at CS Graphics Pte Ltd, Singapore

Available through
D.A.P. / Distributed Art Publishers
155 Sixth Avenue, 2nd floor
New York, New York 10013
Tel.: 212 627 1999 · Fax: 212 627 9484

FIRST EDITION
Printed and bound in Singapore
This book was printed on acid-free paper.